The word and image are one.

Hugo Ball (1915)[1]

...AROUND THE CO... THE SIDE STREET. HE SWI...
LL CRASH AS IT'S CHASSIS VIRTUALLY...
THE HUMP, LANDS WITH A CRASH, THE DRIVERS EYE...
MMERS BENEATH THE WHEELS. WITH OUT SHIFTING UP A GEAR A...
LEAVES WIDE SNAKY TRACKS IN IT'S WAKE. THE RIM OF HIS CA...
ILL. THE CAR BEHIND SCREECHES ROUND THE CORNER, IT'S DRIV...
HE CRANES HIS NECK ROUND AND LEANS OUT OF THE DRIVERS...
ST AND SQUEALS OFF, FRANTICALLY MONKEYING THE STEERING...
IS FORWARDS AND GLANCES DOWN THE SIDE STREETS AS HE PA...
CAR IS FRAMED THE WINDSCREEN. THE LINE OF THE DASH IS INT...
SHING TOWARDS THEM. THE DECLINE BECOMES EVEN STEEPER AN...
THEM. THEN THE HILL CURVES SLIGHTLY AND THE HORIZON IS VIS...
T THE HILL. THE ROAD HURLS ITSELF TOWARDS HIM, AND HIS CAR...
LIEVABLE. HE YANKS THE STEERING WHEEL ROUND AS HE TAKES THE...
EP CONTROL. THE ROAD JERKS IN FRONT OF HIM. HE SKIDS ROUND...
ECOND THE SECOND CAR IS RIGHT ON IT'S TAIL. THE CURVE ARCS E...
AIL. HE BRAKES HARD ONTO IT, THE BEND SHARPENS AND ANOTHER...
EAKS OFF. THE FOREGROUND WHIZZES BY, ALL THE SAME. FOR A SPL...
LERATES. THE VIBRATION OF THE ENGINE'S DEAFENING AS THEY CAREE...
AKES SCREAM AND THEN THEY'RE GUNNING ACROSS THE STRAIGHT AG...
I FRONT OF THE DIRTY WINDSCREEN. THE DRIVER OF THE GREEN CAR S...
HE BLACK CAR APPEARS FIRST. THE TRAFFIC IS MUCH THINNER NOW...
OBLIQUELY, GLIMPSING THE CAR BEHIND. THE GAP BETWEEN...
ACH OTHER GLANCES IN THEIR WING MIRROR...
ROAD, BLINDED BY ONCOMI...
SECOND...

Simon Morley

Writing on the Wall

**Word and Image
in Modern Art**

University of California Press
Berkeley Los Angeles

For my parents

University of California Press
Berkeley and Los Angeles, California

Published by arrangement with
Thames & Hudson Ltd, London

© 2003 Simon Morley

Designed by Keith Lovegrove

Cataloging-in-Publication data is on file with the Library of Congress
ISBN 0-520-24108-8

Printed and bound in Hong Kong

9 8 7 6 5 4 3 2 1

Frontispiece: 1 **Fiona Banner** *Car Chases (Bullitt)* (detail) 1998

Foreword

Words in art are words.
Letters in art are letters.
Writing in art is writing.

Ad Reinhardt (1966)[1]

This is a survey of the ways in which written words have been used in modern art from the Impressionists to the present day. I define writing relatively narrowly, taking as my starting point the entry in the *Oxford English Dictionary*: 'the penning or forming of letters or words, the using of written characters for purposes of record, transmission of ideas, etc.' This definition I have expanded upon to include what Roland Barthes called 'graphism' – modes of motivated inscription not so bound to the tasks of visualizing speech or forming legible characters, but instead directed towards conveying the restless energy of the body via some normally hand-held tool. In this context, the distinction between drawing and writing often breaks down, but a residual linearity and clear spatialization of marks signify the basis of these inscriptions in a primal act of writing, a rhythmically visual phenomenon independent of speech. (Readers may be relieved to learn, however, that I do not go so far as Jacques Derrida, who defined writing as 'all that gives rise to inscription in general, whether it is literal or not and even if what it distributes in space is alien to the order of the voice: cinematography, choreography, of course, but also pictorial, musical, sculptural "writing".[2]) So, two poles of the phenomenon of writing are established in *Writing on the Wall*, the first concerning legibility, discursive communication and the mind, the second illegibility, direct, unmediated communication and the pulse of the body.

This is a time when digitalization has fundamentally undermined basic distinctions between media. The coordinates established long ago in the caves of Lascaux (and then rather more recently in Johann Gutenberg's printing office) are being replaced by the 'zero dimension' of virtual reality. But this study should not be thought of simply as a record of the demise of traditional writing conventions or of the book itself, nor as a 'requiem' for their passing. Rather, it hopes to function as a guide to the many ways in which modern artists have paved the way for – and sometimes resisted – the dawning of our brave new electronic and post-literate world, a world in which word and image together inhabit a new kind of both physical and conceptual space.

The structure of *Writing on the Wall* is essentially chronological, but the chapters are by no means entirely discrete from one another and often overlap. So, for example, Chapter 2 seeks to situate Impressionism in its broader cultural context; Chapter 3 begins with Symbolism and ends with Expressionism, taking in along the way van Gogh and Gauguin. Chapter 9, on the other hand, takes a more thematic approach in exploring the impact of totalitarianism on the visual arts and communication. In such a panoptic survey omissions are inevitable, and I am sure that readers may find some of their own favourites missing. As the book gets closer to the present day, the

increasing presence of words in artworks means that the overview becomes more selective, seeking to draw attention to major trends, in particular to the impact of globalization and new media. Furthermore, I do not attempt to deal thoroughly with either poster art or the phenomenon of the 'artist's book', although on occasion important examples of both will be mentioned. There are already a number of very good studies on these subjects – some of which can be found in the Bibliography – and I felt it was more important to stick to a survey of interactions between word and image that actually take place on the wall of the art gallery (with a brief final excursus concerning writing on the computer screen). Indeed, *Writing on the Wall* is a small slice of a potentially enormous cake, a probably unwieldy confection that would address all the ways – direct and indirect – in which language has interacted with image throughout world history.

As my own artistic endeavours investigate the interactions between word and image, reading and seeing, this book is based on some practical experience. It is also the result of many years spent on the 'shop floor', working with members of the public in art galleries and museums, and with students in their studios. I hope this background has served to enliven my account which, nevertheless, clearly draws on the pioneering work of such art historians as Johanna Drucker, Rosalind Krauss, W. J. T. Mitchell, Marjorie Perloff, Robert Rosenblum and John C. Welchman. I would like to thank the institutions that have made images and texts available, the artists who have answered my questions, those who have knocked ideas around with me over the years – especially Simon Pummell – Paul T. Werner for suggesting some contemporary word artists, Eugene Tan for reading over the Conceptual art chapters, the Library at the Sotheby's Institute of Art, Kendall Smalling Wood for some research early on, and the Wordsworth Trust for much needed mountain air in the last stages. I would especially like to salute the team at Thames & Hudson for their enthusiasm and dedication, particularly Philip Collyer, Christopher Dell, Keith Lovegrove and Katie Morgan. Finally, I would like to thank Lindy Usher for helping to grapple with the Index, and much else besides.

Simon Morley. March 2003

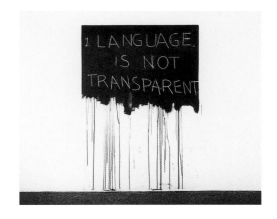

2 **Mel Bochner** *Language is Not Transparent* 1970
A crudely scrawled text announces the awkward truth that the words we use do not give us direct access to the world they describe but are just arbitrary signs.

3 **Ed Ruscha** *"-So"* 1999
Some kind of advertisement, perhaps? Words in modern art are often
inspired by the mass media, but rarely deliver a clear message.

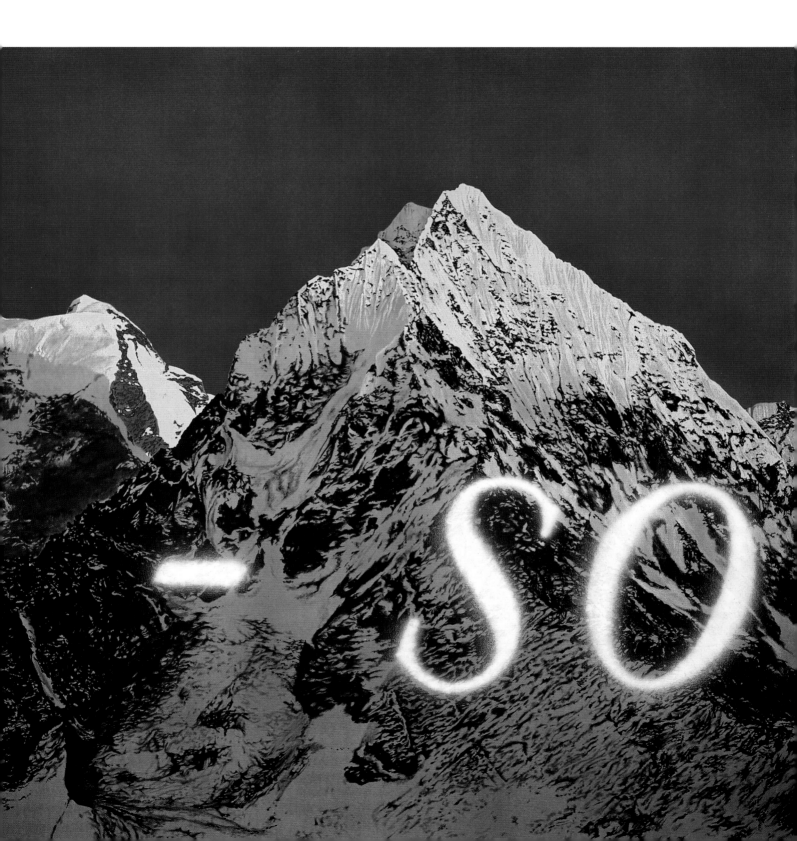

1

Introduction: Words and Pictures

A snow-covered mountain, its peak touched by sunlight, rears upwards into the deep blue sky. Across its flank can be read a curiously equivocal piece of text that looks semi-transparent, as if it may actually be projected onto the face of the mountain itself. Could it be an advertisement for something? Mountains have been used to sell most things, though if so, the product is certainly rather obscure. A new perfume, perhaps?

Of course, this is no advertisement, but a recent painting by the American artist Ed Ruscha. It may indeed trade on the language of advertising, but it is most definitely a work of art, and engages the viewer in two distinct modes of information gathering – one involving the visual scanning of the image and the other the reading of the words. The former mode allows openness of interpretation and freedom of mental and sensual movement, while the latter confines the reader to a predetermined route constructed from a horizontal row of letters to be deciphered from left to right and top to bottom. Indeed, the activities of seeing and reading occur at quite different tempos and involve different orderings of perception – the brain must configure consciousness in distinct ways for each activity and we simply cannot do both simultaneously. Scientists, in seeking to find the roots of this difference in the structures of the brain, have distinguished between the 'left brain', which has a bias towards the rational, logical and discursive, and the 'right brain', which is image-based and the site of non-logical, intuitive skills. Thus, it is argued, reading and seeing also involve wholly different mental faculties and motor skills.[2] By mixing up the spaces of writing and picturing, Ruscha has, perhaps deliberately, perhaps inadvertently, engineered a collision between our two 'brains'.

This kind of play with perception and conception – image and text – can, in fact, be located within a broad typological schema that traces the verbal and the visual through increasingly complex and intimate kinds of relationship. As the American philosopher Charles Sanders Peirce suggested in the late nineteenth century, words and images are all *signs* and can be reduced to three basic types: the 'iconic', the 'symbolic' and the 'indexical'.[3] Images are 'iconic' in that they resemble the thing to which they refer, and, as a consequence, seem to have a close bond to reality. Words – defined by Peirce as 'symbolic' – are far more arbitrary in their sound or shape, and are only by convention related to their referent. They refer to what they name, operating by way of description, depending on a shared lexical storehouse for mutual comprehension. Finally, the 'indexical' sign Peirce described as having some directly causal or existential connection to the referent, as in the case of a pointing finger or a physical trace that links the sign directly to the body of the maker. Furthermore, written sentences have highly differentiated structures based on rules of syntax and semantics; images, on

I can see why many visual artists dislike words in artworks. They feel that words dirty the clear water that has reflected the sky. It disturbs the pleasure of the silent image, the freedom from history, the beauty of nameless form.
I want to name our pains.
I want to keep our names.
I know that neither images nor words can escape the drunkenness and longing caused by the turning world.
Words and images drink the same wine.
There is no purity to protect.
Marlene Dumas (1984)[1]

the other hand, are difficult to break down into distinguishable and meaningful components. The Swiss linguist Ferdinand de Saussure, in addressing the structure of the linguistic sign specifically, argued (not too long after Peirce) that a word could be understood as comprising three aspects: the 'signifier' (the aural and written form of the word itself), the 'signified' (the meaning ascribed to that form), and the 'referent' (that element of reality that these components bring to mind when combined).[4] Like Peirce, Saussure stressed that the union of 'signifier' and 'signified' is an entirely arbitrary one, as words do not have a natural relationship to meaning, a point that was to be made a little later by René Magritte's celebrated marriage of an image of a pipe with the words 'Ceci n'est pas une pipe' – this is not a pipe – in *The Betrayal of Images*.

Four kinds of interaction between the visual and the verbal sign can be identified and these form recurrent themes in this book.[5] Firstly, there is the *trans-medial* relationship. Here, word and work are connected by way of transposition or substitution: the one is essentially a supplement to the other. Such visual–verbal interfaces include any kind of writing or imaging in which the linguistic and the visual remain clearly distinguished both in time and in space, and also in relation to the division of labour. This implies a hierarchy in which the text remains subordinate to the image (or vice versa). Illustrated books and surveys such as this one, art criticism, theoretical discourses and commentaries, or gallery wall labels are all examples of the trans-medial. In the modern period (starting with the nineteenth-century Romantics), however, the clarity of this division can become blurred when artists themselves take on the literary roles once laid aside for others, either writing within the traditional sites of literary discourse or else bringing words into the art gallery, as in a recent work by the American Conceptual artist Lawrence Weiner, *A Basic Assumption*.

Secondly, there is the *multi-medial* relationship. Here, word and image coexist more closely, sharing the same space, though remaining clearly distinguished in terms of spatial relations, kinds of intelligibility and often the division of labour. Prominent examples of this category are shop signs and public notices, advertisements, comic books, or artworks that

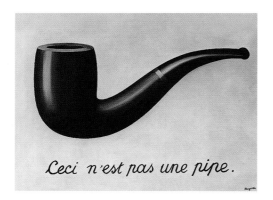

4 **René Magritte** *The Betrayal of Images* 1928–29
One of the most celebrated instances in art of word and image apparently misbehaving but actually imparting a profound truth.

5 **Lawrence Weiner** *A Basic Assumption* 1999
A recent work by a veteran Conceptualist in which words become the raw material for making art.

incorporate the title, caption, or some kind of elucidating text while still keeping word and image spatially and cognitively segregated. Traditionally, this relationship has also been hierarchical, with either the image serving to illustrate some text or, conversely, the text used to tie down the specific meaning of an image. Images, after all, are mute and intrinsically vague from the point of view of communication. Without the Latin warning *Cave canem* – beware of the dog – we might assume that the sign from the ruins of Pompeii is simply a representation of some favourite canine. The text in Fra Angelico's painting of the Annunciation from the 1430s – a kind of ancient ancestor of the comic-strip speech bubble – is there to consolidate and make specific the Christian message also carried by the image, while the person depicted in an etching by Dürer from 1526 might be any learned scribe, but the written text informs us that he is one in particular – *Erasmi Roterodami* [*14*]. But, as we shall see, in modern art this kind of orthodox coupling is often deliberately confused or reversed. In the *livre d'artiste* – the 'artist's book' – as it emerged in France in the late nineteenth century, for example, a more independent, yet mutual, role was envisaged for both artist and poet. As artists began to engage with mass media, other multi-medial approaches emerged in Cubist and Dada works, titles inscribed on Surrealist paintings, or Pop art appropriations of comic book images. Thus, the work of the present-day white South African artist Marlene Dumas [*9*] can be categorized as multi-medial, the customary sharing out of roles and hierarchies being thoroughly disrupted, with Dumas taking responsibility for both word and image, mixing up meanings and confusing traditional roles.

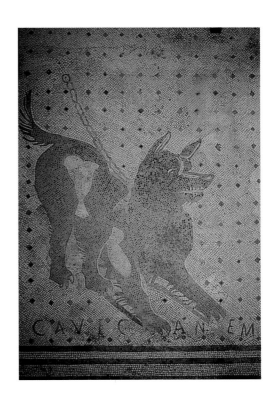

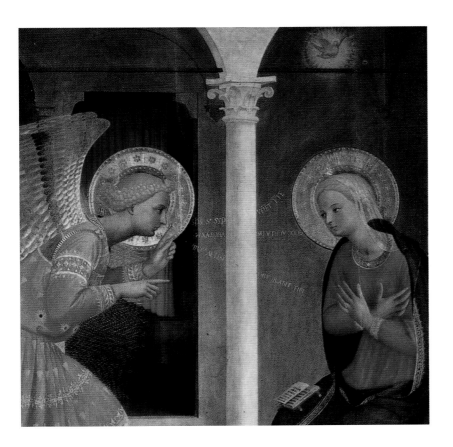

6 **'Cave canem'** Before AD 79
A classic instance of the conventional relationship between word and image in which the former serves to anchor the meaning of the latter.

7 **Fra Angelico** *Annunciation* (detail) c. 1432–33
Writing used in a painting to visualize speech.

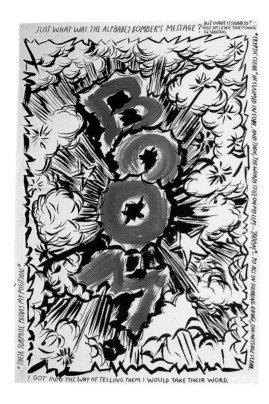

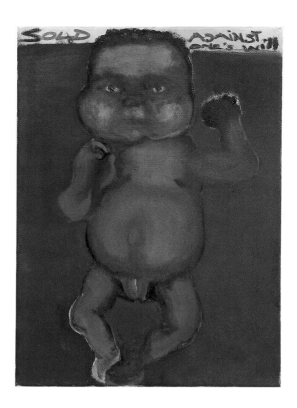

8 **Raymond Pettibon** *No Title (Just what was)* 2001
The artist takes on the roles of both image maker and writer in a style indebted to comic books.

9 **Marlene Dumas** *Sold against One's Will* 1990–91
The apparent innocence of an image is cruelly betrayed by its accompanying text.

A work by the contemporary American artist Raymond Pettibon, on the other hand, contains elements of a third type of interaction, that typical of the *mixed-media* relationship. Here, word and image have less intrinsic coherence and are only minimally separated from one other, having been enfolded, decanted or scrambled into each other's customary domain. Emblems are examples of this kind of relationship from the pre-modern period, while in more recent times, posters and advertisements often share such traits. Indeed, the modern world provides a particularly rich harvest of the mixed-medial, and artists have been quick to learn from the forest of signs that constitutes the urban environment, directly depicting it (as in the work of a contemporary realist such as the American Richard Estes), borrowing fundamental stylistic elements (as in Ruscha's painting), or confusing the codes (as in the contemporary English artist Simon Patterson's adaptation of the London Underground map [*13*]).

Finally, there is the *inter-media* relationship. The Book of Kells [*12*] is an example of an inter-medial work from the early Middle Ages, while the artist's monogram in Dürer's engraving is one from the Renaissance. Recognition of the visual, material side of letters (and of the performative and sensory dimension to the act of writing) is also at the heart of the traditional practice of calligraphy, as it is of typography. Again, advertising offers a rich harvest of the inter-medial in the modern environment. Here, too, Pettibon's drawing is interesting, for in the central part of the work the coherence as well as the distinction between word and image breaks down, and a hybrid form is produced. This category especially emphasizes the fact that writing is indeed *visual* language, that is, it is something which appeals to the *eye* as well as to the mind. In historical terms the spatialization and

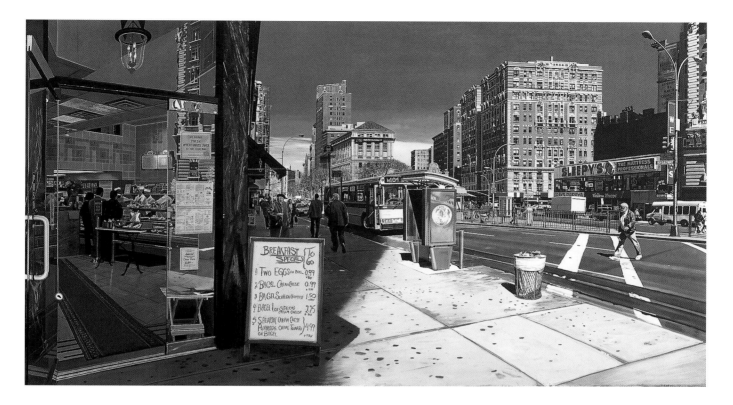

10 **Richard Estes** *M104* 1999
The modern city is a rich source of written words, which come in a
bewildering variety of styles.

visualization of language through the technology of writing came many
thousands of years after man first set himself apart from other animals by
learning to communicate through a complex system of coded sounds. The
origins of writing lie in pictographic and ideographic forms that were
entirely independent from speech and an explicitly visual mode of
communication. The invention of the alphabet by the Phoenicians, however,
transformed writing into something intended to record the spoken word and
henceforth, at least in the West, it would become both subordinate to oral
language and increasingly non-pictorial. This was a trajectory that the
Western invention of moveable type by Johann Gutenberg in the fifteenth
century continued and exaggerated: writing became a uniform, colourless,
mechanized medium housed within the organized space of the folio. The
activity of inscription was decisively severed both from image-making and
from its origins in the bodily gesture. Indeed, in an era dominated by the
protocols of the printed book the visual nature of written words can easily be
forgotten. 'The wonderful thing about language', wrote the philosopher
Maurice Merleau-Ponty of the typical experience of reading a printed page,
'is that it promotes its own oblivion…. My eyes follow the line on the paper,
and from the moment I am caught up in their meaning, I lose sight of them.
The paper, the letters on it, my eye and the body are there only as the
minimum setting of some invisible operation. Expression fades before what
is expressed, and this is why its mediating role may pass unnoticed.'[6] The
inter-medial relationship between word and image exposes the fact that
writing and image-making share common roots, and this is true in terms of
the visual nature of an inscribed sign and in the sharing of the technology
(such as the chisel, pen, pencil or brush) required to make such notations.

11 **Ilya Kabakov** *The Communal Kitchen* 1991
For the contemporary artist, words, images and objects become part
of a total inter-medial experience.

12 **Book of Kells** *Folio 8 recto c.* 800
Writing as a strikingly visual form.

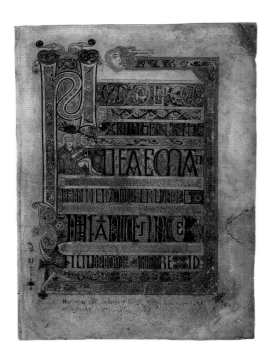

But in the modern period the inter-medial relationship has also come to signify much more than the melding of the visual and the verbal on a two-dimensional surface. In the mass media and in art there has been a strong impulse to extend notions of the inter-medial by breaking down the boundaries between the various media in radical ways. This generally involves the integration of diverse spaces, movements and sounds, as seen in the work of the contemporary Ukrainian artist Ilya Kabakov. A multi-sensory experience – a kind of 'total work of art' – has been created that operates within an vastly expanded field of communication and information. Here it is no longer possible to speak in terms of specific genres, either visual or verbal.

The broad cultural context for such visual–verbal cohabitations is one in which, for religious, political and philosophical reasons, word and image have often been in contest, even open conflict. Plato initiated a philosophical tradition that not only judges all representations to be mere simulacra but is also deeply suspicious of writing. The alphabet, which in the fifth century BC was still a relatively recent invention, was seen by Plato as a dangerous new technology. This was because he believed that as information was 'downloaded' and stored within written texts the power of memory was diminished, and as writing distanced the two sides of any communication, deception could prosper.[7] Later, in Judaism, Christianity and Islam, a prejudicial distinction was made between the word and the image on religious grounds. The spoken word, being a mental or spiritual entity (rather than a mere physical manifestation), was now credited with the highest status because God, being invisible, was understood to communicate to Man not through visual forms but rather through the medium of a divine language – The Word of God or the *Logos*, which is intelligibility itself. 'In the beginning was the Word, and the Word was with God, and the Word was God', declares the first line of the Gospel According to St John.[8] While in the Middle Ages in the West (and more generally under Islam) veneration of the word led to an exploration of calligraphy as a visual phenomenon, more generally the monotheistic religions have been suffused with a deep-rooted suspicion towards the potentially seductive nature of all images. In the West this became especially evident under Protestantism – a Lutheran altarpiece from 1537 in the Spitalskirche in Dinckelsbühl [*15*] shows the form this iconoclasm could take. Not only has the traditional imagery of the altarpiece been replaced by a group of texts, but these words have been inscribed in the standard letterform of the period and place, 'blackletter' (also known as 'gothic' or, later, 'Fraktur'), which was intended to be visually unassertive.[9]

With Gutenberg's invention of moveable type just a short time before the Protestant Reformation, the visual dimension to writing would be further suppressed. This served to segregate word from image as text came to be organized according to mechanical criteria and as painting turned increasingly to the task of representing the world of appearances. So, while subsequent secularization in the West diminished the hold of such theologically sanctioned iconophobia, new technology would erect another kind of barrier between words and images. In art itself, the quest for verisimilitude or naturalism placed strict limitations on the possibility of incorporating words into pictures. Fra Angelico's device would thus no

13 **Simon Patterson** *The Great Bear* 1992
The artist as a subverter of conventional codes.

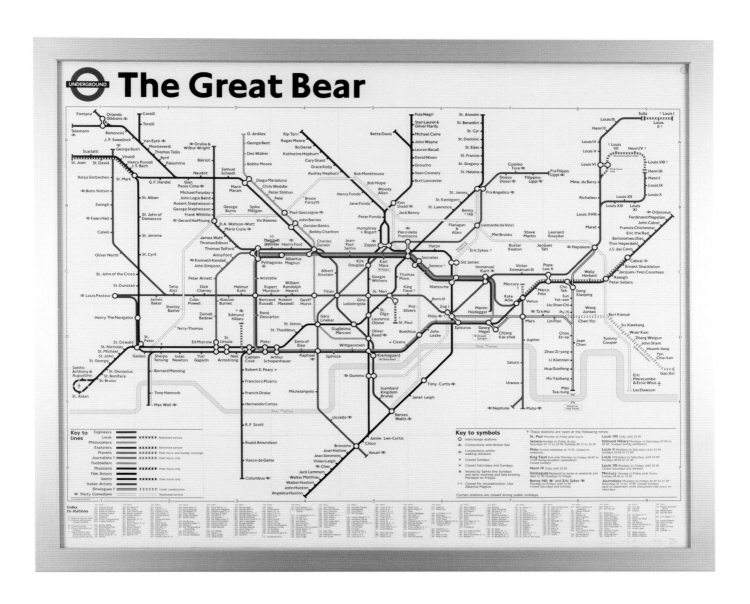

longer be a credible one, for it negates the attempt to construct a three-dimensional space. Dürer's insertion of an inscribed tablet into his representation, on the other hand, suggests a possible solution: the depiction of a text that is ostensibly sited, and therefore depicted, within the illusionary three-dimensional space.

During the Enlightenment, this sequestering of word and image was consolidated on theoretical grounds as the various artistic media were distinguished both operationally and epistemologically. It was argued that the literary arts were centrally involved with narrative because they unfolded in *time*, whereas the visual arts' proper domain was deemed to be *space*, and so could not be said to owe anything to verbal language.[10] Because, it was argued, we use the faculty of *taste* in appreciating a painting or sculpture – this being a *sense* like seeing or feeling – the response to the visual arts should be understood as fundamentally non-cognitive and non-conceptual, innate and unreflexive. The consequence of this was that verbal language, because it was based on conceptual rather than sensual entities, could be said to have no place in the practice or appreciation of visual art.[11]

Such arguments would subsequently become cornerstones of the kind of art theory and practice that came to dominate much nineteenth- and early twentieth-century art. Even after the collapse of naturalistic conventions of imitation, a division of the arts was still deemed necessary in order to protect the purity of each artistic medium from the encroachments of a seemingly debased mass society. Thus, the influential American art critic Clement Greenberg, drawing on earlier formalist art theory, could argue in the 1950s and 1960s that the goal towards which painting unerringly moved was the articulation of a purely *optical* experience. It was necessary, Greenberg declared, to eliminate anything from this experience that might interfere with the detached operation of 'taste' upon the ineluctable essence of painting, which was identified by Greenberg as its flatness. The arts were envisaged as fields of specialist knowledge, autonomous and independent both from the world of daily life and from other media, and a fundamental distinction was made between the directly sensual response appropriate for the visual image and the mediated one intrinsic to the reading of text. Painting and sculpture, by drawing attention to the *visual* nature of art, provided the groundwork for practices that were subordinate neither to literature nor to the task of representation. Clearly, such policing of media boundaries represented an approach to visual art that was profoundly inimical to text, or at least to text that was meant to be *read*. Words, as linguistic elements, were regarded as the province of the literary arts. As a result, Greenberg would suggest that the importance of the letters, numbers and words that began to appear in the work of Braque and Picasso in 1911 lay exclusively in the fact that, 'by their self-evident, extraneous and abrupt flatness, [they] stopped the eye at the literal, physical surface of the canvas in the same way that an artist's signature did.'[12]

Such restrictive readings of modern art are now being broadened, just as artists themselves have increasingly sought to escape media specificity. Such revisionism has also permitted the re-evaluation of earlier art. For example, the linguistic dimension of the fragments of text in Cubist paintings and collages that was suppressed in formalist writings such as Greenberg's, has

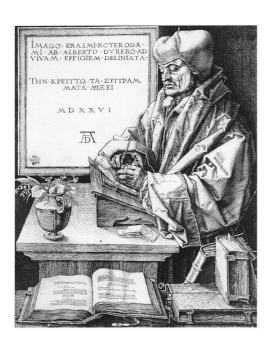

14 **Albrecht Dürer** *Desiderius Erasmus of Rotterdam* 1526
Words are incorporated into a naturalistic representation and give specific information that the image alone cannot provide.

become the focus of attention for a number of more recent historians. This new approach has also addressed other previously neglected movements from the nineteenth and early twentieth centuries, such as Dada.[13] Earlier interpretations of modern art have been challenged and supplanted, and while the fascination of modern artists with the 'primitive' was once recognized primarily as an assault on the hallowed conventions of naturalism, it is now also understood to have been driven by the desire for a kind of artistic practice that was able to incorporate multiple elements – visual and verbal – rooted in integral forms of organization, rather than in specializations, and in models that repudiated discrete categories in favour of a promiscuous mixing of media. Indeed, by looking beyond the traditional canon of Western artists, we encounter numerous examples of the kinds of visual–verbal interaction that had been largely banished from the West since the Renaissance. Various forms of 'primitive' picture-writing, such as glyphs, sigils, pictograms, hieroglyphs and ideograms, or the oriental traditions of calligraphy and scroll painting, expose the visual roots of writing, the role of the body, and the temporal dimension to inscription.

The specific critical context for *Writing on the Wall*, then, is the battle that has been waged over the past four decades against practices and theoretical interpretations that seek to separate artistic media; a battle that had in fact already been started by the avant-garde of the late nineteenth century. The story of modern art told in the following pages amounts, therefore, to a narrative with a number of linked themes, including the impact of non-Western ideas, the relationship between words and power, the influence of the mass media and new communication technology, and the fruitful interactions between writers and artists.

In place of the overly linear, hierarchical and segregated relationships between reading and writing, and between the seeing and reading that characterize normal practice, the artists in *Writing on the Wall* can be said to engage with what has been called 'topographic' space – a space in which writing is severed from its role as mere verbal description and is experienced instead as both a verbal and a visual phenomenon.[14] By so doing, artists have sought different organizations of the spaces and contexts within which word and image appear. Artists make a series of incursions from the domain of the image and of the body, invading the territory of a print-saturated culture, a culture dominated by the rigid and constraining protocols of the book. But this enterprise also amounts to a fundamental investigation into basic categories of meaning. For the study of how visual artists have interrogated language – of the myriad ways in which they have subverted the norms of writing and challenged the conventions of seeing and reading – is also, ultimately, a study of how they have sought to map out different modes of consciousness by upsetting customary categories and practices.

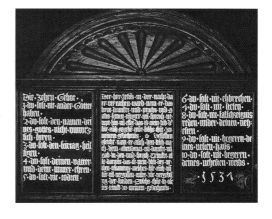

15 **Evangelical-Lutheran Congregational Altarpiece** 1537
This early Lutheran altarpiece from Dinckelsbühl, Germany, substitutes the pure, infallible and sacred Word for the potentially idolatrous image.

16 **Eugène Atget** *Little Market, Place Saint-Medard, Paris 5* 1898
In the late nineteenth century the now familiar sight of billboards was
still a new phenomenon.

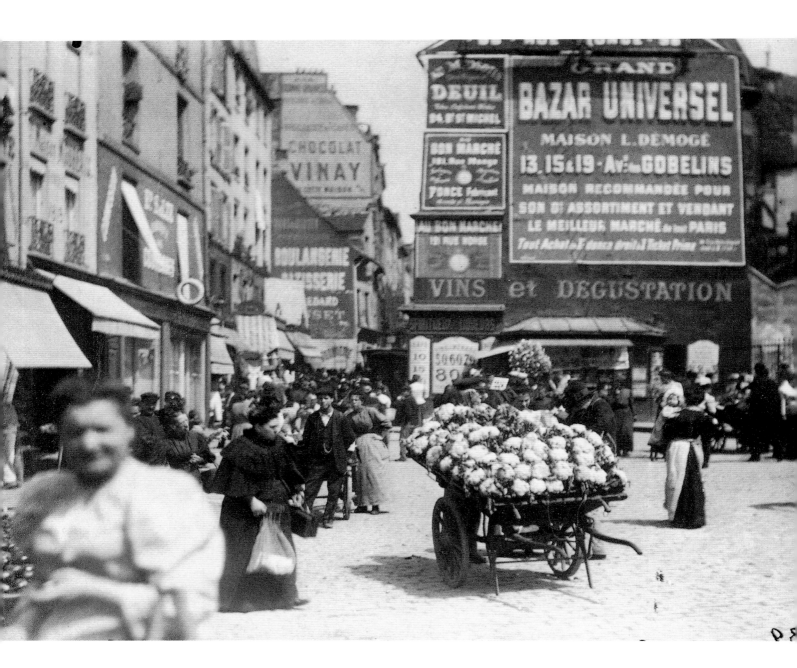

Grand Bazar Universel: Impressionist Words

'All that is solid melts into air',[1] declared Karl Marx and Friedrich Engels in their stirring evocation of the modern era in *The Communist Manifesto* (1848), and, as if in response to these new forces, written words began to overflow into the wider environment, sometimes in the most chaotic ways. Where once they had largely been confined to ordered ranks on the pure white of the book page, they now seemed to roam uncontrollably within the vertical visual field – on walls, shopfronts, billboards, advertising pillars, street signs, passing vehicles, even people (the sandwich-board man became a common sight in the late nineteenth-century city street).

The narcotic effect of these transformations is vividly captured in a travel book about Paris written by an Italian, Edmondo de Amicis, in 1878:

> Here is splendour at its height; this is the metropolis of metropolises, the open and lasting palace of Paris, to which all aspire and everything tends. Here the street becomes a square, the sidewalk a street, the shop a museum, the café a theatre, beauty, elegance, splendour dazzling magnificence, and life a fever. The horses pass in troops, and the crowds in torrents. Windows, signs, advertisements, doors, facades, all rise, widen and become silvered, gilded and illumined…. Oh, Heavens! A gilded advertising carriage is passing with servants in livery, which offers you high hats at reduction. Look at the end of the street. What! Half a mile away there is an advertisement in titanic characters of the *Petit Journal* – 'Six thousand copies daily – three million readers!' You raise your eyes to Heaven, but, unfortunately, there is no freedom in Heaven. Above the highest roof of the quarter, is traced in delicate characters against the sky the mane of a cloudland artist who wishes to take your photograph…. So there is no other refuge from these persecutions except to look at your feet, but alas, there is no refuge here even, for you see stamped upon the asphalt by stencil plate an advertisement which begs you to dine on home-cooking in rue Chausée d'Antin. In walking for half an hour you read, without wishing to do so, half a volume. The whole city, in fact, is an inexhaustible, graphic, variegated and enormous decoration, aided by grotesque pictures of devils and puppets high as houses, which assail and oppress you, making you curse the alphabet.[2]

While certainly familiar to us today, this visual cacophony of word and image was clearly a heady new experience in the mid-nineteenth century, and the city is envisaged by De Amicis as a fabulous spectacle, a monstrous text composed of words and images that are there not so much to be deciphered or understood as to be taken in passively through all the senses. It seemed that words were everywhere and De Amicis emphasizes that this

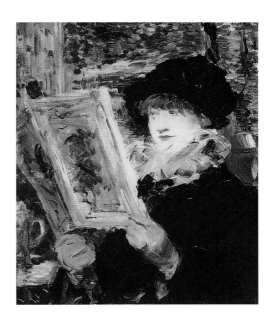

17 **Edouard Manet** *Woman Reading* 1878–79
Words disappear under the artist's virtuoso paint handling. Only the signature is legible.

script is at once public and impersonal. The principal aim might be to persuade, but the visual impact appears to the author to be, at least in this context, largely decorative, a rich display, though one that could also be perceived as aggressive and suffocating. The effect leads the author to say that he wants to 'curse the alphabet', a sentiment echoing the criticisms levelled at the mass media by some self-appointed custodians of 'high' culture, though his more obvious delight in the typographic jungle of modern Paris would also find its counterpart in the work of artists and intellectuals. Anyway, to resist the lure of the spectacle, De Amicis declares, would be futile and, as the tone of his book suggests, rather boring.

While photographers such as Eugène Atget provide us with a visual record of this new word-landscape [*16*], we look for it largely in vain in the paintings of the major avant-garde French artists of the 1860s and 1870s – at least in any legible form. So, we might get the excitement of Paris as a visual experience in Impressionist art, but unlike De Amicis and his visitors we are not meant to linger long enough to decipher any of the typographical detail. Instead, these works seem to demand that we be immersed in an instantaneous impression. Time after time, the Impressionist painters blur and smudge parts of their compositions where words might have been read. Indeed, the optics of Impressionism seems to aim at a kind of verbal illegibility. The typography on the cover of the journal the woman holds in her hands in Edouard Manet's 1878–79 painting, *Woman Reading* [*17*], for example, is completely obliterated, transformed into a dynamic display of brushwork.*³* This erasure of written text signifies the triumph in painting of the seeable over the sayable, of the direct experience of reality over the kind of mediated discourse *about* reality typical of mainstream 'Salon' painting. Indeed, Manet seems to pit the passive, 'feminine' act of reading against the more 'masculine' activity of vigorous painting-performance. His signature, on the other hand, boldly parades itself across the surface, defying this anti-verbal censure. But such legible script in fact serves merely to reiterate the fact that the whole painting is to be understood as a kind of calligraphic 'handwriting' – an 'indexical' sign that is a record of the gestures of the hand that traversed the canvas as it responded to complex visual sensations. With a directness not available to verbal language, the technique itself constitutes a tangible sign of the work's authentic connection to the author, and one that the signature merely affirms in more conventional fashion.

Manet's painting also tells a story of changing norms and modes of readership. Due to the kind of far-reaching social and economic transformations recognized by Marx and Engels, the activity of reading had shifted from the ordered and essentially private confines of the book to the more open, anonymous and expansively public formats of newspapers, and the kind of journal the young woman in Manet's painting is reading. Near universal literacy meant that the act of reading itself no longer provided the basis for class distinctions and hierarchies, and this traditional indicator of social and cultural privilege began to be supplanted by the more fluid and less overt distinction between those who read the newspapers, and the cultural elite who read books, enjoyed poetry and perused cultural periodicals. These new social conventions would be of endless interest to the Impressionists, and while we may not be able to share in the content of the

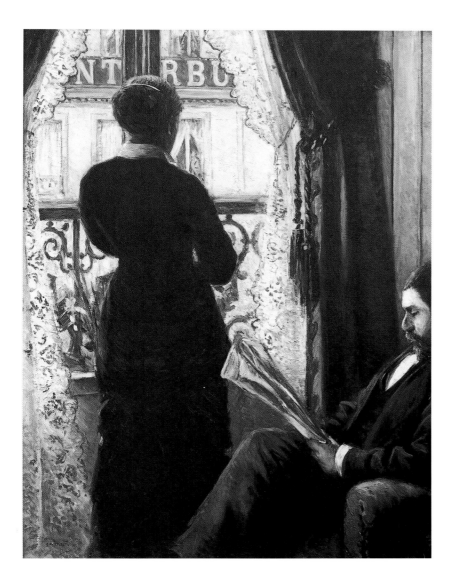

18 **Gustave Caillebotte** *Interior* 1880
A fragment of text plays its part in conveying a mood of *anomie* and breakdown in communication.

journals, newspapers and books that populate Impressionist paintings, we are nevertheless able to recognize from their settings the formation of specifically modern customs of readership and social discourse. The gentleman's absorption in his newspaper in Gustave Caillebotte's *Interior* (1880), for example, plays an important role in conveying the overall mood of *anomie* that pervades the work, and the private act of reading here also signifies a wilful act of non-communication.

There was now a huge market for books, newspapers and journals. The mass circulation newspapers exploited the visual aspects of typography in unprecedented ways, varying font sizes and faces, and breaking up rows of tightly ordered text with assertive advertisements and bold headlines. Technological change also directly affected the way words were produced. Paper manufacture improved in terms of speed and quality, and the mechanization of printing led to an increased efficiency in terms of both volume and turnover. The development of new methods for mass producing metal type for presses – notably the Linotype and Monotype machines –

pushed aside the traditional process of cutting punches, making matrices, and casting type in hand-moulds – practices that had remained virtually unchanged since the time of Gutenberg. This new and infinitely more efficient technology transformed the nature of the print shop. Meanwhile, the invention of lithographic printing in the early nineteenth century had the effect of freeing lettering altogether from the restraints imposed by metal type. Using the same tool to produce both word and image, it allowed for much more spontaneous and gestural writing, produced by the drawing or brushing directly onto stone or metal the image and text with oil-based ink or wax crayon.

The publishers of newspapers, like the manufacturers of goods, recognized that in order to attract the consumer within the busy and chaotic public spaces of the new commodity-driven economy, words needed to be eye-catching enough to make a direct appeal to the senses. There was, therefore, a growing demand from the burgeoning economy for public advertisements – the bold colourful combinations of word and image that were soon, as De Amicis observed, covering all available urban surfaces. The most obvious result of this was the design of a large number of visually assertive typefaces – called 'display' faces – that were intended to grab the public's attention. Both traditional and new printing methods now employed an unparalleled variety of shaded, expanded, condensed, ornamented and decorated letterforms. These styles were visually stronger, brasher and more exaggerated than conventional letters, and brought into play the third dimension, manipulating forms into extreme distortions. On shop fascias and in advertisements lettering was compressed or expanded, made to slope backwards or sit out from the supporting surface.

We get a glimpse of one of these new display faces through the window in Caillebotte's painting. A rather sober, elegant line of gilded letters is clamped to the façade of the building opposite – probably it is the name of a *brasserie* or hotel. Caillebotte employs this word fragment as part of his larger narrative of alienation and social fragmentation, and by depicting only a partial view of the word, essentially neutralizes its status of legibility, reducing the letters to spatial figures in a pictorial composition. The more fashionable Jean Béraud, meanwhile, because he remained essentially illustrative and anecdotal (in spite of being influenced by Manet and the Impressionists) provides the kind of detail necessary for us to be able to read many of the advertisements and other public notices he depicts. Indeed, Béraud returned again and again to the abundance of street typography to be found in the chic quarters of Paris, and *Colonne Morris* (1870), for example, features a particularly characteristic piece of such word-clad street furniture, one designed specifically for the purpose of carrying publicity posters. Somewhat later, the more radical Raoul Dufy would also respond to the new urban wordscape, and in a work painted in the popular seaside resort of Trouville he captured some of the dynamism of advertising that had been evoked by De Amicis. Across the Atlantic the Ashcan School painter John Sloan, in *Hairdresser's Window* (1907), provides a lively record of the cheaper kind of public signage that covered Manhattan's Lower East Side. Sloan also evidently delights in the wordplay manifested in the texts and the work represents an early example of what will become a dominant theme for

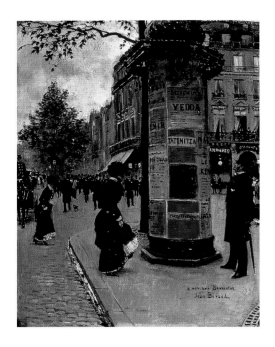

19 **Jean Béraud** *Colonne Morris* 1870
The ubiquitous Morris Column created a new kind of public space for reading.

20 **Raoul Dufy** *Posters at Trouville* 1906
The artist incorporates the texts of billboards into his depiction of a fashionable French seaside resort.

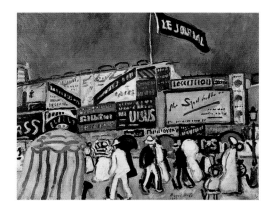

American artists – the vernacular and popular wordscape spawned by the mass media.

By the late nineteenth century, changes in commerce, law and technology had resulted in public advertising reaching overwhelming proportions, with almost every urban wall a potential billsticking opportunity. As the conservative French writer Maurice Talmeyer declared dejectedly in 1896: 'Nothing is really of a more violent modernity, nothing dates so insolently from today…[as] the illustrated poster.'[4] The specific context for Talmeyer's anxieties was the vogue for the 'artistic poster', a fashion that allowed several important artists – among them Pierre Bonnard [23] and Henri de Toulouse-Lautrec [22] – to contribute rather more directly to the public visual and verbal barrage. Such was the success of the format that special editions of posters were often made for collectors and exhibitions mounted, while examples were regularly stolen from walls and advertising columns. The pioneer of poster art was Jules Chéret, whose striking advertisements first appeared around Paris in 1866. Chéret exploited the fluidity and spontaneity of the medium of lithography, which permitted swift calligraphic letter-drawing and the blending of word and image. Simple design, large format and strong colour ensured that posters were effective from a distance, with an optimistic tenor guaranteeing broad appeal. Bonnard would prove to be a particularly innovative force in this field, also influencing Toulouse-Lautrec, and the bold and exaggerated drawing, the limited colour scheme and the dramatic use of visual contrast between rounded hand-painted letters and printed text evident in their work, signals an intimacy between word and image not seen since the Middle Ages. But the 'artistic poster' was merely part of a much broader revolution in the decorative arts – Art Nouveau – which led to further important innovations in the field of letter-making and typography. Mutability invaded the once ordered and stable domain of the alphabet, as ornamentation became increasingly extravagant, with scrolls and trailing wisps sometimes almost burying the original shapes of letters under a mass of curves. Both the structure of letters and their arrangement within printed compositions were transformed as new concepts of layout emphasized asymmetry and curved or diagonal settings. Words were being further liberated from the closed form of the printed book, roaming instead within the environment as boldly visual phenomena.

Behind the organic excess and *joie de vivre* of Art Nouveau, however, economic forces and the accompanying new technologies were unleashing energies that, as Marx and Engels had foreseen, modern society was ill-equipped to understand or control. While literacy was becoming universal, and words and images through the exigencies of commerce were being disseminated throughout the urban environment, these phenomena also had the effect of undermining confidence in language as the cheapening and dehumanizing impact of the mass media was felt. Indeed, a major consequence of these huge changes was that despite the obvious signs of confidence and exuberance, and of progress and change for the better, late nineteenth-century culture was for many shadowed by a growing sense of profound doubt and suspicion. This was a crisis rooted in the recognition that language no longer necessarily bound man to a tangible world. Instead, science, philosophy and art were converging on the recognition that

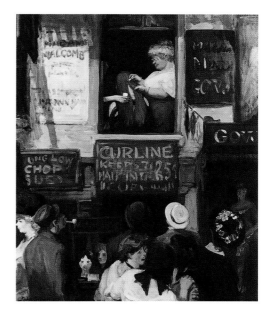

21 **John Sloan** *Hairdresser's Window* 1907
A more downmarket kind of advertising populates Sloan's painting of New York's Lower East Side.

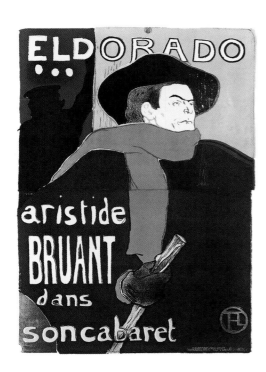

22 **Henri de Toulouse-Lautrec** *Aristide Bruant dans son cabaret* (Aristide Bruant in his Cabaret) 1892
Artists join in the advertising boom, in the process creating a new kind of visually assertive lettering style.

language was merely an opaque man-made construction without any claim to universality or objectivity. This would have far-reaching implications. 'What, then, is truth?' asked Friedrich Nietzsche in the 1870s. He could answer only that far from being some universal, underpinned by the *Logos*, 'truth' was merely a 'mobile army of metaphors, metonyms and anthropomorphisms – in short, a sum of human relations, which have been enhanced, transposed and embellished poetically and rhetorically, and which after long use seem firm, canonical, and obligatory to the people.'[5]

Indeed, scientific progress and technological progress were themselves to blame for this crisis. The non-verbal semantic systems of mathematics were becoming central to the way in which man explored and understood his world, and the expansion and success of the exact sciences undermined confidence in any world that could be revealed by mere words. But the crisis also had important social and political implications. Marx, Engels and their followers exposed the ways in which language was always caught up in oppressive social hierarchies. They showed the contaminating link that exists between material and intellectual power, between the form of language and who controls it. There were also psychological dimensions to this pervasive sense of doubt. Sigmund Freud demonstrated that we cannot be said to be in control of our thoughts and actions. In his theory of psychoanalysis, language was cast against a backdrop of a body that pressed upon it, a speaking body that through needs and desires manifested in dreams, slips of the tongue and other instances of involuntary use of language, was always saying something different from any conscious discourse.

As we will see, the modern period as a whole is deeply scarred by the legacy and continued ramifications of this crisis. It created a situation in which artists became aware that the signs they use no longer render a coherent and believable account of reality, and as a result, faith in the power of word and image would often be replaced by an all-pervading scepticism. Adrift in a world where language gives no convincing access to truth, to the real, or to the self, writers and artists could no longer assume that meaning would be generated through precise verbal or visual equivalents for things, nor that reality might be accessible, as the Romantics had hoped, through the temperament of the individual. For the Impressionists, at least, the solution seemed to be to grasp the present and to seek to represent it as an incandescent moment of pure perception, and in this context words were literary invaders from the realms of reflection and memory. Such emphasis on the visual experience alone would continue to preoccupy many artists well into the twentieth century but it would also be increasingly challenged by more confused and confusing attitudes as different kinds of relationship between the verbal, and the visual and between the signs they used and the world they shared, were formulated and explored.

23 **Pierre Bonnard** *France-Champagne* 1891
This design for a brand of champagne blends word and image in ways largely unseen since the Middle Ages.

3

Merahi metua no Tehamana: Symbolist Words

By the late 1880s, the animosity felt towards mass culture by a conservative like Maurice Talmeyer had come to be shared by many artists and writers of a more progressive persuasion. As the periodical *L'Art Moderne* declared in 1889: 'There is now a need for the other-worldly, for remote and *mystical* ideas evoking dreams'.[1] The generation after the Impressionists – the Symbolists – would therefore challenge their predecessors' commitment to perceptual realism and to the painting of modern life; they aimed instead at creating an art that stood in opposition to what was now regarded as the vulgar culture of a basely materialistic society. Indeed, to the Symbolists it seemed that the Impressionists' quest to be free from the excessively literary conventions that dominated academic Salon painting and to make painting a purely visual experience had succeeded only in turning painting into a mere record of sensations, just as the newspaper merely recorded events. The new conception of art, on the other hand, would be an expanded one in which it was possible to incorporate a wider range of associations and experiences. It would thus appeal not so much to perception as to the faculty of memory – a faculty that could be accessed equally through the visual or the verbal. As a result, in the radical art of the 1880s and 1890s written words are not usually present as part of some depicted scene as they were in the works discussed in the last chapter. Instead they would often be employed as weapons in an armoury of anti-naturalism, appearing alongside images in the guise of elusive titles, enigmatic verbal evocations or graphic signs.

The co-presence of word and image was a common characteristic of the kind of art admired by the artists who now sought to escape the influence of naturalism. In his copies of the Japanese woodblock prints that he owned, Vincent van Gogh also incorporated the ideographic writing that is a characteristic part of the originals. In his 1887 painted version of Hiroshige's *The Ohashi Bridge in the Rain* (*c.* 1857), for example, he even painted calligraphic markings all around the image that are not actually to be found in the original; it turns out that these are a combination of real Kanji letters (and shapes like them) which, though legible, have meanings that are apparently unrelated to the subject. It was an exotic effect that van Gogh was after and he employed the 'oriental' inscriptions as part of the decorative and non-naturalistic composition as a whole. The appeal of the calligraphy lay in its unusual visual dynamics rather than in its legibility, and above all van Gogh understood that its presence emphasized the two-dimensionality of the picture plane and carried an energizing trace of the artist's gesture.[2]

The assimilation of non-Western art such as Japanese prints had the effect of revealing the shapes of alternative traditions, ones in which word and image had never been severed from each other as they had in post-Renaissance art in the West, and in which the actions of drawing and writing

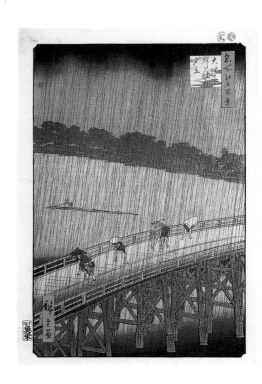

25 **Utagawa Hiroshige** *The Ohashi Bridge in the Rain* *c.* 1857

24 **Vincent van Gogh** *The Bridge in the Rain (after Hiroshige)* 1887
The artist's copy of a woodblock print uses the oriental calligraphy both to create an exotic effect and to generate a surface rhythm. A comparison with the original (above) reveals that van Gogh took considerable liberties.

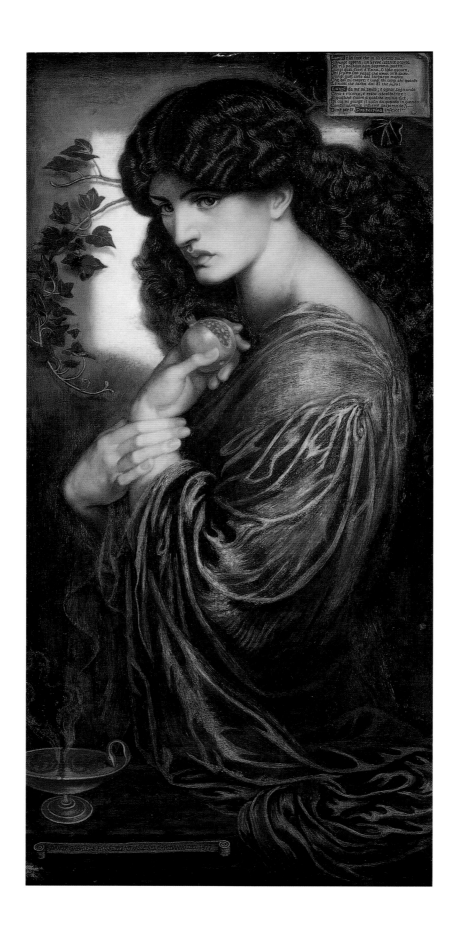

were still intimately related. But such visual–verbal interplay could also be found nearer to home in another source that now became a reformative model: medieval art. Interest in the so-called Italian 'primitives' and in the work of the often anonymous craftsmen of the Gothic period drew attention to a *Western* calligraphic tradition, and also to pictorial conventions in which the incorporation of text into the field of the image was the norm. Such historical influences were particularly strongly felt in England. *Proserpine*, a work by the Pre-Raphaelite poet and painter Dante Gabriel Charles Rossetti from 1877, shows how the new medievalism could inform easel-painting – the illuminated scroll depicted in the picture contains one of Rossetti's own poems written in Italian, while for good measure an English version is carried on the frame. Another important figure in this regard was the artist, designer and writer William Morris, who made a special study of the evolution of Western calligraphy and of early printing. In 1891 Morris put this research into practice by founding the Kelmscott Press, which went on to publish a number of modern illuminated books in an overtly medievalizing style. Morris insisted on the use of woodcut technique rather than metal punches or lithography, but despite his conscious archaism, his quest to save book design and production from the mediocrity into which it had slumped signalled the beginning of a revival in the medium that runs parallel with and often overlaps artists' engagements with written text.

The context for such assimilations of non-Western and historical sources would be a drive inwards, away from the external world. For growing scepticism concerning the signifying power of representations had the effect of making artists reflect upon their media and try to avoid clear and explicit meanings. The principles espoused by the new generation demanded a retreat from the word and image as they were conventionally used. The poem or the painting in Symbolist theory was meant to evoke not clear, rational and concrete meanings, but rather vague states of mind and poetic moods, the conjuring of a chimera, or of the mysterious, equivocal or indeterminate sign.

In fact, from the point of view of meaning, the vagueness of music and the unstable nature of the visual image now seemed better models for the poet than the clarity and determined nature of verbal language, and in their use of language the Symbolist poets sought an indeterminacy and ambiguity of meaning more characteristic of pictures. Central to the new conception, however, was the image of the universal 'Book', a metaphor intended to suggest that reality was composed of a network of signs to be interpreted, translated or deciphered, and where Nature was envisaged as a vast text to be *read*. This concept would also be central to the visual arts, as painting was remodelled in opposition to the tenets of naturalism and redirected instead towards the pursuit of the enigmatic and all-embracing 'symbol'. In this new aesthetics, a painting was regarded as a surface upon which could be laid a range of signs evoking an allusive and transcendent reality beyond mere appearances. Thus, the Symbolist critic G.-Albert Aurier, in an essay about Paul Gauguin written in 1891, could cite Charles Baudelaire's poem 'Correspondences' (1857) and argue that it was necessary to distinguish between those 'elevated' minds – like Gauguin's – capable of recognizing obscure symbols, and the 'imbecile human flock, duped by the appearances

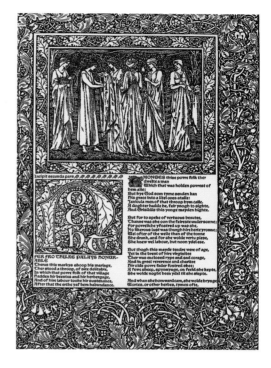

27 **William Morris** Page from *The Works of Geoffrey Chaucer*, Kelmscott Press 1896
The medieval illuminated manuscript becomes the inspiration behind the renewal of book design. The images are by Edward Burne-Jones.

26 **Dante Gabriel Charles Rossetti** *Proserpine* 1877
The *trompe l'oeil* manuscripts enhance the medievalizing effect; the one at top right carries a poem by the artist-poet.

that lead them to the denial of essential ideas'.[3] The task of the artist, Aurier declared, was to eschew 'tangible things' so that the deeper, essential reality would appear 'only as *signs*'. These, Aurier wrote, 'are the letters of an enormous alphabet which only the man of genius knows how to spell.'[4] Baudelaire's 'Correspondences' would, in fact, prove to be an important touchstone generally for the Symbolists. In it the poet treated reality not as something that could be clearly described or named, but rather as if it were 'un fôret des symboles' (a forest of symbols), a mysterious and vague territory to be navigated by the visionary power of the artist using a rarefied language of suggestion, equivocation and ambiguity.[5]

So, the new poetics would also involve a wholesale reassessment of goals and of the nature of the relationship between poetic and everyday language. Symbolist poets abandoned traditional metre in favour of the openness of free verse, a style closer to the rhythm and syntax of normal speech. But at the same time they sought to emancipate the writing process from conscious and rational control and texts were made to unfold spontaneously as what Rimbaud had in 1873 called an 'alchemy of the word' took over.[6] Not only was the structure of language changed, but so too was its relationship to subject matter. Furthermore, the Symbolists envisaged a new relationship between work and reader in which there was no coherent grid of reference and in which the semantics of language were no longer anchored in the 'real'. In reading texts imbued with this new spirit, it becomes impossible to decide which particular associations are relevant and which are not; no unitary purpose is manifest and, as a result, an equal or reversible relationship is established between poet and reader.

It is the work of the French poet Stéphane Mallarmé that best embodies the underlying goals of Symbolism in literature, and his influence extended to many artists. Of all of Mallarmé's poems, one in particular was to prove of major significance. 'Un Coup de dés jamais n'abolira le hasard' (A throw of the dice will never abolish chance) – originally published in 1897 but actually only published in its strikingly typographic version in 1914[7] – highlights the visual status of the verbal sign, making the reader aware of the concrete, material nature of letters and words, and drawing attention to the character of the typeface (the font in the later version is 'Didot') while also highlighting the enveloping blankness of the page. Mallarmé focused on the *form* of language rather than any external references and sought thereby to establish an autonomous space for language beyond the debased everyday world. Like the other Symbolists, he had a fundamental distaste for the mass media, regarding the newspaper as a decadent medium in which language was thoroughly corrupted. But he also recognized that in the quest to free language from its customary roles, the newspaper could be regarded as a potential source of inspiration for the poet, a kind of collective work in which unrelated items were juxtaposed in discontinuous ways. Both repelled by and drawn to the anonymity of this new kind of public language, Mallarmé became fascinated by the loss of the personal voice and the lack of clear authorship the newspaper implied. There, in the bold page displays, he also saw an inadvertent recognition of the essential materiality of the written word and its status as an object rather than a transparent window onto reality. So, in 'Un Coup de dés', Mallarmé draws directly on the kind of

C'ÉTAIT

issu stellaire

LE NOMBRE

EXISTÂT-T'IL
autrement qu'hallucination éparse d'agonie

COMMENCÂT-IL ET CESSÂT-IL
sourdant que nié et clos quand apparu
enfin
par quelque profusion répandue en rareté
SE CHIFFRÂT-IL

évidence de la somme pour peu qu'une
ILLUMINÂT-IL

CE SERAIT

pire
non
davantage ni moins
indifféremment mais autant

LE HASARD

Choit
la plume
rythmique suspens du sinistre
s'ensevelir
aux écumes originelles
naguères d'où sursauta son délire jusqu'à une cime
flétrie
par la neutralité identique du gouffre

typographic irregularities that are typical of the newspaper: mixing font sizes, using a combination of upper case, lower case and italics, and creating asymmetrical layouts and visually motivated spacings. But the result could not be more different from that intended in the press, and rather than directing us towards a tangibly represented reality we are instead made to ponder the word's materiality, the way in which meaning is constituted by the physical arrangement of letters on the page. Words stand marooned in a sea of pure whiteness, atomized and stripped of their customary ability to communicate, just as they are also devoid of a clear authorial presence.

But the Symbolists were bent on more than simply retreating from the commonplace. In an essay written in 1849 the composer Richard Wagner had stated that his operas sought to express the reality of the *Gesamtkunstwerk* or 'total work of art'. This new concept was intended to replace the old media forms altogether, drawing all the arts into a new unity, with music as the model. For, as Wagner declared: 'Artistic Man can only fully content himself by uniting every branch of Art into the *common* Artwork.'[8] The literary and the visual arts were to be united in a complex and all-embracing event. The phenomenon of synaesthesia was also central to this new vision, and in the wake of Wagner's example the Symbolists explored the ways in which the distinctions between different media could be blurred on the level of sensation. Synaesthesia could take many forms, including, for example, the imagistic interpretation of the alphabet.

28 **Stéphane Mallarmé** Spread from 'Un Coup de dés jamais n'abolira le hasard' (A throw of the dice will never abolish chance) 1914
The conventional layout of the printed text is subverted and the message carried by the words obscured in a page from a poem that would have a huge influence on both writers and artists.

Arthur Rimbaud's 1871 poem 'Les Voyelles' (The Vowels) – a work that would prove to be highly influential – made playful reference to the links between letters, colours and feelings: 'A noir, E blanc, I rouge, U vert, O bleu: voyelles' (A black, E white, I red, U green, O blue: vowels), it begins.[9] Mallarmé also made forays into similar territory, and in an essay devoted to the English language suggested that, for example, the letter 'J' expressed, quick, direct action, while 'K' was an image of knottiness or joining together.[10]

As a consequence of the new artistic priorities, the links between the practitioners of the literary and the visual arts grew closer. Artists, poets and musicians became aware of the many ways in which their media and goals overlapped and shared common ground – the fact that Rossetti was both painter and poet illustrates this point. Collaborations between poets and artists spawned a new hybrid genre – the *livre d'artiste* or 'artist's book' – that aimed at providing a balanced dialogue between painting and poetry, staged within the format of the folio book. In these projects, images were used not simply to illustrate a text but rather to complement or enhance the verbal element as an equal partner. The French artist Odilon Redon, for example, in collaborations with poets such as Mallarmé, produced what were in effect anti-illustrations where the image is no longer anchored to text in order to produce some clear meaning but rather expresses similar elusive ideas in another medium. Redon declared that all his works in fact functioned as images in search of unwritten texts, and wrote in relation to the carefully chosen but chimerical titles of his pictures:

> The title is justified only when it is vague...and aspires even rather confusingly, to the equivocal. My drawings inspire and do not provide definitions. They do not determine anything. Just like music, they place us within the ambiguous world of the indeterminate.[11]

Within the more open space of the canvas, painters were actually often better able than poets and writers to explore many of the implications of a verbal language that had been severed from its conventional roles and contexts. For example, words often play a significant role in the paintings of Paul Gauguin. They are usually present in the form of inscribed titles, which have migrated from the frame, the reverse of the canvas, or the gallery pamphlet, onto the composition itself. On one level, as with van Gogh, such verbal presences located within the traditional space of painting have the effect of re-emphasizing what is already made clear through anti-naturalistic modelling and colour, and through avoidance of perspective: that the work is to be understood as a construction, a surface. But the inscriptions also direct the viewer towards envisaging the artwork as a matrix of signs or symbols that are not so much to be *seen* as *read* as part of an enigmatic evocation.

In practice, Gauguin used either a roughly painted sans serif letterform or cursive script, and these texts are not inscribed with much attention to the formal relationship of lettering to other aspects of the composition. Indeed, from the pictorial point of view, and in comparison with oriental and medieval art, they often seem awkwardly sited or weak in visual form, as if text was supplementary to visual image, rather than integrated with it. But their presence within the visual field was clearly of great importance to

29 **Paul Gauguin** *Tehamana Has Many Ancestors (Merahi metua no Tehamana)* 1893
Three different kinds of writing coexist within Gauguin's painting, a portrait of his fourteen-year-old mistress.

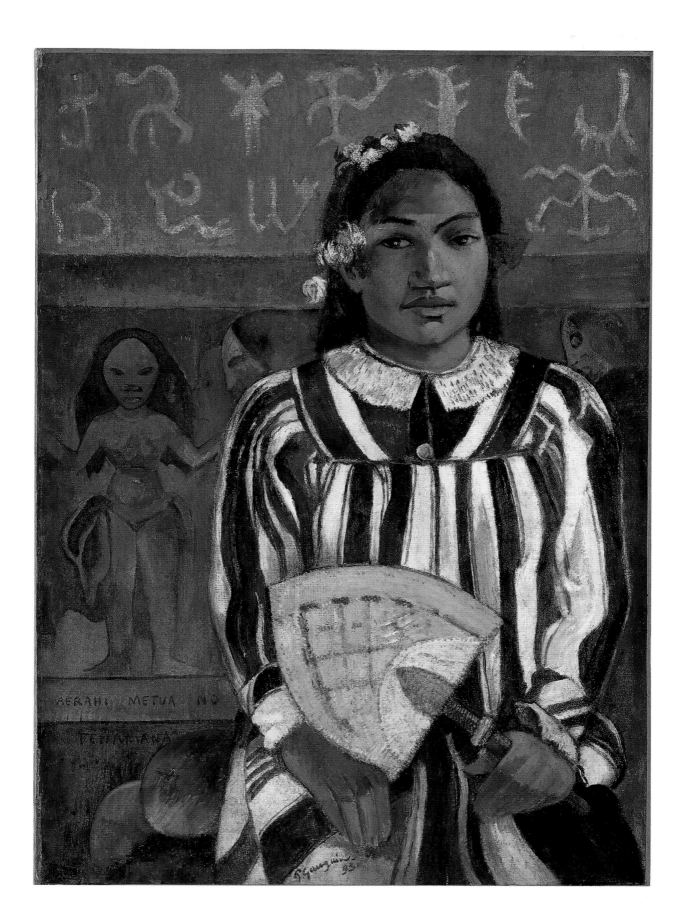

Gauguin, and he claimed that script provided continuity between title, signature and image. He argued, however, that the words were not to be understood so much as a title or as a specific description of the work's meaning but as what he called 'signatures' – personal acts of naming and allusive commentaries on the imagery.[12] Equivocation and evocation are all. Indeed, Gauguin inflicted upon the relationship between words and images a regime of radical indeterminacy, where the anchoring role of words is deliberately undermined.

After his move to the South Seas, such characteristics were exacerbated by Gauguin's habit of painting the titles in alphabetic transcriptions of the oral language of the Tahitians (though subsequent research has shown that he did not actually know the native language very well, and often left out connecting particles and juxtaposed roots in crude pidgin style). A work from 1893, *Tehamana Has Many Ancestors (Merahi metua no Tehamana)* [*29*], for example, depicts a Tahitian girl – Gauguin's fourteen-year-old mistress – set against a background of enormously enlarged glyphs. The painting can be interpreted as a meditation on the relationship between different kinds of language. The glyphs, which are an accurate transcription of part of a stone from Easter Island carrying what is known as 'Rongorongo' writing, were something of a cryptological cause célèbre in the 1890s, but the marks remained linguistic enigmas, signs of an apparently ancient and obscure civilization that Gauguin here explicitly holds up as a reformative model.[13] Such occult carvings, which lie close to the origins of writing as a form of graphic mark-making, are also complemented in the painting by an alphabetic rendering of a phrase in Tahitian. This serves ostensibly as the title, but is also likely to be an illegible enigma. Two forms of writing here collude in Gauguin's broader goal, which is to convey a feeling of essential 'otherness', of the inscrutability and mystery of the subject matter. Only the artist's signature, which constitutes a decisive mark of authorial presence and authority – even colonization – is actually legible in the normal sense, and stands against the general suppression of meaning as a vestige of Western cultural propriety.

Gauguin sought out cultures untarnished by Western materialism and was in thrall to a view of language that was in essence a crude form of reverse Darwinism, that is, one in which language was regarded as progressively weakening as it evolved. The pre-alphabetic 'savage', Gauguin believed, lived in a more essential reality, and experienced a spiritual, moral and aesthetic existence far richer than was possible in materialistic Western cultures. Informed by similar assumptions, artists in the early years of the twentieth century often regarded the written word as an obvious sign of a spiritually vacant and language-saturated culture that neglected the needs of the body in favour of the disembodied and fetishized reason for which the written word was a vessel. The artist cast as a 'modern savage' was someone who identified with pre-literate cultures and who embraced a more spontaneous and authentic oral, imagistic and sensual 'tribal' consciousness.

Inspired by Gauguin and others, the cult of the 'primitive' coalesced in the first decade of the twentieth century in the Expressionist movement. When words appear in such works – as, for example, in posters or books – they are deliberately made to look rough, blockish and archaic. The German

Expressionists, such as Ernst Ludwig Kirchner, rediscovered medieval woodblock printing techniques, but not the elegance of that period's lettering. By adopting such pre-industrial methods they hoped to produce a typographic style that would be more authentic, as well as being strikingly different in form from both the sophisticated and mechanically produced lettering of the mass media and the more lyrical styles of Art Nouveau.

But hostility to the written word in art could go deeper than an assault on staid forms of typography and decorative organicism. In *The Blue Rider Almanac* (1912) the Russian Expressionist Vassily Kandinsky discussed the difference between the letter as something participating in a conventional code, and the letter as a *thing* capable of resonating with an 'inner' reality: 'When a reader looks at some letter in these lines with unskilled eyes', he wrote, 'he will see it not as a familiar symbol for part of a word, but first as a thing. Besides the practical man-made abstract form, which is a fixed symbol for a specific sound, he will also see a physical form that quite autonomously creates a certain outer and inner impression.'[14] This reduction of text to its textuality should be seen in the context of Kandinsky's conception of the role of the artist as a purifier of the sign. For him, the essence of the letter, like any form, lay not in the part it may play in visualizing speech or denoting meaning, but rather in its being possessed of its own optically generated 'inner' and 'outer' resonances. But Kandinsky's real goal was the achievement of an art in which a direct equivalence between sign and referent could exist, one that he believed would, in effect, be a non-discursive and universal language. In this way, the essence of painting for Kandinsky – as for the other pioneers of abstract art – came to lie in its status as a kind of visual music. The goal of the artist was to challenge the authority and range of conventional symbols and signs, thus avoiding the fall into mediated and discursive modes by embracing a directly expressive vocabulary of the visual. Such essentialism represents a powerful obstacle to the incorporation of words into art. Kandinsky and the other abstractionists rejected the model of both the discursive linguistic sign and the representational image – Peirce's 'symbolic' and 'iconic' signs – in favour of what they saw as the transparency, universality and directness of expressive line and colour – Peirce's 'indexical' sign. Indeed, the constraining net of the discursive was exactly that from which abstract art sought to liberate itself as it embraced a more fundamental and unmediated mode of communication.

But the art of the late nineteenth century can also be seen to have had other, even contrary, implications. By writing titles or other extraneous texts onto the surface of their works artists opened painting up to all that had been excluded from the rectangle of the canvas since the Renaissance. Far from reducing art to some abstract essence, artists were inviting a new degree of interpretative mobility by rendering the frame of the work permeable. Henceforth, in the 'total work of art' the various artistic media would be thoroughly confused and combined, and the relationship between artwork and world destabilized. In the process a multiplicity of written words were decanted into spaces previously reserved for images; but where once they had offered clarity and closure of meaning, they were now used to generate a powerful sense of indeterminacy and ambiguity.

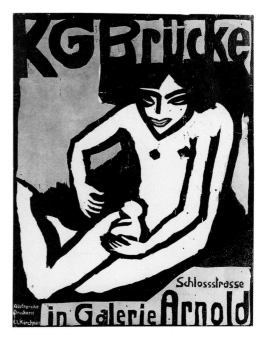

30 **Ernst Ludwig Kirchner** *Die Brücke* 1910
Crude but virile woodblock lettering in a German Expressionist poster design advertising an exhibition by the Die Brücke group.

31 **Pablo Picasso** *Landscape with Posters, Sorgues* 1912
Billboards and product labels provide small areas of recognizable
content within the dense camouflage of a Cubist painting.

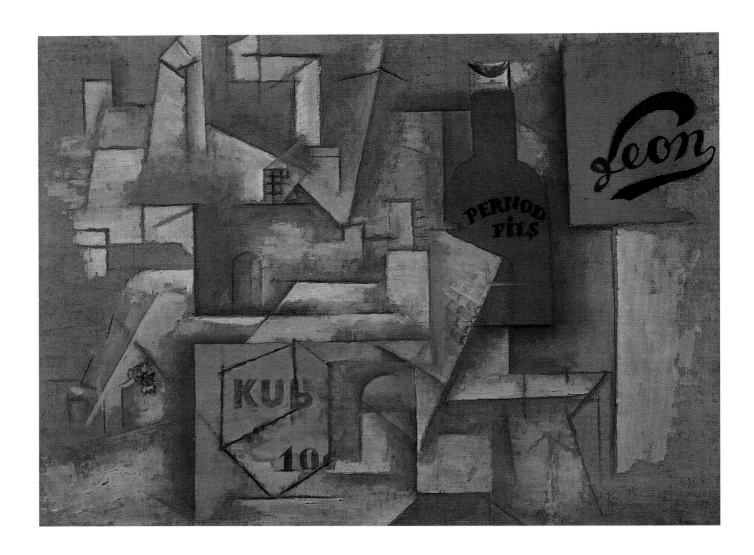

4

KUB: Cubist Words

In the summer of 1911 Henri Matisse decamped to the fishing village of Collioure in the southwest of France – the place where, six years before, he and André Derain had painted their first controversial Fauvist canvases. On this occasion he was perturbed to discover that a poster advertising the bouillon cube 'KUB' had been attached to the side of his house, a close encounter that must have confirmed Matisse's fears about the wide and invasive reach of the mass media.[1]

Like the Symbolists and most of his fellow Expressionists, Matisse was intent on creating an art that could act as a bulwark against just such base encroachments of the commercial and banal. But what if the new man-made landscape of which the billboard advertisement was such a prominent part were regarded not as something to be spurned but rather as something to be embraced as part of the dynamic modern experience? What if engagement with the world of advertising and the newspapers – popular mass culture in all its brash forms – was in fact seen as a way of pulling modern art down from its rarefied Mount Olympus of vague and poetic symbols, onto the sidewalk and shop floor where it might speak a language that ordinary people could understand? A year after Matisse's brush with the brand name, Pablo Picasso would paint two works containing the very same 'KUB' logo, its inclusion no doubt meant as a punning reference to the new style with which he had now become intimately associated, Cubism. By incorporating contemporary advertisements in his work, Picasso was also making it clear that he was bidding farewell to the land of Symbolist and Expressionist escapism. The modern artist, Picasso seems to say, could no longer simply turn away from the carnival of contemporary life; neither could he rely on old techniques of representation. The Impressionists and the Symbolists had seen the mass media as something that could be held at bay – learnt from perhaps, but also immunized against – but by the first decade of the twentieth century this market-driven culture had grown much more sophisticated, complex and powerful.

Indeed, far-reaching changes were taking place in the communication media. As we have already noted, the development of the mass-circulation daily newspaper meant an enormous extension in the reach of the popular press. But there were other technological innovations in the field of communication to contend with, such as the typewriter (first manufactured by Remington in 1873), the phonograph (1877), the wireless telegraph (1894), the cinema (1895), phototypesetting (1895) and magnetic audio recording (1899). Meanwhile, commerce began drawing together previously disparate aspects of the economy into a unified whole, giving birth to a powerful advertising industry and creating such new social spaces as the department store, where, surrounded by a cornucopia of material goods and texts, the

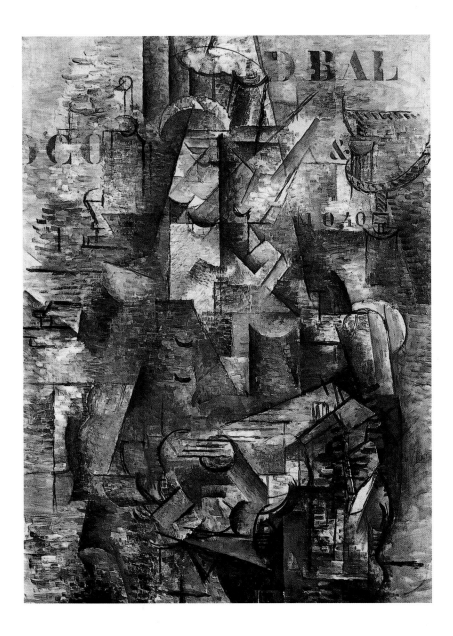

various classes could rub shoulders. These new media and new contexts directly challenged the dominance of print in a culture organized along strictly hierarchical lines, as well as wresting the control of language from its old custodians. As the poet and advocate of Cubism Guillaume Apollinaire announced, the modern poet and artist were obliged to absorb and represent the impact of these phenomena in their work: 'One wonders why the poet should not have an equal freedom, and should be restricted, in an era of the telephone, the wireless and aviation, to a greater cautiousness in confronting space.'[2]

Even during Picasso and Braque's most hermetic period (1910 to 1912), elements within Cubist compositions guide the viewer to specific patches of recognizable reality – the shape or simplified sign of a guitar, a bottle, an arm, a moustache. Then, in 1911, Braque started to introduce letters and words into his compositions, first as stencils, then rendered freehand.[3]

Picasso was soon doing the same, and Cubist compositions began to fill up with texts derived from newspaper mastheads, bottle labels and the typography of musical scores. A few months after the appearance of these painted verbal signs came the collages, in which actual pieces of newsprint, real labels, advertisements, calling cards, tickets and various other extraneous elements, such as wallpaper, sandpaper and cigarette butts, were glued to the surface of the canvas or paper. Such small oases of the readable or tangibly recognizable are set amid areas of the disfigured and act as welcome signposts back to the real, material world.

It seems, however, that the letters and words that the artists now incorporated into their work were not initially chosen for their legibility and powers of reference. Rather than seeing his texts as things to be read, Braque said he intended them to serve a purely formal purpose, as compositional devices or spatial figures that draw attention to the textuality of text and highlight the visible nature of writing as a graphic mark. In this context, letters were exploited as key structural components – the 'J' harmonizing, for example, with the curve of a glass [36] – or were used to bring unambiguous flatness to the composition. In collages the small type clipped from newspapers could be seen to function not so much as text but as texture – novel kinds of patterning, like cross-hatching. In this light, typography contributed to the visual experience of artwork conceived as a play between flat surface and illusionistic three-dimensionality. Thus, Braque observed that for him the letters painted onto his canvases were to be seen as 'forms that could not be deformed because, being flat, [they] were outside of space and their presence in the painting, by contrast, permitted one to distinguish the objects that were situated in space from those that were outside space.'[4]

On the other hand, these fragments appear to have been derived from very specific sources and an inventory of the varieties of texts in Cubist art reveals the following categories:

- titles of newspapers, rarely used in full
- press cuttings documenting current political events, such as the war in the Balkans
- newspaper advertisements for a wide variety of products
- fragments of billboard posters
- depictions of lettering on shop and café windows
- handbills to music hall events, the theatre and the cinema
- song sheets and book covers
- brand names and logos, especially for drinks

These items amount to a compendium of the kind of public lettering that could be found in the environment surrounding artists in the Paris of the period. Indeed, the street, the café and the studio must have offered countless opportunities for the kind of encounters with the advertisements, brand names, newspaper headlines and song titles that Matisse wished to avoid. But, significantly, what these things also have in common is that, like the actual materials used in collages, such as wallpaper and wrapping paper, or like Ripolin (the enamel house paint used by Picasso in many of his works), they tended to be the cheapest and least culturally elevated examples of

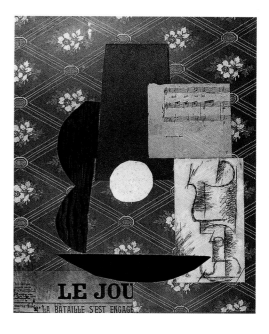

33 **Pablo Picasso** *Guitar, Sheet Music and Wine Glass* 1912 A fragment of newspaper and musical score allows Picasso to incorporate a piece of his surroundings into his work and engage in a bit of wordplay.

whatever was available. The newspaper *Le Journal*, for example – a mainstay of both Picasso and Braque – was a downmarket example of the 'penny press'. The advertisements in Picasso's *Still Life 'Au Bon Marché'* promote not luxury items but banal utilities of dubious quality. The drinks that feature in café and studio still lifes are the workers' favourite beverages – Bass, Suze, Pernod, Anis del Mono, Vieux Marc – not high-class brands. Similarly, the Cubists preferred the bottom end of the typographic market, the crude letterforms with blockish serifs or without ornamentation – sans serifs – that were designed for easy setting and cheap printing. Furthermore, in opposition to the intrinsic value of the crafted work, the hand-painted lettering in Cubist art was drawn not with the skill of the professional sign-painter, but rather with a seemingly deliberate crudity or using a utilitarian stencil. The fancy fare of Art Nouveau or the elegant lettering of luxury brands rarely find a place in the frugal economy of the Cubist artwork. The stencil – mainstay of the house painter and the factory worker – first carried words into Cubist painting, and from then onwards the preference would continually be for the functional, visually bland or brash styles of the popular press and the workman's café. Indeed, the poor materials used, the common typographical styles adopted, like the very simplicity of the cut-and-paste technique, imply a deliberate repudiation of the values of 'high' art, but also of taste and craft in general and the kinds of skills that in the wake of mechanization were being threatened by new methods of mass production.

34 **Pablo Picasso** *Still Life 'Au Bon Marché'* 1913

35 **Page from *Le Journal*** 25 January 1913
The newspaper advertisement illustrated opposite becomes part of a scurrilous visual–verbal pun in Picasso's collage (above).

So, while the fragmentary lettering in Braque's *The Portuguese* [*32*] is turned into a spatial figure, it also brings with it a field of allusions that direct us towards the environment in which the Cubists worked, and to the kind of identifications they wished to make – in this case a bar, perhaps, the lettering on a café window or in a newspaper. The letters JOURN, in Braque's *The Programme of the Tivoli Cinema, Sorgues* [36] from 1913 indicate that a section of the drawing is to be regarded as representing a folded newspaper – but the atomized nature of the word, as Braque noted, actually transforms the letters into spatial forms, and in so doing, distances them from their role as signifiers within the verbal chain. But it is also clear that once letters form up into words, they invite the act of reading – they engage the viewer in linguistic interpretation, turning them into a reader. This discursive aspect is also obvious in Braque's collage, which incorporates fully formed sentences of readable text in the hand-bill from the cinema. The writing we see here cannot be described as merely a novel kind of shading or texture set within the pictorial logic of the composition, but begs also to be interpreted within the discursive frame of language.

On occasion, contemporary political events do very clearly intrude via the collaged texts. This relationship to current affairs is particularly evident in a series of collages made by Picasso in 1912 [*33, 37*] where fragments of newspaper copy report episodes from the contemporary and ongoing conflict in the Balkans. The viewer reads of battles engaged, of cholera decimating

36 **Georges Braque** *The Programme of the Tivoli Cinema, Sorgues*
1913
Two styles of writing – one printed the other hand drawn – become
part of a still life.

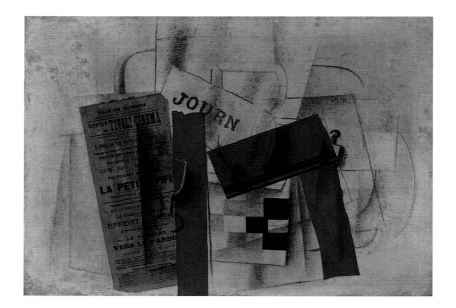

37 **Pablo Picasso** *Glass and a Bottle of Suze* 1912
A plethora of bits of newspaper copy report the contemporary war in
the Balkans, while a drink's brand name takes centre stage.

the Turkish army, and of continuing peace negotiations. In fact, the
technique of collage itself was born at the same moment as the war began, as
though the force of external events had broken down the barrier between art
and life and compelled Picasso to allow the sanctuary of the studio and the
purity of the artwork to become sullied by the clamour of the daily news.
Picasso's attitude to the events is ambiguous, however. Anti-war sentiments
seem to be present, but so too does a grim, even cynical, humour that
permits him to cut up the bad news and turn it into a bottle of aperitif.
And the events appear as fragments, dislocated and often confusing,
without any clear point of view.[5]

That the text in Cubist works was often intended to be read is also clear
from the use of elaborate and sometimes scurrilous verbal and visual puns.[6]
A heady mixture of often childish or ribald wordplay, full of irony and
satirical intent – which took as its raw material the passing spectacle of
advertisements, newspaper stories and popular songs – seems in many ways
akin to the mood of the kinds of entertainment then popular in the music
halls. These allusions certainly work against the difficulty of making sense of
Cubist compositions on a purely visual level. Double- and triple-meanings
abound as words are cut up to engender a host of different allusions – to
friends and lovers, and to popular themes and cultural debates. In Picasso's
work the words LE JOURNAL, for example, undergo constant
metamorphosis, becoming LE JOUR (the day), or LE JOU (which suggests
the French word for play) [*33*]; in one instance, the letters JO are dropped
leaving the fragment URNAL, a deliberately tasteless allusion to URINAL.
Picasso could also engage in visual–verbal play of a somewhat risqué nature.
In *Still Life 'Au Bon Marché'*, for instance, he pastes a commercial drawing of
the upper half of a fashionable lady above a label for the lingerie and
embroidery section of the department store, and below, in small letters
pointing to a gap in the complex composition, he glues the words
TROU ICI (hole here) – an allusion, surely, to a salient aspect of the
female anatomy.

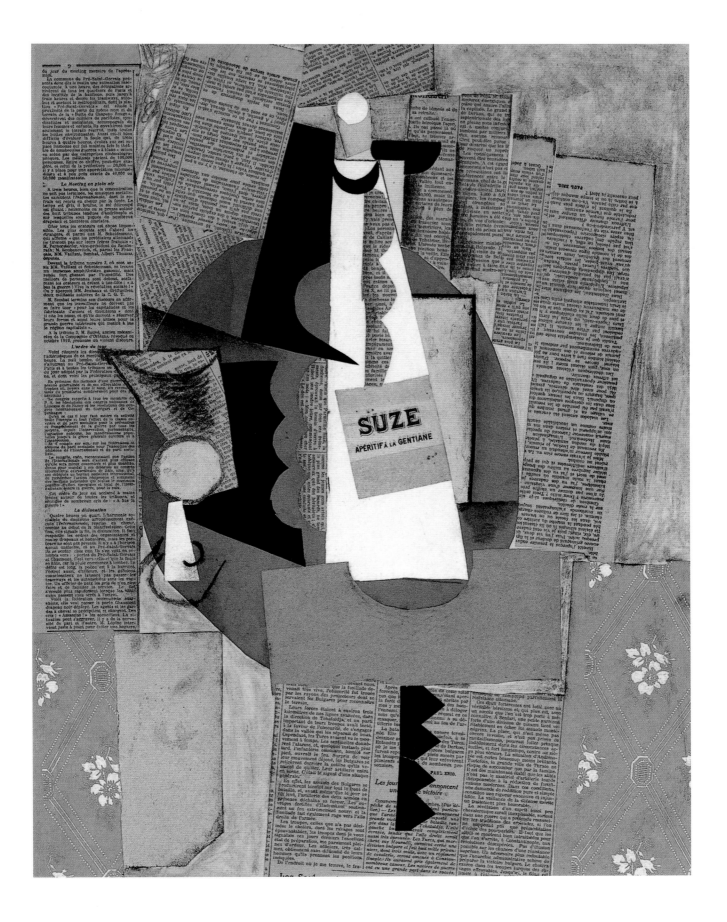

38 **Georges Braque** *Bach* 1913
Text provides a reference to music via the name of a composer.

Links to the world of the music hall could in fact become quite manifest, as in those works from 1911 in which Picasso borrowed the phrase MA JOLIE from a contemporary music hall number to signal his affections for his lover at that time, Marcelle Humbert: a decidedly populist note sounded within the otherwise dense and hermetic jungle of the work's Cubist camouflage. Indeed, Picasso's musical references indicate that, as well as making connections to the outside world, words could often be employed in Cubist paintings in order to generate synaesthesic effects. Both verbal and figurative references to music abound, especially in the work of Braque, where they more usually refer to classical, rather than popular, forms. The name of the composer Bach, for example, and words such as SONATE, VALSE (waltz) and ARIA, as well as pasted sheets of music, are often to be found. As in the case of fragments of text in general, the invoking of the medium of music through such references serves to open the painting up to a range of connections that extend well beyond the purely visual and spatial, taking us into the aural, oral and temporal dimensions.

It is clear, however, that despite such widely allusive references to everyday life, in Cubist works words are used very differently from the way they are employed in the sources from which they come. The authoritative, detached reporting of the newspaper, for example, gives way to a far more alienated, displaced or estranged voice. Text fragments are appropriated from the external world, but the mode of reading required to decipher this language is very easily distinguishable from the habit of linear scanning instilled by the conventional structures of printed text, although as the Symbolists had been aware, there were indeed precedents for just this kind of non-linear, multi-layered reading in the new forms of mass media. While the printed book communicated meaning directly through minimally visual typography, using clear syntax and an orderly unfolding of content, the burgeoning worlds of advertising and the popular press were increasingly dominated by visually assertive styles. Display fonts, non-linear organization and new printing techniques such as lithography stressed the graphic, material aspect of written words. And, as attention was drawn to the dynamically visual aspect of letters, the syntactical structures of language were also broken down, with the result that readers were forced to engage in more active, spatial and public modes of interpretation.

Through the fragmentary incorporation of letters and words, the legible nature of written language was also fractured in Cubist art, to be replaced by a more fluid, often illegible or decontextualized, language that is now far more materially evident as visual form. The collage technique also contributed to this disruption as it undermined the material homogeneity of the work, importing bits and pieces of apparently extraneous matter into the rectangle of the work. Against the mechanization of reading produced by the norms of print, the Cubists open the reader/viewer up to a far more syncopated, spatially expressive experience in which constellations of phrases, words and shapes have shifting inter-relations. No clear line of narrative, and often no obvious anchoring of content, is provided by the texts. Indeed, these typographical intruders are of an entirely different kind to the lettering found in post-Renaissance painting in general. Radically dislocated from any realistic support, they are no longer clearly embedded

within a coherent representation, and nor can they be classified as labels, titles or legends.

Similarly, although texts in Cubist works might indeed invite readership, what kind of relationship do the fragments actually establish with the viewer/reader? Are these texts meant to be making specific commentaries on the social lives of the artists? Or, when they refer to the context of current events – political, social, economic – is some implied or explicit judgment then being made by the artist? If we acknowledge that the various texts are in some way voices, then who exactly can be said to be speaking? Do the often multiple fragments of newsprint, the headlines, denser areas of type and advertisements add up, perhaps, to a cacophony of voices, to raucous arguments, heated debates, or intimate conversations taking place in a café or studio? Or are the words we read emanating from a single source, from one point of view, or perhaps, on the contrary, from none?

As the critic Maurice Raynal put it (in idealist terms that evoke Plato), the Cubists 'no longer imitate the misleading appearance of visual phenomena but the truer ones of the mind'.[7] That is, a typical Cubist work can no longer be said to *depict* the world, but instead *describes* it in a mediated fashion through the deployment of a vocabulary of visual–verbal forms. In this light, a Cubist work can be understood as a combination of hieroglyphics. It is involved in a sophisticated play with a repertoire of signs that go indeterminately through metamorphosis without being grounded in any fixed point of reference to reality. Circulating within this system, a piece of newsprint might become a sign for a bottle, the surface of a table, an area of shadow, or a flat shape on the picture plane. Within the Cubist system, typography functions as both image *and* information, and the verbal can no longer be regarded as a counterpoint to the visual. Instead, it is employed as but one aspect of a broader conception in which a painting is seen as a complex weave of visual signs that gain their meaning from their participation in a sequence of rule-bound conventions that need to be read discursively by the viewer.

Ultimately, this transformation in the approach to visual art also meant that the division between the spatial and the temporal in art – between painting and writing – narrowed further. Within Cubist circles the creative dialogue between artists and writers proved especially fruitful, and such collaborations were expressed in a number of ways: through poets and writers defending the new painting in their roles as art critics (as was especially the case with Apollinaire), in collaborations between artists and poets (Picasso and Max Jacob, or Juan Gris and Apollinaire), and in poets and artists borrowing techniques from each other's medium. And while words – the traditional preserve of the writer – now became part-and-parcel of the visual artist's domain, so too did poets and novelists learn from the artists' experiments, forging a new kind of literature characterized by shifting personal pronouns and shattered syntax. In their preoccupation with language as a material, opaque form, the influence of Cubist multiple perspectives, fragmented space and attention to formal structure can be clearly perceived in the pioneering works of such varied modernist writers as James Joyce, Virginia Woolf, T. S. Eliot, Ezra Pound and Gertrude Stein.

39 Francesco Cangiullo *Pisa* 1914

A train journey evoked through Futurist *Parole-in-Libertà* (words-in-freedom).

Parole-in-Libertà: Futurist Words

'Have you ever thought about the sadness that streets, squares, stations, subways, first class hotels, dance halls, movies, dining cars, highways, nature, would all exhibit, without the innumerable billboards, without show windows (those beautiful, brand new toys for thoughtful families), without luminous signboards, without the false blandishments of loudspeakers, and imagine the sadness and monotony of meals and wine without the polychrome menus and fancy labels', asked the French poet Blaise Cendrars, in the process offering something of an inventory of the kind of typographical sources in which the Cubists had revelled.[1] But not all artists were interested merely in an occasional borrowing of such material, and for the Italian Futurists, this modern chaos, and these new technological inventions and scientific discoveries, were themselves the only fitting subject matter for truly modern art. For them, the Cubists had only begun to suggest how the reality of the new life should be approached.

Their leader, the poet Filippo Tommaso Marinetti, best articulated their credo when he announced that the pace of social change had transformed all areas of human life, rendering old assumptions about the arts redundant. He recognized that these changes had profound implications for language, and in the *Technical Manifesto of Futurist Literature* (1912) and *Destruction of Syntax – Imagination without Strings – Words-in-Freedom* (1913), proposed that what was needed was a more direct and emotional idiom. Imagination, Marinetti declared, must henceforth be driven by 'the absolute freedom of images or analogies, expressed with unhampered words and with no connecting strings of syntax and with no punctuation.'[2] The new language of poetry, he argued, must banish not only the forms of traditional metre, but also free verse, the innovation central to Symbolist poetics. These now outmoded lyrical modes were to be replaced by what Marinetti called *parole-in-libertà* – words-in-freedom. 'Casting aside every stupid formula and all the confused verbalism of the professors', he announced, 'I now declare that lyricism is the exquisite faculty of intoxicating oneself with life, of filling life with the inebriation of oneself.'[3]

But the Futurist linguistic revolution went further than a reform of poetic style. Marinetti's argument was grounded in the belief that the structure of language mirrored the oppressively hierarchical nature of society. The open, rhythmic space of sensory experience, he argued, was suppressed by the strict spacing and separation of the intelligible world created by the hold of the alphabetic word over consciousness. The Western mode of writing had the effect of severing language from the body, for the alphabet disengages language so that the audible, pictorial, tactile and olfactory aspects of communication are funnelled into one sense: the visual. And while handwriting still has some connection to the body, print severed this

40 **Filippo Tommaso Marinetti** 'Pallone Frenato Turco' from *Zang Tumb Tumb* 1914
A page from the Italian poet's pioneering collection, which describes the drama of the war in the Balkans visually as well as verbally.

connection altogether. Grounded in hierarchical logic and analysis, print objectifies time and space, and by removing language from the specific context of bodily gesture and vocalization, creates the illusion of a disembodied and permanent realm of discourse. Ordered ranks of letters, dutifully organized into words and sentences, were like soldiers on parade, marshalled through spacing, interval and linear structure to defend society against the destabilizing forces of human emotion and imagination.

But this ordering and disciplining structure was now being swept away by the new forces unleashed by electronic technology, and Marinetti declared that it was the goal of Futurism to give artistic form to these changes. Futurism's task was to liberate language, to return it to a more primal, concrete and dynamic kind of medium rooted in the sensory world, participatory and empathetic, even agonistic, in its confrontational and aggressive practice. Verbal language, Marinetti urged, must encompass all the senses, and he stressed the importance of a performed poetry that would draw attention to the oral, aural and theatrical aspects of the spoken word:

> With words-in-freedom we will have: CONDENSED METAPHORS. TELEGRAPHIC IMAGES. MAXIMUM VIBRATIONS. NODES OF THOUGHT. CLOSED OR OPEN FORMS OF MOVEMENT. COMPRESSED ANALOGIES. COLOUR BALANCES. DIMENSIONS, WEIGHTS, MEASURES, AND THE SPEED OF SENSATION. THE PLUNGE OF THE ESSENTIAL WORD INTO THE WATER OF SENSIBILITY, MINUS THE CONCENTRIC CIRCLES THAT WORDS PRODUCE. RESTFUL MOMENTS OF INTUITION. MOVEMENT IN TWO, THREE, FOUR, FIVE DIFFERENT RHYTHMS. THE ANALYTIC, EXPLORATORY POLES THAT SUSTAIN THE BUNDLE OF INTUITIVE STRINGS.[4]

The written word was to be subjected to processes of rigorous deconstruction: 'I initiate a typographic revolution', declared Marinetti, 'aimed at the bestial, nauseating idea of the book of passéist and D'Annunzian verse, on seventeenth-century handmade paper bordered with helmets, Minervas, Apollos, elaborated red initials, vegetables, mythological missal ribbons, epigraphs and roman numerals. The book must be the Futurist expression of our Futurist thought.'[5] Words, which had functioned as the visualization of speech and had been held in the service of communicating information, were to be reimagined as material things in themselves, independent of the voice. The space of reading was to cede to visual space, and the connections between writing, hearing and understanding challenged by the more open and unregulated experience of looking, and by a new awareness of the connection between writing and the rhythmic space of the body. Language was to be atomized, exposed at its roots, and recognized as a material event. Typography, Marinetti argued, was expressive in its own right, irrespective of which words the letters were used to signify. In this situation spelling need no longer conform to the norms of the dictionary, but would instead be based on what Marinetti called 'free expressive orthography'. Layout, scale and visual–verbal juxtapositions were directly to evoke emotions rather than merely describe them. As Marinetti

announced in the manifesto *The Geometric and Mechanical Splendour of words-in-freedom*, published in 1914: 'Despite the most skilful deformations, the syntactic sentence always contains a scientific and photographic perspective absolutely contrary to the rights of emotion. *With words-in-freedom this photographic perspective is destroyed* and one arrives naturally at the multiform emotional perspective. E.g. *Man + mountain + valley* of the free-wordist Boccioni'.[6]

But like the Cubists, Marinetti also recognized that this 'primitivizing' of language was already evident in the emerging forms of the mass media, and it was to the examples of the press, advertising and popular entertainment that the Futurists would often look for inspiration. The mass media had, it seemed, already absorbed the lessons of the new simultaneous and accelerated lifestyle and Marinetti called on artists and poets to take them at face value. The very crudity and vulgarity that had offended Mallarmé, and which the Cubists had sought to transform into a witty play of hermetic signs, was now welcomed by Marinetti as proof of vitality and absolute modernity.

So what did 'words-in-freedom' look like in practice?[7] Marinetti himself quickly produced examples in the Futurist journal *Lacerba* and subsequently for such collections as *Zang Tumb Tumb* (1914) [*40*] and *Les Mots en Liberté Futuriste* (1919).[8] Written words are here regarded as the visual equivalents of the onomatopoeic effects of the Futurists' performed poetry. Through the stringing together of nouns, the omission of connectives, and the use of onomatopoeic articles, the hold of conventional syntax is challenged, opening up words to multi-layered and expressive modes. Various forms of shaped typography – 'designed analogies' – aimed at expressing meaning directly rather than using letters merely as signifiers. The role of the word was no longer limited to its meaning as an isolated sign, but expanded to include the whole surface of the visual field. Understanding was to come through a simultaneous vision, and words were to function as part of a total effect. Freed from syntax, they also ceased to be conceived successively and were instead seen as single images. Rather than serving as referents, they were now deemed self-illustrative, identified with their own aural and visual properties. No longer corralled into a linear syntactical structure, words were at liberty to roam freely across the page or canvas. The goal was maximum emotional impact.

The poet Francesco Cangiullo embraced Marinetti's call for the liberation of words. In *Pisa* [*39*] from 1914, he attempts to give visual form to the train journey that is also described through the words. But Futurist painters were also quick to grasp the potential of 'words-in-freedom'. Marinetti inspired various types of poetry-influenced collage that intentionally blurred the boundary between painting and poetry in order to produce what he called *dipinto-parolibero* – 'free-word-painting'. Drawing on Cubist innovations in collage technique, Futurist painters produced some striking examples of what can happen to words when they are emancipated from what Marinetti called 'the logical canal of syntax'.[9] Adapting Marinetti's theory of poetic analogies, artists explored an analogical approach to painting, juxtaposing different visual and verbal elements, and working to produce dynamic confrontations between word and image. Concepts of synaesthesia took on

far more radical forms. Carlo Carrà talked of 'the painting of sounds, noises and smells', and declared: 'Know therefore! In order to achieve this *total painting*, which requires the active cooperation of all the senses, *a painting which is a plastic state of mind of the universal*, you must paint, as drunkards sing and vomit, sounds, noises and smells!'[10] Like the Cubists, the Futurists envisaged painting as a *surface*, a two-dimensional plane onto which texts could be written. But these texts were of a different order to those found in Cubist art, and rather than existing as part of a described subject (such as a still life or café scene), the Futurists inscribed words on their works in ways that have much in common with the strategies of advertising and other forms of visual–verbal presentation such as the diagram and the labelled illustration. The concept of 'words-in-freedom' also invited a far more inventive use of typography than is evident in Cubist art, as lettering was not now necessarily derived from sources within the surrounding environment, but was instead often conjured up from the imagination.

Carrà's 1914 collage *Interventionist Demonstration* hurls at the viewer a plethora of texts, some pasted from newspapers and advertisements, some hand-painted. In a letter to his fellow Futurist, the painter Gino Severini, Carrà wrote that this work was intended to be an experiment in getting rid of 'all representation of the human figure'. This content, he said, was to be replaced by 'a painterly abstraction of the uprising of the citizens.'[11] And part of this 'abstraction' is a wealth of texts. The work has to be *read* in order to be understood, but the act of reading is challenged and undermined by our sensory responses to the complex visual space within which the words are located. We can make out the Italian *tricolore* flag, fragments of scored music, newspaper, and the artist's own name and signature. The shattered syntax demands that we engage actively in patching together the word-fragments into a comprehensible whole, and intelligibility is constantly under threat as we must take in a bewildering variety of words – 'AUDACIA', 'ROMA' – gathering to a focus at the central vortex along with words like 'aviatore', 'Italia', 'battere il rècord'. There are also phonetic spellings, and Carrà seems to have included the sound of a siren, so the painting engages oral and aural dimensions as well. This is visual–verbal overload, a celebration of the modern experience of simultaneity, where, in the absence of any clear syntax, the viewer is transformed into an unorthodox kind of reader, and in the process is compelled to take on a more active role and to make their own connections between competing parts of the work. Advertising was one obvious prototype for the dynamic impact of Carrà's work, but more broadly, works like this reflect the fact that in a culture increasingly dominated by the mass media, experience of events usually comes in mediated form. But to some extent, the work itself is a kind of advertisement, not just for Futurism – which is signalled, as is often the case in Futurist collages, through various textual references within the work – but also in support of a political principle dear to the Futurists. Painted just before the outbreak of the First World War, the 'interventionist demonstration' evoked in the title was staged in support of Italy's more active involvement in the growing tensions between the Great Powers.

When war finally came,[12] the Futurists were fervently supportive. Umberto Boccioni's collage *Charge of the Lancers* (1915), echoes this militancy,

41 **Carlo Carrà** *Interventionist Demonstration* 1914
A brash visual–verbal onslaught captures the excitement of a street demonstration.

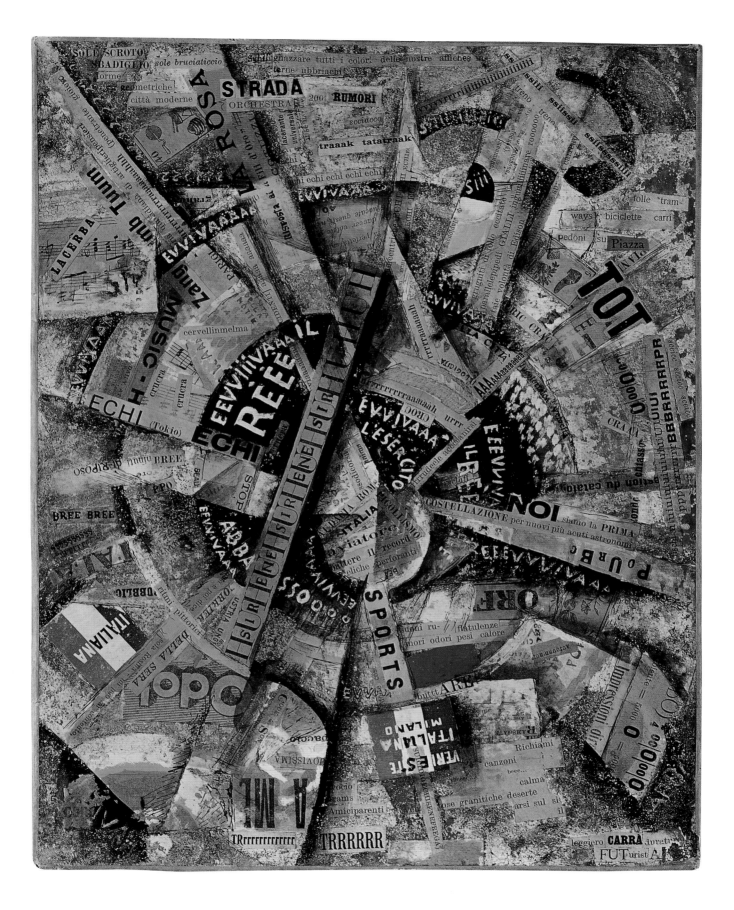

celebrating a French victory in the Oise Valley. A newspaper fragment at the top right of the work proclaims: 'Punti d'appoggio tedeschi presi dai Francesi' (German strategic point taken by the French), and the image of the lancers (cavalry were still considered at this early stage of the war to be a significant part of military strategy) bursts through the surface of the placid text, making dynamically real on a more somatic level that to which the words can only refer. Gino Severini's *Cannon in Action* (1915), meanwhile, puts us in the gun emplacement of the French artillery. In a pastiche of the technical illustration Severini has resorted to words in order to convey something of the drama – but also the mediated nature of the reportage – of a bombardment. The clarity of verbal content is constantly challenged by its incorporation into a visual composition. Some of the words, like *BBBOUMM*, are onomatopoeic and the style of the lettering used by Severini is designed to mirror visually the aural effect. Other words seem to be more basically informative – '100,000 éclairs déchirements' (100,000 lightning bolts, rips) – and these phrases, in contrast, are painted in a more deadpan typographic style modelled on the instruction manual or diagram, with capitals for important information and lower case for the more prosaic data. Some phrases, on the other hand, are clearly meant to be understood as the commentary of an eyewitness – 'Puanteur Acide – oh là là! ça sent mauvais' (Acid Gas – oh là là! that smells bad) – and to indicate this

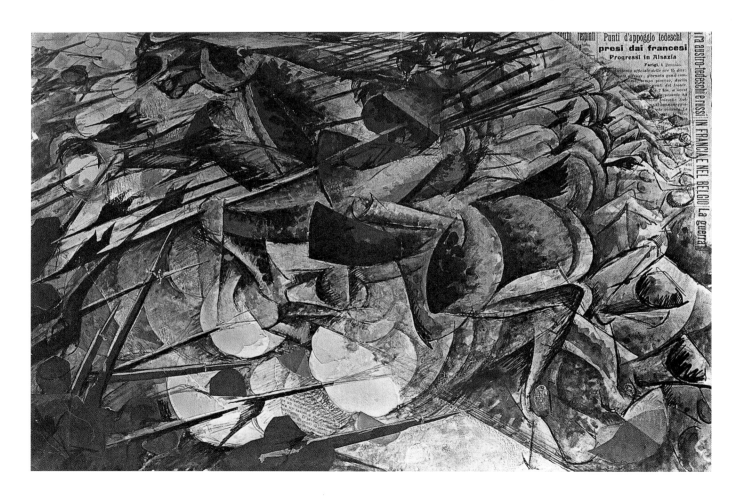

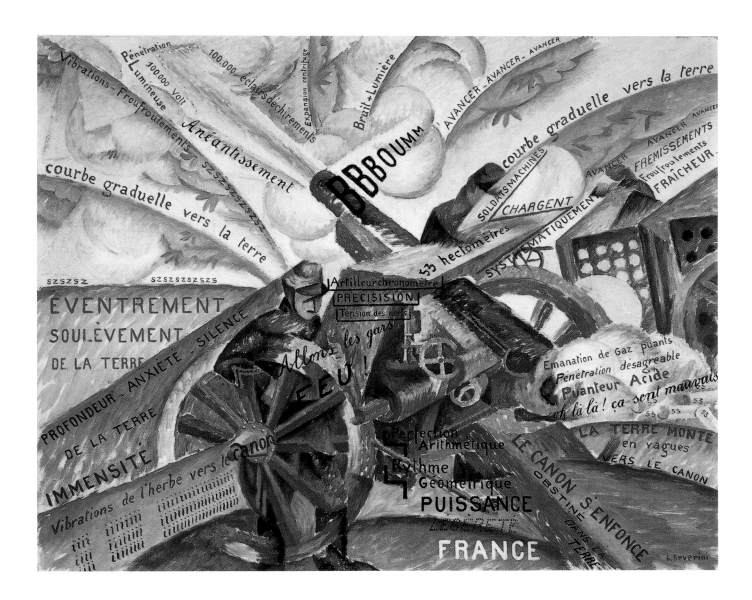

visually, Severini has painted the text in a more personally cursive and italicized hand.

The influence of such Futurist interactions between word and image was soon to be felt throughout the entire avant-garde. But at least in Paris enthusiasm was often moderated by certain reservations about the Italians' wholehearted and uncritical embrace of technology and their rhetoric of anarchic violence. The Futurists' closest allies among Parisian artists were Robert Delaunay and Sonia Delaunay-Terk who, to a much greater extent than others in the Cubist circle, were also willing to regard the mass media and consumer culture not so much as a resource to be controlled through a complex visual–verbal play as a way of disseminating the gains of their artistic experimentation. But they defused Futurism of much of its aggressive force, and Delaunay-Terk actually designed advertisements producing colourful, dynamic compositions in which word and image combine in ways far removed from the detached and sombre irony and wit typical of Picasso

43 **Gino Severini** *Cannon in Action* 1915
In a parody of the technical manual, words are used by the artist to label his depiction of a cannon in action.

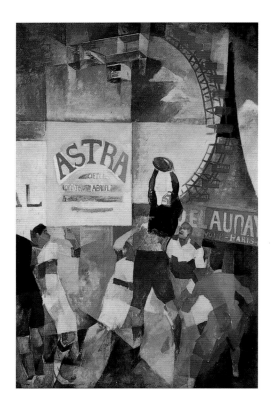

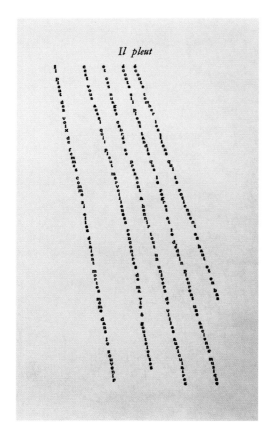

and Braque's work of the same period, and also from the confrontational work of the Futurists. Robert Delaunay's huge painting from 1913, *L'Equipe de Cardiff*, meanwhile, makes the desire for a positive relationship with the mass media explicit, and in a stirring evocation of an international rugby football match, he celebrates the fusion of sport and advertising, throwing in for good measure an aeroplane, the Eiffel Tower and the Big Wheel (which had been constructed at the same time as the tower, but was subsequently demolished). The word 'Astra', the brand name of an aeroplane construction business, means 'star' in Latin, and the classically educated Delaunay seems to be making an allusion to mankind's victory over the skies with the invention of the aeroplane. Indeed, in his optimistic vision of the new urban life, Delaunay evidently sees no conflict between his privileged education and the celebration of the life of the masses. Even the artist's own name triumphantly enters the painting in the form of an advertising brand name.

The ideas of Marinetti and the Futurists were also influential on French poetry, and this impact was felt not only on the level of content but also on that of *form*. In Apollinaire's *Calligrammes* (1916), for example, the poet laid words out on the page spatially in order to echo their subject so that they function as iconic images or poem-drawings.[13] As a contemporary critic put it, this could be regarded as heralding something of a 'revolution' because 'our intelligence must adjust itself to understanding in a synthetic-ideographic way, rather than in an analytic-discursive way.'[14] Another stunningly innovative poetic work produced in Paris during this period was also a radical departure in the form of the book *La Prose du transsibérien et de la petite Jeanne de France* (Prose of the Trans-Siberian and of the Little Jeanne de France). Published in 1913 in a limited edition fold-out two metres long, it was announced as the 'First Simultaneous Book'. Telling the story of a train journey from Siberia to Paris, the text, composed by Blaise Cendrars, was typeset in multicoloured and varied fonts and accompanied by vibrant coloured swashes by Sonia Delaunay-Terk.[15]

A similar spirit of collaboration informed the short-lived English Vorticist movement, a counter-attack to the incursions of Marinetti into the London art scene led by the artist Percy Wyndham Lewis and aided by, among others, the expatriate American poet Ezra Pound. Here, too, a significant contribution to the typographic revolution was made through the publication in early 1914 of the journal and manifesto, *Blast*. With a puce-coloured cover, the large block-like sans serif letterforms carry a characteristically aggressive artistic agenda and are laid out in ways that clearly refer to the world of advertising.[16] Like Apollinaire, Pound also investigated the ideographic roots of writing, and in an argument that would recur in various forms throughout the following decades, proposed that a new unity of the visual and verbal arts was emerging, founded on the principle of the non-discursive and concrete ideographic image. Pound observed that while in the West the alphabet was employed as a series of graphic signs in order to describe sounds, in China they used 'abbreviated pictures AS pictures'; that is to say, he noted, 'a Chinese ideogram…means the thing or the action or situation, or quality germane to the several things it pictures.' As a result of such observations, Pound advocated what he called the 'Imagist' poem, a reform of language in order once again to root words in the concreteness of

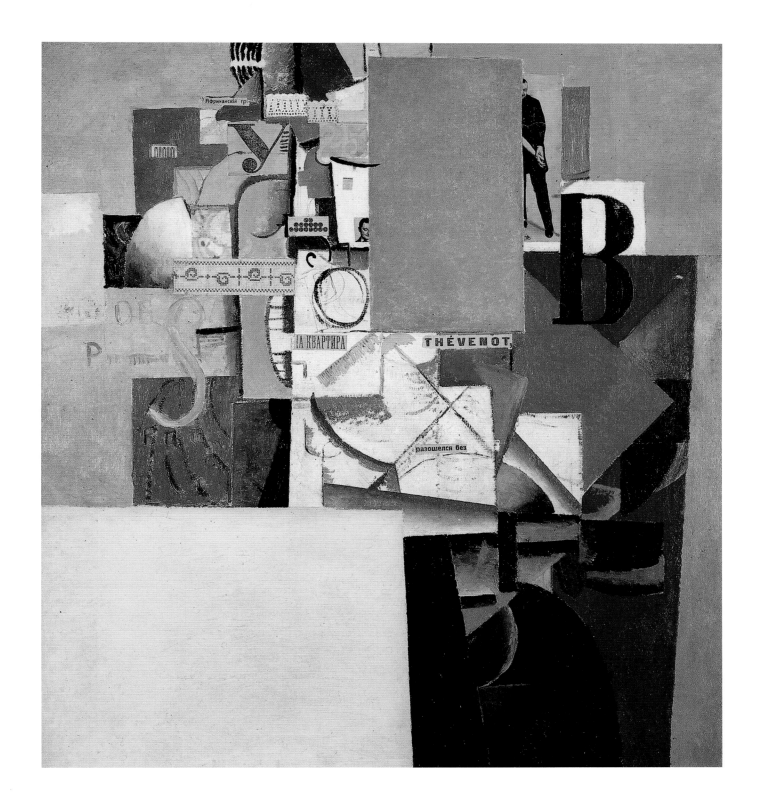

44 **Robert Delaunay** *L'Equipe de Cardiff* 1913
Advertisements play their part in this celebration of modern life.

45 **Guillaume Apollinaire** 'Il Pleut' 1914
An example of a pattern poem or 'calligramme'.

46 **Kasimir Malevich** *Woman at a Poster Column* 1914
The Morris Column undergoes radical deconstruction.

the image.[17] Inspired by the desire to create a universal language, such reflections envisaged a language of signs that could collapse the difference between the signifier and the signified and, in being rooted in the visual and the physical, could claim to exist outside of cultural determinations.

This was a Utopian quest that was also to be central to the work of the Russian 'zaum' poets, such as Velimir Khlebnikov, who developed what was called a 'transrational' language. They often reduced verbal language to the sound of the individual letter or to groups of letters, and focused on the visual nature of letters and their spatial arrangement on the page.[18] Deeply imbued with mysticism, the 'zaum' poets sought signs that were closer to the 'real', and for them this entailed going much further than Marinetti or Pound towards the creation of an entirely new kind of language lifted to a higher plane beyond reason. This quest for a 'transrational' language also informed Russian Cubo-Futurist painting. In Kasimir Malevich's *Woman at a Poster Column* (1914) [46] the collaged composition merges a female figure into a confusion of partially glimpsed advertisements and announcements in both Cyrillic and Latin alphabets. The sensation is one of spatio-temporal dislocation, with the legibility of the word fragments barely surviving the chaotic effect. But significantly, out of this urbane subject Malevich is already starting to fashion flat geometric areas of colour that seem to have no relation to the depiction. These independent forms – which are also an indication of the Suprematist style that Malevich would soon adopt – are free of any representational function, and constitute what is essentially a 'transrational' *visual* language. Soon he would abandon the external world altogether in order to paint instead what he envisaged as a purely non-objective, concrete 'icon'. For Malevich, in order to make way for a more direct experience of 'reality', both word and image – indeed all socially constructed codes – had to be destroyed so that the intelligible, sensory world could cede to a timeless, transcendent and universal state.

But there were other artists for whom the possibility of escape from the material world or the desire to celebrate the modern technological spectacle seemed to be overshadowed by a sense of foreboding. The vision of German artist George Grosz, coloured by the trauma of combat in the First World War, combined Expressionist distortion with the dynamism of Futurism and the angularity of Cubism in order to evoke a society in crisis. In Grosz's work, the overlapping planes and lines of force of Futurism are employed not to convey a sense of the metropolis as a place of excitement and liberation, but rather as a hell of alienation and despair. In *The City* (1916–17) fragments of text, though often partially dislodged from the depiction, are not incorporated in accordance with the principles of 'words-in-freedom' but (as in Cubism) as part of an essentially representational, though fractured and tortured, composition. Advertisements and other kinds of street signage animate the scene, and Grosz seems to make their hollow messages of material well-being serve as a kind of libretto accompanying the music to which the ant-like masses perform a dance of self-destruction. The Cubist and Futurist paean to the modern city has here turned into a nightmarish vision of the apocalypse. We have entered the troubled world of Dada.

48 The opening of the First Dada International Fair, Burchard Gallery, Berlin, June 1920

'Take Dada seriously! It's good for you' says one of the mock-advertisements (third from the left). Among the Dadaists photographed are Raoul Hausmann (second from left), Hannah Höch (second from right), George Grosz and John Heartfield (far right).

6

<div style="text-align: right;">

L.H.O.O.Q.:
Dada Words

</div>

'What is DADAISM?' asked the German artist and poet Richard Hülsenbeck in a lecture given in Berlin in February 1918. He continued: 'The word Dada symbolizes the most primitive relation to the reality of the environment… with Dada a new reality comes into its own. Life appears as a simultaneous muddle of noises, colours and spiritual rhythms, which is taken unmodified into Dadaist art, with all the sensational screams and fevers of its reckless everyday psyche and with all its brutal reality.'[1] No doubt in 1918, as the First World War reached its terrible conclusion, the 'brutality' of which Hülsenbeck spoke must have seemed self-evident. The cult of reason upon which modern society was founded had not, it seemed, produced a more just world but had instead bred a crassly materialistic and bloodthirsty culture devoid of moral purpose.

By being arbitrary yet fixed, words seemed to the Dadaists to be the epitome of this decadent culture, of the inauthentic and second-hand. Indeed, recognition of the worn-out and debased nature of language was a widespread theme during this period. James Joyce, for example, in *Ulysses* (1922), and later to an even greater extent in *Finnegans Wake* (1939), would signal his suspicion regarding the ability of written language to act as a credible vessel for communication by exploring the autonomy of the written sign, substituting for the representational function of language a complex tapestry of puns and neologisms. 'As a result of custom, comfort and mindlessness', declared the German Dadaist Raoul Hausmann, as if to echo Joyce, 'we must realize that we are surrounded, in our conventional lifestyle, and its naturalistic grasp of things, only by fossilized and lifeless stereotypes, by clichés of real life.'[2] But in the intense heat of the crucible of Dada, language was to undergo yet more radical deconstruction. Melted down and recast as a seemingly meaningless material entity, words would be deliberately impoverished by focusing attention on senseless rhetoric rather than genuine expression, and by playing on already constituent and clichéd meanings rather than on new and original content. Dadaist poets would use cryptic and invented words, and fail to provide clear transitions from topic to topic or evident links between words. Sometimes their language appears telegraphic, with extensive meanings condensed into single or few words or phrases that remain obscure in the absence of the necessary background information. Common words would often be employed in personalized and idiosyncratic ways, and the normal causal and practical contexts for the language deliberately confused or absent. The Dadaists would also rob language of its metaphoric range, autonomizing it and emphasizing opacity over transparency – in the case of speech, attention would be focused on the acoustic dimension, while in writing, the visual, material qualities of letters were brought to the fore. The flow of discourse in Dada poetry was also

more likely to be determined by rhyme or alliteration than by any external meaning or theme. Indeed, choices of words and phrases would often be the result of their status as found collage elements with nonsensical meanings, rather than their function as descriptions or meaningful narratives. Obscure and apparently random juxtapositions abound, as well as the complete abandonment of syntax, with deliberately confusing results, as in this extract from a poem by the German artist Kurt Schwitters:

> lanke tr gl
> pe pe pe pe pe
> ooka ooka ooka ooka
> lanke tr gl
> pii pii pii pii pii...[3]

Hülsenbeck would talk of the 'Bruitist poem', the 'Simultaneist poem' and the 'Static poem', new forms that aimed at capturing all the 'brutal reality' of contemporary life.[4] And while acknowledging a debt to Futurism, he nevertheless emphasized that Dada was willing to take such experimentation with these forms much further into the realm of non-sense. 'We have developed the plasticity of the word to a point which can hardly be surpassed', declared Hugo Ball (the Swiss Dada poet and founder of the controversial 'Cabaret Voltaire' nightclub) in 1916. 'This result was achieved at the price of the logically constructed, rational sentence, and therefore, also by renouncing the document (which is only possible by means of a time-robbing grouping of sentences in a logically ordered syntax).'[5]

> Take a newspaper.
> Take some scissors.
> Choose from this newspaper an article of the length you want to make
> your poem.
> Cut out the article.
> Next carefully cut out each of the words that make up this article and put
> them in a bag.
> Shake gently.
> Next take out each cutting, one after the other.
> Copy conscientiously in the order in which they left the bag.
> The poem will resemble you.[6]

The linguistic sign is the most complex and influential product of human reason, and to assail language was also to assail the most cherished of Western values. So, this recipe for the composition of a poem by the Romanian Tristan Tzara (the most nihilistic of the Dada poets) was intended to be an attack on far more than simply the syntax and semantics of verbal language. Tzara announced that culture was a shallow fraud, and his procedures amounted to an absurdist anti-aesthetic founded on Nietzschean principles of creative destruction. As he declared in his 1918 *Dada Manifesto*: 'DADA MEANS NOTHING'.[7] Bringing poetry into direct and awkward confrontation with the debased language of the mass media, the content, typographic style and layout of Tzara's poems, like the journals he edited, all

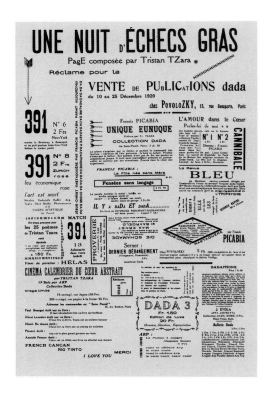

49 Tristan Tzara Page from '391' 1920
The conventions of the newspaper are borrowed by the Romanian poet in order to write provocative nonsense.

bear the trace of their sources in the world of the newspaper, the advertisement and other forms of everyday printed matter [49]. Works often read and look like excerpted samples from advertisements, arranged so that habits of linear scanning and the familiar structure of syntactical codes are comprehensively thwarted. In Tzara's eyes, the 'crisis situation' meant that there was no possible salvation, no escape from the worn-out conventions of language, and he saw the task of the Dadaist as that of exposing through ridicule the pretensions of bourgeois culture. Words were liberated from any obligation to make sense, but only so that they might herald the advent of an era of the absurd.

As the forays by an artist like Schwitters into poetry show, the Dadaists sought to bring together the arts into a new (dis)unity. Hugo Ball declared: 'The word and image are one. Painting and composing poetry belong together.'[8] The ideal of a medium's self-sufficiency was replaced by the desire for an interactive fusion of painting, sculpture, poetry, prose, performance and music. The ultimate goal, however, was not simply to create a Wagnerian-style 'total work of art', but rather to erase altogether the line between art and non-art, art and life, not only challenging the hierarchical relationship between the arts by questioning their traditional domains, but also bringing into question the status and value of art within society.

This promiscuous cross-fertilization of genres is typified by the work of the French artist Francis Picabia. After flirting with Cubism and Futurism, Picabia quickly found that his goals coincided perfectly with the nascent spirit of Dada, and arriving in New York in 1913, he helped to establish what effectively became a transatlantic base for the movement. Influenced by Tzara's example, Picabia also investigated language, introducing dramatic and nonsensical typographic effects into the journals he edited – what his collaborator Maurice de Zayas dubbed 'psychotype'.[9] He aimed at assaulting as many cherished values as he could, but a special target was the bond between subject and name. Picabia thus developed a number of disturbing strategies for severing this union. In one work, for example, he twinned a black ink-blot with the words *LA SAINTE-VIERGE* (the Blessed Virgin), an act that challenges in blatant fashion conventional assumptions about the nature of the anchoring relationship between word and image. In his mechanomorphic paintings and drawings produced in the late 1910s and early 1920s, Picabia pursued the Futurists' cult of the machine into the realms of portraiture and human sexuality, and drawing on the absurdist work of the playwrights Alfred Jarry and Raymond Roussel, he learnt to use pseudo-scientific procedures and nomenclature to mock Man's idealism.[10] These paintings function as satires on the technological model of social progress while at the same time ridiculing bourgeois faith in art. The curious amalgam of mechanical parts in *Prenez garde à la peinture* (Pay attention to painting) from 1919, for example, is accompanied by a variety of words that seem to be sited with the intention of functioning as labels or legends. But instead of clarification we are presented with a series of non sequiturs and apparently contextually meaningless phrases. By taking images from technical manuals and twinning these now enigmatic fragments with unrelated words and phrases, Picabia undermines in decisive fashion the traditional function of the word vis-à-vis the image, deliberately frustrating

50 **Francis Picabia** *Prenez garde à la peinture* (Pay attention to painting) 1919
The subject is severed from the name and a disturbing non sequitur is produced.

our faith in its ability to anchor the meaning of the latter. 'The title for him has in effect no forced bond with the work', remarked a contemporary journalist after interviewing the artist, 'for, he says, "a man can be named Brown and be blond".[11] As a result, Picabia also withdrew any hope of mutual understanding based on a shared code of public meaning. But, he declared, this wilful rejection of reason had an immediate, albeit brief, consolation:

> We paint without worrying about the representation of objects, and we write without considering the meaning of words. We seek only the pleasure of expressing ourselves – at the same time giving the diagrams we trace and the words that we order a symbolic meaning, a value of translation: not only outside all current convention, but through a convention which is unstable, hazardous, lasting only for a moment of use. Moreover, once the work is finished and the convention lost from sight, it is unintelligible to one and carries no further interest. It belongs to the past.[12]

Picabia was joined in New York by another Frenchman, Marcel Duchamp. Though very much in the spirit of Dada, Duchamp's work was not driven by the same nihilistic motives as Tzara and Picabia but rather by the wish to redirect the energies of art towards more philosophical ends. Duchamp claimed that his goal was to put art back in the service of the mind – to free it from merely perceptual, retinal preoccupations – and in his opinion Dada meant bringing visual art back into the orbit of the literary imagination. Indeed, as he later said in an interview, for him Dada was 'an extreme protest against the physical side of painting. It was a metaphysical attitude. It was intimately and consciously involved with literature.'[13] Duchamp, too, found in the work of Jarry and Roussel models for the kind of severing of words from normal usage that had appealed to Picabia, and sought out the deliberately nonsensical. Central to his philosophy, therefore, would be the principle of *indifference*, an attitude that was intended to ensure the avoidance of self-expression or the taking of a position in order instead to pursue a detached art of practical, though unorthodox and often amusing, philosophical speculation. The concept of the 'readymade' was a central part of his strategy, and in effect it constitutes a new kind of visual–verbal hybrid: 'One important characteristic was the short sentence which I occasionally inscribed on the "readymade"', Duchamp said later. 'That sentence instead of describing the object like a title was meant to carry the mind of the spectator towards other regions more verbal.'[14]

Duchamp's intentions here seem close to those of the Symbolists, in particular Odilon Redon, whom he greatly admired. But the vocabulary has changed and, unlike Redon, it is to the more neutral and consciously non-artistic realm of the 'verbal' rather than the evocative realm of the 'poetic' that Duchamp wants to direct us. By emphasizing the linguistic component, Duchamp also drew attention to the fundamentally discursive nature of his enterprise, placing his work at the service of analysis rather than expression. But the results are by no means intelligible in the conventional sense. Motivated by the belief that because language offers

51 **Marcel Duchamp** *Apolinère Enameled* 1916–17
A tin-plate advertisement becomes the host for a characteristically
Duchampian wordplay in homage to the poet Apollinaire.

no direct access to an objective reality or truth it should be treated as a
system of arbitrary signs to be manipulated at will, Duchamp practised an
extreme form of nominalism that deliberately robbed language of its
metaphoric range, forcing it to be taken literally. Recognition of both the
opacity and the conventionality of language therefore led Duchamp to regard
the word as a mere assemblage of letters devoid of intrinsic meaning, and
sentences as a body of clichés, aphorisms, proverbs and dictums. 'Words are
absolutely a pest as far as getting anywhere', Duchamp declared. 'You cannot
express anything through words'.[15] The goal was thus to exhaust the normal
meanings of existing words and to expose this purely conventional status.
Words were subjected to a ceaseless play of allusion, puns, anagrams,
cryptograms and suggestive brevities. To this end, like James Joyce,
Duchamp exploited a key aspect of the autonomous life of language: the way
words can relate to each other not according to the kind of referential
meaning established by use and context, but through linkages of rhyme and
rhythm. This phenomenon, known in linguistics as 'paronomasia', exposes
the rift between writing and speaking and is in fact a normal part of the life
of verbal language, being a staple of both poetry and the popular press.
Of this semantic linking of two words based on similarity of sound
structure, Duchamp advised: 'If you want a grammatical rule: the verb
agrees with the subject in consonance: For example the negro-ego, the
negress-egress or regress'.[16]

In *Apolinère Enameled* (1916–17), a tin-plate advertisement is transformed
by Duchamp into a witty homage to the poet Apollinaire. The play on
Apollinaire's name highlights the central characteristic of the words most
eagerly exploited by Duchamp: their tendency to have similar
pronunciations but different meanings and spellings. Perhaps the most
notorious instance of this kind of punning, however, involves the letters
inscribed by Duchamp under a moustachioed print of Leonardo's *Mona Lisa*,
'L.H.O.O.Q.', whose scurrilous meaning when spoken sounds like a French
phrase that loosely translates as 'she's got a hot ass' [*52*].

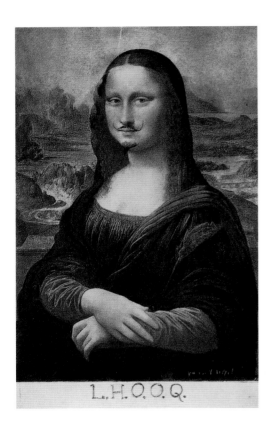

52 **Marcel Duchamp** *L.H.O.O.Q.* 1919
The artist as vandal. An icon of Western art falls victim to Duchamp's wit – the mock-classical inscription when spoken in French sounds like the phrase 'she's got a hot ass'.

Duchamp's most radical revisioning of the traditional relationship between word and image – the series of notes gathered together in the 1934 work *La Boîte verte* (The Green Box) – also involves a pun. This work, produced as a limited edition, contains various facsimile notes relating to his 1915–23 work *La Mariée mise à nu par ses célibataires, même* (The Bride Stripped Bare by her Bachelors, Even) also known as *Le Grand verre* (The Large Glass): the French word for 'green' – *vert* – puns with *verre*, meaning 'glass'. Rather than being bound in conventional book form, however, the leaves comprising the various texts are left loose so that they can be looked at or read in any order. But these handwritten jottings, extended reflections, drawings, diagrams and photographs, were not intended to be merely preparatory in nature, and are presented as part of the total but indeterminate meaning of the finished ensemble, circulating in an open-ended fashion around the physical artwork to which they refer. This curious hybrid cannot be defined according to the categories of the traditional media, and in its non-linear organization and active engagement of the viewer, *La Boîte verte* challenges conventions both of reading and of looking. Indeed, it can be seen as a multifaceted reflection on the dialectic between the visual and the verbal, and on the legacy of print and reproduction for a culture preoccupied with questions of originality.

Many other examples of Duchamp's verbal fecundity and ingenuity could be cited. Indeed, inscription of text was absolutely central to Duchamp's work, in which art is transformed from a perceptual field into a conceptual one. His seemingly playful reknitting of the complex fabric of language might seem nonsensical and, indeed, it certainly is by the standards of conventional language usage. But like the nonsense of the other Dadaists, Duchamp's absurdity and wit is put in the service of a self-conscious critique of the foundations of meaning itself. In responding to his work we are invited to use not just our eyes but also our vocal cords as well as our minds. Furthermore, we may be given an embarrassing lesson in the limits of our knowledge of other languages, a situation that is also a sign of the extreme cultural specificity of words. Indeed, any claim to the universality of art is flatly contradicted by Duchamp's rich display of Gallic and English puns and wordplays.

But neither the radical negativity of Tzara and Picabia, nor Duchamp's playful and irreverent deconstructions, are the whole story of Dada. In fact, Tzara's use of chance effects in poetry was much indebted to the Swiss artist and poet Hans Arp, who regarded the results in a very different light. Also a resident of Zurich during the years of the First World War, Arp hoped to use accident and the indeterminate not simply as gestures of destructive defiance but as a central part of a counter-mythology to be employed in opposition to what he saw as Western society's glorification of reason. Deeply influenced by Eastern philosophical traditions such as Daoism, and also by Western mystics such as Jacob Böhme, Arp sought the 'without-sense' of the illogical as a way of purging what he saw as the 'non-sense' of the logical. Looking back on the period from 1949, Arp noted: 'From 1915 to 1920 I wrote *Wolkenpumpe* (Cloudpump) poems. In these poems I tore apart sentences, words, syllables. I tried to break down language into atoms, in order to approach the creative.'[17] Such Utopian mysticism was also shared by Ball,

who in a diary entry from 1916 consciously echoed Rimbaud: 'We totally renounce the language that journalism has abused and corrupted. We must return to the innermost alchemy of the word.'[18] Ball went on: 'language will thank us for our zeal, even if there should not be any directly visible results. We have charged the word with forces and energies which made it possible for us to rediscover the evangelical concept of the "word" (*Logos*) as a magical complex image.'[19]

Like Arp and Ball, the Berlin-based artist Raoul Hausmann was also inspired by mystical, alchemical and magical sources, and from them learnt to treat the letter as an enigmatic material presence. He was especially interested in what he called the medieval 'epoch of heraldic, hieroglyphic vision',[20] when he believed that through the centrality of emblematic signs a more transparent mode of communication had been possible. In order to stage a renewal of language, Hausmann also looked to the findings of contemporary studies in linguistic history, and argued that for early man, language had functioned with 'total relations to and perceptions of the world and the powers stirring within them were symbolically and magically grasped, condensed, transfixed.'[21] It was to this more primal experience that Hausmann hoped to return art, and in his phonetic poetry he fashioned an elemental language, believing that by removing the decadent accretions of modern culture he could reveal the purer forms of an unmediated communication. Modern mechanical typography was also a principal focus for Hausmann's criticism because it was far removed from the pure source of language. But in producing what he called his 'Poster Poems', Hausmann nevertheless appropriated these modern typefaces, engaging thereby with the

53 **Marcel Duchamp** *La Mariée mise à nu par ses célibataires, même (La Boîte verte)* (The Bride Stripped Bare by her Bachelors, Even (The Green Box)) 1934
The artist creates a new kind of book in which unbound and differently sized pages can be read in any order. They provide an elusive supplement to the work *Le Grand verre* (The Large Glass), the French word *verre* (glass) sounding similar to *vert* (green).

decadent forms of the mass media in order to purify them (unlike the Expressionists, who used woodblock printing to produce crude and virile letters). In these poems, letters are put to work not as part of a signifying code, but as purely optical and acoustic phenomena.

We can see fragments of one of these poems at the sides of his 1923–24 photomontage *ABCD*, a work that mirrors the pictorial and textual structure of the illustrated newspapers and advertisements of the period – non-linear forms, semantic breaks, wordplays, juxtapositions of text and image. But it is clearly fundamentally at odds with the intentions of the mass media. At the centre is a photograph of the artist himself, grasping between his teeth the first four letters of the alphabet in an exaggeratedly vertically stressed slab-serif letterform. By placing the letters in his mouth, Hausmann seems to allude to the function of the alphabet as the visualization of speech, but by choosing a particularly visual typeface, he also highlights the material, concrete character of the written letter. The self-portrait is surrounded by a dynamic mixture of mechanical and typographic forms, including a Czech banknote and a photograph of the stars. This ensemble, whose homogeneity is ruptured by the white spaces of the paper support, can be understood as the schematization of a state of mind, and addresses what Hausmann saw as the proper role of the artist in the new technological era – a worker-artist integrated into the chaos of modern urban existence.

Photomontage was, in fact, the most important technical innovation of Dada. By robbing photography of its presence as a convincing illusion, through its gaps, blanks and spacings photomontage brings to the fore the fact that we are looking not at 'reality' but at an interpreted, mediated world, a system of signs, and at an ordered syntax that is the essential condition of any conventional code. In an essay entitled 'Typography', written in 1932, Hausmann linked the new medium to Dadaist innovations in poetry: 'Not without reason the purely phonetic was discovered which was optically supported by a novel Typography', he noted. 'Photomontage, also propagated by the Dadaists, served the same purpose: renewal and strengthening of the physiological and typography. It was already recognized then that the increasing need of the age for the image – thus the doubling of a text through optical illustration – was not to be solved through simple juxtaposition, but rather only through an optical construction referring back to linguistic-conceptual foundations.'[22]

In the event, Hausmann was able to unite his mysticism with a commitment to revolutionary politics, and as in Berlin Dada as a whole, the assault on language was understood to be part of a broader crusade to bring about social revolution. After the end of the war, Berlin Dada forged an alliance with German Bolshevism, their journal *Der Dada* declaring in 1919 that they stood for 'the international revolutionary union of all creative and intellectual men and women on the basis of radical Communism'.[23] Hannah Höch's photomontage, *Cut with the Cake Knife* (*c.* 1919), brings to the new medium this more directly political dimension, joining it to a proto-feminist statement. The visual confusion of typography and photograph is actually organized to set up a contest between the forces of progress and those of conservatism: the upper right of the work features the 'anti-Dada' faction, comprised of representatives of the former German Empire, the military and

55 **Raoul Hausmann** *ABCD* 1923–24
Fragments of advertising copy and an example of one of the artist's 'Poster Poems' collide in a classic Dada photomontage.

54 **Hannah Höch** *Cut with the Cake Knife* *c.* 1919
Dada versus anti-Dada in a photomontage that sets the forces of reaction (top) against those of revolution (bottom).

the Weimar government, while the lower right gathers together Communists, other radicals and the Dadaists. But this masculine confrontation has its counterpoint in an array of female figures – dancers, athletes, actresses and artists – and at the lower right is a fragment of a newspaper map showing the countries in which women had gained the right to vote. They include Germany, which had granted women suffrage in the same year Höch began the work.

Raoul Hausmann's photomontage also contains a fragment of an announcement designed by the Russian Constructivist artist El Lissitzky for a *Merz* soirée. *Merz* was the self-styled movement of Hanover-based Kurt Schwitters, and derives its name via the appropriation of a fragment of the name of the Commerz-und-Privat-Bank (a characteristically Dada strategy). Like Arp and Ball, Schwitters belongs to the Utopian, mystical wing of Dada, but unlike the Berlin Dadaists he preferred to eschew politics. Schwitters worked in a bewildering range of mixed-media and multi-media, arguing as a fundamental principle that no distinctions need exist between media and activities. As the Dada artist Hans Richter was later to put it in his survey of the movement, Schwitters 'pasted, nailed, versified, typographed, sold, printed, composed, collapsed, declaimed, whistled, loved and barked, at the top of his voice, and with no respect for persons, technique, traditional art or himself. He did everything, and usually he did everything at the same time.'[24] Taking collage into new territory, Schwitters made his works from the accumulated detritus of the city streets. His raw material was the overlooked, things ignored because they were of no obvious value, either economic or aesthetic. And much of this rubbish inevitably carried lettering – posters, tickets, handbills, newspapers, advertisements, banknotes, calling cards, labels. Such diverse elements were integrated into his compositions in ways that exploited both the word's visual status and its narrative qualities. Something of the dynamism typical of Futurist art is evident, but Schwitters fuses this with a more evocative and enigmatic mood. In the process, he also produces an informal document of a specific time and place, one that avoids the directly biographical or self-expressive, but nevertheless serves as a very real record of the artist's interactions with the world.

Schwitters believed that new connections and meanings would be generated out of the existing elements of the shared, man-made world, rather than from any inner reality of the artist. He declared that, 'Merz meant establishing connections, preferably between all things in this world',[25] and in what he called his *Merzbau* – a construction built within his own house – he pushed collage in the direction of the fully three-dimensional assemblage and environment. In the process, Schwitters helped to further the convergence of word and image, and to drive art out of the sanctuary of the gallery and museum and into the wider world.

56 **Kurt Schwitters** *Picture with Light Centre* 1919
The detritus of the city street becomes the raw material of art.

57 **Examples of handwritten and typewritten text taken from**
***L'Esprit Nouveau* 21, 1924**
The messy informality of handwriting is compared derisively with the
clear geometry of the typewritten script.

Théatre.

JE VOUDRAIS JOUER

Il y a " Le Tombeau sous l'Arc de
Triomphe". J'en parlerai. Déjà on peut en
juger plus tranquillement , les passions
se décantent assez vite, surtout lorsque-
ainsi que cela s'est produit pour la
pièce de M. Paul Raynal - adversaires et
amis ne sont ni les une ni les autres con-
vaincus à la manière de pièces de bois .
Le Tombeau a été attaqué au nom de préju-
gés pusillanimes ; il a été défendu pour
des raisons d'"esprit de guerre" devant
lesquelles nous devons nous incliner avec
respect, mais devant lesquelles l'art n'a

La machine à écrire elle-même affranchit notre œil des tortures de l'informe ; la géo-
métrie de la typographie se conforme mieux à nos fonctions naturelles.

7

**Futura:
Constructivist Words**

In 1924 the journal of the Paris-based Purist movement, *L'Esprit Nouveau*, featured an illustration juxtaposing the visual languages of two specimens of writing: handwritten script and the letterforms of a typewriter. The caption invites the reader to compare the former, which carries the traces of the movement of the author's arm, with the mechanized order of the typed copy. But rather than bemoaning, as we might perhaps expect, the loss of individuality and artistry evident in the latter, the writer points out that the scripted fragment inflicts on the word what he calls the 'tortures of the informal', while the cool, clear and impersonal medium of the typewriter, on the other hand, offers by far the more effective vehicle for efficient communication, in addition to being preferable because it better conforms to what he calls 'our natural functions'.[1]

As this analysis suggests, the contributors to *L'Esprit Nouveau* were advocates of the new rationalistic spirit that emerged in the period after the First World War in the wake of Futurist- and Dada-inspired chaos, and saw the typewriter as further evidence of the triumph of the ordered structures of Culture over the messy organicism of Nature. Indeed, while much of the art we have so far encountered seems largely to have waged war on reason and to have attacked language as the *Logos*'s most valued offspring, the new Constructivist vision would embrace reason in the belief that culture needed purifying of the kind of deformities characterized by 'tortures of the informal'. The old languages – visual, verbal, oral – had to be purged and a new functionalism based on the essentialism of geometric and mechanical form and on the articulation of clear, unequivocal content was to take the place of old disorderly and debased styles. A new age required a new language, and this was to be one of logic and construction.

Artists committed to the new spirit saw the destructive impulses behind Dada as merely a necessary prelude to more affirmative activities, a demolition job clearing the site for their Utopian edifice. Dada was not therefore entirely incompatible with their goals. Theo van Doesburg, the founder of the Dutch Constructivist group, De Stijl, could also be sympathetic to Dada, even devising a pseudonym – I. K. Bonset – under which he produced Dada-inspired phonetic and typographic poetry. Writing as Bonset about the state of contemporary poetry in 1923 van Doesburg noted that 'the reconstruction of poetry is impossible without destruction. Destruction of syntax is the first, indispensable preliminary task of the new poetry'.[2] But van Doesburg was also firmly committed to the aesthetics of Constructivism, and his fundamental goal was to redirect Dada energies towards a more positive agenda. He argued that the common task for the artist was to build a new visual and verbal language that could claim to have universal validity. This affirmative trajectory was summed up by the Russian artist El Lissitzky

when he observed in the journal he edited that 'the negative tactics of the "dadaists", who are as like the first futurists of the pre-war period as two peas in a pod, appear anachronistic to us. Now is the time to build on ground that has been cleared.... In the flux of forms binding laws exist, and the classical models need cause no alarm to the artists of the New Age.'[3]

Underpinning such optimism lay an awareness of the profound transformations occurring in society in general and in the communication media in particular. Due to mechanization, the world of printing itself was undergoing a technological and conceptual revolution. But as the Futurists had recognized, other new forms of media, such as the radio, the phonograph and especially film, were actually challenging the dominance of print. 'It is not Utopian to say', noted the Hungarian artist Laszlo Moholy-Nagy in 1925, that in the future, 'film and record collections will often replace the libraries of today.'[4] The German literary philosopher, Walter Benjamin observed in a now celebrated essay written in the mid-1930s that such new forms of machine production were also of great and direct consequence for the visual arts themselves. Through printing and photography, techniques of mechanical reproduction were undermining what Benjamin called the 'aura' of the unique work of art. He argued that the inventions of lithography, photography and film were of far-reaching significance; lithography, for example, 'enabled graphic art to illustrate everyday life', and to 'keep pace with printing', while photography, 'for the first time in the process of pictorial reproduction…freed the hand of the most important artistic functions which henceforth devolved only upon the eye looking through the lens.'[5] Such developments, as Benjamin saw, blurred the traditional distinctions between the visual and the verbal media: 'Since the eye perceives more swiftly than the hand can draw, the process of pictorial reproduction was accelerated so enormously that it could keep pace with speech.'[6] Meanwhile, the technological reproduction of sound in the cinema, along with the development of radio, further shifted experience of communication away from print and towards oral and imagistic dimensions. The consequences of these technological transformations would democratize art: 'In photography, exhibition value begins to displace cult value',[7] noted Benjamin, and this in its turn allowed for greater and more comprehensible access to the experience of art. In film, 'the reactionary attitude toward a Picasso painting changes into the progressive reaction towards a Chaplin movie.'[8] As the 'aura' of the unique work of art withered, Benjamin concluded, so too did the dividing line between the various arts, and between art and life, as new, more socially and psychologically integrating experiences were made available.

But studies like Benjamin's also reflected profound changes in attitudes towards the masses and popular culture. What had once been seen by many exponents of the modern in art as a faceless mob devoid of its own culture had under the impact of socialism become the revolutionary proletariat – a beacon of hope. Furthermore, as we have seen, the radical changes occurring in the structure of the economy and in the organization of society also made it increasingly difficult to maintain the traditional idea of 'high culture'. This shift entailed an opening-up of literature to forms of popular and colloquial language, which were now studied and celebrated as evidence that the

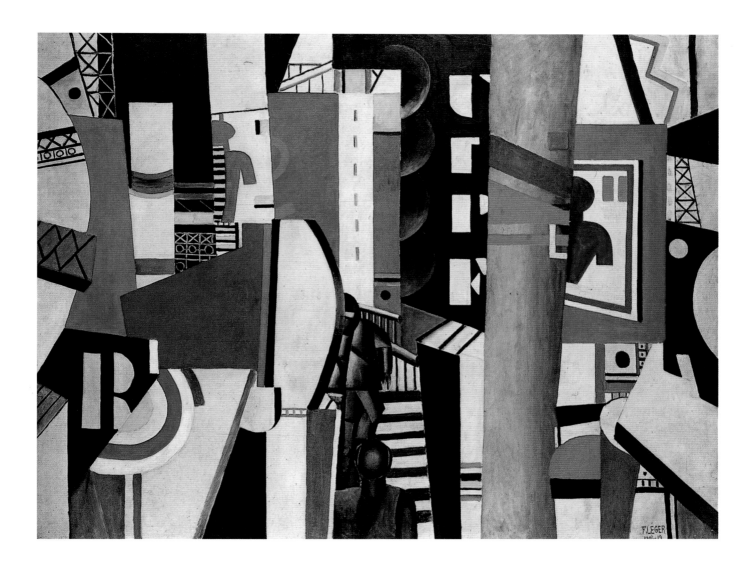

debased and clichéd forms of conventional bourgeois culture were not totally hegemonic. This could also affect artists: the French painter Fernand Léger, for example, who allied himself with the new machine aesthetic, was profoundly moved by the stoic endurance of the working men with whom he had done his military service during the War, and like many others came to believe that the future of modern culture lay in their hands. '*Slang*', Léger affirmed, 'is the finest and most vital poetry that there is.'[9]

But, as Léger was also to observe, the dividing line between art and mass culture was being blurred in other ways. Advertising continued to grow in sophistication and range, incorporating new developments in printing techniques but now also the lessons of the avant-garde itself. Writing about his monumental painting *The City*, Léger noted:

> In 1919, in *The City*, pure colour incorporated into a geometric design was realized to the maximum; it could have been static or dynamic – the important thing was to have isolated a colour that had a plastic activity of its own, but bound to an object.

58 **Fernand Léger** *The City* 1919
The artist delights in the colourful urban scene, incorporating the mechanical forms of typography, machinery and architecture.

It was modern advertising art that first understood the importance of this new quality – the pure tone from the pictures took hold of the roads and transformed the countryside. A mysterious abstract symbol of yellow triangles, blue curves, red rectangles spread before the motorist to guide him on his way. This was the new object. Colour was free; it had become a new reality; the colour-object had been discovered.[10]

These influences also extended to the typography used by the mass media, as advertising began to draw on the experiments of the Cubists and Futurists. Léger was as fascinated by the rich variety of such lettering on display in the city and countryside as he was by the strong colours of advertisements. In a similar vein, El Lissitzky, confirming the observations of Marinetti, noted that advertising had radically altered conventions of readership. The traditional book, he declared, 'had been torn into separate pages, enlarged a hundredfold, coloured for greater intensity and brought into the street as a poster.' He added: 'The book is becoming the most monumental work of art: no longer it is something caressed only by the delicate hands of a few bibliophiles: on the contrary, it is already being grasped by hundreds of thousands of poor people.'[11]

For a generation of artists who felt that traditional artistic subject matter no longer had any contemporary relevance, the factory, railway depot, and the banal, commonplace and utilitarian architecture of the commercial and industrial zones became an inspiration. In the United States, painters such as Edward Hopper and Stuart Davis, and photographers such as Walker Evans, responded to the forest of man-made signs that seemed increasingly to characterize the modern environment. There, the Precisionists embraced the industrial heartland, and Charles Demuth transformed the architecture of his native Pennsylvania into models of classical order. His painting *I Saw the Figure Five in Gold* (1928) is an emblematic poster-like homage to his friend the poet William Carlos Williams that used lines from Williams's poem 'The Great Figure'. Demuth combines finely drawn typography and hard-edged imagery – a style derived as much from the world of commercial design as it is from Cubism and Futurism – to produce a heraldic icon of the heroic Machine Age.[12]

But this new aesthetic involved more than simply a change in style. Artists were also stripped of the last vestiges of Romantic bohemianism, and re-envisaged as technicians or engineers. They were now 'producers' rather than 'creators', and the line dividing 'fine' art and 'applied' art was erased. While the Cubists and Futurists might only have flirted with mass culture, always retreating to the safe, gilded cage of 'high' art, now the artist was asked to enter the factory and the office, and to participate in a broader social revolution that, it was announced, would radically transform the relationship between art and life.

So, this new art was not only directed towards a detached and aesthetic vision, and in the newly created Soviet Union – for a short time at least – it would also be consciously in the service of the new communistic society. Here, under unprecedented conditions, it seemed that the traditional role of the artist was indeed dead and buried, vanquished with the bourgeois society that had been overturned by the Revolution. The unifying principles behind

59 **Walker Evans** *Roadside Stand near Birmingham, Alabama* 1936
Public signs cover all available surfaces in the modern environment.

60 **Charles Demuth** *I Saw the Figure Five in Gold* 1928
Such signage is incorporated into an abstract portrait of the American poet, William Carlos Williams.

this new proletarian art were to be the form of the geometric unit and the model of technological progress. Newer media, such as photography, were embraced because of their lack of history, and because, as Benjamin had noted, they challenged traditional bourgeois notions of originality and value. In Alexander Rodchenko's photomontage of Osip Brik, from 1924, the spirit of modernity and the utilitarian goals of the new art are signalled by the choice of medium, as well as by the simple but visually assertive style of typography that can be seen on the decal pasted over the right lens of Brik's spectacles (which spells the word LEF, the name of the journal edited by Brik, and to which Rodchenko contributed). The status of the work as a synthetic construction built of word and photograph rather than as a naturalistic portrait makes it, like Demuth's painting, a kind of icon of the new age, and the subject of the work a secular saint.[13]

A principal goal of the Constructivists was to apply their insights across all fields of production. Collaborations between poets and artists expanded the concept of the 'artist's book' into the field of the new rationalism. Lissitzky, for example, worked closely with the poet Vladimir Mayakovsky to produce a radically innovative collection called *For the Voice* (1923), which focused on rendering the text typographically.[14] More broadly, an interest in language as a formal structure meant that special attention was paid to the visual, material dimension of writing, to the letterforms themselves and to the way in which typography was laid out on the page. 'The ornament of rococo calligraphy is very graceful', observed Lissitzky, but he continued, echoing the sentiments of *L'Esprit Nouveau*: 'however...the typeface of the *standard typewriter* is clearer and for that reason more convincing.'[15] In a text devoted to typography the first three principles outlined by Lissitzky were therefore:

1 The words on the printed surface are taken in by seeing, not by hearing.
2 Ideas are communicated through conventional words, the idea should be given form through the letters.
3 Economy of expression: optics instead of phonetics.[16]

But the broader goal of Constructivism was to forge a new universal language, one that could dispense with the cultural specificities of the old altogether. 'In the future there will only be one art', van Doesburg declared. 'It will be a language that everybody will understand. This common language will carry the message of love.'[17] Indeed, the need to develop modes of communications for a newly emancipated proletariat led artists to envisage a language that could overcome the distinction between the visual and the verbal altogether. Lissitzky compared what he called the 'hieroglyphic' writing of China – which uses a symbol for each idea and is universal, 'at least in its potentiality' – and the alphabetic writing of the West, which uses a symbol for each sound and is purely 'national'. He argued that in the future language would learn from the former and be 'plastic-representational' so that it could appeal universally.[18] The Russian film-maker Sergei Eisenstein, meanwhile, saw cinema as offering the possibility of a new language of electronically generated images that would be infinitely more subtle and democratic than the old kinds of communication media.[19]

61 **Alexander Rodchenko** *Osip Brik* 1924
The artist as technician. The Russian text is the title of the journal *LEF* (which Brik edited) and stands for 'Left Front of the Arts'.

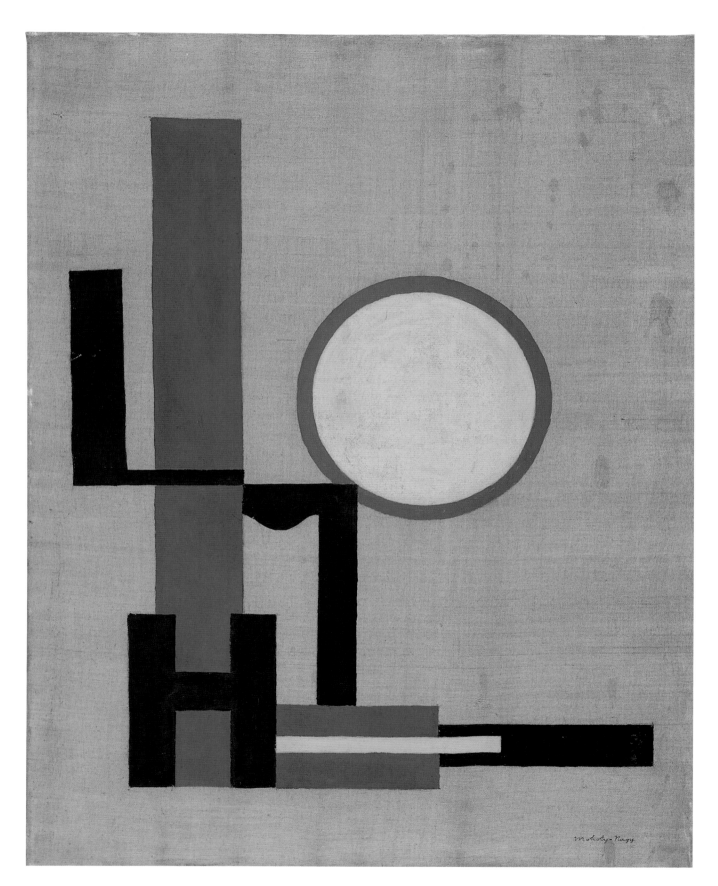

Such ideas find a parallel in contemporary literature and in the linguistic theory fired by the same spirit of structural analysis. Indeed, as we have already seen, early twentieth-century writers were often as quick to learn from recent developments in the visual arts as they were from literature and poetry. Such interaction also extended to theory. The Russian formalist theorist Ramon Jakobson, for example, pointed out that for him the most important lesson of Cubism was that it was not things in themselves that mattered but the relationship *between* things, and this led him to analyse language primarily not as a carrier of information but as a self-contained entity with purely internal interconnections. Furthermore, Jakobson argued that the significance of a poem lay not in any images it might evoke through metaphoric tropes, but rather in the *material* character of the text.[20] But such formalist studies into the structure and function of language were actually part of a much broader epistemological shift – one that marked a movement away from the analysis of subject matter or author, and onto the study of the system in which the work functioned. So, just as Marxist theory emphasized that consciousness was always the consciousness of a particular social group, Russian formalist literary criticism redirected the study of language away from questions of expression and subjectivity and onto an interrogation of the ways in which the individual was socially constructed through the different systems of signs they used. 'There are no poets and writers', declared Osip Brik, 'just poetry and writing.'[21]

In practice, however, it can be said that the result of the attentions of the new constructive artists to written language was to further its atomization and desocialization. *Yellow Disc* painted in 1919–20 by Moholy-Nagy demonstrates this tendency. A composition that appears to be resolutely abstract and geometric on closer inspection turns out to be made up of interlocking letters; the work's alternative title, *Typographical painting spelling out MOHOLY*, makes this explicit. Moholy-Nagy plays on the geometric form of the alphabet, but it is deliberately unclear how the work is to be understood. Is it to be *read* or *seen*? The large 'O', for example, can be interpreted in at least four ways. As part of a purely formal architectonic it occupies a key position within the composition, its roundness played off against the rectilinearity of other forms in order to generate visual stress. But this shape might also be understood in a more figurative and metaphorical sense, as a sun or moon set above and behind a natural or man-made mass. Then again, as a form associated with a letter of the alphabet – and as an 'O' belonging to the name of the artist – it can also be read as part of a signature. Finally, in a metonymic substitution, the 'O' can be read as Moholy-Nagy's spectacles, and so be seen to stand in for the artist himself, thus effectively making the painting a kind of stylized self-portrait. None of these readings, however, is visually prioritized by Moholy-Nagy, and the alternative titles simply serve to re-emphasize the indeterminacy or relativity of the activities of reading and seeing.

By the mid-1920s the Bolsheviks had turned against the avant-garde (see Chapter 9), and from then until its closure by the Nazis in 1933, the most important centre for the development of Constructivist ideas would be the Bauhaus school in Germany. Moholy-Nagy taught there, and he and other members of staff made central features of their teaching the relationship

62 **Laszlo Moholy-Nagy** *Yellow Disc* 1919–20
The geometric shapes of letters are explored in a work that spells the artist's own name.

between verbal and visual signs and the quest for a universal sign-system. In an essay devoted to typography written in 1925 Moholy-Nagy observed that it was now necessary to apply to the maximum the potentialities of the machine; and nowhere more so, he added, than in the field of typography: 'The future form of typographical communication will largely depend on the development of mechanical methods'.[22] In the same article he discussed the transformations that had revolutionized the written word and, echoing the thoughts of El Lissitzky, indicated what he saw as the nature of the present task – to move typography towards greater visual presence:

> While typography, from Gutenberg up to the first posters, was but an intermediate (though necessary) link between the content of a communication and its recipient, the first posters opened up a new phase of development. In the typographical material used so far (object-like) as an instrument only, there were now potential effects of their own (subject-like) existence to be recognized, i.e. it was taken into consideration that form, size, colour and layout of the typographical material (letters, symbols) may exercise a strong visual effect. The organization of these possible visual effects provides the content of communication with a visual validity; in other words, by means of printing, the content will be recorded pictorially as well. To support, strengthen, emphasize and, above all, *represent* this, is the actual task of visual-typographic work.[23]

Moholy-Nagy's *Typo-Collage* (1922) is typical of the kind of 'visual-typography' that he pursued. It is of startling minimalism, with the letters entirely shorn of any visual complexity but also of their role as building blocks for the production of words. They stand instead as a monumental architecture dedicated to functionality. Moholy-Nagy drew the letterform type of choice for the Constructivists – sans serif – a style that was considered the purest and clearest expression of the new spirit. In fact, sans serif has its roots in three quite distinct letterforms: firstly, the 'grotesques' or 'gothics' which are close in form to 'blackletter'; secondly, the clearly contoured Renaissance-style letter; and, thirdly, a form based not on historical precedent but on the geometric order of the compass and set square. Sans serifs of the first family appeared in the early nineteenth century when they were immediately associated with the ancient world – that is, with the essential and primitive – and they also became popular for cheap, mass printing because they were durable and easy to set. Cubist art often features such letterforms, where they are intended as signs of the vulgar and unaesthetic. But the sans serif of the Constructivists, on the other hand, derives from a fascination with geometry. The goal was to produce the *essential* typographical form, one which was also in their opinion the most appropriate vessel for direct, uncomplicated and universal communication. The clear and rational appearance of the new sans serif, the teachers at the Bauhaus argued, transcended the merely individual, putting typography in the service of the collective. Moholy-Nagy's version of sans serif employs capitals, but soon even upper-case would be deemed unnecessarily complex at the Bauhaus, with lower-case alone sufficing for all that was

63 **Laszlo Moholy-Nagy** *Typo-Collage* 1922
Typography shorn of any ornament and reduced to pure forms.

typographically necessary from the purist and universalist point of view. And so, in 1925, capitals were abolished at the Bauhaus.[24]

The effects of this new rationalist spirit on the profession of typography and on commercial art as a whole proved to be far-reaching. Responding enthusiastically to the new ideas, the influential German typographer Jan Tschichold in 1925 published a short manifesto for the new faith, proclaiming the birth of what he called the 'elementary typography', and announced that this was 'oriented towards purpose', its purpose being 'communication'. Text, he went on, must appear in 'the briefest, simplest, most urgent form' and be 'serviceable to social ends'.[25] In his seminal handbook, *The New Typography* (1928), he dismissed the whole period from 1440 (the invention of printing) to 1914 as the age of the now defunct 'Old Typography'.[26] Playing the role of prophet, and bringing to the conservative world of the print shop the innovations of the artistic avant-garde, Tschichold was fired with the spirit of this new vision. But the dissemination of Constructivist ideas into the field of advertising and graphic design was also directly carried out by artists themselves. The Bauhaus explored the effects of combining text and photography, Moholy-Nagy noting that the juxtaposition of print and image created optical relationships that occurred at varying speeds of perception, and that by thoughtful use of word and image the designer could control the tempo of visual–verbal interaction.[27] Beyond the Bauhaus, Kurt Schwitters – an artist who, like van Doesburg, crossed and recrossed the art-historical line dividing Dada and Constructivism – was also interested in applying avant-garde styles to the marketplace, and pursued a briefly prosperous career in advertising design during the 1920s as typographical consultant to the city of Hanover. 'Typography may be art', Schwitters declared succinctly in *Merz*, the journal he edited.[28]

In the event, the Constructivist aesthetic would prove vital to the development of an efficient language of modern communication, and its influence can be seen on book design, advertising and other forms of public communication, as well as architecture and interior design. In 1927, the quest for an internationally and universally applicable alphabet led to the commercial issue of the sans serif letterform that would quickly become the most perfect embodiment of the new rationalist, geometric, spirit – 'Futura', designed by Paul Renner at the Bauer Type Foundry in Germany. 'Futura' is still widely used, though it has since been joined by other sans serifs that also build on 'grotesques' and Renaissance styles. But already by the early 1930s, Fernand Léger's observations about advertising seemed to have been confirmed everywhere, as the lessons of the avant-garde were avidly assimilated deep into the heart of the capitalist system, a system that, paradoxically, many of this avant-garde also sought to overthrow.

64 Kurt Schwitters Spread from 'Typoreklame' issue of *Merz* 1924
The new typography and design was quickly turned to the needs of the marketplace. A design for Pelikan ink by Kurt Schwitters.

65 Paul Renner 'Futura' 1928
The name of the new commercial letterform – inspired by the Bauhaus – reflects the ambition to fashion a truly modern style.

A collection of objects, images and texts collude to conjure up what
Breton called 'the marvellous'.

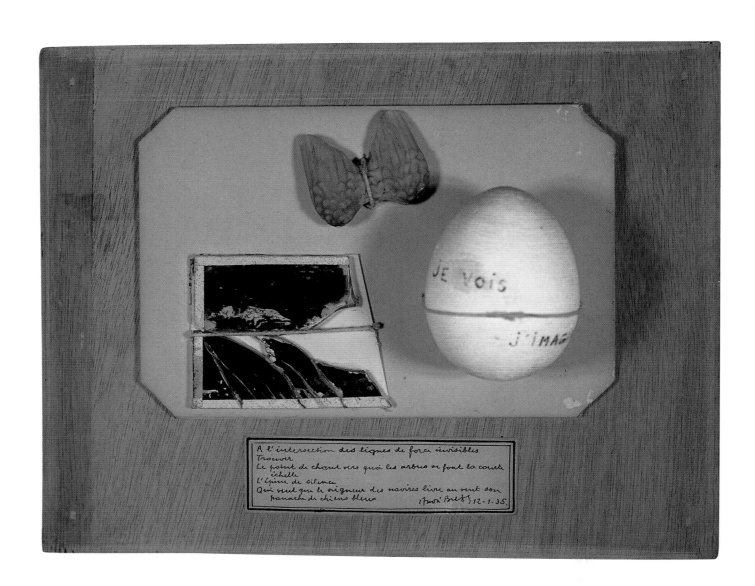

8

L'Alphabet des rêves:
Surrealist Words

In 1928, André Breton, poet and 'Pope' of Surrealism, published a novel entitled *Nadja* that was illustrated by a number of photographs of the story's key Parisian locations.[1] These pictures, taken by Jacques-André Boiffard, sometimes contain billboards, advertisements, placards, shop signs and other such fragments of urban text. But these were no longer meant to be interesting primarily because they were subversive signs of mass culture, as was the case with Cubism, Futurism and Constructivism, but rather because, through uncanny juxtaposition with their surroundings, such street signage helped to generate a sense of what Breton called 'the marvellous'. Indeed, the public texts of the city of Paris are presented in *Nadja* as though they were inextricably bound up with the author's love affair with the girl of the book's title. Similarly, Breton's friend the poet Louis Aragon in his novel *Le Paysan de Paris* (1926) described coming across arresting texts everywhere, and here too it was as if Paris was a vast forest of fabulous hieroglyphics beneath whose placid and banal surface were inscribed more arcane and unsettling kinds of narratives. 'Forward, forward, let us clear the path on either side of us of its enigmas, or rather let us call forth these enigmas as the mood takes us, as temptation lures us', writes Aragon. 'To the left, the doorway of number 17 and its shadowy staircase are framed by placards which immediately send me into a reverie.'[2] For the Surrealist imagination, Paris was like a giant cryptogram waiting to be deciphered by the liberated mind: 'the most dreamed-of of their objects', as Walter Benjamin put it in an essay written in 1929.[3]

As a poet, Breton was obviously centrally involved in the problem of verbal language, but his thinking on the subject of the written word would soon have important implications for art as well. Regarding the contemporary situation, Breton was essentially in agreement with the rest of the avant-garde: a revolution was needed. But the form that this revolution would take was evidently to be of a rather different kind from that advocated by the earlier avant-garde. In an essay written in 1922 when he was still under the influence of Dada, Breton surveyed the state of modern literature and declared that what was now required was 'words without wrinkles' – words brought thoroughly up-to-date.[4] Looking back over the previous decades of literary experimentation, Breton observed that it was clear that writers were 'beginning to distrust words', and were 'suddenly noticing that they had to be treated other than as the little auxiliaries for which they had always been taken'. 'Some thought', Breton went on, 'that they had become worn down from having served so much; others, that by their essence they could legitimately aspire to a condition other than the one they had.' 'In short,' he summed up, 'we had to free them.'[5] Referring to Rimbaud's desire for a true 'alchemy of the word', Breton cited the poet's attribution of colours

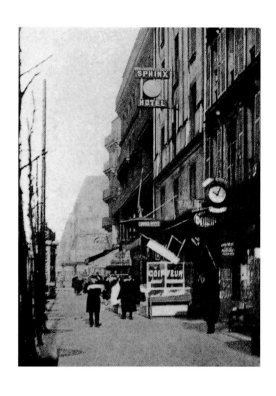

67 **Jacques-André Boiffard** *Boulevard Magenta, outside the Sphinx Hotel* 1928
Parisian street signage as enigmatic presences in a photograph from Breton's novel *Nadja*.

to the vowels as a very significant gesture towards this liberation – here, for the first time, Breton averred, 'consciously and in full knowledge of the consequences, someone turned the word away from its duty to signify'.[6] But it was only now, Breton said, that the word was ready fully to come into its own. It was a matter: '(1) of considering the word itself, and (2) of examining as closely as possible the reaction words could have to each other. Only at this price could we hope to take knowledge a giant leap forward, and exalt life by as much'.[7] With the work of the modern poet – indeed with the work of Breton himself – words, he proclaimed, were finally 'making love'.[8]

Two years later, in the *First Surrealist Manifesto*, Breton revealed how this new erotics of the word was to be achieved. The cornerstone of the new literature was to be founded on what Breton called the process of 'psychic automatism', a technique applicable to all creative activities and intended to generate 'either verbally, or in writing, or in any other way, the true functioning of thought'.[9] In total opposition to the Constructivists' quest for a purification of rationalism, Breton argued that the arts must unite in a common campaign waged against reason, and be based on 'thought expressed in the absence of any control exerted by reason, and outside all moral and aesthetic considerations'.[10] But the results would be far from Dada nonsense. Breton had studied the work of Sigmund Freud during his time as a medical intern during the First World War and concluded that psychoanalysis offered the arts a new model of how the imagination worked on language. For Breton, the free-association advocated by Freud as part of the analytical process offered a means by which the conventions of language could be used against themselves and the rules of semantics and syntax employed not in the service of reason and orthodoxy but to give voice to the unconscious, to desire itself. Psychoanalysis showed how language was exposed to the pressures of the body and beholden to the irrational forces of the instincts that wrest it from the control of conscious and rational meaning. Through the activity of free-association and through the interpretation of dreams, argued Freud, analyst and patient came to understand what this strange language was saying, and as a result, by acts of sublimation, the patient would once again be able to function effectively in society. In this sense, the aims of psychoanalysis were profoundly conservative, as they were intended to ensure healthy conformity with the law of society. For the Surrealists, however, these repressed and potentially socially incompatible dimensions to the human experience mapped by Freud were exactly those that were to be encouraged. Breton declared that it was necessary to embrace a more spontaneous, ecstatic existence, one rooted in desire and the needs of the body, one in which an emancipated consciousness rejected the ethical and religious compulsions of bourgeois culture in order to live fully in harmony with the instincts.

The Surrealists' task, then, was to learn to recognize and to speak the language of the unconscious. They started by looking for examples of the voices of 'desire' as they were already spoken or written in literature. But though Breton suggested that poets such as Rimbaud and Lautréamont and playwrights such as Jarry might show the way, he felt that no one had gone far enough. Thus, it was to the margins of culture – beyond literature as it was conventionally conceived – that the Surrealists went searching. Some of

these margins had already been charted by the avant-garde – the primitive language of the 'savage', or the occult visions of the mystic, for example. Others, however, had only more recently begun to be explored – the voices of madness, the child, the proletariat, the feminine and the transgendered. Using these borderline codes, the Surrealists began to plot what Breton called boldly a true 'revolution of the mind'.

As Breton noted, as well as free-association and the narration of dreams, Freud himself had developed practices such as hypnosis for releasing the mind from conscious control. Spurred on by such discoveries, Breton himself began to note down the various phrases that came into his head as he fell asleep each night. Though he was unable to find anything that might have triggered them, these sentences – which were syntactically correct and, according to Breton, remarkably rich in imagery – struck him as 'poetic elements of the first rank'.[11] He subsequently set about systematically noting down these spontaneous outpourings and, in collaboration with the poet Philippe Soupault, published some of the results in 1921 as the collection *Les Champs magnétiques* (The Magnetic Fields).[12]

The Surrealists also continued the avant-garde's exploration of various mystical traditions, both Eastern and Western. Oriental religious and philosophical traditions, they argued, confirmed the need to be freed from the normative codes of language. Daoism, Buddhism and Hinduism all stressed going beyond the illusions created by all conventional signs and symbols, and through meditation and other forms of mental and physical discipline such as yoga, of achieving profound insight into the 'real'. From Western gnosticism and cabbalism, meanwhile, the Surrealists absorbed the concept of the word as not so much a tool for communication as something to be equated metaphysically with the structure of the human soul itself. Inspired by such traditions, in the *Second Surrealist Manifesto* (1929), Breton once again referred to Rimbaud's 'alchemy of the word', but now took the reference to alchemy more literally, stressing that, like the medieval sages in search of the Philosopher's Stone, the modern poet or artist must distil from language the essence of 'reality'.[13]

The contemporary vogue for séances – where spiritual mediums claimed to be in communication with the dead – also seemed to the Surrealists to suggest that, even without leaving the living rooms of Paris and in the absence of the severe regimes of the mystics, it was nevertheless possible for some people to produce a kind of speech or even writing that was truly beyond rational control. For a period in the early 1920s Breton and his circle would themselves repeatedly hold their own séances, and though Breton did not believe that contact with the dead was actually achieved, he saw the practice as an occasion for the free play of thought and imagination. The poet Robert Desnos, aided by drugs and alcohol (in themselves rather effective techniques for stimulating irrational speech), proved particularly adept at entering such states, and what he said and wrote was recorded by Breton as if the words were those of an oracle.[14]

From 'primitive' cultures the Surrealists developed earlier insights into a more holistic kind of consciousness, freed altogether from the constraints of the alphabet and writing. Like the Expressionists, Dadaists and Futurists, they saw how oral cultures preserved a more primal, sensual voice and

68 **Paul Klee** *Eros* 1923
The text stands as a title but does not tie down its meaning. Rather a sense of poetic correspondence is generated.

therefore they sought to emphasize direct modes of communication, such as aural recitals and performances, that engaged the body more centrally. But other kinds of such 'primitivism' could be found in the midst of modern society itself. The mentally ill [*85*], and those who had for one reason or another fallen foul of the law, were regarded by the Surrealists as models of the truly creative artist because such people could not, or would not, conform to the regulatory norms of society. Children's writing and image-making were also admired because here too were creations that, because the makers were not yet fully conditioned by society, could speak more truthfully. In addition, such spontaneity was welcomed in the less culturally inhibited speech of rural and urban workers, and in the 1930s Breton steered Surrealism towards support of Communism. Only in a movement ready to embrace the proletariat, Breton argued, could political support for the total cultural transformation envisaged by the Surrealists be found.

But as such sources suggest, the focus of Surrealism was largely on the *content* of verbal language rather than on its material *form*. Indeed, in many ways, Surrealism represents a retreat from the visual and verbal pyrotechnics of Futurism, Dada and Constructivism. Visually, Surrealist journals show none of the extraordinary typographic innovations of the earlier movements' publications. As a poet, Breton was concerned with the word as a carrier of (albeit estranged) meaning, rather than on the word as a stridently visual form. His priority was the 'signified' rather than the 'signifier', and his linguistic 'erotics' essentially envisaged language as a transparent medium for the voices of desire. The defining terms for the Surrealists were 'thought' and 'poetry', and the supremacy of these concepts meant that for them the synaesthetic 'total work of art' was formulated as the synthesis of all aspects of the work into a unified sign embodying the poetic condition.[15] As Breton put it, whether it was a painting, poem, photograph, play or film, the goal of the Surrealist artwork was to function as a 'communicating vessel' – like the medium at a séance.[16]

So, when Breton went in search of visual artists to exemplify Surrealist principles, he was drawn to visual–verbal hybrids, but predominantly of the mixed-media kind. Breton himself produced his own kind of enigmatic unions of image, object and word in what he called *objet-poèmes* (object-poems) [*66*]. In these he attached disparate objects and texts to various supports, seeking through strange juxtapositions to generate the experience of the 'marvellous'. For him, words in paintings should perform largely as carriers of verbal meaning rather than as visual components in their own right. As a result, the title would play a central role in the art he promoted. Essentially this was to be deployed in three ways: appearing within works themselves, at their margins, or, more traditionally, on the back of their supports. As we have seen, the presence of the title within the visual field had been pioneered by Symbolists such as Gauguin. The result, as the Surrealists recognized, was to generate in the onlooker two different scanning tempos – one for the visual imagery, the other for the lines of text – and they are given the task of interpreting two kinds of message – the verbal and the visual. The onlooker becomes both a viewer and a reader. This blurring of the distinctions between the site of depiction and that of description set up new kinds of visual–verbal interactions, with the presence

of the title also implying a kind of collaboration in which text supplies some kind of anchorage for the meaning of the image. But the Surrealists would continue to attenuate or sever this bond.

Words as title or label play a central part in the work of the Swiss artist Paul Klee, who proved to be a model for Breton. For Klee, the role of the artist was to generate a variety of pictorial signs that, by being obscure and elusive, could conjure up a sense of the fantastic. In *Eros* (1923), for example, Klee combined symbolic and indexical signs and juxtaposed them with the more intangible atmosphere produced by sombre coloration. Within this hermetic landscape, words are set amid the more personal and mysterious, and two kinds of language – the visual and the verbal – run in parallel, never intersecting but always exerting a force of attraction upon each other. Klee often located his delicately scripted text at the foot of the composition, its separate space neatly demarcated by a ruled line, where one might normally expect to find the caption to an illustration. But while the domains of word and image are in this way clearly segregated, the title's position within the frame makes it an insistent presence. Furthermore, it does not have a conventionally descriptive link to the image. Such carefully organized texts set up an allusive discursive field, mixing prosaic information – like the date of the work and signature – with enigmatic words or phrases that have no immediately obvious relationship to the image, while formally still qualifying as titles. By being at least partially incorporated into the same space as the artwork, the title demands the viewer's attention, also in the process turning them into a reader. But this seemingly discordant dialogue between the visual and the verbal is intended gradually to bear fruit, conjuring what Klee saw as a magical meaning that could not be identified as originating in either realm – it is neither fully perceptual nor conceptual but feeds on both levels.

In Surrealist work, word and image become equal partners in a process of thwarting interpretation, and in this context works by Giorgio de Chirico and Picabia were also singled out by Breton as a model for how to generate a mysterious, enigmatic condition through juxtaposition of image and text (though in De Chirico's work they rarely appear on the paintings themselves). Titles were to be designed deliberately to malfunction, engendering instead a 'poetic' mood or condition, and generating ambiguity and indeterminacy by destabilizing the integrity and meaning of the depicted object. Drawing on De Chirico (and Klee), Max Ernst began to explore the possibilities of non-descriptive and bizarre titles. Continually exploiting the relationship between the visual and the verbal, Ernst employed words not in order to anchor meaning or to provide clarifying description, but rather as elusive and enigmatic generators of the psychological states of the uncanny and mysterious. His goal was the creation of a special atmosphere, mood or 'colouring' that would stimulate unconscious processes, and to this end, the potency of the image was extended into the verbal register. In some works Ernst situated titles on the reverse of the canvas so that in a conventional fashion textual information remained spatially and conceptually separated from the visual image; in other cases, like Klee, he framed images between lines of text, or placed titles well within the space of the image. Ernst's application of writing to pictures can in fact be seen to allude to illuminated

69 **Max Ernst** *Pietà or Revolution by Night* 1923
A choice of titles inscribed on the painting provides two possible interpretations without explaining anything.

manuscripts, but he also referred to the conventions of contemporary technical and scientific publications. In an essay written in 1930 on Ernst's work, Louis Aragon noted that there were two important precedents for Ernst's practice of titling, but added that Ernst had taken things much further: 'The title, elevated beyond the descriptive for the first time by Chirico and becoming in Picabia's hands the distant term of a metaphor, with Ernst takes on the proportions of a poem.'[17]

As well as producing paintings, Ernst extended the reach of collage, appropriating nineteenth-century book and magazine illustrations. In his Dada period he often employed technical jargon and nonsense neologisms. The title of an early work from 1920, written below an anatomical engraving altered with gouache and pencil, translates as: *Stratified rocks, nature's gift of gneiss lava iceland moss 2 kinds of lungwort 2 kinds of ruptures of the perineum growths of the heart (b) the same thing in a well polished box somewhat more expensive.* But Ernst's most sustained venture in title–image cross-fertilization, made after joining the Surrealists, was undoubtedly the 1929 collage book *La Femme 100 têtes* (The Hundred Headless Woman), which was also cut-and-pasted from book and magazine illustrations. To Breton at least, these proved that the artist was 'the most magnificently haunted brain of our day'.[18]

Another favourite of Breton, the Belgian painter René Magritte, also aimed, like Klee and Ernst, at crafting a language of hermetic or magical signs, but in Magritte's case this was achieved through exposing underlying assumptions about the conventional languages of words and images. Magritte's work actually amounts to a rich store of the consequences of language's failure to mirror reality, and to this extent invites parallels with the contemporaneous philosophy of Ludwig Wittgenstein, who drew attention to the fact that many of the problems of philosophy were really problems of language. As a constructed code, Wittgenstein argued, the map of words does not tally with the territory of reality, and as a consequence it must be recognized that questions of value, ethics and the meaning of life cannot really be encompassed. Indeed, on the contrary, to seek to deal with them using words, Wittgenstein averred, was more likely to result in confusion rather than clarity.[19]

In *The Interpretation of Dreams* (1927) Magritte established the format of subsequent works by parodying the deadpan presentation, style and writing of a school blackboard or a page from a child's primer. The neat cursive script would become Magritte's 'signature' style of writing, a style that, as the historian and theorist Michel Foucault put it in his study of Magritte's craft of word and image, was 'handwritten in a steady, painstaking, artificial script, a script from the convent'.[20] The message is communicated with an almost clinically exact directness. But the lesson that this obedient script and anonymous pictorial style impart is not what might be expected. Ordinary objects are juxtaposed with scrupulously legible words, but only one word in *The Interpretation of Dreams* actually corresponds to its adjacent image, or conversely, only one image corresponds to its label – the image and the word for 'sponge'. Otherwise, something seems seriously amiss: the word for 'sky' sits beneath a bag, that for 'bird' beneath a penknife, and that for 'table' beneath a leaf. In an illustrated text published in 1929 in the Surrealist

70 **René Magritte** *The Interpretation of Dreams* 1927
The style of a school primer becomes the device for a disturbing
lesson in the failure of words and images to cooperate – only the
sponge is twinned with its rightful name.

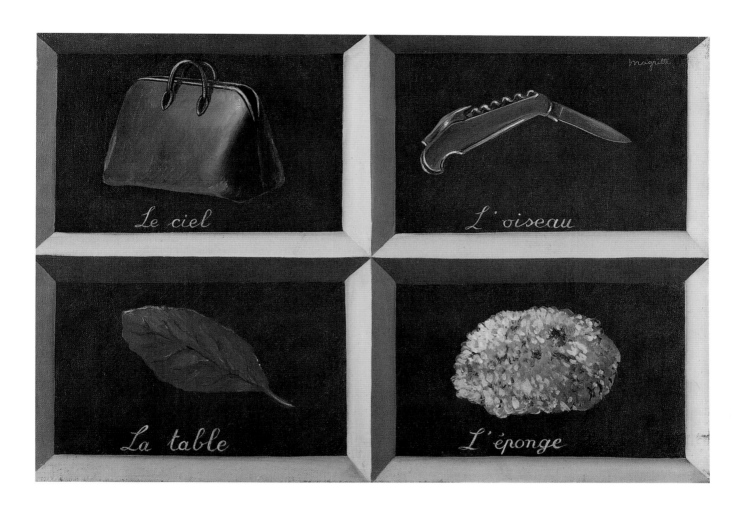

journal *La Revolution surréaliste*, entitled 'Les Mots et les images' (Words and Images), Magritte informs us that, 'an object is not so possessed of its name that one cannot find for it another which suits it better.' Neatly encapsulating the arbitrary status of the verbal sign, the formulation is stated with disturbing starkness in his painting.

Magritte spells out the arbitrary nature of both the linguistic and the visual sign even more clearly in his most famous word-painting, *The Betrayal of Images* (1928–29) [*4*]. In 'Les Mots et les images', again, Magritte noted that, 'an object never performs the same function as its name or its image' – one cannot smoke either an image of a pipe or its name; indeed, in another language, the word used to designate such a utensil would be an entirely different one, just as also the conventions used to represent a pipe must vary from culture to culture, and in time. But this kind of dissection of the relationship between word and image was not meant to be purely didactic. The unharnessing of word and image from reality was intended rather to open up an epistemological gap through which the light of 'the marvellous' could shine. However, it is clear that this gap might also be an abyss that swallowed all sense of meaning and purpose. Magritte gives voice to the ambiguous consequences of the modern crisis of language, both celebrating the emancipation from the bonds of conventional usage, and reflecting on the existential anxiety that comes with the loss of these bonds. When words and images so plainly commit treason, who or what, it might be asked, can be trusted?

The Surrealist artists discussed so far were predominantly interested in the meaning – however obscured – of the words they employ. Others, however, would seek to engage more fully with the visual and performative

aspect of writing, though in very different ways to the earlier avant-garde. The Catalan artist Joan Miró, for example, pursued a more spontaneous and visually assertive form of inscription, and between 1924 and 1927 developed what constitutes another genre of Surrealist word-art, one that would also be essayed by Klee and Ernst – the *tableau-poème* (painting-poem). In these works, calligraphy and painting merge, the same brush mark employed to fashion abstract shapes and legible words. But in Miró's work the clear distinction between word and image that had been largely maintained in the works of Klee, Ernst and Magritte, begins to break down to be replaced by a more emphatic use of writing as a kind of rhythmically visual language. As can be seen in the 1925 painting *Ceci est la couleur de mes rêves* (This is the Colour of My Dreams) [73], Miró's texts unfold across the space of the painting, ignoring the rules of conventional layout and becoming assertively visual phenomena. His preference for a highly visual kind of cursive and decorative script harks back to the organicism of Art Nouveau – a style that was particularly popular in his native Catalonia. These traits, like the whimsical, natural, abstract imagery Miró employed, deliberately distanced his paintings from the rigours of the Constructivists' machine aesthetic. Instead, he sought a magical language of symbols, and shifted from the legibility of the conventional verbal sign to more hermetic and personal code, declaring that he generated words and images in the same spontaneous way; both were 'born', Miró said, 'in a state of hallucination'.[21] The meanings of the self-generated phrases – which have the quality of dreamlike fragments – reveal a clear preoccupation with the sensual and the erotic. The following texts from paintings made in the late 1920s give something of the general flavour: 'Sourire de ma blonde', (The smile of my blonde), 'Etoiles en des sexes d'escargot' (Stars in the form of snail's genitals), 'Le corps de ma brune/puisque je l'aime/comme ma chatte habillée en vert salade/comme de la grêle/c'est pareil' (The body of my dark-haired woman/because I love her/like my pussycat dressed in salad green/like hail/it's all the same), 'Oh! Un de ces messieurs qui a fait tout ça!' (Oh! One of those gentlemen who did all that!), 'Un oiseau poursuit une abeille et la baise' (A bird pursues a bee and embraces it).

In Miró's work we see a more dynamic and physical dimension being given to the theory of 'psychic automatism'. While Breton was primarily interested in the estranged *content* of language, he was equally aware that automatist writing was also valuable for the *process* it employed. In this sense, the flow of spontaneous writing or drawing was to be understood as oriented less towards literary description than towards the tracing of the rhythms of the body, which in their sum were generated by desire. This was the 'rhythmic unity' that revealed, Breton wrote, an 'absence of contradiction, the relaxation of emotional tensions due to repression, a lack of the sense of time, and the replacement of external reality by a psychic reality obeying the pleasure principle alone'.[22] In other words, for Breton automatism was also the royal road to unconscious *processes*, and could be a record of the 'emotional intensity stored up within the poet or painter at a given moment'.[23]

Breton's observations were largely coloured by his encounter with the work of the French painter André Masson. Here, Breton saw the action of writing becoming indistinguishable from that of drawing: both were now

72 **Max Ernst** *Picture Poem* 1923–24
An example of a *tableau-poème* (painting-poem).

74 **André Masson** *Furious Suns* 1925
Distinctions between writing and drawing collapse in Masson's automatism.

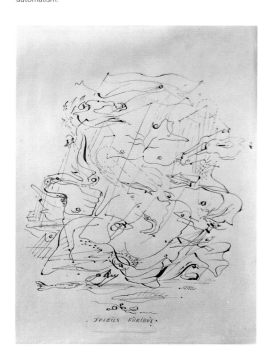

directed not towards the transcription of the spoken word or the conventional sign or image, but instead towards the production of direct indices of the unsuppressed presence and impulses of the body, signalled through the traces left by the movement of the hand as it traversed the paper or canvas. In looking for a form of art that was directly *presentational* (rather than representational) and rooted in desire, Masson spoke of his working methods as follows:

a) The first condition was to liberate the mind from all apparent ties. Entry into a state similar to a trance.
b) Abandonment to interior tumult.
c) Rapidity of writing.
d) These dispositions once attained, under my fingers involuntary figures were born, and most often disturbing, disquietening, unqualifiable.[24]

The results cannot, however, be described as 'writing' in any conventional sense. Masson's marks aimed at being non-verbal and unmediated traces of a somatic rhythm, and because the improvisatory nature of the work did not allow for deciphering by the artist, the act of drawing/writing can be understood as aspiring to be a non-discursive medium of the emotions. Indeed, in this kind of writing, the way in which the action structures time is as important as any linguistic content.

A similar trajectory was followed by the Belgian artist and poet Henri Michaux, though at least initially Michaux was more concerned to maintain a residual link with the conventions of alphabetic or sign-based writing. In a series of drawings from the late 1920s, he sought to reinvent the alphabet as a personal system of signs, and in *Alphabet* (1927), for example, replaces the familiar form of Roman letters with a far hermetic sequence – part ideogram, part glyph, part hieroglyphic, part gestural mark. Michaux recognized that

once visual traces started grouping themselves and forming a chain in which it is possible to recognize gaps, blanks, spacings, continuities, differentiation and interdependence along a horizontal or vertical register, drawing had metamorphosized into a kind of primal writing. So, despite the spontaneity of his work, a consistent return to horizontality and to distinct spatial units implies Michaux's adherence to the notion of linguistic syntax. But this was a new, more personal and rhythmic language, and it was not one that could be 'read' in any conventional sense. Rather, it was to be seen and sensed as a form of basic graphic notation or sign-making. Like Masson, however, Michaux would soon become interested in the rhythmic pulsations of the bodily gesture as an end in themselves. In this both Masson and Michaux were influenced by oriental calligraphy. Like Ezra Pound and El Lissitzky, they were struck by the way in which the Chinese language of signs seemed to retain the original relationship with its referents, and this suggested to them the possibility of a unity between 'signifier' and 'signified' and so also the basis for a universal language. In the early 1930s, Michaux travelled in Asia and encountered at first hand the oriental belief that the state of mind and quality of gesture were central to the ability to shape beautiful script. Calligraphy practised in this way, it seemed to Michaux, was an art of writing that, unlike that of the West, sought to place the body at the centre of its aesthetic.

In the work of Masson and Michaux, then, we are confronted by a kind of 'pseudo-writing', emancipated from codes, liberated from history, and, by being empowered to speak directly from the body, the graphic expression of the pre-linguistic. Through gesture and trace, a link between the psychic interior world and the material outer one was sought, generating a writing largely delivered from the set forms that make it an instrument of coded communication and representation: a mode of communication so intrinsically human that it could be comprehended by all. In this, the work of Masson and Michaux could not be further from the world of print and of the legible sign. Indeed, Surrealist automatism of this kind celebrated exactly those aspects of writing that the editors of *L'Esprit Nouveau* had abhorred when they contrasted handwritten script with the typewritten. Here in the hands of Michaux and Masson, the 'tortures of the informal' were not something to be overcome as an obstacle to the clarity and purity of mechanical form – on the contrary, they were to be indulged as a true record of the convulsions of a lived and shared experience. Both Surrealism and Constructivism sought the 'universal', but they clearly differed fundamentally over how it was to be reached. In the event, as we shall see, it would be the Surrealist expressive language of the bodily gesture that triumphed in the art of the years immediately after the Second World War, while the Constructivist aesthetic would be absorbed into mass culture as a utilitarian model of design and production.

75 **Henri Michaux** *Alphabet* 1927

76 **Shen Zhou** *Ode to the Pomegranate and Melon Vine* c. 1506–1509
Oriental calligraphy (below) inspires a Western artist (above).

9 Beat the Whites with the Red Wedge: Words and Power

During July 1937 an exhibition organized by the German National Socialist Party opened in Munich entitled 'Entartete Kunst' (Degenerate Art). In the galleries of the city's Archaeological Institute were displayed works by many radical European painters and sculptors, and in some rooms the curators attempted to take their mocking exposé of what they called *Kulturbolschewismus* (cultural Bolshevism) a step further by incorporating examples of the kind of gallery installation and typography they felt was preferred by the avant-garde. So, for example, along the south wall of Room 3, Dada works were hung beside slogans, some of which were painted directly on the wall. 'Take Dada seriously! It's good for you', reads the principal one, which is attributed to George Grosz. The phrase is in fact authentic Dada, insofar as it also graced the walls of the First Dada International Fair held in Berlin in 1920 [*48*]. But the Nazi script is significantly different. First of all, it is painted rather freely by hand and does not attempt to duplicate the ersatz advertising typography of the original. Furthermore, the curators have actually wedded the text both spatially and stylistically to a Kandinsky-like abstraction, thereby conflating two artistic tendencies of very different, even opposing, kinds. And it goes without saying that the irony of the original slogan has been completely missed.

Hitler and his allies were not alone in seeking to control and censor artistic production during this period. All the totalitarian regimes that emerged in Europe during the 1920s and 1930s took art very seriously, recognizing that it was through control of the media that they would win the battle for the minds of the people. Their concerns extended well beyond art to take in fundamental issues of communication. Indeed, the radical acts of linguistic censorship indulged in by the totalitarian states clearly expose the fundamental connection that exists between language and power – the intimate bond between the act of naming and possession that means that language is always also about control. Because of this, encounters between opposing political and cultural forces are therefore also battles fought out in terms of different semiotic codes.

The Bolsheviks, for example, upon coming to power embarked on an extensive campaign of renaming – St Petersburg became first Petrograd and then Leningrad (and in a similar spirit is now once again St Petersburg) – and paid special attention to the reform of the syntax and semantics of the Russian language itself. Likewise, the Nazis' purging of literature went much further than the burning of books, extending to the invention of new simple, efficient words employed to describe key aspect of Nazi mythology – 'Blubo', for example, was used as a contraction of the Nazi catchphrase *Blut und Boden* (blood and soil) – while in Franco's Spain regional languages such as Basque and Catalan would be ruthlessly suppressed in an attempt to impose

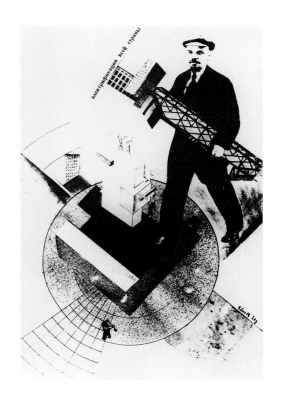

78 **Gustav Klucis** *The Electrification of the Entire Country* 1920
Word and image in the service of the Revolution.

cultural unity. Furthermore, the dictators were quick to recognize that in addition to traditional print-based media they needed to gain control of the new electronic technologies, such as radio and cinema, and they soon became adept at utilizing these as propaganda tools.

It was also necessary to enlist the arts. From the Communist point of view, the role of art was clear. After the first, failed, Russian revolution of 1905, Lenin had declared: 'Literature must be Party literature. As a counterweight to bourgeois morals, as a counterweight to the bourgeois entrepreneurial and commercial press, as a counterweight to bourgeois literary careerism and individualism, to "lordly anarchism" and the pursuit of profit, the socialist proletariat must put forward the principle of *Party literature*: it must develop this principle and realize it in the most complete and integral form.'[1] As we have seen, when Lenin led the Bolsheviks to power in 1917, many writers and artists were indeed ready to endorse the belief that art should be subordinated to political necessity, and both Party and avant-garde shared the same faith in historical inevitability and in the possibility of transforming society by force of will. In their commitment to a mass art, the Russian avant-garde saw the role of the artist as that of social engineer whose function it was to produce the propaganda to ensure the success of the Bolshevik revolution. As the manifesto of the Productivist Group proclaimed in 1920: 'The task of the Constructivist group is the communistic expression of materialistic constructive work.'[2] Art was to be a weapon in the ideological struggle and, as the manifesto went on, the erasure of the gulf between art and life was necessary in order to achieve 'the real participation of intellectual production as an equivalent element in building up communistic culture'.[3]

Gustav Klucis's 1920 poster *The Electrification of the Entire Country* [78] marshals the energy of the Dada language of photomontage not in order to speak of fragmentation or conflict but to celebrate in graphic terms the Party's Utopian policy of rapid modernization. Lenin, harbinger of the new electronic age, carries in his arms, like weapons, futuristic forms of technology. The text looks like the cutting edge of this device, and by being pasted at an acute angle, the words actually seem to be part of the image rather than simply labelling it. Klucis observed that there were two distinct kinds of photomontage: 'one comes from American publicity and is exploited by the Dadaists and Expressionists – the so called photomontage of form', while the second, with which Klucis himself identified, was 'militant and political photomontage…created on the soil of the Soviet Union.'[4] In this latter convention, Klucis noted, legibility of word and image was not to be sacrificed as the work was consciously intended as propaganda.

But while Klucis made his work accessible by employing photography and readable text, the Russian Constructivists also claimed that, because it spoke the primary universalist language of geometry, the more resolutely abstract visual language used in their posters was actually more comprehensible than traditional words and images. 'The Bible of our time cannot be presented in letters alone', El Lissitzky declared.[5] To that extent, in the 'classless society' words were something to be superseded, and in *Beat the Whites with the Red Wedge* (1919–20), a propaganda poster produced by Lissitzky, the contest between the Bolsheviks and the anti-Revolutionary

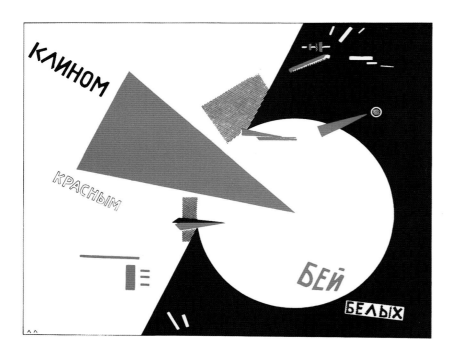

79 **El Lissitzky** *Beat the Whites with the Red Wedge* 1919–20
An abstract geometric language of forms and flat colours
incorporates texts in order to tell the story of the triumph of
Communism.

forces is staged both in the abstract language of elemental geometric forms, and in dynamic typography. Once again, while words still serve to anchor meaning in the conventional sense, Lissitzky's goal was also to make this meaning explicit on a more tangible level through universal visual signs, and letters begin to assert themselves as pure visual presences (at the price of legibility). Their flat forms emphasize the two-dimensionality of the composition and echo the geometric elements, while the words disengage themselves entirely from the structure of the sentence, drawing together the two systems of signs, one conventional, the other, derived from Malevich's 'Suprematism', more concrete and obdurate.

As we have seen, by the late 1920s the Party line in the Soviet Union had shifted radically, and the art that found official favour was rather more pragmatic about its role as loyal servant of the Soviets. Indeed, in fundamental ways the agenda of the avant-garde was obviously at odds with the new totalitarian regime. For, despite a shared Utopianism and a desire to make art serve society in practical ways, the impulse behind radical Soviet art was still essentially individualistic and steeped in idealized notions of the artist's role. Furthermore, the new collectivist and authoritarian Communist government exploited the crude rhetoric of populism, whereas modernist culture, despite the Productivists' claims to the contrary, continued to appeal only to a minority, to an elite. In the Stalinist doctrine of Socialist Realism as it came to be formulated in the early 1930s, Lenin's argument of 1905 was interpreted as calling for an art based on the more conventionally comprehensible pictorial language of pre-modernist nineteenth-century realism. In the field of typography, the experimentation of Lissitzky and others was pushed aside to make way for a far more orthodox and legible manipulation of verbal language, and for more conventional styles in propaganda and book design. Word and image were ordered henceforth to

obey the increasingly repressive Party diktats, and to collude in the perpetuation of the Stalinist regime.

Like the Bolsheviks, Mussolini's Fascist regime found common cause with the avant-garde – in this case the Futurists – who in turn also welcomed the Fascists' rhetoric of struggle and aggression. Marinetti might have claimed to be destroying conventional language in order to set words free, but in reality, it can be argued, words in Futurist poetry and art were often liberated only to more readily sing the praises of disintegration, violence and destruction, and to give voice to the 'superior' mind's reckless indifference to the lives of ordinary people. As Walter Benjamin would write in 'The Work of Art in the Age of Mechanical Reproduction', the Futurists aestheticized war, and in this attitude shared with Fascism the belief that the only way to control and direct the new energies unleashed by technology was to mobilize for armed conflict.[6] But where Fascist leaderships sought to exploit the national past on their own behalf, the progressivist stance of modernism proved less sustainable. Nor was the avowed internationalism of the avant-garde conducive to ideologies founded on racism and nationalism.

But this did not stop the Fascists and then the Nazis from adapting elements of Soviet Constructivist design to their own purposes, and they were quick to learn the lessons of photomontage and graphic design, while also investigating the new electronic media. In fact, it can be argued that on a diffuse level many of the artistic vanguards' attitudes to language were in fact mirrored by the dictatorships of both the Left and the Right. The avant-garde's preoccupation with the autonomy of language – with strategies of atomization, desocialization and purification – had had the effect of severing language from the life-world, the complex web of references and historical usage. As a result, such strategies also ran the risk of impoverishing the word, turning it into something that could be manipulated at will. Thus, in the Constructivists' vision, the abstracting of verbal language went hand in hand with principles of efficiency and standardization – these were the values that were to be substituted for the organicism and redundancies of normal language usage, the 'tortures of the informal' as *L'Esprit Nouveau* had put it. Now such principles were also embraced to very different ends by both the Communists and the Fascists. Thus, the spirit of rationalism could have unforeseen dystopian, as well as apparently Utopian, consequences. And the pursuit of efficiency could also justify the purging of the syntax and grammar of language. Here too, as we have seen, there were precedents in avant-garde practice. At the Bauhaus in 1925, Herbert Bayer had written of the need for a simplified letterform, and asked: 'why have two symbols for one sound such as A and a? Why two alphabets for one word, why twice the number of symbols, if half the number accomplishes the same thing?'[7] Indeed, the dangers inherent in this 'will to purity' were in fact acknowledged by at least one of the major advocates of the new rational typography. 'To my astonishment I detected most shocking parallels between the teachings of *Die Neue Typographie* and National Socialism and fascism', Jan Tschichold observed, looking back on the inter-war years in 1959. 'Obvious similarities consist in the ruthless restriction of typefaces, a parallel to Goebbels' infamous "gleichshaltung" ("political alignment"), and the more or less militaristic arrangement of lines.'[8] Furthermore, while Bayer and

Tschichold had, of course, restricted their streamlining and essentializing agenda to the *form* of language, the same operation could easily be practised on the *meaning* as well, a theme that would subsequently be central to George Orwell's celebrated dystopian novel *Nineteen Eighty-Four* (1948). Parodying the totalitarian language of both the Left and Right, Orwell imagined a speech and writing that had been totally stripped of any connection to truth or the life-world: 'It's a beautiful thing, the destruction of words', says one of the characters responsible for writing this empty verbiage. 'Of course the great wastage is in the verbs and adjectives, but there are hundreds of nouns that can be got rid of as well. It isn't only synonyms; there are also antonyms. After all, what justification is there for a word which is simply the opposite of some other word? A word contains its opposite in itself. Take "good", for instance. If you have a word like "good", what need is there for a word like "bad"?'[9]

But while such parallels with avant-garde ideas can be drawn, the dictators' obsession with the role of words as carriers of unambiguous information (part of the propaganda machine) led to a neglect of the concrete, visual and non-signifying aspect of the verbal sign – the dimension that had been explored with such richly varied consequences in modern art before, during and after the First World War. In Nazi Germany, for example, a rather confused attitude to the visual life of typography prevailed. Initially the Nazis championed 'blackletter' or 'Fraktur' as the essentially Teutonic style. This was not an uncommon or especially right-wing view; indeed, the celebrated German Expressionist typographer, Rudolf Koch, writing in the 1920s, declared: 'German script is like a symbol of the inherent mission of the German people, who, among all civilized races, must not merely defend but also act as a living model and example of its unique, distinctive, and nationalistic character in all manifestations of life'.[10] But in practice, historical and modern approaches to letterforms competed for Nazi approval, so that it was quite possible for a poster for the newly manufactured Volkswagen to employ a decidedly modernist sans serif while other examples of Nazi-approved advertising stuck to the more traditional letterforms.[11] In 1941, however, in an extraordinary *volte face*, the Party turned decisively against 'Fraktur', decreeing – in what was a totally spurious argument – that it betrayed Jewish origins. Henceforth, all territories of the Third Reich were ordered to adopt the more universally legible and contemporary letterforms of the Roman alphabet.

Language, however, could serve many masters, and word and image were also mobilized to oppose the dictators. In 1920s Germany, photomontage became a primary weapon in the opposition to right-wing agitation. John Heartfield, a member of Berlin Dada and a committed Communist who had anglicized his name in protest against the First World War, adopted the technique for posters and magazine covers, engaging in savage satires, first at the expense of the enfeebled Weimar Republic, and then, eventually from exile, against the Nazis. Heartfield's style is closer to the Soviet model of photomontage than it is to Dada, but it also derives its visual language as much from advertising and the press as from art. Text in Heartfield's work is used to sharpen the point of the satirical knife, underlining and focusing a message already obvious in the seamless cut-and-paste style visual

80 **John Heartfield** *Hangman and Justice* 1933

81 **Joan Miró** *Aidez L'Espagne* (Help Spain) 1936
Protests against political oppression and war – word and image as propaganda.

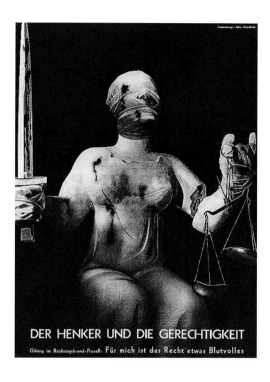

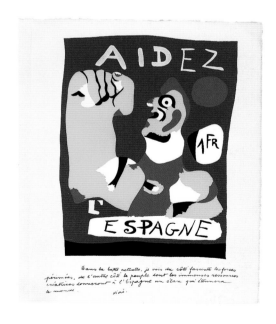

caricature. Indeed, in comparison to the more overtly experimental Futurist, Dadaist and Constructivist typographies, Heartfield's texts behave quite traditionally. Legibility is the prime concern. Unadorned and pragmatic, his words and images go about the business of exposing the lies of National Socialism as if the act of drawing attention to their materiality would be to indulge in aesthetic frivolity. But like the dictators he opposed, Heartfield acknowledged that it was through the new mechanical media and the mechanics of mass communication that the most effective kind of propaganda could be achieved, and unlike the Dadaists who made photomontages as unique works, he followed the Russian Constructivists' practice of mass-production. Posters, newspapers and magazines reached far wider audiences than the traditional easel painting. In Spain during the Civil War – a conflict that brought together a broad spectrum of anti-Fascist groups, including many artists and writers – the possibilities of propaganda were explored by both sides. Miró, for example, eager to pledge himself to the Republican cause, contributed in 1936 a striking poster, *Aidez L'Espagne* (Help Spain) [*81*], which effectively turned his experiments in visual–verbal interactions to practical and political ends. But it would often prove difficult to fuse commitment to political engagement with belief in the freedom of artistic expression.

The traumas of the Spanish Civil War were soon to be dwarfed by much greater crimes. 'To write poetry after Auschwitz is barbaric', declared the left-wing German-Jewish cultural critic Theodor Adorno in a celebrated moment of hyperbole.[12] It became clear to many that language of any kind was wholly inadequate to describe the enormity and horror of the Holocaust. Indeed, the success of the Nazi propaganda programme depended in large part on the manipulation and deployment of exactly the same alphabet that had also to be marshalled to expose their crimes. Under the dictators, language was emptied of any real meaning because it was often treated as if it had no intrinsic relationship to truth, and the obscene mendacity of the slogan above the entrance gateway to Auschwitz – *Arbeit Macht Frei* (Work Makes You Free) – constitutes a pollution of the word beyond the worst nightmares of even the most pessimistic critics of mass culture. But the Holocaust was also a travesty of administrative efficiency, and despite verbal acuity – or because of it – language could be exploited in brutally instrumental fashion. 'It was one of the peculiar horrors of the Nazi era', the cultural critic George Steiner would write in a discussion of the lingering effects on the German tongue of the Nazis' abuse of language, 'that all that happened was recorded, catalogued, chronicled, set down; that words were committed to saying things no human mouth should ever have said and no paper made by man should ever have been inscribed with.'[13]

But words could also be used to bear witness to atrocity. In literature, Anne Frank's diary is justly celebrated as a covert act of resistance, and later, in the memoirs of writers such as Primo Levi and Elie Wiesel, the realities of the Holocaust were brought horribly, but necessarily, alive. The period of Nazi terror also gave rise to an extraordinary example of visual–verbal art: the painted life history of the German Jew, Charlotte Salomon, *Leben? Oder Theater?* (Life? Or Theatre?). This unique work was produced in exile in France between 1940 and 1942, and comprises 782 pages, most of which

82 **Charlotte Salomon** Page from *Leben? Oder Theater?* (Life? Or Theatre?) 1940–42
Running to 782 pages, a unique autobiographical account of the life of a German Jew living in France during the Nazi Occupation.

contain combinations of word and image. Here, words are not employed in the manner of the conventional book illustration or comic-book caption, but rather integrated so that the material and visual features of the text are highlighted in ways that synthesize the innovations of Expressionism and Futurism. Furthermore, Salomon also often made words an aspect of the visual meaning of the composition as a whole, setting them within the imagery, so that the activities of seeing the work and reading it become unsettlingly co-mingled in ways reminiscent of medieval art. Remarkably, however, Salomon's autobiography makes no direct mention of the Nazis, though the whole story can nevertheless be seen as an act of resistance on the part of a woman threatened by the personal and political oppression of the times. In Salomon's hands, the traditionally 'masculine' order of the written text is made to cede to a more fluid, personal and imagistic idiom, one that takes Futurist notions of 'words-in-freedom' into a less aggressive and destructive register.

Salomon died in Birkenau concentration camp in 1943. As peace came, it was overwhelmingly clear how easily words *and* images – indeed all the communication media – had been mobilized by the Nazis in order to murder Jews, gypsies, Communists and homosexuals, and to feed a diet of lies to the people. Meanwhile, in Stalinist Russia, millions were still being sent to their deaths, the actions of their murderers justified by mendacious words and pictures. It is not surprising, then, that in the period immediately after the defeat of Fascism, and during that of continued Stalinist oppression, words and images would be subjected to intense critical examination, and that many artists would elect silence as the best form of resistance. Indeed, the engagement of artists with written words in the years following the Second World War would be deeply conditioned by the abuses inflicted on language by Left and Right alike. And to such calumnies would now be added those of an ever more rampantly commercial and powerful mass media.

10

Writing Degree Zero: Post-War Words

In the existentialist philosophy that Jean-Paul Sartre shaped during the Nazi Occupation of France, the argument was put forward that language should be judged by the simple criterion of authenticity: either words were mobilized in the service of lies, as with the Nazis, or, in the service of truth, as in the literature and art Sartre admired, and the Marxism he supported. Martin Heidegger, his major philosophical influence, argued that language as it was customarily used was hopelessly inadequate for the task of expressing the true nature of man's primordial existence. He believed that the experience of 'Being' could not be fathomed by a familiar use of words because this experience was fundamentally pre-logical.[1] Furthermore, the individual – indeed a whole culture – was always in danger of succumbing to what Sartre would call 'bad faith' – living inauthentically.[2] Words were fraught with danger for those who used them, because through their mediation the self was revealed, or actively concealed, from others. And, as both Heidegger and Sartre observed, the *written* word in particular was far more likely to be a vehicle for falsehood than the spoken one, for in the spatial and temporal void between the two sides of written communication any number of duplicitous and destructive motives could prosper.

Both Heidegger's and Sartre's philosophies were attempts to understand and respond to the loss of traditional religious values, the impact of technology, and the realities of political oppression. As a result, they would draw special attention to the consequences of the collapse of confidence in the coincidence of word and world. Roquentin, the anti-hero of Jean-Paul Sartre's 1938 novel *Nausea*, experiences loss of conviction in the word's ability to describe his reality as a kind of visceral revulsion, a nausea that sweeps over, robbing him of the ability to act. The world literally seems to be dissolving before his eyes:

> The root of the chestnut tree plunged into the ground just beneath my bench. I no longer remembered that it was a root. Words had disappeared, and with them the meaning of things, the methods of using them, the feeble landmarks which men have traced on their surfaces.[3]

For Roquentin, this nausea was provoked not only by the alien thing-ness of the material world, which no words could convincingly convey, but also by the insincere bourgeois banality that surrounded him; thus, Sartre's description of the vacuum created by the opacity of language also has profound ethical implications. For the task of words in bourgeois culture, Sartre argued, was merely to act as a veneer covering over the fallen, stained and degraded nature of existence; and to the recognition that words gave no

84 **Isidore Isou** *AMOS ou Introduction à la métagraphologie* 1952
A photograph of the founder of Lettrism is overlaid by a screen of ideogram-like markings.

83 **Jean Dubuffet** *Wall with Inscriptions* 1945
An interest in graffiti – an illicit and often obscene or aggressive form of inscription – signals the post-war romance with the 'raw' and the 'uncivilized'.

credible access to reality was added this additional failure of language to constitute an authentic sense of the self.

In terms of art, the message of existentialism was in many ways a familiar one, though it now came with an added urgency coloured by the tragedies of the Holocaust and Hiroshima: representations were not to be trusted, they were flawed at their very centre. For many artists and writers in this period, the only authentic option was silence, or near silence. In literature, Samuel Beckett emptied language of content and style and then put it to work in pursuit of the consequences of this emptiness. In a formulation that directly challenged the Surrealists' faith in the possibility of re-firing language with libidinous desires, and that also mocked the Constructivists' search for the essential sign, Beckett declared that the opacity of language meant also that there was nothing outside it, nothing that might be called reality. In his writings on the artists Tal Coat, Bram van Velde and André Masson, he sought visual analogies for this self-imposed muteness, and argued that the most important evidence of these artists' contemporary importance was their willingness to accept that the act of painting was essentially meaningless. And yet, Beckett argued, in spite of this recognition they were still compelled to work.⁴ Indeed, it seemed to him that painting might perhaps have certain advantages over writing because artists were able to fly free of the hopeless business of reference altogether and through the pure mark and the liberated gesture enter the realm of the non-sensical. It was the individual's challenge, Beckett's own work suggested, to live in the light of this nothingness, and in this context the visual arts were able to venture where words could never go, for verbal language was always part of a conventional code and could never be entirely severed from meaning.

Another kind of 'language of silence' could be achieved by denuding the alphabet itself of its linguistic role, severing the umbilical cord between signifier and signified, and rescuing it as a pure visual form. This, at least, was the avowed goal of the Paris-based Lettrist movement, founded by the Romanian Isidore Isou [84]. In the *Manifesto of Lettrist Poetry* (1947), the enemy of authentic language was described as words themselves, which could only function, Isou said, as stereotypes. The aim of Lettrism was therefore to loosen the grip of the word and to reveal the purer presence of the letter. 'ISOU', he announced, 'will unmake words into their letters.'⁵ In practice, the Lettrists employed both calligraphic writing and printed typography, and works ranged in style from plain letters to glyph-like markings and gestural traces, with letters also often superimposed on three-dimensional surfaces, such as clothing and furniture.

Suspicion of conventional language's ability to do anything more than give voice to an inauthentic existence could thus imply the complete rejection of words' communicative role. But while verbal language itself could be robbed of signifying power, other strategies in the post-war period built on the attempts of the pre-war avant-garde to bring to 'high' art the energies of creative activities that were generally derided, overlooked or marginalized by mainstream culture. Sartre believed that it was among the dispossessed, the criminalized, the stigmatized or the neglected that some kind of integrity and authenticity might still be discovered. With a similar credo, the French artist Jean Dubuffet described what he was looking for as 'Art Brut' – raw art – and

in order to inspire his own practice amassed a huge collection of the works of inmates of insane asylums, criminals and children – anything that struck him as embodying 'authentic' values.⁶ This seemingly crude and often apparently nonsensical art was for Dubuffet the opposite of decadent 'cultural' art, for he believed that 'outsiders' were driven to create by their own inner necessity – a quest for truth that had to be undertaken at any price. 'Madness gives wings and helps [the] power of vision', Dubuffet announced, ignoring the obvious pain and despair that such pathological states bring to those who suffer them.⁷ His concept of Art Brut clearly owes much to Surrealism, although he was willing to draw far more directly on his stylistic models, absorbing the seemingly naive and crude forms of the culturally dispossessed into his work. Indeed, the desocializing, atomizing and fragmenting strategies of the avant-garde can be seen to have many striking parallels with the language of psychopathology. The shared goal was the assault on logical and conventional forms. In a culture where standards of apparent 'normality' had led to the Holocaust, it could be argued that the thoughts of those designated by society as 'insane' were not so worthless after all.

Art Brut typically made no clear distinction between media. Dubuffet defined the genre as, 'works created by those untouched by artistic culture; in which copying has little part, unlike the art of intellectuals. Similarly, the artists take everything (subject, choice of material, modes of transposition, rhythm, writing styles) from their own inner being, not from the canons of classical or fashionable art. We engage in an artistic enterprise that is completely pure, basic, totally guided in all its phases solely by the creator's own impulses. It is, therefore, an art which only manifests invention, not the characteristics of cultural art which are those of the chameleon and the monkey.'⁸ Written words therefore often appear in the new 'raw' artwork – at least in that of the literate – as the extraordinary corpus of the most famous 'outsider artist', Adolf Wölfli, shows [85]. Lack of familiarity with the conventions of 'high' art means that in making such works the maker does not in practice draw a clear line between the spaces normally reserved for depiction and those set aside for inscription – between the sphere of verbal language and that of drawing and painting. For Wölfli, as for other such 'outsiders', the paper is conceived of as a two-dimensional surface rather than as a window or stage because the rules of fixed-point perspective are unknown or ignored. Consequently, a wider variety of symbolic and decorative graphic notations could be accumulated, and visual and verbal languages – the latter sometimes entirely invented by the maker and therefore beyond linguistic interpretation – collaborate in the establishment of a physical and mental narrative structure that, however fanciful or incomprehensible the work might appear to others, can nevertheless bring to their author a degree of inner calm. Works like Wölfli's are profoundly obsessional, a daily record of real or imagined events that could be communicated through both words and images. In the twenty-two years between 1908 and 1930 during which Wölfli worked on his 'autobiography', he amassed a grand total of over twenty-five thousand pages of combinations of text, musical composition and illustration, his clear *horror vacui* leading to obsessive logorrhoea, melomania and iconophilia.⁹

Dubuffet's own *Wall with Inscriptions* of 1945 [*83*] draws on such sources – especially children's art – and makes an analogy between a defaced urban wall and the surface of a painting. The Paris that for the Cubists had carried the rich and lively signs of the burgeoning mass culture, and that for the Surrealists had served as a stimulant for reverie and the free play of the imagination, now exposes a darker, more violent side. This interest in an image-making and writing that was in effect a kind of 'degree zero' of creativity generated by primal and visceral drives rather than deriving from more sophisticated, intellectual sources was shared by the Cobra group (so named after the three cities – Copenhagen, Brussels and Amsterdam – around which the artists gravitated). In particular, children's art was admired for its clear lack of self-consciousness, and its expressive origins in the instincts. For creativity, declared the Cobra artists, was the birthright of all. A premium was placed on expression as an end in itself and on the need to root art in physical experience. The Danish Cobra artist Asger Jorn, for example, envisaging a revolutionary art not determined by Socialist Realist dogma, declared that 'a materialist art must put art back on a foundation of the senses.'[10]

The body would, in fact, prove to be a major preoccupation of much post-war theory and practice, again finding expression in the existentialist philosophy of the period. 'We cannot imagine how a *mind* could paint', remarked Sartre's close associate Maurice Merleau-Ponty in an essay of 1961. 'It is by lending his body to the world that the artist changes the world into paintings. To understand these transubstantiations we must go back to the working, actual body – not the body as a chunk of space or a bundle of functions but that body which is an intertwining of vision and movement.'[11] But the celebration of an art grounded in the life of the senses – one that was in effect based on processes of *becoming* rather than on any fixed and predetermined forms – also invited suspicion of the mediated, discursive and mental nature of verbal language. For, as with Expressionism earlier in the century, in a conception of art oriented towards the physical, words would

85 **Adolf Wölfli** *General View of the Island Neveranger* 1911 Psychopathology revealed in the obsessive drawing of an inmate of a mental asylum. Word and image combine in the quest to combat *horror vacui* (fear of emptiness).

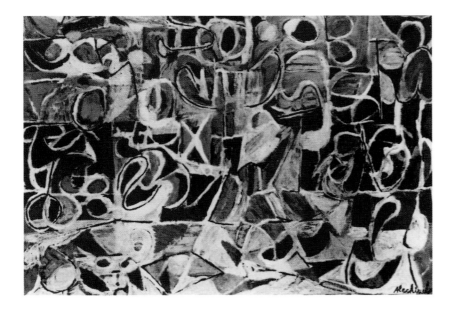

86 **Pierre Alechinsky** *Writing Exercise* 1950 A looping and energized calligraphic line suggests writing while resisting legibility.

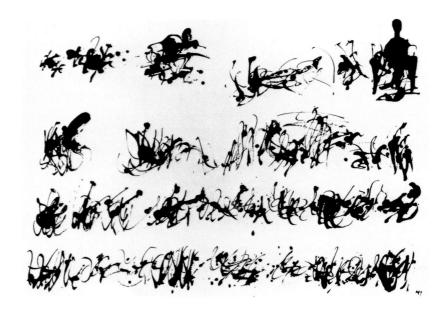

often be deemed corrupted by their status as part of a conventional, ready-made code. Furthermore, within the norms of writing that had been established by printing techniques, bodily presence is rigorously denied, being replaced by mechanical precision. Thus, in an attempt to find a more emancipatory form of inscription, the Belgian Cobra artist Pierre Alechinsky's *Writing Exercise* of 1950 links the act of writing not so much to any verbal communication as to the communication of the movements of the body – just as Michaux and Masson had done before the war. The lessons of Surrealist automatism seemed to affirm for Alechinsky and other artists of the period that the *act* of writing was not necessarily related to the visualization of the mechanics of speech, nor to any kind of linguistic code, but was fundamentally a kind of liberating graphic mark-making.

The activity of inscription as a spatial manifestation would now frequently supplant its function as delineator of linguistic space. As in the works of Masson and Michaux, this tendency could find support in oriental art. In fact, links between artists of East and West grew close during this period – Alechinksy, for example, corresponded with the Japanese calligrapher Morita Shiryū, and in the mid-1950s he travelled to Japan to learn about Zen calligraphy at first hand. But the focus was now not so much on the nature of the oriental ideographic sign itself as on the quality of the action that generated this sign. Asger Jorn, for example, noted that for him Chinese calligraphy was of value 'not because a certain style is imposed on handwriting, but because, as conceived by the Chinese, it acquires expressive force', while Alechinsky declared that the principal lesson to be learnt from the oriental masters with whom he had studied was, 'don't write with your hand, don't write with your arm, write with your heart'.[12]

For several Western artists, the model of oriental gestural calligraphy would suggest that the somatic trace could be an end in itself. Paris-based 'Tachism' or 'Art Informel' grounded painting in the informality and unstructured nature of the painterly mark. Furthermore, unlike the Cobra group – which in the event remained committed to an essentially figurative

form of expressionism – the artists associated with Tachism were more willing to jettison altogether the image and the legible sign in order fully to embrace the spontaneous *tache* (mark). In this context, Henri Michaux proved to be an important point of contact with pre-war automatism. Writing of his decision in the late 1940s to redirect his work decisively away from the ideographic sign-making he had began investigating in the 1920s, Michaux captured the mood of the period when he noted: 'I had been urged to go back to composing ideograms…I tried once more, but gradually the forms "in movement" supplanted the constructed forms, the consciously composed characters. Why? I enjoyed doing them more. Their movement became my movement…I invaded my body.'[13] This emphasis on dynamism and gesture at the expense of the sign had the effect of undermining the distinction between drawing/painting and writing. While the modest scale and persistent horizontality and linearity of much of Michaux's mark-making still preserved references to the character of linguistic writing, in the work of such Paris-based artists as the Frenchmen Georges Mathieu, Jean Degottex and Pierre Soulages, and the German Hans Hartung, the act of painting was instead envisaged as an expansively expressive record of a series of spontaneous passages of the paint-laden brush across the surface of the canvas – a form of performative mark-making that carries the record of the whole body's energy, and liberates the gesture from any linguistic context. Such work proposed that the recognizable sign – linguistic or ideographic – had to be destroyed in order for the truly spontaneous and authentic act of painting to occur. Emphasis was now placed above all on speed of execution and absence of premeditation, with oriental calligraphy providing a model for the purposeful free gestural act. As Georges Mathieu put it when discussing his own contribution to what he saw as the sadly lapsed Western calligraphic tradition, 'apart from a few Merovingian writings, our calligraphy has never been anything but the art of reproduction.'[14] The new painters were, in his eyes, severing writing from its erroneous tie to verbal language and returning it to its rightful source in the graphic notations of the body.

Calligraphy and graffiti collide in the work of the Catalan artist Antoni Tàpies, who mixed marble dust and other media into the oil paint in order to create a tangibility that alludes to the weather-worn surfaces of the ancient walls of his home city, Barcelona. The painterly gesture that energizes the surface of *Grey with Black Traces XXXIII* (1955), can be construed as a crude form of ideogram, while in relation to the wall analogy, this wild and ultimately illegible black mark functions both as an index of a now absent human presence and as a potentially subversive sign. The allusion to the graffito was for Tàpies a way of binding his work to more atavistic and primitive sources. 'If we are affected by graffiti', he later noted, 'it is because in essence it echoes in us necessary links with the harmony of the cosmic order, with natural cycles which are lost today.'[15] But at the same time, within the context of Franco's Spain, his mark would also have automatically signalled a form of resistance to political oppression, echoing as it did the clandestine nature of street protest while being sufficiently hermetic to avoid any actual threat of persecution. Here the analogy between painting and wall has the effect of making art an act of defiance. It is a field

88 **Antoni Tàpies** *Grey with Black Traces XXXIII* 1955
An illegible scrawl, part graffiti, part oriental calligraphy.

89 **Mark Tobey** *Shadow Spirit of the Forest* 1961
A dense jungle of spidery lines – 'white writing' as the artist called it.

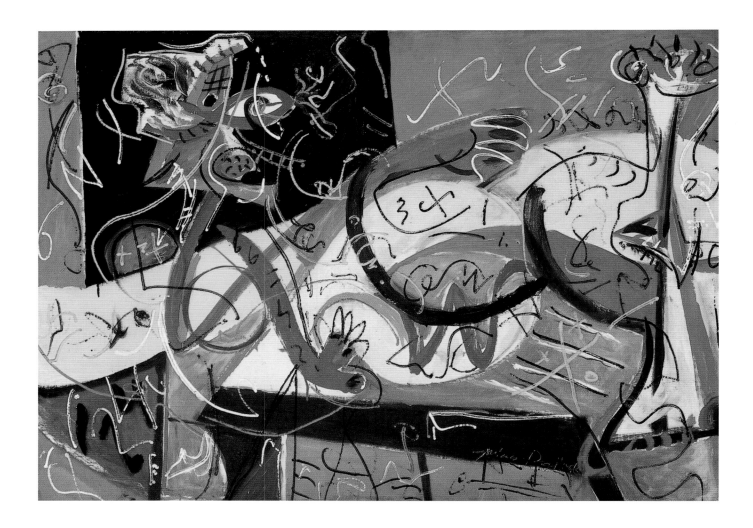

90 **Jackson Pollock** *Stenographic Figure* c. 1942

91 **Rudolph Burckhardt** *Pollock Painting* 1950

92 **YU-ICHI (Yu-ichi Inoue)** *Bone* 1959
A parody of shorthand writing – stenography – partly effaces the
imagery in a pre-'drip' Pollock (above), while top right, a photograph
of Pollock at work on one of his later monumental paintings invites
comparison and contrast with a near contemporary Japanese artist
employing techniques inspired by Zen calligraphy.

of allusions that Tàpies puts in play, the indeterminacy of the sign generating
a range of references that deflects the quest for some clarity of meaning, and
that substitutes instead a connection to a deeper, more essential and
chthonic reality.

The drive to liberate the gesture from the code was also central to post-
war American art. There, the proximity to Asia meant that oriental ideas
often had more direct impact and, as early as 1934, the California-based
painter Mark Tobey had travelled to China and Japan where he had been
especially drawn to what he described as the 'moving lines' made by oriental
artists. He went on to investigate the special qualities of expressive gesture
central to Far Eastern calligraphy, developing his own form of what he
called 'white writing' [*89*], an all-over matrix of calligraphic marks that, to a
much greater extent than with Michaux, deliver inscription from the linear
syntax of the linguistic form, substituting instead a total field of dynamic
somatic traces.[16]

The influence of such graphic writing is also evident in much early
Abstract Expressionism. Through the scale and form of brush stroke, the
spacing and outline of linear shapes, and the source of this trace in the
movement of the wrist, the works from the early 1940s of such artists as

Arshile Gorky, Ad Reinhardt, Adolph Gottlieb, Willem de Kooning, Robert Motherwell, Lee Krasner and Jackson Pollock, show a close bond to various kinds of archaic or non-Western writing.[17] Lee Krasner, for example, drew on Hebrew manuscript illumination and on kufic script – an ancient form of Arabic writing – in the early 1940s, while Adolph Gottlieb explored the pictogram in a series of paintings.[18] Jackson Pollock also drew on such sources and was interested in 'primitive' forms of graphic notation, especially the glyphs, pictograms and ideograms of Native American art. Ultimately, as was the case for van Gogh and Gauguin, the attraction of such mysterious and 'savage' markings lay precisely in the fact that they were *illegible* in the modern sense. They spoke an elemental, archaic language that could touch a universal level of communication. In Pollock's *Stenographic Figure*, from around 1942, crude ideogram-like markings traverse the composition, defacing the quasi-figurative image and forcing upon the viewer a strong sense of the material surface of the work. The title affirms the status of these markings as a form of writing, but it also places the work ironically in the context of modern writing methods – stenography is the art of writing in shorthand. But this is a form that even the most competent secretary is unlikely to be able to decipher.

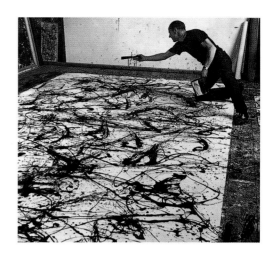

In the mature work of many of the Abstract Expressionists, however, the spontaneous gesture comes decisively to disengage itself both from the conventions of writing and from scriptive antecedents. Instead, as in Tachism, painting now metamorphosized into a more direct record of the unfettered movement of the whole body. By 1947, Pollock, for example, had abandoned the calligraphically based gesture in favour of a more elemental kind of all-over mark that buried the skeletal forms of a residual 'writing'.[19] He now worked on vast expanses of unstretched canvas laid on the ground, and allowed gravity and the whole of his body (rather than the wrist action of the handheld paintbrush) to determine how the paint was distributed. Line and surface became thoroughly confused and any sense of the linear disposition of discrete forms disappears. Pollock's working methods can usefully be contrasted with those of the Japanese artist Yu-ichi Inoue, a member of the Tokyo-based 'Bokujin-Kai' (The Human Ink Society). Although clear parallels in approaches to the act of painting are evident, so too are significant differences. Indeed, in terms of intentions and in the nature of their bodily engagement – as well as in relation to scale, distribution and quality of mark – the Japanese artist's painting, by being far more closely allied with Zen calligraphy, shows how far Abstract Expressionism had moved from modes of graphic sign-making. For now the model for Pollock – as indeed for the other 'action painters' – was less that of the oriental calligrapher and more that of the dancer. As the critic Harold Rosenberg argued in a celebrated essay, for Pollock and several other American artists of the period the canvas had become an arena in which to act, rather than a surface onto which to lay down marks, with the painterly results construed as an *event*, rather than a picture.[20]

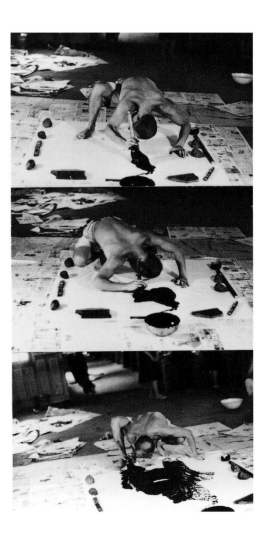

An element of graffiti-like vandalism is also evident in Pollock's scrawlings, and this aggression is made even more explicit in works such as Franz Kline's *Untitled* of about 1952 [*93*], which was made by defacing pages of the New York City telephone directory. The painterly and calligraphic sign

93 Franz Kline *Untitled* c. 1952
The tedium and banality of print is cathartically erased by a bold calligraphic gesture.

here functions as an act of erasure or overlay, an aggressive cancellation of prior meaning that also substitutes a kind of elemental writing for the decadent and banal printed alphabet. Like Dubuffet's painting of the scrawlings on a Parisian wall, or Tàpies's own dynamic brushwork, such paintings suggest links to the illicitness and archaism of the urban graffito, and to a kind of mark-making that presupposes an already complete surface. By identifying with the graffito, post-war artists took 'high' art's romance with the outlawed into the territory of the trangressive and confrontational written sign. As a record of a process of overlay and erasure, the graffito constitutes a kind of random historical deposit, and a wall may thus become a site for the accumulation of a potentially endless series of scrawls and scribbles that will then partly or wholly conceal what is already there, also altering and supplementing meanings in a continual and unpredictable process. What links such marks is the desire to establish at a crudely material level the record of an emotionally and physically frustrated presence – 'Morley was here' – while, in fact, graffiti always speaks in the past tense, as the perpetrator is already gone. Such marks are usually rapidly executed – a condition of this illegality – but such speed can also promote concision and power of expression.

The signature of the artist could also be inflected with the aura of the graffito. In the work of Motherwell, Pollock and De Kooning, as in Manet's painting years before, the inscription of the proper name causes a bifurcation of the painterly gesture into the verbal and figural registers. In the otherwise pictorially minimal work of the American painter Barnett Newman, for example, the signature takes on the role not only of a modest but significant spatial figure but also of a symbolic allusion. The act of self-nomination – always combined in Newman's case with the inscription of the year in which the work had been painted, and inscribed in a neat and unostentatious handwriting – plays on the fortuitous symbolism of the artist's name: New Man.[21] In the early work of Robert Ryman, on the other hand, the quest to reduce painting to its basic formal constituents also involved the incorporation of the artist's own signature as an assertive element. 'I used the signature as a line,' Ryman observed, 'and I generally put it up the side or on the end…just to make it more abstract so that it would be read more as a line and not so much as my name, necessarily. I used my name because that was an accepted element of all painting.'[22]

As the works in this chapter show, the desire to evoke a primal and 'demotic' form of writing characterizes much post-war art, representing a kind of abasement of writing, one that eschewed the sophistications of typography and mechanical lettering and the pleasures of clarity and comprehension in favour of the authenticity of the direct and deliberately artless scrawl.[23] The great master of such 'demotic' writing from either side of the Atlantic in this period is undoubtedly the American Cy Twombly. Taking the lessons of Pollock's gesture back to their point of origin in the wildly calligraphic graffito, Twombly also treated the painting as if it was a wall, covering his often vast canvases [*95*] with a manic carnivalesque of material traces – abstract scribbles, diagrams, phalluses and pudenda, faces and words – made with crayon, paintbrush or pencil, and laid on in clots and smears and, on occasion, more clearly contoured forms. The surface of the

94 Robert Ryman *Untitled* 1959
The artist's signature, bottom left, becomes a key compositional feature. It is a species of writing that, as Ryman noted, is 'an accepted element of all painting'.

95 **Cy Twombly** *The Italians* 1961
'Demotic' writing – part graffiti, part calligraphy – a maelstrom of
dynamic marks out of which legible words occasionally emerge.

painting becomes in Twombly's hands an expanse of vulnerable flatness
upon which he seems to vent his frustrations and desires. But it is also a
surface that is ripe with possibilities for inscription, and Twombly often
deliberately mimics the look of writing – its rhythm and slant, horizontal
axis, scale, concision and contrast – while failing to form any legible letters
or words. In this sense, it is the *possibility* of language that Twombly
addresses, rather than its actuality, and he generates what Roland Barthes
would call an '*allusive* field of writing', one that aims at putting us back in
touch with a more primal level of communication, rooted in the movements
of the body rather than in elaborate culture codes.[24] But legible words do also
appear, and their scrawling awkwardness is in stark contrast to their
meaning. In particular, Twombly, who settled in Rome in 1957, invokes the
Classical world – the heritage of ancient Greece and Rome. Such allusions,
which exploit the word's role as a signified in almost hyperbolic fashion and
emphasize painting's role as a vessel for the communication of narrative
content, are therefore also rooted in the artist's own environment and
experience. Indeed, within a more constructive framework, Twombly's work

can be interpreted not so much as an assault on a defenceless surface, but as
a form of annotation – as if the artist was making commentaries on the
already marked surface of art. The analogy then, as Barthes notes, would be
to the marginalia made in books by avid readers, so that the writing of the
name of the Roman poet Virgil, for example, conjures up any number of
previous references in art, as well as the poetic works of Virgil himself. The
whiteness of many of Twombly's works, would in this context allude not only
to the wall but also to the whiteness of the page, so that the relationship to
literature, and to the analogy of painting as book, becomes visually explicit.
Out of the seemingly chaotic and abject scrawls traversing his work – as
indeed out of the uncertain times in which he painted – Twombly actually
invokes a sense of continuity, perhaps even of eternal values.

Intermedia: Neo-Dada Words

Writing in 1966, the American artist, poet and publisher Dick Higgins looked back on recent developments in art and, challenging the legacy of abstraction and expressionism discussed in the last chapter, noted the emergence during the same period of what he called 'intermedia' art, a hybrid form that involved 'the dialectic between media', and that was the result of keeping pace with contemporary technological and social transformations. 'For the past ten years or so', Higgins observed, 'artists have changed their media to suit this situation, to the point where the media have broken down in their traditional forms, and have become merely puristic points of reference. The idea has arisen, as if by spontaneous combustion throughout the entire world, that these points are arbitrary and only useful as critical tools, in saying that such-and-such a work is basically musical, but also poetry.'[1]

Around the same time, the media theorist Marshall McLuhan argued that the kind of boundary-blurring cultural transformations noted by Higgins could in fact be traced to changes in the media employed by society as a whole. In the West, McLuhan announced, the 'typographic' and 'mechanical' eras were now being superseded by a new 'electronic' age; and just as these earlier media had provided the structure within which a certain kind of consciousness could develop, so too was this new 'electronic' age having profound consequences for the ways in which culture and society operated and people thought and acted. McLuhan argued that within this new media age the central nervous system was being technologically expanded to encircle the globe, radically transforming awareness of time and space. Indeed, with an optimism that was largely alien to the cultural commentators of the inter-war and immediate post-war periods, McLuhan welcomed these changes, announcing that they heralded what amounted to a new era of global tribalism that was putting modern man back in touch with more 'primitive' orally grounded modes of being in the world: 'The new media – the new languages – which have increasingly supplemented writing and print, have begun to resemble the multiple sensuousness of integral speech', announced McLuhan. 'Touch, taste, kinesthesia, sight and sound are all recreating that acoustic space which had been abolished by phonetic writing.'[2]

An example of the kind of blurring of boundaries envisaged by Higgins and McLuhan was the emergence of Concrete Poetry as practised by such diverse writers and artists as the Germans Dieter Roth and Max Bense, the Swiss-German Eugen Gomringer, the Scot Ian Hamilton Finlay, the Frenchman Henri Chopin, the Swede Öyvind Fahlström, the American Emmett Williams and the Brazilian 'Noigandres' group. Inspired by the pioneering work of Mallarmé, Apollinaire, the 'zaum' poets, Futurism and Dada, and drawing on the more recent example of Lettrism, the central focus

silencio silencio silencio
silencio silencio silencio
silencio silencio
silencio silencio silencio
silencio silencio silencio

98 Eugen Gomringer *Silencio* 1954
In Concrete Poetry the look and layout of words become as important as their linguistic meaning.

97 Robert Rauschenberg *Trophy 1 (For Merce Cunningham)* 1959
As in the work of Kurt Schwitters, the junk of the street becomes the raw material of art – but now on an American scale.

99 **Dieter Roth** Ideogram from *Bok* 1956–59

An example of an artist who produced Concrete Poetry, working
across media and here using the format of the book.

of Concrete Poetry was on the written word as a visual phenomenon. Typography was therefore a central concern, with letterform, weight, scale and page layout all contributing to the meaning of the work. Max Bense, for example, defined 'concrete' as the opposite of 'abstract', and declared that Concrete Poetry was 'a style of material poetry if it is understood as a kind of literature which considers its linguistic means (such as sounds, syllables, words, word sequences and the interdependence of words of kinds) primarily as representations of a linguistic world which is independent of and not representative of an object extrinsic to language or of the world of events.'[3] In practice, the results could be very diverse – Bense and Gomringer's works represent the Constructivist-inspired wing of the movement. *Silencio* [*98*], influenced by Gomringer's association with the Swiss artist and typographer Max Bill,[4] employed a typography and spacing of consummate purity and order. Fahlström and Roth, on the other hand, stand at the movement's other extreme, pursuing a hybrid form tinged with Dada-inspired primitivism. Refusing to acknowledge hard-and-fast boundaries between different media, they both worked in a multitude of forms, including books, paintings, graphics, poetry and music. Roth, in particular, explored the relationship between the text and material texture of writing, and in such works as *Diter Rot bok 56–59* (1956–59) and his albums made from separate sheets of perforated paper, the reader/viewer is asked to examine not only language as a signifier but also as a signified, the materials in which language is constructed and presented.

Another kind of blurring of boundaries was being pursued in the United States by the Beat movement. Fuelled by a heady mixture of drugs, alcohol and jazz rhythms, and justified by loose interpretations of Zen Buddhist ideas, novelists such as Jack Kerouac and William Burroughs, and poets such as Allen Ginsberg and Gary Snyder, sought not so much to investigate the formal, visual nature of words but to liberate language from the shackles of censorship and to oppose what they saw as the deadening conformity of 1950s America. Committed above all to freedom of speech, the Beats were in fact sharing in a wider project: the avant-garde's testing of the boundaries of the permitted. In poems such as 'Howl' (1956), for example, Ginsberg challenged the limits of the acceptable by loudly proclaiming his homosexuality. But the Beats also revived earlier avant-garde tactics, with Burroughs employing Dada and Surrealist techniques of cut-up to produce novels such as *The Soft Machine* (1961) and *The Ticket That Exploded* (1962) in order to explore non-linear perceptions of time and space.

The appeal of Zen for the Beats, as for others, lay in the basis it gave for an attack on the hold of conventional morality and of reason and logic over consciousness. The Japanese Zen Master D. T. Suzuki, for example, lectured widely in the West and taught that Zen demanded attention to the facts of experience rather than to logical, verbal, prejudices. In his influential study *An Introduction to Zen Buddhism* (1949), Suzuki noted: 'We generally think that "A is A" is absolute, and that the proposition "A is not-A" or "A is B" is unthinkable. We have never been able to break through these conditions of the understanding; they have been too imposing. But now Zen declares that words are words and no more. When words cease to correspond with facts it is time for us to part with words and return to facts.'[5] It was necessary,

Suzuki stated, to take hold instead of what Zen calls the 'Nameless'. For here, he declared, 'is no logic, no philosophizing'.[6]

An important synthesizer of these ideas was the American composer, poet and artist John Cage. As a teacher at the seminal Black Mountain College in the early 1950s, and as a central presence in New York in the 1950s and 1960s, Cage exerted a profound influence on American avant-garde culture. Fusing an understanding of Zen and Daoism with an interest in the work of Marcel Duchamp and the contemporary theories of writers like McLuhan, Cage argued that chance – what he called 'indeterminacy' – was of central creative importance.[7] A principal target was the hold of the logical structures of language over consciousness, and Cage's aim was to challenge the ways in which language broke down reality into discrete, controllable segments and put an artificial frame around experience. In this light, the attitude of Dada towards language seemed to Cage to be exemplary, for by embracing chance in order to produce the subversive confusion of the non-sensical, and through attacking habits instilled by reason and logic, the hold of reason over the mind was also undermined at its roots. Cage himself developed a range of procedures in mixed-, multi- and inter-media forms, which he used to challenge assumptions about art and the relationship of art to experience. He hoped thereby to draw attention to a condition of being in the world that preceded language and any questions of knowledge or ethics, one that was, through force of habit and convention of behaviour, generally overlooked. With this in mind, Cage emphasized silence over sound, the void over form, and non-sense over meaning. He applied chance procedures to all his practices, and sought not to author new content but to sample and rearrange ready-made material. He composed music, performed, and made art, and also reworked already existing texts by such writers as Thoreau and Joyce, generating events with unforeseeable outcomes and discourses with indeterminate meanings.

In very Cageian terms the American artist Robert Rauschenberg declared in 1959: 'Painting relates to both art and life. Neither can be made. (I try to act in that gap between the two.)'.[8] Drawing on the earlier practice of De Kooning and Franz Kline, Rauschenberg had begun in the early 1950s to use newspaper as the surface for his all-over paintings. This procedure, Rauschenberg said later, was intended to 'activate a ground so that even the first strokes in the painting had their own unique position in a gray map of words'.[9] Text here functioned as an already-given, an apparently worthless and overlooked material. Using a 'gray map of words' was a way both of avoiding the overblown rhetoric of the Abstract Expressionists' existential encounter with the empty canvas, but also of bringing art back into contact with the everyday world. Furthermore, as Cage himself would put it in an essay on the artist's work, this kind of ground announced that 'beauty is now underfoot wherever we take the trouble to look.'[10]

In his mid-1950s 'combine' paintings, Rauschenberg went on to enlarge the scope of collage to incorporate any found object, declaring that, 'a pair of socks is no less suitable to make a painting with than wood, nails, turpentine, oil, and fabric.'[11] Informed by the new aesthetics of inclusivity and indeterminacy, the doors of art were being thrown wide open to the world and words came tumbling in. In an attempt to theorize the new work,

the art historian and critic Leo Steinberg called it 'post-modern', arguing that Rauschenberg was effectively transforming painting from a convention based on the simulation of a window-like opening into one grounded in the 'flat-bed' surface, a two-dimensional plane on which could be accumulated a rich mixture of two- and three-dimensional materials. This, Steinberg asserted, shifted art from its old relationship to Nature to a new one with Culture.[12] Rauschenberg scrawled and poured paint over the cluttered surfaces of his accumulated bric-a-brac, which also incorporated found fragments of text. As in Cage's work, a sense of indeterminacy of meaning pervades these pieces, with the materials generating a good deal of information without also providing any single key to interpretation. *Trophy 1 (For Merce Cunningham)* [*97*], from 1959, for example, brings together a stolen street sign and fragments of text from advertisements, along with a host of other bits and pieces. In this case, however, the text does also permit a degree of personal and interpretable narrative to enter the work, for the painting was meant as a homage to his friend and collaborator, the dancer to whom the work is dedicated – Merce Cunningham, depicted in the top right photograph – who had recently hurt his ankle in a fall on an old uneven stage floor. The road sign refers playfully to this mishap.

Through his collaborations with Cunningham's dance company, Rauschenberg was also a prime example of the kind of artistic cross-fertilization that Dick Higgins had dubbed 'intermedia'; but this mixing or blurring of genres and media was more fully embraced by the exponents of the 'happening' such as Allan Kaprow and Jim Dine. Echoing Cage and Rauschenberg's sentiments, Kaprow, for example, declared that anything could be used to make a work: 'These things may include clothing, baby carriages, machine parts, masks, photographs, printed words and so forth, which have a high degree of associational meaning; however, they may just as often be more generalized, like plastic film, cloth, raffia, mirrors, electric lights, cardboard or wood – somewhat less specific in meaning, restricted to the substances themselves, their uses, and their modes of transformation. There is no apparent theoretical limit to what may be used.'[13] Within this new expanded field, the artwork became a site for a variety of events or multi-sensory and interactive experiences that no longer set out primarily to function on an aesthetic or even a purely visual level. This new conception was intended fundamentally to change not only the limit placed on the materials of art, but also the nature of the relationship between the work and the beholder; and the latter was now to be invited not merely to participate in detached contemplation but also to play a more active role in the interpretation and making of the work. Written words took on a central but highly ambivalent role in this new conception, introducing levels of narrative into the dynamic experience but also a degree of discursiveness that was at odds with the quest for more direct experiences. In this new conception, Kaprow noted, words were to be placed among those elements with associative meanings, but they were also challenged on all sides by other more obdurate materials, and by more direct and unmediated kinds of responses. In one of his 'environments', actually called *Words* and designed in 1961, the audience was invited to negotiate and rearrange a veritable labyrinth of texts – handwritten and stencilled and attached to every

100 **Allan Kaprow** *Words* 1961
A physical environment overflowing with words.

available surface – and also to play a selection of voice recordings on record-players. Here, as in his other works, Kaprow was hoping to engage the audience in an ongoing process that confused maker and viewer. But the verbal overload he provided can also be interpreted as a critique of the mediation of experience by language. Through verbal excess, and through an overflowing of texts into the environment, Kaprow seems to be pointing both to the omnipresence of words – how they literally conceal reality – and to their inadequacy as effective vehicles of expression. Through strategies of direct participation and sensory stimulation, this was something that the 'environment' and the 'happening' specifically sought to circumvent.

The loose coalition of international artists, composers, performers and writers known as Fluxus – of which Dick Higgins was himself part – took a similarly cavalier attitude to customary forms and decorum. Committed to breaking down the traditional barriers between the arts, and between art and life, Fluxus was established first in New York and later in Germany by the Lithuanian-born artistic impresario George Maciunas. It was, as Maciunas himself put it, an unlikely fusion of 'Spike Jones, Vaudeville, gag, children's games, and Duchamp'.[14] He contrasted mere 'Art' with what he called 'Fluxus Art-Amusement', and argued that the goal of Fluxus was to knock the former from its pedestal. Fluxus was to be available to and accessible by all: 'The value of art-amusement', Maciunas announced, 'must be lowered by making it unlimited, mass-produced, obtainable by all and eventually produced by all'.[15] As a result, words play a central role in Fluxus, their legibility contrasted with the obscurity of much modern art but also helping to draw the works into the familiar and less elitist territory of popular entertainment. Indeed, words in Fluxus projects function in comparatively uncomplicated fashion, naming, designating and describing, providing clear labels and instructions. Much of this approach was modelled on the protocols of advertising and product design, though in practice Fluxus writing styles could vary considerably; at the one end, the eccentric but mechanically printed typography of posters and labels for Fluxus 'games' and boxed editions (usually designed by Maciunas himself) or the visually unobtrusive 'event scores' produced by the American multi-media artist George Brecht and composer La Monte Young; at the other end, the cursive hand-painted script of the Frenchman Ben Vautier. The latter preferred a freely drawn, signature-like lettering – a reprise of sorts of Magritte's schoolboy handwriting, but made with a rather less law-abiding hand – with which he covered any available surface, including the 'shop' he ran in his native Nice, generating a playful kind of graffiti-writing of witty and profound-sounding slogans. But it is the style preferred by Maciunas himself that is perhaps most memorable. Maciunas effectively revived the display fonts of the nineteenth century that had been popular with the Cubists, Futurists and Dadaists, and by appropriating these flashy and now historically loaded typographical models he was able to distance Fluxus texts from both the angst-ridden calligraphy of the post-war avant-garde and the cool, rational, typo-aesthetic of much contemporary Constructivist-inspired graphic style. The whimsical deployment of slab serifs and shaded, elongated letters was a direct challenge both to the artful graffito, and to the hegemony in the marketplace of sans serif. Expression, on the one hand, and sobriety on the

101 **Fluxus Collective** *Fluxkit* 1964
Examples of Fluxus kits and games.

102 **Ben Vautier** *Le Magasin de Ben* 1962
The shop enters the art gallery.

other, were replaced by a festive, carnival spirit of Fluxus fun, with such textual largesse also clearly signalling the rejection of the customary division and hierarchy between media.

For a brief period the influence of Fluxus was widespread, and there were several adherents in, among other places, Japan. One artist, Yoko Ono, soon moved to New York, where she produced several works in which Japanese script played a central part, creating, for example, a series in which in a neat calligraphic hand the instructions for making paintings were written at the centre of pieces of paper. Commenting on these works, she noted: 'my interest is mainly in "painting to construct in your head"'.[16] In other words, Ono was using text as a way of substituting the idea of the work for its concrete and material realization, thereby bringing to the fore the process of conceptualization by investigating the artwork as a condition of potentiality rather than actuality. George Brecht had already moved in a similar direction, describing his work as 'an expression of maximum meaning with minimal image, that is, the achievement of an art of multiple implications, through simple, even austere, means.'[17] One of Brecht's 'event scores', printed in plain sans serif on card reads:

DRIP MUSIC (DRIP EVENT)

For single or multiple performance.

A source of dripping water and an empty vessel are
Arranged so that the water falls into the vessel.
Second version: Dripping

G. Brecht (1959–62)[18]

As we will see in Chapter 13, this kind of emphasis on conception over execution would become a central preoccupation of many artists after the mid-1960s, initiating an artistic practice centred on the written word.

The spirit of playful Dada-inspired anarchism that suffuses Fluxus can also be found in the work of the short-lived but influential Italian artist Piero Manzoni. Words play essentially two roles in Manzoni's art, both of which mean that the viewer/reader is to take language at face value. Firstly, they are employed as basic descriptive terms – as labels, or titles that designate the nature of the often obscure or hidden identity and meaning of the work. In one notorious instance, for instance, Manzoni canned his own excrement, though we would be unaware of this uniquely personal content were it not for the presence of the label which, in bold and unadorned type mimicking a product brand label reads: 'Merda d'artista'. Secondly, Manzoni would explore to amusing effect the convention of the artist's signature, and his habit of signing not only objects but also people themselves pursued this gesture of creative nomination, authorship and possession towards an absurd apotheosis. In signing a living person, Manzoni instantly turned them into a (spurious) work of art, and by burlesquing the role of the signature in establishing the authenticity and value of the artwork he also exposed the logical non-necessity of the physical work in a view of art as self-expression.

103 **Yoko Ono** *Smoke Painting* 1961
Japanese ideograms give instructions for making art.

104 **Piero Manzoni** *Living Sculpture* 1961
The artist enjoys himself.

A group of artists based in the south of France with whom Ben Vautier was associated – the 'Nouveau Réalistes' – also shared this general desire to push against traditional notions of the media and subjects of art. Written and spoken words were a prominent part of their activities as well, but at least in the case of their most original contribution words functioned in a very different context to Fluxus, one closer in fact to graffiti and the raw collage aesthetic of Robert Rauschenberg. The French artists François Dufrêne, Raymond Hains and Jacques de la Villeglé, the Italian Mimo Rotella, and the German Wolf Vostell all sought to bring the street directly into the gallery by producing works that were made from torn advertising posters. In appropriating hoardings these artists were drawn both to the purely abstract effects of brightly coloured areas of printed paper and also to the chance arrangements that were generated between fragments of images, clusters of words and different typographies. Taking hold of this mass-produced ephemera by literally tearing it from walls and attaching it to canvas, the 'affichistes' (as they were dubbed) also further expanded the concept of collage (though they preferred the term *décollage*), moving it in the direction of large-scale abstract art. As in the case of Hains's *Paix en Algérie* (1956) – a work that refers directly to protests against the war being fought at the time in Algeria – these anonymous-seeming lacerations could at times be quite directly political. Alternatively, they could, as they did for Mimo Rotella, open out on to territory that would soon be more fully annexed by the Pop artists – the world of celebrity, glamour and mass media entertainment. Through these actions and interventions, the 'affichistes' sought to redirect the banal and transient language of advertising towards culturally subversive ends, but rather than merely being influenced by their sources (like the graffiti-inspired artists of the immediate post-war period), they actually appropriated them as their own. Furthermore, they did not use language as if it were an original, personal and expressive outburst – a handwriting – but instead took on the established and debased codes of mass culture, its typographic conventions and familiar standards of layout, and set about exposing them as ruins of their original selves. Applying the logic of the 'ready-made' to the phenomena of the new urban scene, while also pursuing the role of the artist-as-vandal that had been initiated by Duchamp, the 'affichistes' in uncompromising fashion further sought to break down the barrier between art and a now mass media-saturated life. The Surrealists' idea of generating 'the true functioning of thought' through the juxtaposition of previously unrelated sources, took on new life, with their works exposing what de la Villeglé described as the 'collective unconscious' of modern society.[19]

The Paris-based 'Internationale Situationiste' movement – the politicized offshoot of the Lettrists – recognized in the actions of the 'affichistes' a prime example of what their leader Guy-Ernest Debord called *détournement* – the subversion of mass media information through appropriation and reordering. 'Ultimately, any sign or word is susceptible to being converted into something else, even its opposite', Debord and his colleague Gil J. Wolman declared, citing the Symbolist poet the Comte de Lautréamont as a precedent.[20] The Situationists believed that the 'detourning' of books, films, advertisements and so on, was merely the prelude to the inevitable revolution, and in the event, after some initial engagements with art –

105 **Raymond Hains** *Paix en Algérie* (Peace in Algeria) 1956
Fragments of billboards and a hand-painted poster torn from their
locations and used as ready-made materials.

including, for example, a collaborative 'detourned' book produced by Debord and Asger Jorn – the Situationists became increasingly frustrated with aesthetics, pledging themselves fully to the direct overthrow of capitalism. 'In spite of what the humorists think, words do not play. Nor do they make love, as Breton thought, except in dreams', their journal declared ominously in 1963. 'Words *work*', the article continued, 'on behalf of the dominant organization of life…. Power presents only the falsified, official sense of words; in a manner of speaking it forces them to carry a pass, determines their place in the production process (where some of them conspicuously work overtime) and gives them their paycheck.'[21] Despite this uncompromising verdict, however, the 'dominant organization of life' was increasingly becoming a source of inspiration. Indeed, artists were now turning with enthusiasm to the commercialized mass-media spectacle engulfing the cities in which they lived and worked.

12

Coca-Cola: Pop Words

What would Edmondo de Amicis, our guide to the typographic splendours of Paris at the end of the nineteenth century, have made of Times Square in the 1960s? In some ways not much has changed; the brand names might be different, but the message – the instruction to buy – is the same. What is really striking now, however, is the magnitude and saturation of the machinery of consumer culture: it dwarfs anything that De Amicis could have imagined. Indeed, by 1962 *Time* magazine was claiming that the typical American was likely to be exposed to an average of 1,600 advertisements per day, and thanks to new technologies of illumination the spectacle was now a twenty-four hour one, with neon filaments pulsing through the night. Furthermore, the billboards were now so large and colourful that often they almost hid the buildings to which they were attached.[1]

It was in the United States that this commercially motivated sign-scape was most overwhelmingly in evidence, and since the 1920s artists such as Stuart Davis had focused on the logos and typography of consumer products. He worked in a style derived as much from graphic design as it was from an admiration for Fernand Léger.[2] But it was to be in Britain in the early 1950s rather than the United States that the avant-garde would first begin wholeheartedly to engage with the new urban environment. Turning their backs on existentialist-fired expressionism, a number of artists, architects and writers formed the Independent Group, and through discussions, publications and exhibitions they sought to address the multifaceted phenomenon of commercialized mass culture. One of their number, the artist Richard Hamilton, noted in 1957 that a new kind of market-oriented art had emerged, one that he dubbed 'pop art'. This art was, he wrote:

Popular (designed for a mass audience)
Transient (short-term solution)
Expendable (easily forgotten)
Low cost
Mass produced
Young (aimed at youth)
Witty
Sexy
Gimmicky
Glamourous
Big Business[3]

But the members of the Independent Group recognized that the impact of the new popular culture was not merely stylistic; indeed, they saw that the balance of power between 'high' and 'low' culture had shifted radically.

109 **Stuart Davis** *Lucky Strike* 1924
The iconic 'Lucky Strike' logo becomes part of a still life in which the artist celebrates modern pastimes.

108 **View of Times Square at night, New York City** *c.* 1968
The city as a forest of signs.

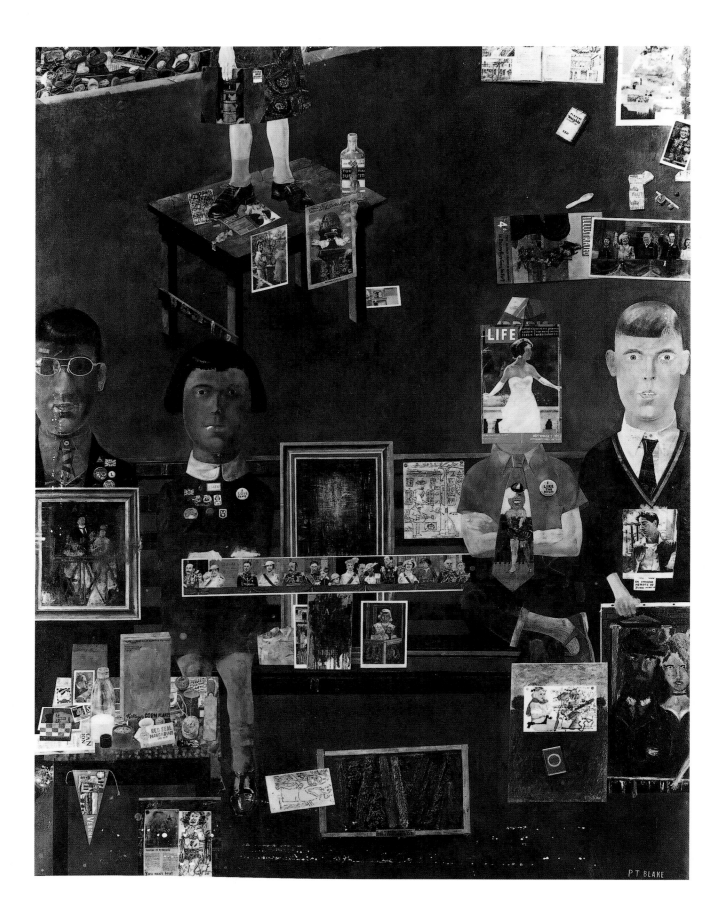

Another member of the Independent Group, the critic Lawrence Alloway, described the development of what he called 'the Long Front of Culture', observing that there was bound to be resistance to this new kind of culture because, 'the abundance of twentieth-century communications is an embarrassment to the traditionally educated custodian of culture. The aesthetics of plenty oppose a very strong tradition which dramatises art as the possession of an elite.'[4] But for a young British artist like Peter Blake, the new situation posed not so much a threat as an opportunity, and in his painting *On the Balcony* (1956–57) Blake tacitly acknowledges the reality of this cultural transformation. The work provides a virtual roster of 'high' and 'low' influences, with the accumulated material – another manifestation of the Steinbergian 'flat-bed' format – including typographical components that range from the label on an abstract painting to the cover of *Life* magazine and a lapel badge saying 'I love Elvis'.

In Alloway's view, this newly emerging art was to be understood as a response to a transformation from a pyramidal conception of culture ('high' art at the apex, the dregs of popular culture at the foot) into a horizontal continuum in which, as Alloway put it, culture was perceived in a less judgmental and hierarchical fashion as simply 'what a society does.'[5] This realignment would have many consequences for the style and content of writing in art. The calligraphic gesture was now replaced by the look of mechanical typography, while the texts that were incorporated into artworks increasingly focused on the cliché and the omnipresent chatter of the mass media. As these words did not originate with the artist, they also epitomized the quintessentially modern experience of reality as something thoroughly mediated. No longer signalling some expressive intention, words would henceforth be seen as constituting part of the raw material of the new expansive commercial environment. But the context had also changed, and this new engagement with public text would be played out against the backdrop of the growing availability and importance of other media, especially television, which was single-handedly shifting communication away from print-based forms and towards new electronically driven oral/aural and visual modes. Thus, while artists sought to initiate a response to an environment characterized by a riotous and often invasive cacophony of words, they would at the same time be experiencing the increasingly significant effects of electronic modes of communication, effects that were displacing the written word from its central position in culture. 'A great many things will not work since the arrival of TV', observed Marshall McLuhan in typically hyperbolic mode in 1964. 'Not only the movies, but the national magazines as well, have been hit very hard by this new medium. Even the comic books have declined greatly. Before TV, there had been much concern about why Johnny couldn't read. Since TV, Johnny has acquired an entirely new set of perceptions. He is not at all the same.'[6]

These artistic developments were occurring in a climate of unparalleled prosperity and the emergence of a highly competitive marketplace. Not only were the new media assuming increasing importance, but so too were the changes accompanied by a fundamental modernization of the world of print and graphic design such as the introduction of electronic technology and the advent of automated typesetting. In 1961 IBM launched the first golfball

110 **Peter Blake** *On the Balcony* 1956–57
The cover of *Life* magazine and a lapel badge saying 'I love Elvis' compete with a photograph of the British Royal Family, a copy of a famous painting by Edouard Manet, and a host of other words and images.

typewriter, a machine that allowed users to vary typefaces, while in 1959 the first plain paper photocopier had come onto the market, and in the early 1960s the method of dry transfer lettering – Letraset – helped bring the once complex and expensive business of typographical design and layout to a wider clientele. Commercial design became a prosperous and well-organized profession that was quick to absorb the experimentation of the avant-garde.[7] In the marketplace, guarantee of consumer loyalty was vital, and the expansion of television advertising – which now joined the more familiar and increasingly universal forms of the billboard, placard, store window, newspaper, magazine and handbill – made product visibility vital. Juxtapositions of word and image reached new levels of complexity as the language of advertising became more sophisticated and more pervasive – copy-writers were now masters of the kind of wordplay that had once been reserved for poets – and captions became a form of entertainment in their own right. The traditional goal of communicating facts was supplemented or even supplanted by far more seductive modes of seemingly personal address that had the effect of luring the viewer/reader into their new role as satisfied consumer.

A pioneering work by Richard Hamilton from 1956, *Just What Is It That Makes Today's Homes So Different, So Appealing?*, explores the 'cool' style of this mass media environment via Dadaist and Constructivist photomontage. Hamilton appropriates the language of photographically based mass media in order to produce a synthetic depiction of the 'ideal' modern interior that is built out of fragments of advertising, comic books, illustrations and other products of popular culture, including a bewildering array of different text fragments. However, these bits and pieces are not intended to produce a personal accumulation of discarded and apparently worthless junk as in, say, Kurt Schwitter's work. Rather, Hamilton's photomontage is closer to the satirical style of John Heartfield, and the culled words and images work together to produce the effect of a parodic mock advertisement, an absurdist resumé of the consumerist dream.

This new media-oriented and Americanized avant-garde was more than a mere species of fine art that had been absorbed into the popular cultural mainstream, and in significant ways it was very different from the kind of overtly populist art that Hamilton had identified. For, just as earlier avant-garde artists had sought to revitalize 'high' art and challenge ruling artistic norms by forcing confrontation with non-Western or marginal art, so the vanguard now brought into galleries and museums the 'vulgar' and commercialized visual and verbal languages they encountered around them in the urban, consumer-driven environment. By absorbing the language of the mass media, artists were also obliged to transform the nature of their relationship to their work, as the subjective aesthetic that had largely dominated art since the Romantics ceded to a more rationalistic, detached relationship with experience, one that was close to the neutrality and emotional indifference of the mechanical media. To some extent, then, this new media-conscious avant-garde art can be understood as a further attempt at democratization, the culmination of a process that had begun in earnest in the mid-nineteenth century with Gustave Courbet and the Realists. Now, it seemed, 'low' culture was finally invading the sanctuary of the 'high' in

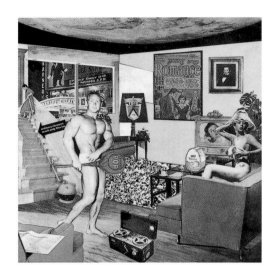

111 **Richard Hamilton** *Just What Is It That Makes Today's Homes So Different, So Appealing?* 1956
The 'American Dream' seen from a Britain that was still experiencing rationing. An updated version of Dada photomontage.

112 **Jasper Johns** *Numbers in Colour* 1958–59
'Everyone had an everyday relationship to number and letters', noted Johns, but, 'never before had they seen them in the context of a painting'.

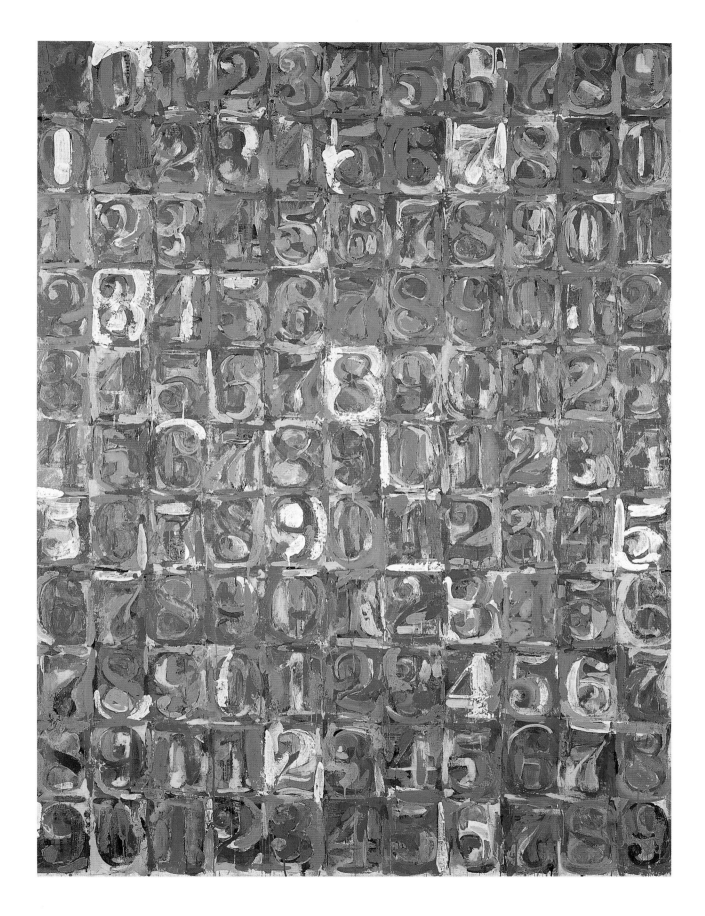

definitive fashion, and in so doing had achieved the goal of making art accessible to a far wider public. The American artist Jasper Johns, for example – a pioneer of the new sensibility, and like his friend Robert Rauschenberg, a bridge between the Neo-Dada anti-aesthetic and Pop – stated that a principal reason why he had started using letters and numbers in his work in the mid-1950s was that these were 'things that people knew'. They were something anyone (at least in the literate West) could read and thus understand in ways that they might not have been able to understand a work by Jackson Pollock.[8] But Johns argued that while the elements in his work might on the face of it be familiar to the viewer, 'in the sense that everyone had an everyday relationship to numbers and letters', they actually possessed subversive significance because, as Johns explained, 'never before had they seen them in the context of a painting'. He concluded: 'I wanted to make them see something new.'[9]

Like Kline, De Kooning and Rauschenberg, Johns painted his early works over collaged newspaper, but he went further than Rauschenberg in distancing himself from the Abstract Expressionist idiom by the use of simple, iconic and already-existing forms. Johns noted in 1965 that the motifs he employed seemed valuable precisely because they were 'preformed, conventional, depersonalized, factual, exterior elements', a string of adjectives that deliberately inverted the period's artistic rhetoric. Johns was saying that he no longer sought a *spontaneous, unconventional, personal, allusive* and *internal* reality, as had the Abstract Expressionists and the European expressionists.[10] This quality would be enhanced by the use of the stencil, Johns's preferred technique of lettering. Stencilling represented a letterform that placed utility above aesthetic considerations or questions of expression; like the content it was often employed to describe, such lettering could not be further from the existentialist-inspired gestural, calligraphic automatism of the post-war period. In Johns's work it came to stand for the detached voice of an instrumental and administered society and the signage of the military-industrial complex.[11]

While Johns employed a system of extant and socially coded signs through which not to communicate personal emotion, like Duchamp he sought to engage in a discursive fashion with the complex field of already existing forms and meanings. From this mediated reality, however, Johns was able to prise a subtly deconstructive lesson in the arbitrariness of visual and verbal signs, and the dangers inherent in an art that had lost contact with the commonplace. His fascination with the failure of words to signify, and the fact that they point only to themselves, also links Johns's work to Duchamp's, while his preference for the kind of paraphernalia associated with the environment of the elementary school – maps, flags, alphabets, numerals and rulers – suggests a connection with Magritte's use of the reading primer format. Johns saw his role as an artist as being that of someone who was in the business of undermining certainties, so that in confronting one of his works such as *Map* from 1961 [*114*] we are caught between a response to the familiarity of its ostensible subject (the map of the United States), the unfamiliarity of this as a motif for a painting, and also the seeming inappropriateness of the painterly and colourful treatment of such a graphic and orderly source. We are thus confronted with the problem of

interpreting a familiar sign that now, however, eludes just the kind of precision and instrumentality that Johns's source was intended to provide.

As Johns's work suggests, the impact of mass culture during this period was to register in art more than simply as a new kind of subject matter. *The Demuth American Dream #5* (1963) [*115*] by the American artist Robert Indiana celebrates continuities with earlier modern art while also making clear that the new art represented a significant departure. For although Indiana draws on Charles Demuth's 1928 painting *I Saw the Figure Five in Gold* [*60*], he seems no longer to be seeking guidance primarily in the art gallery or museum but instead has chosen to take lessons in the streets of the city. Indiana employs not so much the techniques of the Old Masters (or even the young ones), but those of the graphic designer and commercial artist. The visual citation of Demuth's work in the central motif turns the original into a kind of pseudo-mass-produced advertisement for the American 'dream' (or nightmare) whose course is charted by the enigmatic verbs ERR, DIE, EAT, HUG rendered, as in Johns's work, in neutral, utilitarian, stencilled lettering. So while Indiana quotes from another modern painting, the language of his homage owes far more to the world of billboards and street signs than does the original.

The new generation of artists largely ceased to cast themselves as bohemian outsiders alienated from an indifferent bourgeois society. But neither did they believe, as the Constructivists had, that there was a role for the artist as social engineer. Thus, their engagement with mass, commercial, culture could be very real, and some of the artists who subsequently became successful during this period actually earned their living in the apparently 'low' professions of graphic design and commercial art. In the late 1950s and early 1960s the American Pop artist James Rosenquist, for example, painted the kind of giant billboards that might be seen gracing Times Square, and later came to use this technique in his own work.

Most famously of all there was Andy Warhol, already a successful Madison Avenue advertising draughtsman. In a far more uncompromising fashion than Johns, Warhol selected as the raw material of his art the mass-produced imagery of the popular media with which he was already dealing on a daily basis. In his work the word returns with the signifying authority that it had been stripped of by the modern interrogation of language; but it now refers not to some reality grounded in 'nature', but rather to one generated by the commodity itself. Like the other Pop artists, Warhol treated both word and image with the same cool detachment, and by engaging with the style and content of the mass media, he also treated all representations of reality as filtered though its screen. Furthermore, the verbal is decisively severed from the personal voice, and relocated in the sphere of the anonymous mass media. In his early work, aspects of touch and voice lingered on through the handmade painting technique – a technique that provided a degree of individuality with which to counter the mechanical forms of appropriated typography and photographic image. But in works like *Five Coke Bottles* (1962), Warhol decisively broke with the look of the handmade, and then by the use of the mechanical silk-screen technique pushed the sense of aesthetic and moral detachment into the realm of the mass produced.[12] But the Coca-Cola logo was not chosen at random.

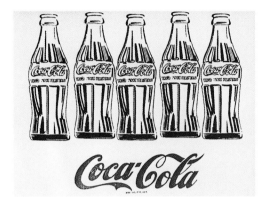

113 **Andy Warhol** *Five Coke Bottles* 1962
One of the most famous and enduring of all brand designs celebrated by an artist who recognized such things as the modern equivalents of the old religious icons.

114 **Jasper Johns** *Map* 1961

A map of the United States gets the Johns treatment, transforming
it into a dynamic semi-abstract painting.

115 **Robert Indiana** *The Demuth American Dream #5* 1963
'Die', 'Eat', 'Hug', 'Err': the American Nightmare. Indiana consciously
quotes a painting by Charles Demuth [*60*].

Its characteristic look – a piece of Art Nouveau-style typography that, like the shape of the bottle, had lingered on into the age of sans serif and the machine aesthetic – was (and still is) a primary icon of commercial success: according to a survey conducted in 1949 only one in 400 Americans could not identify a Coke bottle.[13]

Echoing the arguments of such writers as Benjamin and McLuhan, Lawrence Alloway had observed that techniques of mass production resulted in 'an expendable multitude of signs and words' and what had once been handwritten or drawn was now mechanically generated, and infinitely reproducible.[14] This, Alloway argued, undermined the principle of the original, handmade object, and the readily accessible and cheaply produced item thereby threatened the value of art itself. For Warhol, as for other artists of his generation, there seemed to be only one way ahead – onwards into the man-made forest of 'expendable signs and words'. In adopting the technique of silk-screening, Warhol grasped the significance of this transformation, finding by simple mechanical duplication of the already existing text and image a means through which it was possible further to remove signs of the artist's personal presence in the work. In 1963 Warhol remarked: 'I think it would be great if more people took up silk screens so that no one would

know whether my picture was mine or somebody else's.'[15] The artwork, severed from its familiar craft-based context in ways that were first essayed in the 'readymades' of Duchamp, was now decisively relocated in a close, even parasitic, relationship to the world of the anonymously mass produced.

Graphic design graduate Ed Ruscha took this new mediated reality for granted, and in the process has gone on to produce some of the most richly nuanced word-paintings of the modern period. Discussing his attraction to words, Ruscha noted: 'I guess I'm a child of communication, and I have always felt attracted to anything that had to do with that phenomenon of people speaking to each other. Maybe that itself becomes synonymous with popular culture in that newspapers, magazines – printing, specifically – have had the most dramatic effect on me. Printing was it, to me...I felt newspapers, magazines, books – words – to be more meaningful than what some damn oil painter was doing. So I suppose it developed itself from that – into the idea of questioning the printed word. Then in questioning, I began to see the printed word, and it took off from there.'[16] In his paintings, decontextualization combined with the preservation of tenuous links with recognizable and prosaic sources, generates a sense of enigma and unease that often has parallels with the evocative use of verbal language typical of the Symbolists and the Surrealists. 'I'm not thinking of the literary aspects,' Ruscha remarked in an interview, 'I'm not a poet. I'm more of a wordsmith – like a tunesmith – than I am a writer. I go for quick, simple combination of things. I'm not storytelling.'[17] Ruscha described how, in encountering advertisements on his automobile journeys, he sensed their presence as *things*, as word-sculptures rather than simply as meanings. But without succumbing to the inertia of appropriation or repetition, he aimed instead at treating the 'ready-made' environment of commercially motivated verbal signs as the occasion for a witty and richly suggestive journey. Typographical space collides with pictorial space, generating unstable hybrids in which the material presence of the letter competes with its role as a carrier of meaning. In *Large Trademark with Eight Spotlights* (1962), for example, Ruscha takes the logic of his insight into the nature of visual language to an extreme, transforming a movie corporation's sign (which is inherently sculptural in form) into a monumental piece of kitsch-classical architecture rendered in a kind of burlesque of fixed-point perspective. Other works by Ruscha demonstrate a sensitivity to the ways in which writing visualizes speech, and he frequently plays with phonetic spelling and slang, finding ways to bring the visual appearance of words into provocative confrontation with their ostensible content [*3*]. In the process Ruscha would also transform the 'artist's book', producing (in a characteristically paradoxical move) a series of book-based works, such as *Twenty-six Gasoline Stations* (1962), which, apart from their title pages, consist entirely of photographs.

The quintessentially modern, popular and *American* fusion of word and image, however, is the comic-book, a genre that was also annexed enthusiastically by artists in the 1960s. The most celebrated appropriations of these sources are Roy Lichtenstein's paintings based on greatly enlarged panels of editions of DC Comics. As can be seen by comparing Lichtenstein's *Hopeless* (1963) [*117*] with its source, a panel from the comic-book story 'Secret Hearts' [*118*] drawn by a leading illustrator of the period,

117 **Roy Lichtenstein** *Hopeless* 1963

118 **Panel from 'Run for Love!' in** *Secret Hearts* **83** 1962
The large-scale version (above) of the original comic-book image
drawn by Tony Abruzzo with lettering by Ira Schnapp (right), is more
than a simple copy; note, for example, the change in hair colour and
shape of the speech bubble.

Tony Abruzzo, Lichtenstein did far more than simply copy the original. His paintings are actually the result of editing and selection, of mixing sources and making additions and subtractions. Unlike the originals, Lichtenstein was after an image that could become representative of its kind, the essence of the genre, one that distilled the cliché in order to present a more stereotypical image and text than was actually evident in his sources. So while in the original comic book the role of text is to help relay the narrative through the linear sequence of the story, in Lichtenstein's versions it is marooned, and like the images made to serve as a composite summary of a hypothetical and prototypical plot. In *Hopeless*, for example, the look of the raven-haired girl in the original comic-book illustration has been metamorphosized into a more generic All-American blonde. Similarly, Lichtenstein manipulates his sources' texts, and although in this case it is copied word for word from the original, in other instances words are altered subtly but significantly in order to provide the appropriately generic tone. And as can also be seen from *Hopeless*, Lichtenstein has departed somewhat from the visual layout and calligraphic style of the original's lettering. In the source, the lettering – by Ira Schnapp[18] – is tightly drawn, blockish, and has an easy visual flow. In Lichtenstein's version, on the other hand, it is enormously enlarged, has become thinner, and the sentence as a whole is less easy to scan. Furthermore, the speech bubble has become more intrusive, overlaying the image itself.

The work of Warhol, Ruscha and Lichtenstein might suggest an accommodating, easy-going relationship with the new consumer society. But as the European Situationists' assault on 'the dominant organization of life' suggests, not everyone was quite so optimistic. The potentially divisive dimension to advertising was highlighted, for example, by an influential study published in 1957, *The Hidden Persuaders*, in which the American sociologist Vance Packard exposed the ways in which the industry manipulated consumers by playing on their innermost needs and fears.[19] Meanwhile, with a far broader brush, the German–Jewish sociologist, Herbert Marcuse, in his 1964 study *One-Dimensional Man* – a bold synthesis of Freud and Marx that built on earlier panoptic critiques of capitalism – developed existentialist critiques of bourgeois culture, and seemingly concurring with the Situationists, defined what he called the 'false consciousness' of consumer society. A particular target was the abuse of language under the mass media, and Marcuse lamented the emergence of a new 'language of total administration', observing – in terms that implicated Pop art in a complicit relationship with oppression – that modern capitalism exploited the mass media in order to generate the illusion of security and contentment: 'This sort of well-being, the productive superstructure over the unhappy base of society, permeates the 'media' which mediate between the masters and their dependants.'[20] Such negative social, economic and political prognoses would now help to provoke the emergence of a highly critical intellectual avant-garde determined to drag language even further into the apparently pure spaces of visual art.

TIPS FOR ARTISTS
WHO WANT TO SELL

● GENERALLY SPEAKING, PAINT-INGS WITH LIGHT COLORS SELL MORE QUICKLY THAN PAINTINGS WITH DARK COLORS.

● SUBJECTS THAT SELL WELL : MADONNA AND CHILD, LANDSCAPES, FLOWER PAINTINGS, STILL LIFES (FREE OF MORBID PROPS ___ DEAD BIRDS, ETC.), NUDES, MARINE PICTURES, ABSTRACTS AND SUR-REALISM.

● SUBJECT MATTER IS IMPOR-TANT: IT HAS BEEN SAID THAT PA-INTINGS WITH COWS AND HENS IN THEM COLLECT DUST ___ WHILE THE SAME PAINTINGS WITH BULLS AND ROOSTERS SELL.

13

Art as Idea as Idea: Conceptual Words I

In December 1969 the American artist Robert Barry held an exhibition at the Art & Project Gallery in Amsterdam, which, no doubt to the consternation of the less au fait gallery-goers, consisted solely of two pieces of paper attached to the locked front door of the gallery. One carried the gallery's letterhead and gave the name of the artist and the dates of the exhibition; the other – a single typewritten sentence – announced: 'During the exhibition the gallery will be closed.' That was it. No work on show, simply this bald statement. Barry's action displaced an object or an event by a piece of verbally communicated information relayed in the most prosaic fashion possible and effectively substituted words for artwork. With art like this it now became possible to speak not simply of words *in* art, but of words *as* art.

Barry was certainly not alone in making this transition, and his minimal offering is just a particularly uncompromising example of a broader tendency towards what was described at the time as the 'dematerialization' of art.[1] This new 'Conceptual' or 'Idea' art sought to redirect the attention of the artist and the viewer away from the morphology – the material presence – of the aesthetic object and onto the thinking process. The aim was not so much to blur the boundary between the visual and the verbal as to substitute the model of the linguistic sign for that of the image. As the British artist Terry Atkinson noted, in the new art, 'the content of the artist's idea is expressed through the semantic qualities of the written word.'[2]

As we have seen, there were numerous precedents for the displacements of the special, visual, experience into the realm of language: Duchamp's desire to produce art that was anti-retinal and engaged in mental processes, Magritte's lessons in the opacity of language, Johns's substitution of the preformed, conventional codes of letters, numbers, words and pre-existing images for the automatic, spontaneous and informal styles of Abstract Expressionism, Warhol's collapsing of the distinction between words in art and words in the mass media. Such strategies – which might collectively be dubbed 'anti-aesthetic' in intent – come to spiky fruition in the work of the Conceptual artists. For here was something even more rigorously iconoclastic: an art that seemed to be exclusively about language, about information understood as a discursive medium, about *ideas*. This was an art that envisaged the work as an analytic proposition that needed no basis in an aesthetic judgment.

In fact, this 'linguistic' turn in art was paralleled at this time by the growing influence of language-centred theories in the Humanities as a whole. Reacting against the subjectivity and emotionalism of existentialist approaches, the new thinking concentrated on the ways in which structures of consciousness worked, and how they often actually concealed rather than revealed the reality of the world, isolating individuals by partitioning

Moderne Kunst

120 **Sigmar Polke** *Moderne Kunst* (Modern Art) 1968
The heroic visual rhetoric of generic abstraction is mocked by the addition of a label.

119 **John Baldessari** *Tips for Artists* 1967–68
The artist employed a Mexican sign-painter to complete this work, signalling Baldessari's belief in the centrality of concept over execution.

discourse, thought and action. This new focus had the effect of shifting attention away from the author and onto the *system* within which words circulated – language was regarded as existing before any user and capable of generating meanings of which they were unaware. The French Structural anthropologist Claude Lévi-Strauss, for example, focused on the status of language as an ideological construct. Discussing the impact of the invention of writing on culture, he echoed the sentiments of Plato, observing that the conventions of writing always 'facilitate slavery', because they colonize and empower. Apart from any linguistic function writing may have, the simple act of inscription, he argued, hierarchized authority.[3] Consolidating the Marxist critique of writers such as Marcuse concerning the relationship between language and power, the French Marxist philosopher and sociologist Louis Althusser focused on the importance of the superstructures of the ideology carried by language in securing the economic base of the social system. He drew attention to the central role played by the media in integrating individuals into the economic system in order to secure the hegemony of the dominant capitalist class. For Althusser, words were always implicated in acts of social control.[4] The writer-critic Roland Barthes, meanwhile, sought an overarching theory of the sign and, at least in his writings of the 1960s, put the discursiveness of verbal language at the centre of semiotics – the study of signs – by arguing that 'there exists a general category language/speech, which embraces all the systems of signs; since there are no better ones, we shall keep the terms language and speech, even when they are applied to communications whose substance is not verbal'.[5] Again influenced by Marxism, Barthes set about demonstrating the ways in which the messages of the mass media could be subversively 'read' in order to expose how they manipulated signs. For Barthes these contemporary 'myths' were fabricated in order to disguise real social and political conditions and it was necessary therefore for the critic or artist to devise 'second-degree mythologies' as forms of cultural deconstruction and resistance.[6]

The legacy of Wittgenstein was also strongly felt, and brought to the critique of language the tools of analytical philosophy. Drawing on his work, linguistic philosophers such as J. L. Austin set about exposing the ways in which the use of language distances thought from a commonsense view of the world, often creating a metaphysical fog of abstraction. For Austin, as for Wittgenstein, the role of philosophy was to free the mind from the patterns of erroneous belief instilled in us by the words we habitually use.[7]

This was also a period when the understanding of how language works and how human beings learn the skills of literacy was significantly expanded. The linguist and philosopher Noam Chomsky, for example, placed the study of language within the broader context of cognitive psychology and made the creative aspect of the use of language central to his theory. In looking at abstract levels of linguistic structure in order to establish the grounds for the analysis of universal properties, Chomsky revolutionized thinking about language, arguing for the innate ability of humans to learn spoken language. Writing, on the other hand, Chomsky stressed, was clearly a taught skill – a technology – which was to be understood quite differently from speech.[8] Meanwhile, from a very different perspective, scientific

analysis was also increasingly being applied to the understanding of the mechanics of communication. Systems, game and information theories, and the new sciences of cybernetics and computing pioneered by such thinkers as Norbert Wiener and John von Neumann, would use mathematical models to understand modes of message transmission, focusing on abstract concepts rather than on what any particular message might mean.[9]

Such diverse ideas were absorbed by artists who saw them as providing the ammunition for the avant-garde's continued assault on conventional assumptions about art. Indeed, it often seemed as though these disciplines were merely confirming ideas that had already been explored by artists. Profound questioning of notions of self-expression and awareness of the way in which the individual was socially conditioned meant that language now took centre stage. Then – as indeed now – assertions about this leading role often met with hostility. Quite simply, viewers of visual arts were used to tangible objects that could be engaged with, a reflection of the traditional view that asserts art's concern is with seeing, not saying. In the late 1950s and early 1960s heyday of the modernist formalist abstraction advocated by Greenberg and his followers, this seemed particularly axiomatic. So, part of the attraction of using verbal language, noted the American Conceptual artist Joseph Kosuth, was that 'by being so contrary to the art one was seeing at that time it seemed very personal to me.'[10]

But this new, linguistic, idea-art also had the effect of bringing to the surface the dependency of visual art as a whole on the context and ideas provided by words, a dependency that was never more evident than in relation to modernist abstraction itself – as the critic Harold Rosenberg noted in 1969: 'A contemporary painting or sculpture is a species of centaur – half art materials, half words.... The secretion of language in the work interposes a mist of interpretation between it and the eye; out of the quasi-mirage arises the prestige of the work, its power of survival, and its ability to extend its life through aesthetic descendants.'[11] A painting from 1968 by the German artist Sigmar Polke, *Moderne Kunst* (Modern Art) [*120*], playfully exposes this dependency. A domestication of gestural abstraction, it is a witty reminder of the generally suppressed fact that abstract art depends for its meaning on an elaborate gloss of designation, interpretation and contextualization.

An exhibition held at the Museum of Modern Art, New York, in 1970 called simply 'Information' would mark a significant moment of recognition for the new idea art. In her catalogue essay, the curator, Kynaston McShine, summed up several of the goals of the Conceptualists when she noted that they aimed 'to think of concepts that are broader and more cerebral than the expected "product" of the studio'.[12] They sought, she said, to challenge preconceptions about the role and content of art by using language to make links to broader questions of how communication happens and information is relayed. Acknowledging the disparate nature of the new art, McShine nevertheless listed a number of shared points of reference: 'an intellectual climate that embraces Marcel Duchamp, Ad Reinhardt, Buckminster Fuller, Marshall McLuhan, the *I Ching*, the Beatles, Claude Lévi-Strauss, John Cage, Yves Klein, Herbert Marcuse, Ludwig Wittgenstein, and theories of information and leisure.'[13] Echoing the observations of Fluxus artist Dick

Higgins concerning 'intermedia' art, McShine argued that: 'With the sense of mobility and change that pervades their time...[artists] are interested in ways of rapidly exchanging ideas, rather than embalming the idea in an "object".[14] The evidence of 'Information', and of other exhibitions dedicated to the new art, demonstrated very clearly that artists were now seeking to minimize their dependence on the object or action. The American artist Sol LeWitt, who participated in the show, noted (in terms consciously echoing Duchamp) that the conception of the artwork was to be seen in opposition to perception: 'Conceptual art is made to engage the mind of the viewer rather than the eye or emotion. The physicality of a three-dimensional object then becomes a contradiction to its non-emotive intent.'[15]

It was also the intention of the Conceptual artists to seek out new constituencies for art, to make it more accessible, and to appeal to those who had found the reductive forms of modernism incomprehensible. So the incorporation of words could also be the means of rendering the artwork 'legible' in the most obvious sense. The American artist John Baldessari, for example, noted that his decision to use texts and photographs was motivated by the example of Pop art. He resolved 'to give people what they want', though he added that, in the event, 'they probably don't want this either.'[16] Baldessari's goal in the series of works of which *Tips for Artists* [*119*] from 1967–68 is part was, he said, to take language out of its original context and thereby invest it with a new and provocative meaning that would force the viewer/reader to ask fresh and awkward questions.[17] And, as in most Pop art, the text chosen by Baldessari is not one that originated in the thoughts or beliefs of the artist himself. On the contrary, it was taken from a popular book of the 'How To Paint' variety, and though it might be clearly legible, the content was intended to be ironic – a comment on the kind of kitsch art that modernism had sought to oppose, and on the relationship of radical art to other kinds of artistic practice.

But in an important act of distinction from Pop, Baldessari employed a Los Angeles-based Mexican sign-painter to do the lettering and he was instructed to use the same style for the whole series of paintings, keeping it simple, straightforward and without embellishment. This decision to delegate the painting of the work to someone else reveals the centrality of the idea for Baldessari. Likewise, another American, Lawrence Weiner, declared in a now classic Conceptualist statement:

1. The artist may construct the piece
2. The piece may be fabricated
3. The piece need not be built[18]

The text goes on to assert that a new relationship between work and viewer was envisaged: 'Each being equal and consistent with the intent of the artist the decision as to condition rests with the receiver upon the occasion of receivership.'[19] As this statement suggests, a key motive behind Weiner's work was the desire to renegotiate the nature of the transaction between the work and the audience – or 'receiver' in Weiner's terminology. As the namer of things, carrier of information and mode of public address, written language could therefore be used to direct viewers towards becoming more than the

EARTH TO EARTH ASHES TO ASHES DUST TO DUST

contemplators of an aesthetic object – the model of reception within the modernist paradigm. Instead they were to become active *readers* and involved participants in the generation of the work. Weiner's wall paintings, like Baldessari's works, place the idea at the heart of artistic practice. In *Earth to Earth Ashes to Ashes Dust to Dust* (1970), for example, Weiner took the text of the Christian burial rite and by decontextualizing a familiar phrase he leads the viewer/reader towards a meditation on basic materials and processes. Such works were premised on the belief that by using verbal language he was leaving his work 'more open for the user…. It lets consumers immediately transform it into something they can use in their lives'.[20] Of the language he habitually uses, Weiner observed: 'Every artist's work has a title. Titles are my work'.[21] But he also stressed that the words comprising his work existed independently of any concrete realization in the form of a wall inscription, so although the illustration shows the work as it was materialized at the Guggenheim Museum, the activity of painting was delegated to a technician, and the work's essence is actually an immaterial verbal form, infinitely multipliable and impossible to commodify. In this sense, Weiner's medium can be said to be the immateriality of words; furthermore, as he observed, 'the introduction of language as sculptural material has had the effect of incorporating a larger audience into the same questions and the same world as photography did'.[22]

So, while the new kind of artistic engagement could still take on physical form, the minimum of visual display and physical engagement by the artist signalled the centrality of mental processes. This kind of reductiveness also characterized the work of the New York-based Japanese artist Arakawa, although in his case the actual making of the art remained in his own hands. Arakawa, working with the writer Madeleine Gins, treated the rectangle of a painting not as a surface within which to either open up three-dimensional space or investigate pictorial flatness, but instead, in true 'flat-bed' fashion, as a kind of bulletin board on which experiments into the nature of what the artist called the 'mechanism of meaning' can be carried out.[23]

121 **Lawrence Weiner** *Earth to Earth Ashes to Ashes Dust to Dust* 1970
'Every artist's work has a title', Weiner observed. 'Titles are my work'.

122 **Arakawa and Madeleine Gins** Panel 3 from *The Mechanism of Meaning*, 'Meaning of Intelligence' 1969
The 'mechanisms of meaning' investigated in works that engage the viewer/reader in philosophical game playing.

123 **On Kawara** *May 19, 1991* 1991
In this ongoing series begun in 1966, the date on which the painting was painted becomes its subject. It is also twinned with a copy of the particular day's newspaper.

Visually, Arakawa's sober stencilled letters and symmetrical compositions bring to mind the conventions of industrial signage or the science classroom and textbook, but his instructions and labels are deliberately bizarre and seemingly nonsensical, designed to provoke unconventional thought processes about the signifying process itself. The relationship between the work and the viewer has been remodelled so that the latter is now invited to respond to a series of propositions or tasks similar in kind to the language games proposed by Wittgenstein.[24]

A number of artists also investigated the possibilities of working according to preordained, linguistically bound sequences or series. The serial form held out the possibility of a finite, ordering classification system within an art world – indeed within a society – that seemed to many to be increasingly structure*less*. For, where once the rules of art had been imposed from outside by religious, economic or social fiat, now artists themselves were obliged to create intellectual and practical boundaries. Another Japanese expatriate based in New York, On Kawara, founded his practice on a number of language-based activities all of which have at their core the desire to structure time. The most celebrated of his serial works are the ongoing *Date Paintings* initiated in 1966. Here, although Kawara persisted in the use of the traditional format and media, painting is purged in rigorously reductive fashion of everything but the neatly typographic inscription of the date on which the work was made. The hand-painted but unadorned sans serif letterform preferred by Kawara is transcribed in the language of the country in which Kawara resided at the time – except in Japan where he uses Esperanto. Additional context is provided by the twinning of each work with a newspaper of the same place and date, a device that roots the painting in the wider context of the public world. Kawara's work might appear to be the antithesis of the calligraphic tradition of his native Japan, but it nevertheless shares the preoccupation with the temporal dimension of inscription.

For Kawara, however, time is recorded not through the frozen trace of a bodily gesture but rather via the artist's painstaking process of inscription, a process which he has decreed must be completed within the twenty-four hours of the day recorded.

But in order to make art's hidden assumptions explicit, some Conceptualists were determined to break completely with such traditional media as painting as well as with conventional ideas about art. In seeking to avoid the rhetoric of both expressionism and formalism, artists investigated the anonymity and neutral integrity offered by the techniques, content and structure of the prosaic and instrumental language used in the technological and managerial domains. The components of this non-aesthetic style were typically those which had been made readily available by technical developments in the printing and graphic design industries. Visually, this new anti-aesthetic work was deliberately anonymous, using unassuming letterforms, non-expressive surfaces, black-and-white photography, photostats and grid-like layouts. The texts themselves were founded on banal and functional methodologies, and took the form of the index, the catalogue, the dictionary definition, the philosophical proposition, the list and other such serial structures. The activity of art was turned back on itself in order to use the exhibition space to ask questions about the essence of art and the nature of communication.

Certainly, this was the position taken by Joseph Kosuth who declared: 'Art is itself philosophy made concrete', and explained that his goal was the substitution of the linguistic for the morphological – of words for things, the discursive for the apparently transparent meanings of the image.[25] In *Titled (Art as Idea as Idea (Idea))*, a work from 1967, for example, Kosuth simply presents the viewer with a dictionary definition of the word 'idea' photostatted and mounted on board. He thereby substitutes a discursive definition of the object for its image, arguing that the linguistic nature of his work transforms the seen into the said, turning the viewer into a reader.

1. *Idea*, adopted from L, itself borrowed from Gr *idea* (ἰδέα), a concept, derives from Gr *idein* (s *id-*), to see, for **widein*. L *idea* has derivative LL adj *ideālis*, archetypal, ideal, whence EF-F *idéal* and E *ideal*, whence resp F *idéalisme* and E *idealism*, also resp *idéaliste* and *idealist*, and, further, *idéaliser* and *idealize*. L *idea* becomes MF-F *idée*, with cpd *idée fixe*, a fixed idea, adopted by E Francophiles; it also has ML derivative **ideāre*, pp **ideātus*, whence the Phil n *ideātum*, a thing that, in the fact, answers to the idea of it, whence 'to *ideate*', to form in, or as an, idea.

124 **Joseph Kosuth** *Titled (Art as Idea as Idea (Idea))* 1967 'Changing the idea of art itself' – an enlarged and colour-reversed copy of a dictionary definition becomes a work of art.

125 **Art & Language** *Secret Painting (Ghost)* 1968
According to a member of the Art & Language group, the new task
for art was to occupy 'the space of beholding with questions and
paraphrases', and to 'supplant "experience" with a reading'.

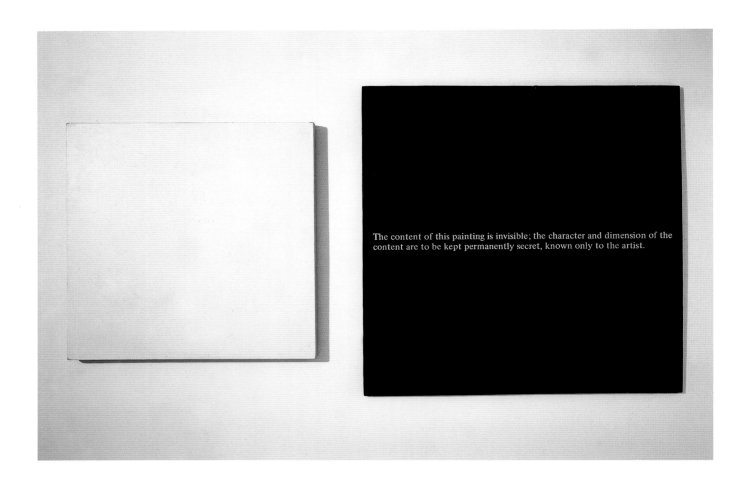

The content of this painting is invisible; the character and dimension of the
content are to be kept permanently secret, known only to the artist.

Kosuth wanted to minimize aesthetic considerations because he believed that aesthetics and questions of taste were not intrinsic to art. Acknowledging the art of Marcel Duchamp as a clear precedent, he also cited the philosophy of Wittgenstein and more recent linguistic philosophers such as Austin as important models for this way of thinking. From these latter sources Kosuth learnt to address language as an interrelationship of meanings conditioned by usage and context, and he sought ways in which to question these semantic and lexical conventions, thereby opening language up to critical analysis. But in addition to such philosophical models Kosuth also emphasized the influence of American abstract artist Ad Reinhardt, an artist not obviously concerned with such linguistic issues. According to Kosuth, Reinhardt had shown a way of pursuing the essence of art through a series of negations, and had reduced the definition of art to the tautological proposition that Kosuth used as the subtitle of many of his works in the 1960s: Art as Idea as Idea. Kosuth explained: "'Art as Idea *as Idea*' – [was] intended to suggest that the real creative process, and the radical shift, was in changing the idea of art itself. In other words, my idea of doing that was the real creative context. And the value and meaning of individual works was contingent on that larger meaning, because without that larger meaning art was reduced to decorative, formalist stuff.'[26]

The same shift towards analytical, conceptual approaches to art practice was soon seen in Britain. Terry Atkinson, David Bainbridge, Michael Baldwin and Harold Hurrel banished the notion of individual authorship in 1968 by becoming the collective group Art & Language and jointly edited the magazine *Art-Language*, of which Kosuth was for a time co-editor. (They were joined in 1971 by the New York-based artists Ian Burn and Mel Ramsden.) Like Kosuth, Art & Language asserted that because ideas were the real material of art, language was the most suitable means of interrogating hidden assumptions and ideologies lurking beneath the apparently purely visual surfaces of art. In the 1968 work *Secret Painting (Ghost)*, for example, a white canvas has been placed next to a black photostat similar to those used by Kosuth, but the statement supplies a more complex kind of naming – that of the status of the adjacent 'painting' as linguistically nominated by the producer. The dependency of the reductive style of modernist painting on a verbal content noted by Rosenberg and Polke is graphically exposed. But it was the *processes* behind the production of meaning that interested Art & Language rather than any physical result. Indeed, the physical form was only to be seen as an ad hoc materialization of what was actually a discursive and ongoing 'conversation' about art, and Art & Language's practice deliberately took a multitude of forms. As Charles Harrison, an art historian, critic and key contributor to *Art-Language*, later wrote: 'The substantial aim was not simply to displace paintings and sculptures with texts of "proceedings", but rather to occupy the space of beholding with questions and paraphrases, to supplant "experience" with a reading, and in that reading to reflect back the very tendencies and mechanisms by means of which experience is dignified as artistic.'[27]

A pledge like this to the anti-aesthetic and conceptual approach could also be motivated by the desire to use art to overtly political ends. In this context, the serial method and anti-aesthetic presentation was useful as a means of

126 **Hans Haacke** *Mobilization* 1975
A multinational corporation becomes the subject matter for a series of
works criticizing its involvement in the art world.

conveying information about the sad state of the contemporary world.
Indeed, for many, the refusal to produce aesthetic objects and to focus
instead on language as a medium, was not predominantly intended to alter
the relationship between maker and viewer, nor to question the
philosophical status of art or avoid the production of a commodity. For some,
'art' in the traditional sense could seem an unjustifiable luxury on political
grounds. There was plenty to protest against during the late 1960s and early
1970s – the threat of nuclear holocaust, the seemingly endless war in
Vietnam, the growing rift between the world-picture of the old and that of the
young, an increasingly impersonal and indifferent materialistic society
saturated with commercially motivated signs. 'Although we cannot currently
affect the publicity messages emitted,' wrote the British artist Victor Burgin,
'we may subvert the messages received'. Looking back to models of the early
Soviet avant-garde, and drawing on a conceptual framework made up of
Marxism, Situationist ideas of *détournement* and Roland Barthes's critique of
modern 'myths', the role of art was understood by Burgin to be intimately
tied up with revolutionary politics: 'A task for socialist art', announced
Burgin, 'is to unmask the mystifications of bourgeois society by laying bare
its codes, by exposing the devices through which it constructs its self-image.
Another job for socialist art is to expose the contradictions in our class
society, to show up what double-think there is in our second-nature.'[28]

In order to oppose what was perceived as a crisis situation, some artists
therefore sought to use the forum set aside for art-viewing as a site for
various kinds of institutional and social critique. And in exposing these
pernicious forces they found it useful to borrow the very techniques and
protocols of the domain of institutional record-keeping and of the mass
media in order to use them against their masters. Burgin for example,
appropriated the look of advertisements in order to moralize on the
inequality and oppression lying behind their rhetoric. In a similar vein, the
New York-based German artist Hans Haacke addressed the hidden
connections between art and power. Behind his activities lay the assertion
that the roots of all artistic judgments in the conventions of language meant
that art was fundamentally inscribed with ideological and economic power
interests. For one exhibition Haacke showed a series of photographs and
texts documenting the roots of the New York elite's wealth in the exploitation
of slum housing.[29] In *Mobilization* (1975) he expanded his target to focus on
a multinational corporation, like Burgin mimicking the visual appearance of
the conventional advertisement and promotional document in order to attack
the power of the oil industry and the controlling hold of 'big money' over
contemporary art.

In *The Bowery in Two Inadequate Descriptive Systems* [*128*] from 1974–75,
the American artist Martha Rosler also adopted the anti-aesthetic neutrality
of the serial approach and documentary format, but her critique dealt not so
much with political exploitation as with the failure of both official and
unofficial representational codes to provide an effective map of the realities
of inner-city deprivation. By juxtaposing deadpan documentary photographs
of the Bowery – a particularly run-down area of Lower Manhattan – with a
gamut of typewritten colloquial terms used to describe the conditions of the
bums that habituated the area – 'the worse for liquor, top heavy, moon-eyed,

127 **Victor Burgin** *A Promise of Tradition* 1986
The techniques of advertising used in order to critique the economic
system it serves.

PRIVATE

A PROMISE OF TRADITION
You mustn't be too hard on them.
So many things to cope with. So much to do.
They keep rabbits. They keep house.
They keep up appearances.
If they fail to keep their word
you must excuse them. They're good people.
Almost all of them. They may not see you.
They may not hear you. They may not want to.
It's not their fault. They mean well.
They have promised to try again.

the worse for liquor

top heavy moon-eyed owl-eyed

pie-eyed shit-faced

snockered

shicker

featured

fortified

piffed pifflicated spifflicated

obfuscated pixilated

inebriated

hard drinker
funnel
drinkitite
emperor
bingo boy, bingo mort
dipsomaniac

boozehound juicehound

rumhound gas hound

jakehound boiled owl

whale

owl-eyed, pie-eyed, shit-faced, snookered, shicker' – Rosler exposed the vast chasm dividing the language of the official record from the reality of lived experience, and its private, colloquial modes of communication.

With language now central to such artistic practices, many of the Conceptual artists published their own written texts as an intrinsic part of their work, and used journals as spaces within which to realize projects. The catalogue of 'Information', for example, did not contain reproductions of the works in the exhibition or essays by art historians or critics, but rather was used as a showcase for projects realized specifically for that published format. The concept of the 'artist's book' was transformed as the format of the book became a context within which to expand public access and confuse categories. The books of Ed Ruscha proved particularly influential, setting a precedent for similar confusions of medium and content. As artists adopted photo-offset printing, Xeroxes, electronic typewriters and Letraset, the range and accessibility of both text and image reproduction greatly expanded. Kawara, for example, produced a set of books entitled *One Million Years* (1970–71) within which the million years from the date of making were listed on typewritten and Xeroxed sheets. Other works concentrated on language itself as raw material, with words rearranged and substituted, and page layout and typography explored in ways that look back to the work of Mallarmé. In one particularly influential book work, the English artist Tom Phillips developed his own version of the cut-up techniques pioneered by the Dadaists and William Burroughs, and blanking out the text of an obscure Victorian novel he had found in a junk shop called *A Human Document*, rechristened it *A Humument*. 'When I started work on the book late in 1966, I merely scored out unwanted words with pen and ink', Phillips noted. 'It was not long though before the possibility became apparent of making a better unity of word and image, intertwined as in a medieval miniature.'[30] But, more broadly, the new linguistically centred activities also meant that any verbal context could become a potential work of art. As the artist-editors of *Art-Language* asked rhetorically in their first issue: 'Suppose the following hypothesis is advanced: that this editorial, in itself an attempt to evince some outlines as to what "conceptual art" is, is held out as a "conceptual art" work.'[31] This was not simply a hypothetical possibility, and a number of artists now created works specifically for the magazine and newspaper.[32]

In the use of the textbook, the dictionary, the information board and the index as models of organization, this kind of art speaks of the desire to purge practice not only of its aesthetic, visual qualities, but also of any aspirations towards subjective expressiveness or any possibility of transcendence of the vernacular world. The gain of these strategies, as far as the artists using them were concerned, was a new level of demystification and pragmatism, and a realism that could lead to a less subservient and commodified artistic practice. Accusations of complicity could be rebuffed by remaining in a critical relationship to the status quo while simultaneously empowering the viewer. In this new idea-heavy art, language speaks plainly and unambiguously – if often rather didactically – in order to achieve both Duchamp's goal of putting art back in the service of the mind, and the Russian Constructivists' ideal of putting art at the service of politics.

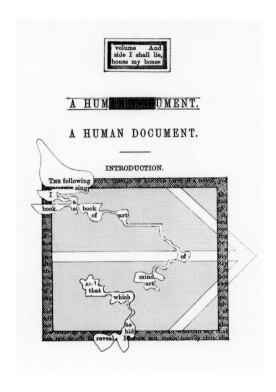

129 **Tom Phillips** Page from *A Humument* 1967
A Victorian book is the host for a *détournement* in which word and image are, as the artist put it, 'intertwined as in a medieval miniature'.

128 **Martha Rosler** *The Bowery in Two Inadequate Descriptive Systems* 1974–75
Part of a serial work in which the photographic document comes into awkward contact with the argot of the street.

14

A Heap of Language: Conceptual Words II

'La société nouvelle doit être fondée sur l'absence de tout égoisme. Notre chemin deviendra une longue marche de fraternité' – 'The new society must be founded on a complete lack of selfishness. Our path will become a long march of fraternity'.[1] So declared a piece of Situationist-inspired graffiti written on a wall in Paris during the so-called 'events' of May 1968, as the tensions of the decade came to a head. Here was a new kind of direct action that seemed to make the political efforts of artists look rather academic and ineffectual. Situationist principles were briefly put to dazzling effect as rebellious students used the walls of the city as a vast surface on which to bill-stick posters, and as student confronted policeman across the barricades, the city's art galleries closed their doors. Paris at last became a place where words refused to work solely 'on behalf of the dominant organization of life'. Or so it seemed at the time.

There was no revolution, of course. But this spirit of radicalism continued to suffuse much of the art and philosophy of the late 1960s and early 1970s, impacting directly on the way in which language was understood. 'Language is legislation, speech is its code', wrote Roland Barthes in an extreme formulation in 1970. 'To utter a discourse is not, as is too often repeated, to communicate; it is to subjugate.... Language – the performance of a language system – is neither reactionary nor progressive, it is quite simply fascist'.[2] In a similar vein, the French philosopher Jacques Derrida discussed how the structure of language should be understood as a self-contained and socially constructed entity, with the self having no real existence prior to the language he or she uses. But Derrida sought to go beyond the rationalism of Structuralism in order to incorporate more fully the indeterminacy that he regarded as central to all sign systems. Drawing on Saussure, he argued that meaning resided only in relation to other meanings, or as a set of what he called *différances* (deferrals) between words. While Structuralism had attended to the linguistic sign over anything to which that sign might conventionally claim to be referring, Derrida went further and argued that writing should be privileged over speech because in the activity of writing it is more evident that language is about the absence of the self and the referent rather than their presence. Language, Derrida declared, was made up not of signs but rather of free-floating signifiers that refer to each other in an infinite, equivocal and indeterminate play of meanings. 'There is nothing outside of the text', Derrida announced.[3] He focused on what he called the 'trace' – that which comes before language and is fundamentally unnameable. 'There are only, everywhere, differences and traces of traces',[4] he declared, and went on to advocate what he described as writing and reading 'without the line', that is, outside the linear, dualistic, ordering structure of language, beyond what he called 'logocentrism'.[5]

131 **Atelier Populaire** *La Lutte Continue* (The Struggle Continues) 1968
A Situationist-inspired poster from Paris.

130 **Joseph Beuys** *Art=Capital* 1980
A blackboard as the site for a lesson in creative thinking.

Meanwhile, the French historian Michel Foucault would sketch a genealogy for the relationship between successive representational systems – *epistemes* as he called them – in which different and incompatible articulations of signifier and signified concealed and determined consciousness. The present *episteme*, Foucault argued, was to be understood as that in which word and world no longer convincingly coincided, causing the fundamental crisis of the sign that marks modern culture.[6] Extending Freudian concepts, the French psychoanalyst Jacques Lacan drew on Saussurian semiotics and Structuralism and, while he placed the linguistic at the centre of his theory, he regarded this unity as always under threat of disintegration. Arguing that human consciousness was structured like a language, he said that notions of language and sexuality were acquired simultaneously. Indeed children, Lacan declared, only achieved a sense of subjective selfhood when they entered into the 'symbolic' order of language and this was at the price of suppressing the experience of what he called the 'Real' and the 'imaginary' – the sources of desire that are always subverting the narratives the self tells in order to constitute a sense of unity. In short, like Derrida and Foucault, Lacan averred that there was no stable self beyond the differentiating structure of language, and it was the role of psychoanalysis to trace the form of this volatile reality.[7]

Such ideas consciously drew on precedents in the visual and verbal arts of the late nineteenth and twentieth centuries. The French philosopher Jean-François Lyotard, for example, discussed Mallarmé's poem 'Un Coup de dés' [*28*] in relation to what he called the 'discursive' and the 'figural' in language, and noted that the attention paid by Mallarmé to typographical layout was intended to add a plastic dimension to the text, thereby exposing language to the gestural experience of the body in space. The poem was, Lyotard said, an example of how the 'figural' can work on language, undermining its unity and liberating meaning from the straitjacket of linear thinking. Like Derrida, Lyotard argued for the importance of what lies outside the intelligible world established by the regulated space of the text. In this other, rhythmic, corporeal space – in what was essentially a visual space – he saw desire challenging the order of discourse.[8]

As a loosely coherent body of radical thought, such Post-Structuralist ideas constituted a fundamental critique of and challenge to the dominance of conventional ideas about the relationship between language and consciousness. This was a critique that was anticipated, but also seized upon and extended, by the artistic avant-garde. The German artist Joseph Beuys, for example, was typical of the general conceptual turn in the art of the 1960s in understanding the medium of sculpture to be the activity of thinking itself, but he was unwilling to apportion the linguistic such a major share of his artistic practice. Beuys saw art as an ongoing and open-ended spiritual process that could be materialized equally in words, things, images or actions. Information as such was not to be understood solely in linguistic terms but was, as Beuys noted in 1971, 'everything the world contains: men, animals, history, plants, stories, time, etc.' He went on: 'In order to communicate, men use language, gestures, or writing. He makes a sign on the wall, or takes a typewriter and turns out letters. In short, he uses means.'[9] Beuys developed a number of inter-medial activities involving a vast range of

materials, many centring on his own shaman-like presence, and these were designed as healing activities for what he saw as a deeply wounded human consciousness, trapped in the binary thinking established by the dominance of language over consciousness. Furthermore, he avoided the cool, technological forms of the institutional world that were preferred by British and American Conceptualists in favour of the battered, peeling and unappetizing appearances of the worn, discarded and memory-laden. In his performances, words, both spoken and written, often played an important role, being the media through which he could make his thought concrete. But he also sought to challenge the conventional scope of language, upsetting and confusing meanings and usage, and forcing words into new alignments. Mostly done by hand in a dynamic and sometimes barely legible script, Beuys's favoured medium was chalk on blackboard [130] – the metaphor of painting as blackboard explored by such artists as Magritte and Twombly now became quite literal – and in these hastily scribbled but impassioned demonstrations Beuys parodied the protocols of the classroom and the scholarly status of the pedant. The blackboard was also useful as a surface from which writing could be fully or partially wiped thus serving as a practical and receptive repository for the accumulation of the artist's freewheeling, scatological thought. The results, in effect, freeze and capture the signs of Beuys's dynamic presence as he sought to unravel for his audiences the intricacies of his mental processes.

In Italy, the artists associated with Arte Povera shared with British and American Conceptualism the desire to use non-artistic materials, but like Beuys they looked beyond the domains of the managerial and technological and towards instead the organic and idiosyncratic in order to imbue their work with poetic and indeterminate meanings. Words played their part, but rarely as vehicles for analytical ideas or in the neutral typographies favoured by the British and American Conceptualists. Indeed, as in Beuys's work, words were largely considered as only one kind of sign – a potentially limiting one – within a broad repertoire embracing a plethora of media and ways of thinking that centred on notions of indeterminacy and openness of interpretation. Mario Merz's *Igloo di Giap* (1968), for example, combines sandbags and neon strips and defies easy categorization while emancipating the word from its customary attachment to flat surfaces and spatially static formats. The text, which in English translation reads: 'If the enemy masses his forces he loses ground. If he scatters he loses strength', is a quotation from a North Vietnamese general, and the work refers to the ongoing conflict in Vietnam, which by 1968 had reached new levels of ferocity. But Merz's intentions cannot be construed as directly propagandist. The neon maxim – which also has the air of some timeless and wise oriental saying – is ambiguously twinned with the unusual materials to create a visual–verbal hybrid that conjures up forms of personal mythology to set against the familiar ones of the mass media.

The possibilities of neon tubing were also explored by another Italian artist, Maurizio Nannucci. Neon allows for a kind of writing that can confuse the distinctions between seeing and reading by countering the static and mundane presentation of text, and provides the material support for a seemingly immaterial writing that can give the appearance of being erased

132 **Mario Merz** *Igloo di Giap (Se il nemico si concentra perde terreno, se si disperde perde forza)* 1968
'If the enemy masses his forces he loses ground. If he scatters he loses strength'. The words of a North Vietnamese general are written in neon and attached to sandbags.

133 **Maurizio Nannucci** *Phoenetic Alphabet* 1967–68
The alphabet as pronounced in Italian displayed in luminous neon.

and rewritten. Nannucci's *Phoenetic Alphabet* (1967–68), for example, exposes the gap between written text and the spoken word and the role of the alphabet as the visualization of speech. The line of neon script seeks to simulate the sounds of letters as they would be pronounced in Italian, but the means used are so stridently visual that this intention seems thwarted. Through timed sequencing neon can also introduce a temporal dimension into the usually static forms of writing, and through its ostentatious chromatics and luminous visuality generate a powerful awareness of ambient space. Like the stencil, neon has its roots in the public, instrumental world, and so its artistic use also pulls works such as Nannucci's into the orbit of popular culture. But unlike the stencil, neon makes a direct appeal to the senses as well as communicating information.

Another artist associated with Arte Povera, Alighiero Boetti, made language a central aspect of his work, but sought to free it from its instrumental and prosaic role as a medium of communication. In search of alternative ways of thinking, Boetti travelled widely spending long periods of time in Afghanistan, and was especially influenced by the teachings of Islamic Sufism, which provided him with philosophical and theological grounds for the attack on the binary nature of Western thinking that was also being undertaken in the philosophy of Derrida and Lyotard. Drawing on mystical and religious ideas, Boetti saw the logical structures of language as

central to the dualism that imprisoned the Western mind, and he engaged in a variety of activities to undermine such polarities and to decentre the concept of the self. The goal was to open the viewer up to the power of non-sense through simple and apparently meaningless gestures: in a work from 1971–72, for example, Boetti simply rearranged the letters of his name in alphabetical order: *ABEEGHIIILOORTT*. He also employed unorthodox materials and saw collaboration with craftspeople and others as an intrinsic part of his expanded conception of practice. Working with Afghan tapestry-makers, for example, Boetti had them embroider works according to his specification, including a series in which words such as *ordine e disordine* (order and disorder) were paired and then organized into squares of sixteen letters, four by four. Reprising the fascination of such poets as Rimbaud and Mallarmé with the alphabet as a collection of plastic forms with their own intrinsic metaphoric resonance, Boetti noted playfully: 'A is a beautiful letter, architectural and masculine. B feminine roundness on a spinal cord. C the palate in X-rays. D a sail. E is not a letter, but a conjunction. F the sacrifice that E accepts to become a letter. G is a Masonic letter. H a bridge. J is a Jack.

134 **Alighiero Boetti** *Ordine e disordine* (Order and Disorder) 1974
Afghan weavers produced many works for Boetti including this one, part of a group that generates a design out of the phrase 'order and disorder'.

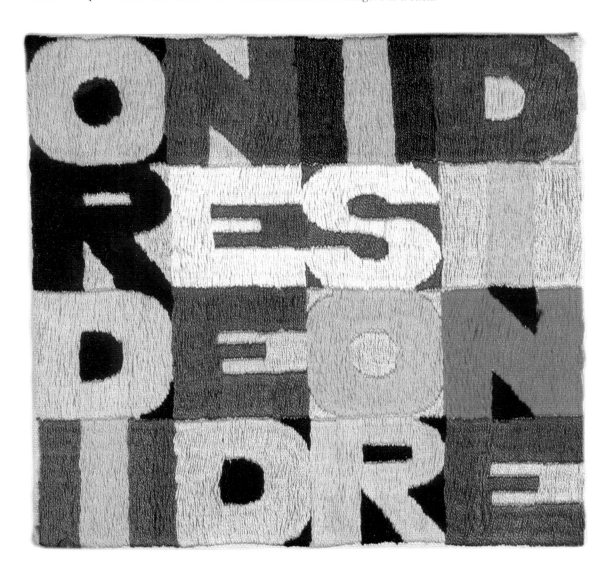

135 **Richard Long** *A Line in the Himalayas* 1975
Text as descriptive title. One of the artist's walks and
interventions recorded.

A LINE IN THE HIMALAYAS
1975

KLM an airline company. MN are a couple. O the mouth that pronounces it.
P is a flag. Q is double in the word *soqquando*. R is a letter that walks. S
spires and T the top. U.V.W.X and Y rush towards Z.'[10]

This desire to expand conventional notions of language and its
relationship to other less easily coded experiences also underpins the work
of the English artists Richard Long and the Scot Hamish Fulton. Long's
practice centred on the walks he undertook into often inhospitable parts of
the natural world, inserting his presence into the landscape through the
construction of basic markers using local materials. These traces were then
photographically documented, and the images twinned with deadpan
descriptive captions. As with much Anglo–American Conceptual art,
photograph and printed text were presented in the neutral format of the
institutional or museological document, highlighting for the viewer/reader
the inadequacy of these formats as descriptive systems. However, whereas
this device was used by, say, Rosler for social analysis, Long uses it to convey
the awesome, boundary-breaking experience of the artist's immersion in the
vastness of nature. Here, once again, art becomes a means of reconnecting
with more primal, atavistic dimensions. Fulton also grounded his work in
the experience of long walks, recording the event through text and
photograph. But unlike Long, his texts often have a more visually assertive
appearance and are more directly poetic in effect. Language is used as an
elusive verbal evocation of Fulton's experience of nature while at the same
time triggering the imagination of the viewer/reader. Indeed, while text often
replaced image altogether in his work, attention to typography, spacing,
layout, scale and colour clearly demonstrate the artist's interest in the visual
status of written language.

This status was something that also preoccupied the American Robert
Smithson who, like Long and Fulton, was part of the tendency known as
'Environment' or 'Land' art. While Smithson placed language at the centre of
his practice, he also resisted its use as a simple vehicle for ideas, instead

136 **Hamish Fulton** *The Pilgrim's Way* 1971
Photograph and text – different codes for communicating
information.

The Pilgrims' Way
1971

A HOLLOW LANE ON THE NORTH DOWNS – ANCIENT PATHS FORMING A ROUTE BETWEEN WINCHESTER AND CANTERBURY TEN DAYS IN APRIL – A 165 MILE WALK

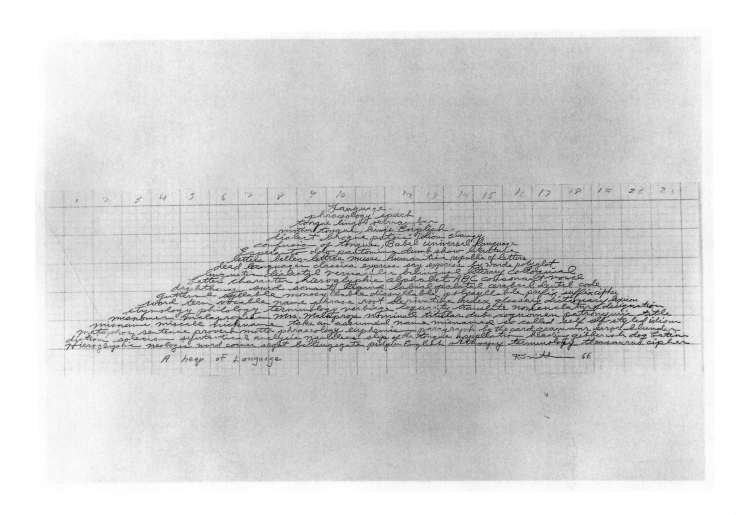

drawing attention to the contradictions inherent in the word as both signifier and signified, meaning and thing. He noted: 'look at any *word* long enough and you will see it open up into a series of faults, into a terrain of particles each containing its own void.'[11] For Smithson, any attempt to use written language as a transparent vessel for communication was always bound to be undermined by the fissures within its physical structures. Discussing his activities as both a writer and artist he observed: 'I thought of writing more as material to sort of put together than as a kind of analytic searchlight... I would construct articles in the way I would construct a work.' As if to put theory into practice, in 1966 Smithson made a drawing in which hand-scripted synonyms for language are piled up randomly into a triangle. The result is called simply *A Heap of Language*.[12]

As Smithson's work suggests, the sponsors of the view that art should aspire to be dematerialized – in the service of the mind – inevitably found that sooner or later the *written* word betrayed their cause. Thus, the American Conceptualist Mel Bochner [2] conceded: 'outside the spoken word, no thought can exist without a sustaining support';[13] any art set in the direction of ideas was likely to find the sensual forms of the written word obstructing the pure experience of the idea.[14] Indeed, as the 1970s unfolded, the assumption that a hard-and-fast distinction between the word and the image could be made based on the categories of mental and sensual data looked increasingly spurious to many artists. John Baldessari, seeking to account for his and other artists' move in the mid-1970s away from a purely textual art, noted in an interview in which he discussed this new work: 'I think what I am positing...is that a lot of our work comes out of that inability to prioritize...is an image more important or is a word more important than an image? They seem to be interchangeable for me with a lot of my work because a word almost instantly becomes an image for me, and an image almost instantly becomes a word for me – it's that constant shifting I think that animates my activity.'[15]

In this context, the legacy of Concrete Poetry proved especially significant. Joseph Kosuth had been quick to deny any relationship with his species of word-based art, but in the work of the Scottish poet and artist Ian Hamilton Finlay the ideas of Concrete Poetry are explicitly developed and augmented. Like the Dadaist Raoul Hausmann, Finlay became fascinated by the tradition of *Emblemata* in medieval and Renaissance culture, seeing in these visual–verbal hybrids just the kinds of instances of an intimate inter-medial collaboration between the linguistic and the visual that generated levels of meaning inaccessible to each alone. Drawing on such models, any desire to give dominance to either the visual or the verbal ceded from the mid-1960s onwards to the development of a range of procedures intended to keep the activities of seeing and reading thoroughly mixed up. The resulting oeuvre is neither poetry nor visual art, but rather a fusion of the two. 'No ideas but *in* things – Imagism', declared Finlay, referring to the kind of poetic strategies advocated by Ezra Pound earlier in the century: 'No ideas but as things – Concrete Poetry'.[16] This was to be a new kind of verbal language that, by attenuating the customary bond of the alphabet to speech, carried the written into the realm of spatial, somatic, experience. In the same statement Finlay announced: 'Concrete Poetry is less a visual than a silent poetry',[17]

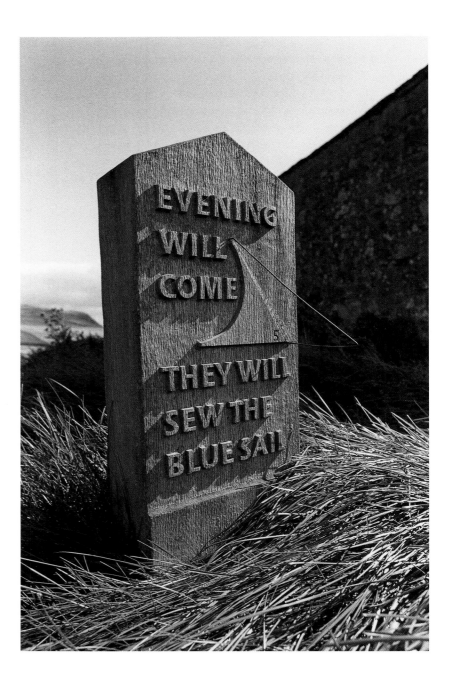

a declaration that drew attention to the fact that the real purpose of his work
was to bring to words not so much the materiality characteristic of visual art,
but the particular muteness that is normal for images. Nevertheless, he also
attended to the roles of works as carriers of linguistic meaning and in
seeking to set up confrontations between past and present, Finlay's work
often brings classical ideas and history into awkward confrontation with the
realities of modern times. A work from 1971, *Westward-facing Sundial*, finds
Finlay in lyrical mode. Made in collaboration with the carver, John R.
Thorpe,[18] and sited in the garden of Little Sparta – the farmhouse deep in the
hills of Lanarkshire where Finlay lives – an evocative poem composed by
Finlay set in low relief and in plain sans serif capitals conjures up a

melancholy and distant land. In addition, because the work faces west, it can only function as a sundial in the evening, thereby also alluding to the enigmatic meaning of the words. Though in an entirely different form and register, Finlay's reference to the Classical world can be seen to parallel the work of Cy Twombly. But rather than applying the deliberate artlessness of the 'demotic' style, Finlay – who relies on traditional craft skills – consistently opts for finely cut lettering in the classical mode. He is Apollo to Twombly's Dionysus.

An ambiguous relationship between art and poetry was also maintained by the Belgian poet turned artist Marcel Broodthaers, but in a rather different context. Broodthaers gave up writing conventional verse in 1964 in order to make works that, like Finlay's, refuse to recognize easy distinctions between visual and verbal media. An early work of 1963 entitled *Pense-Bête* (Think–Stupid/Animal) involved sinking his last volume of poetry into plaster, and from that point onwards his art was concerned with the activity of viewing/reading. 'With the transition towards the visual arts I wanted to turn my back on poetry', Broodthaers declared. 'Symbolically I wanted to free poetry from its ivory tower and therefore I threw it into wet plaster to make a kind of sculpture out of it.'[19] After that he began working in a wide variety of media, attending to the physical embodiment of the texts he utilized. Acknowledging his debt to his fellow countryman Magritte – whose schoolboy script he often mimicked – Broodthaers imbued his work with a rueful humour and produced an enigmatic body of work characterized by the desire to undermine expectations concerning word and image.
A particular focus was the ways in which the interpretation of the visual arts are continuously being supplemented by various kinds of hidden discursiveness. To this end, he carried out a series of guerrilla attacks on institutional and theoretical frameworks – *Museum* (1968–69) [*139*], for example, is part of a large series in which Broodthaers dealt with the nature of the museum as a case study in suppressed visual–verbal hybridity. In the work illustrated here, the cheap industrial technique of plastic vacuum-formed signage has been employed to produce ersatz museum plaques. The punctuation seems to have run riot, jumping clear of its place within the syntax of the text. Of these works Broodthaers said: 'Let's call them rebuses. And the subject, a speculation about a difficulty of reading that results when you use this substance [the plastic]. These plaques are fabricated like waffles you know.' And he added: 'Reading is impeded by the image-like quality of the text and vice versa.'[20]

The unstable interaction of word and image also lies at the heart of the multi-media works of the American artist Bruce Nauman. Indeed, words are central to Nauman's practice. Duchamp's example, Wittgenstein's word games and writers such as Samuel Beckett suggested to Nauman the need to inflict on language a thoroughgoing and corrosive reduction to basic and literal usage. In the late 1960s he also began to explore neon, thus challenging the bond between word and idea and detouring the reader/viewer through a more corporeally replete kind of experience. In *Run from Fear, Fun from Rear* [*140*] from 1972, for example, Nauman played on a disturbing and very Duchampian anagram – 'run from fear/fun from rear'. Employing words in ways that are often closer to the rhythms of speech than

139 Marcel Broodthaers *Museum* 1968–69
Chaotic punctuation misbehaves in a parody of a museum notice.
The artist reminds us that verbal interpretations always
accompany art.

140 Bruce Nauman *Run from Fear, Fun from Rear* 1972
While neon gives the work a decorative quality, the play on words is
far from innocent, mixing existential terror with ribald pleasure.

to the printed text – the wordplay of *Run from Fear* is actually both aural and visual – Nauman also sets up narrative element. Through the balanced contrast between the meaning of the two phrases – one evoking ribald pleasure, the other existential terror – Nauman links the sexual and the violent, reflecting the artist's belief in the centrality of the condition of absurdity and indeterminacy in contemporary experience. He observed: 'I think the point where language starts to break down as a useful tool for communication is the same edge where poetry or art occurs. If you only deal with what is known, you'll have redundancy; on the other hand, if you deal with the unknown, you cannot communicate at all. There is always some combination of the two, and it is how they touch each other that makes communication interesting.'[21]

The exploration of sense and non-sense, and the visual–verbal interface, was also deepened during this period by the influence of feminism. Drawing on the insights of Marxism and Lacan's theory of the dynamics of representation, feminist thought stated that representations were essentially dominated by a masculine logic, that is, they functioned by positing the male as subject and the female as object. Historically, images have depicted women as objects for the male gaze, but this merely made it explicit that signs are constituted in order to consolidate and further the hold of masculine values over consciousness. Feminists noted that this is never truer than in the case of writing: 'Far more extensively and repressively than is ever suspected or admitted, writing has been run by a libidinal and cultural – hence political, typically masculine – economy', wrote the French feminist theorist Hélène Cixous in 1976. 'This is a locus where the repression of women has been perpetuated, over and over, more or less consciously, and in a manner that is frightening since it's often hidden or adorned with the mystifying charms of fiction.'[22]

The goals of feminist art were therefore essentially twofold: first, to expose the underlying mechanisms of power at work in representations, and second, to seek to create a kind of language less subservient to the patriarchy. To this end, the American artist Nancy Spero was concerned to draw attention to the marginality of women within art and within society as a whole. But Spero also sought a way of making art that could challenge gender bias, and her decision to engage with written texts – which were often appropriated from emotionally charged and marginalized sources such as the work of French writer Antonin Artaud – was in part motivated, she said, by the desire to liberate herself from the heroic rhetoric of a 'macho' Abstract Expressionist painting. In *The Hours of the Night* [*141*] from 1974, for example, Spero addressed the horrors of the Vietnam War, casting it as a prime example of the violence lying at the heart of the patriarchal order. Texts and images, taken from such diverse sources as ethnographical studies and newspaper reports (rather than originating with her) are simply appropriated into her work. Asked how she intended text and image to function together, she replied, in terms reminiscent of Symbolism and Surrealism but now tinged with the kind of indeterminacy considered central to the feminine in representation, that, 'they are set in tension with one another and are not illustrative in any way.'[23] Spero thus situated herself within an already existing flow of representations, attacking as fundamentally masculine traits

141 **Nancy Spero** *The Hours of the Night* 1974
The horrors of the Vietnam War are addressed from a feminist
perspective.

the traditional notions of authorship, originality and clarity of meaning. Working on a bulletin typewriter and with wood-type alphabets set by hand, she often photographically enlarged letters in order to emphasize their physical structure. For, in seeking to characterize the form and content of a specifically 'feminine' kind of language, feminists argued that it must be the antithesis to language as it is customarily employed. Thus, materially, Spero's work is characterized by the play of rhythm across her texts and images, and by dramatic spacings that subvert easy linear reading.

The German artist Hanne Darboven, on the other hand, approached the question of a 'feminine' writing from a very different direction [142]. While using the serial structure typical of Conceptual Art – which in Darboven's case was also founded on the logic of the folio page – the discursive field of writing is confronted by the dynamic 'figurality' of the body. Darboven challenged the inherent expectations of written text by often rendering it illegible, and within the feminist framework this gestural, somatic and rhythmical mark-making also signified that the feminine is working upon language ('More body, hence more writing',[24] declared Cixous, for example). But Darboven did not believe she was writing in the void, as did, say, Henri Michaux. Instead, she made palimpsests or 'copies' of already existing sources – literature, scholarly texts, interviews, dictionary definitions – some of which recall the ritual exercises performed by schoolchildren. As is evident from this, at the heart of Darboven's work lies the model of the book as unit of order and conservation, and the traces of preformed and culturally valued meanings traditionally held within the book cast their consoling shadow across her often illegible pages. Darboven claimed to 'write' time, adding that, 'I write, but I do not read': she was not interested in any *idea* communicated by writing, but rather in the temporal activity of inscription as an end in itself.[25] Stressing her desire to reincorporate the activity of writing into a more somatically replete experience, Darboven noted that what she sought above all was the 'handwritten transfer of content-laden form into lived form'.[26]

The feminists' preoccupation with the links between language and the male economic and political order could also take on more rigorously analytical forms. The London-based American artist Mary Kelly, reflecting the views of feminist psychoanalytic theory, argued that because of phallocratic dominance, 'the "feminine" is (metaphorically) set on the side of the heterogeneous, the unnameable, the unsaid; and that in so far as the feminine is said in language, it is profoundly subversive.'[27] In a serially structured work begun in 1973 and terminated in 1978 called *Post-Partum Document* [143], Kelly drew on the models of Lacanian psychoanalysis, sociology and anthropology in order to analyse the first years of her son's life. The work constitutes a multi-layered research into the mother–child relationship from the period of birth to the acquisition of language. A principal goal, Kelly asserted, was to demonstrate that femininity and masculinity are not biological givens, but defined by various institutional discourses. The phase of the work illustrated belongs to the final sequence (January 1977 to April 1978) in which Kelly's son began to read and write – a period that ended when he began to write his own name, and when, according to Lacan, he entered into the patriarchal, 'symbolic' order.

142 **Hanne Darboven** *Seven Panels and Index* 1973
'I write but I do not read', declared Darboven, highlighting the fact
that it was the rhythmic action of writing and the structuring of time
rather than the forming of legible words that were the central
concerns in works such as this.

Each inscription on slate is divided into three registers, like the Rosetta Stone, and the work amounts to a meditation on the relationship between spaces and styles of writing and the exercise of power: the top contains the child's 'hieroglyphic' letter-shapes – a kind of pre-writing alphabet – the middle records the mother's commentary, and the lower a typewritten narrative or diary. Like that of many other artists of the 1960s and 1970s, Kelly's work introduced into artistic practice concepts, concerns and styles drawn from such varied fields as psychoanalysis, sociology, anthropology, politics and linguistic theory. By so doing, both traditional and modernist conventions in art began to seem equally outmoded. But by the late 1970s a reaction to such anti-aesthetic principles was on its way, led by a renewed interest in self-expression and in the possibilities of painting as a vanguardist medium.

143 **Mary Kelly** *Post-Partum Document: Documentation VI, Pre-writing Alphabet, Exergue and Diary* 1978
A child's hieroglyph-like letters, handwritten script, and a typewritten text combine in order to produce a record of the early years of the artist's own son.

144 **Barbara Kruger** *Untitled (I shop therefore I am)* 1987
René Descartes's dictum 'I think therefore I am' is traduced into a
rather more consumerist principle, one well suited to the 'society of
the spectacle'.

While Conceptualists were turning towards analysis of the ways in which information is relayed, and feminists were seeking to resist the dominance of the patriarchy over language, a new kind of illicit script was emerging within urban American popular culture: spray-can graffiti. Exploiting the cheap and readily available technology of the aerosol can and ink-marker it was the limitations of these media that determined what was stylistically possible. But the spray-can soon underwent rapid ad hoc adaptation – the major innovation being that writers found ways of producing larger widths of spray – and in moving from the street to the subway system graffiti also evolved into a form in which signature 'tags' were often painted on a massive scale the height and width of whole subway cars and 'written' in increasingly elaborate styles combining purely visual display with arcane symbolism. At this point – in what is known as 'wildstyle' – distinctions between writing and painting effectively broke down, but in the argot of the sub-culture the term 'writer' persisted, revealing that central to the activity was the inscription of their own special graffiti name. Such inscriptions constantly veer towards illegibility, however, and the term 'bombing' used to describe the act of marking-up the graffiti reveals the extent to which it was intended as an aggressive attack on the law-abiding, legible fabric of the city.

The vogue for the grand 'top-to-bottom' graffiti peaked in the late 1970s, at which point the style crossed over into the commercial gallery system. Part of the reason for this mainstream interest lay in the widely held belief that there was now a need for the reinvigoration of contemporary art with new traces of the 'primitive' and the 'authentic', and for the reassertion of the kind of bodily traces that had been banished from much conceptually oriented art. More broadly, it was also felt that in fundamental ways the impetus behind modern art had been lost, and the progress of styles that characterized the logic of the avant-garde had led to a dead end. Graffiti, in this context, provided the model of an art that seemed sublimely indifferent to the sophisticated and often rarefied explorations of contemporary art.

One artist in particular succeeded in exploiting this new dynamic hybrid form and making an albeit tragically brief career as an artist – Jean-Michel

145 **Henry Chalfant** *Dust Sin* 1982
The side of a New York subway car becomes a vibrant (and illegal) work of art.

146 **Tim Rollins and KOS** *From the Animal Farm I* 1985–88
The political leaders of the period are caricatured as farmyard animals on the pasted pages of George Orwell's *Animal Farm*.

Basquiat [*148*]. First writing graffiti under the name 'Samo', Basquiat went on in the few years before his death from a drug overdose in 1988, to become one of the prominent painters of the 1980s. Using charcoal, pen, oilstick, synthetic polymer paints and collage, his highly charged and dynamically improvisational style generated an art that traded effortlessly on the visual and verbal signs of 'high' and 'low' culture, as well as staging the signs of the 'primitive' within the context of his own identity as a young black artist in an art world that was predominantly white. This was an art that seemed deliberately to embrace styles and reject the conceptual in favour of more accessible and spontaneous forms.

For another North American, Tim Rollins, a job as a teacher in the South Bronx in New York led to a collaborative project called KOS (Kids of Survival) in which graffiti culture would also play an important part. The aim of the project was to bridge the divides between the artistic avant-garde and mass culture and between professional and non-professional artists by orchestrating a creative fusion that actively involved underprivileged students in art making. The group's activities also became a meditation on the future of the book and of reading in an era increasingly dominated by television, a situation that was intertwined with broader issues concerning the future of a materially rooted language in the age of the electronic media. First Rollins would introduce canonical texts to the kids and then invite them to use the dismembered, pasted pages as grounds upon which to overlay their new texts and images – some of the texts treated in this way were Nathaniel Hawthorne's *The Scarlet Letter*, George Orwell's *Nineteen Eighty-four* and *Animal Farm*, Franz Kafka's *Amerika*, and Herman Melville's *Moby Dick*. These superimpositions often carried directly political messages and addressed pressing social problems, such as the AIDS crisis. Furthermore, they were characterized by an ambiguity towards the host text, which, while being defaced, nevertheless in one way or another served as the source of the subject matter of the team's activities.

For Rollins, these strategies meant also making art accessible, and such

developments as graffiti, Basquiat's expressionistic painting and Kids of Survival's irreverent play with canonical texts together reflect the fact that by the late 1970s and 1980s any sense of linear progress had ceded to the pluralism that is a central characteristic of *post*modernism. At the heart of this new cultural climate was a pervasive suspicion concerning any overarching and totalizing ideas. As a consequence of the collapse of any one dominant artistic teleology, a far more open set of artistic practices could prevail. Expressionist painting styles and figuration returned to favour in both the United States and Europe, and with them the 'demotic' lettering that had been banished by minimalist abstraction, Pop art and Conceptual art. Thus, for example, the American artist Julian Schnabel, a key figure in this expressionist revival, could scrawl giant cack-handed letters across unstretched tarpaulin, using the name of a Catholic saint and founder of the Jesuits to evoke a rich and exotic historical context.

Meanwhile, the German artist Anselm Kiefer devised what was essentially a new form of 'history painting'. His massive and heavily encrusted paintings make a direct appeal to the senses, but are also traversed by boldly gestural script often gouged into their surfaces. Such texts are in many cases the titles of the works themselves aggressively superimposed onto the visual field, disfiguring the image and invading the viewer's field of vision. They mediate the visceral immediacy of the surface of the work, inserting a discursive element, and Kiefer also consciously sought to complicate the meanings of his works with the richly allusive potential of these words. He argued that indeterminacy of meaning was important because 'misunderstanding creates distance' and that the texts also introduced a reflexive dimension by being both discursive and semantically ambiguous.[7] But they also have the effect of anchoring the image within a field of narrative references, and these frequently centred on the tragic course of German history. The words *Märkische Heide*, for example, scrawled across the face of one painting [*149*], refer to an area southeast of Berlin – the Heath of the Brandenburg March – rich in historical associations, and one that has been frequently fought over. Indeed, by writing in German Kiefer directly addressed his works to a specific linguistic and cultural context, one that drew them into a particular historical framework. Furthermore, in the process, his texts challenged the dominance of the English language in an art world that had become largely organized in relation to American developments.

The metaphor of the book would also be be employed by Kiefer as a symbol of the accumulation and ordering of knowledge. His massive stacks of lead folios – often interleaved with dried vegetation, stained by chemicals, and occasionally carrying the traces of photographic imagery – or the winged books that occur in his paintings and sculptures, evoke the great sacred tomes of human wisdom that man venerates as bulwarks against forgetfulness and oblivion. But in the Brave New World of consumer culture, there was often no place for history, self-expression or books. Marginalized within a culture dominated by electronic media and devoted to the spectacle where data was produced, stored and transmitted in instantaneous and immaterial modes, the book – indeed, reading itself – could seem redundant. 'I have a theory', said Tim Rollins in an interview. 'When Rip (an assistant teacher) and I were growing up – and we were "TV children" – still, reading

147 **Julian Schnabel** *Ignatius of Loyola* 1987
The name of the founder of the Jesuits is emblazoned crudely on a cruciform-shaped painting. Part of a series made for an exhibition in Spain.

149 **Anselm Kiefer** *Märkische Heide* (Heath of the Brandenburg March) 1974
The weight of German history is evoked in a work that specifically names a much fought-over area to the southeast of Berlin.

had an importance. My mom read "True Story" magazines, my dad read the newspaper, and there were lots of books in the house. But with today's kids – it's all TV and VCR, rented video tapes, and movies and records. It's all through the eyes and the ears, bypassing the mind. And after your daily five hours of television, then the movie, then playing the video games, if there is anytime left in the day for books, you're lucky. But the book – with its little black marks on the white rectangle of the page – is like a foreign language. The experience of reading is, compared to these other forms of culture, boring, because the imagination – like a neglected muscle – is so soft it can hardly function. And particularly in low-income neighbourhoods – the reading levels are incredibly low.'[2]

Television and VCR, as well as the new computer technology, were enormously extending the possible range and saturation of the mass electronic media, while the characters of the proliferating geographical sites of transportation, consumption and entertainment that clog the urban environment were also coming to be increasingly defined as much in terms of commercially motivated words and images as by the raw materials of the buildings themselves. In postmodern society, as the architects Robert Venturi and Denise Scott Brown were to put it in *Learning from Las Vegas* (1977), 'Communication dominates space.'[3]

For many artists, achieving any kind of effective critical distance or detachment from this semiotic behemoth, let alone finding authentic grounds for self-expression, seemed to be mere wishful thinking. 'What characterizes the mass media', wrote the influential French Situationist-inspired cultural theorist Jean Baudrillard, 'is that they are opposed to mediation, intransitive, that they fabricate noncommunication – if one accepts the definition of communication as an exchange, as the reciprocal space of speech and response, and thus of *responsibility*.'[4] The convergence of the new electronic media into a nexus of social machinery and control had

148 **Jean-Michel Basquiat** *Untitled* 1984
Graffiti enters the art gallery and is refined in Basquiat's dynamic expressionist paintings.

the effect of drawing diverse cultures together along an unstable global 'information superhighway' that was dominated by those who policed and controlled its dissemination. The vacuous and beguiling jargon of advertising, the empty and often voyeuristic copy of the newspaper and the television news, the debased dialogues and narratives of the Hollywood movie and of the television soap opera, all announced, it seemed, the triumph of the banal and inauthentic, and heralded the final victory of the culture of consumer capitalism over any possibility of a viable counter-culture of resistance.

Grim diagnoses such as Baudrillard's argued that signs were intrinsically unstable and permanently indentured to capital. The shop-worn, clichéd and stereotypical nature of verbal language that the Dadaists had exposed now also seemed to be the condition of all sign systems. Indeed, this fallen nature came to stand for the whole field of representations, as dreams of revolution faded and any sense of large-scale opposition crumbled before the seemingly inexorable logic of the global marketplace. Basic assumptions about language were exposed as fallacies: meaning is not transparent, there is no such thing as objective knowledge, and language does not give access to eternal or universal truths. Texts have no organic unity, nor are they the product of autonomous individuals or authors. Instead, signifiers should be understood to have floated free from any tie to their signifieds as a fundamental decentring of the sign occurs. The fact that image, word and world no longer intersected in any convincing way – that language was seemingly a sealed system dominated by capital and giving no access to any external reality – seemed to suggest to many that the best way to describe language was as a 'prison-house'.[5] In fact, the 'real' had disappeared entirely, although a false sense of a stable external world could nevertheless be conjured up by the power of the economy to orchestrate the mass media. This postmodern self, wandering aimlessly in a hall of mirrors, was doomed to exist in a wholly simulated reality – a 'hyperreality' – in which the fake and the copy entirely replace the authentic and the original: 'Henceforth it is the map that precedes the territory…it is the map that engenders the territory', declared Baudrillard.[6]

Underpinned by such theory, the new 'anti-aesthetic' art of the late 1970s and 1980s recognized that the principal consequence of the emergence of the 'Long Front of Culture' was that artists were now obliged to work with the belief that they were caught in a web of predetermined and economically motivated signs, and consequently there no longer existed any distance or necessary distinction between radical art and other purveyors of signs. The vertical cultural hierarchy in which the avant-garde had regarded itself either as pursuing separation between 'art' and 'life' or as forcing 'art' and 'life' into awkward contact, had ceded instead to the acknowledgment that art functioned within a newly constituted culture 'industry' and as part of a non-hierarchical and horizontal axis that spawned a dense and homogeneous culture. Notions of creative authorship were thus abandoned by some artists in favour of approaches that emphasized their position as an alienated and displaced appropriator within a field of ideologically determined cultural codes. Artists saw themselves as situated *within* language rather than being the source of its effects, and in this situation were

150 **Simon Linke** *Franz Kline, Summer 1975* 1989
An *Artforum* advertisement announcing an exhibition by the celebrated Abstract Expressionist (see p.110) is revived in a meticulously hand-painted and enlarged copy.

recast as deft manipulators of the mass media's glut of words and images, rather than makers of art objects. 'I see my production as being procedural,' remarked the American artist Barbara Kruger in an interview; 'that is, a constant series of attempts to make certain visual and grammatical displacements.'[7] Or, as one of Kruger's own works from 1980 declared: 'We are obliged to steal language'.

As if to symbolize this new continuum, Kruger curated an exhibition in New York in which advertisements, logos and works of art jostled for equal attention on the walls of the gallery.[8] From this perspective it seemed that the activity of painting as such was only of any critical interest if it could place itself firmly in the service of discursivity, parody and deconstruction. To this end, the presence of words in much conceptually inclined painting of the period continued to signal a repudiation of formalist aesthetics in favour of the reflexivity and mediating status provided by language. The British painter, Simon Linke, for example, absorbing the lessons of Pop art concerning the omnipresence of the mass media, and fusing this with Conceptual art's critique of institutions, produced immaculately hand-painted copies of *Artforum* magazine advertisements, whipping up the oil paint around the letters into burlesques of impasto. These works can be seen as both a homage to the major artists of the day and their powerful dealers, while also being a caustic commentary on the commercialization of art within the culture industry. Linke explodes the fantasy of the painter as somehow segregated from the marketplace, replacing this myth by a more realistic, even complicit, stance.

A similar detached and 'cool' approach prevails in the paintings of the American Christopher Wool. Here the allusion to the book page is joined by that to a wall or other vertical surface covered in industrial signage or stencilled graffiti. For the potentially lush and sensual space of the pictorial, Wool has substituted a smooth, almost mechanically painted, two-dimensional aluminium surface covered in text. Because the letters are not spaced according to conventional rules of grammar they are also difficult to read, an effect that adds to the sense of confrontation and dislocation. Wool assaults our expectations about painting as an aesthetic experience, also divesting writing of its potential roots in the rhythmic, bodily trace.

In their puritanical sparseness and their denial of the usual indications of subjectivity, the works of Linke and Wool treat words as signs of a fundamental alienation. Indeed, the text in the work by Wool illustrated here captures something of the disillusioned mood of much of the art of the 1980s unwilling to embrace the seemingly 'faux' return to Expressionism discussed earlier. The words chosen by Wool are those of the pre-Revolution Russian Nietzschean critic Vasili Rosanov, but they had been given contemporary relevance by the Situationist Raoul Vaneigem who quoted them as being, in his opinion, 'the best definition of nihilism'.[9] In *The Revolution of Everyday Life* (1967) Vaneigem had argued that capitalism strengthened itself through acts of what he called 'recuperation', that is, by absorbing the forms and rhetoric of radical opposition and safely re-deploying them.[10] Avant-garde culture of the 1970s and 1980s offered plenty of evidence of this – Punk rock, for example, had briefly looked like a rekindling of Situationist-inspired *détournement* and anarchy (though it turned out to be simply another

151 **Christopher Wool** *Untitled* 1990–91
The stencilled letters compose a sentence that has been described as 'the best definition of nihilism'.

What a kid I was. I remember practicing the violin in front of a roaring fire. My old man walked in. He was furious. We didn't have a fireplace.

152 **Richard Prince** *What A Kid I Was* 1989
As in Picabia's work [*50*], the image seems to have little relation to the joke text or vice versa.

marketing ploy). In this disenchanted condition, the act of appropriating pre-existing words and images was regarded as a key subversive strategy, and this could occur on the levels of both style and content. But although the plundering of existing media has its roots in *détournement*, such interventions were no longer premised on any belief in the imminent demise of capitalism, but rather on the stoic acknowledgment of its triumph. A work from 1988 by the American artist Ashley Bickerton *Tormented Self-Portrait (Susie at Arles) #2*, is especially poignant. Bickerton explores the impact of commercially motivated signs on notions of identity, stencilling exact copies of a plethora of brand names and logos onto a pseudo-technological construction. These signs of various products replace the kind of signifiers of psychological interiority usually associated with self-portraiture, and words stand here as emblems of the union of the subject with hegemonic capitalism. The American artist Richard Prince, on the other hand, questioned notions of the original and the copy by duplicating photographs from the media, recognizing that the contemporary culture industry had undermined traditional hierarchies of value. In a series of works begun in the mid-1980s he extended this activity to texts, using as his source the kind of jokes found in magazines from the 1950s and 1960. He noted that for him this was the period when 'movies and magazines became the reality'.[11] Sometimes the texts of the jokes appear alone, but in other works, like *What A Kid I Was* (1989), Prince's juxtaposition of the wrong caption with an image makes signs malfunction in ways that had been first engineered by Picabia. In addition, within the context of avant-garde practice, Prince's decidedly 'low' sources not only look back to Pop art but also signal a new awareness of the general levelling of culture.

Works such as these appropriated the appearance of the mass media in order to detour them towards potentially critical ends. Barbara Kruger also pursued this strategy, adopting a graphic signature-style that consciously bound her in a subversive relationship to the world of advertising, and her work is intended to be interpreted within the signifying context of commerce as well as art. Before becoming a full-time artist Kruger worked for ten years as a designer and picture editor for various Condé Nast publications as well as designing book covers. This experience equipped her well when it came to using these conventions against their erstwhile masters, and it is clear that Kruger's artistic language is based on the conventions of commercial graphic design – cropped and overtly historicized photographs are twinned with texts in bold modernist-style sans serif and set against flat superimposed grounds. By adopting the style of mass media design, Kruger also took the logic of advertising to heart: 'I learned how to deal with an economy of image and text which beckoned and fixed the spectator', she noted.[12] This also meant that she was open to the impact of the new media on habits of scanning information, of how to think about 'a kind of quickened effectivity, an accelerated seeing and reading which reaches a near apotheosis in television'.[13] In *Untitled (I shop therefore I am)* [*144*], for example, Kruger has created her own ironic by-word for rampant consumerism by taking Descartes's celebrated dictum *Cogito ergo sum* – I think therefore I am – parodying the total identification of the self with the kind of cornucopia of consumer goods that were itemized by Bickerton. But the viewer is made

conscious of the status of such photographs and the text as coded and culturally loaded, an effect reiterated by the nature of the work as something to be both verbally and visually *read*. Kruger declared that by combining text and image her aim was to mix 'the ingratiation of wishful thinking' that lies at the heart of the promise of advertising 'with the criticality of knowing better'.[14] This also involved using the personal pronoun, a typical device in advertising where it is exploited to simulate the directness and seductiveness of the intimate and vocal address. But her texts were meant to speak to the individual in a less familiar mode, one in which the reader is not a passive consumer but rather someone who the artist hoped would be able to challenge the dominance of ideology over their thoughts and actions.

Building on the example of Conceptual art of the late 1960s and 1970s, Kruger also sought to infiltrate her works into the broader non-artistic environment by siting them on billboards and in other public locations.

This was a goal also shared by another American artist, Jenny Holzer, who in the 1970s and 1980s appropriated a number of the principal sites of mass media spectacle – including Times Square and Piccadilly Circus – to display a work of avant-garde text art, *Truisms*. Electronic Spectacolor signs scrolled through a list of short alphabetically ordered sentences, of which the following are some examples:

ACTION CAUSES MORE TROUBLE THAN THOUGHT
ANY SURPLUS IS IMMORAL
EATING TOO MUCH IS CRIMINAL
MEN DON'T PROTECT YOU ANYMORE
THE ABUSE OF POWER COMES AS NO SURPRISE
WORDS TEND TO BE INADEQUATE
YOUR OLDEST FEARS ARE YOUR WORST ONES[15]

These texts appear impersonal – clichéd – but although they speak to the reader with the power of well-worn truths, they are in fact composed by the artist herself. In answer to a question about what triggered her writings, Holzer replied: 'A combination of reading and events in the world and whatever is going on with my life', and she noted that she admired three kinds of writing: 'One, delirious, flaming, emotional writing, and two, pure, paired-down essential writing. I also like writing that has gears, that is a certain way and then shifts.'[16] Language was useful for Holzer because of its accessibility and ability to convey a store of information and powerful emotional content through a generally comprehensible lexicon, but she was also interested in developing language's metaphoric and poetic dimension. Alert to the visible status of the texts she utilized, she took into account material issues of typography, scale, weight, medium and location.
'I am a printer of sorts', Holzer noted; one who 'spends time on technology to integrate text in a surround.'[17] In the case of the Spectacolor board, the employment of a mechanical device designed for the task of communicating public information in prosaic fashion meant that, materially speaking, Holzer's work fitted seamlessly into the general disorder of public texts and images. Attention to the visual nature of writing was directed towards infiltrating it into contexts in order that it would not be obtrusive. It was the word in its role as signifier rather than as a destabilizing, material signified that was intended to be subversive. By siting her artwork in highly fluid social spaces, Holzer also effectively reversed the avant-garde's practice of bringing the signs of mass culture into the art gallery and museum, though she wasn't infiltrating the aesthetic into the marketplace or engaging in Productivist-style propaganda so much as using the media of mass communication against themselves. In the event, *Truisms* would be the first of a series of such writings and these have subsequently been inscribed on multiple and often unlikely hosts, including baseball caps, condoms, T-shirts, pencils, cash-register receipts, magazines, and marble and granite slabs. The messages have also been displayed through electronic signs and the Web,[18] and have been visualized using giant Xenon and laser projectors [*182*]. Furthermore, in seeking to push her work beyond the boundaries of genre, they have also been recited as performance pieces.

Kruger and Holzer's works trade on the familiar forms and styles of the world of the mass media, but the messages they deliver are far from unambiguous, and their aim was to act against the easy assimilation of the message, substituting instead a call for rigorous decoding and for empowerment of the self. In this context, the lessons of feminism proved to be fundamental to a continued faith in the ability of artists to challenge the authority of the status quo, and subversiveness also implied an agenda in which the feminine confronted the masculine order. Like Spero, Holzer's decision to work with words was in part motivated by a desire to avoid the overblown rhetoric of 'masculine' painting, while Kruger argued that her practice was to be understood as 'a series of attempts to ruin certain representations and to welcome the female spectator into the audience of men'.[19]

The London-based American artist Susan Hiller shared these goals, adopting a detached, ethnographical approach through which to investigate

the ways in which meaning is constituted and power exercised. But unlike Kruger or Holzer she also delved into areas of experience and signification that can be regarded as lying beyond the jurisdiction of the dominant 'masculine' ideology and mass media. One aspect of this multifaceted practice was research into the nature of the bond between the acts of writing and of speaking, and the energies of the unconscious and of the body. In the group of works produced in the late 1970s and 1980s of which *Élan* is part, Hiller drew on the feminist interpretation of the 'feminine' in language as that which subverts or contradicts rational, masculine meaning. Like Darboven, she substituted for the graphic trace as signifier a linguistically motivated *gesture* that was based on an unconscious and automatically generated text written by Hiller several years before. Hiller argued that this gestural writing was of a very different order to that central to the Abstract Expressionists. Talking in an interview about the hold of this tradition she noted that what interested her was that 'certain sorts of marks come up over and over again in the work of many abstract painters, but they never look at the marks themselves as scripts, signifiers without signifieds, if you see what I mean. I think that there is a particular appeal that the calligraphic has that comes about because the kind of ongoingness of the marks relates to body feelings, something like breathing or walking, it just goes on and on, it's interminable in a sense, it has a sort of flow to it which in a sense represents the flow of life if you like…the flow of subvocal speech, mental imagery, ideation and so forth.'[20] Hiller was interested in generating texts that could not easily be recuperated intellectually, seeking, as she put it, to 'speak my desire for utterance'.[21] Consciously framing this gesture as a form of writing, however, she sought a way of generating signs that were 'crypto-linguistic, that is, representing language referring to language, or pretending to be language, a language for which, in effect, we have forgotten the rules'.[22] Thus, unlike Darboven's writing, the texts produced by Hiller were basically alphabetic, although the opacity of the verbal content resists any reasoned interpretation. Hiller brings this unfettered written language into confrontation with sound and speech and introduces a temporal dimension to *Élan* by twinning the visual presentation with an audiotext in which she improvises wordless singing, adding as a final coda a recognizable sequence of words that includes the phrase: 'Here, language breaks free.'

But in the West, where the reach and power of the 'culture industry' had grown parasitically into a 'consciousness industry' – into the society of the spectacle – it would often seem to artists that commercially motivated signs had become the only reality, and that any attempt to break free was doomed to failure. In the face of such blandishments, Hiller's art of resistance – a small personal voice – would certainly be increasingly difficult to sustain. 'This morning, 260,000 billboards will line the roads to work. This afternoon, 11,520 newspapers and 11,556 periodicals will be for sale. And when the sun sets, 21,689 theaters and 1,528 drive-ins will project movies; 27,000 video outlets will rent tapes; 162 million television sets will each play 7 hours, and 41 million photographs will be taken. Tomorrow there will be more.'[23] So writes one of the contributors to the catalogue of 'Image World: Art & Media Culture' held at the Whitney Museum of American Art in 1989–90. How would it be possible to break free from such an oppressive reality?

155 **Susan Hiller** *Élan* 1982
This is a staccato automatic 'writing' in which, declared the artist, 'language breaks free'.

156 **Ken Lum** *Amir New & Used* 2000
An imitation shop sign displays some rather disturbing political and
geographical dislocations.

16 Creolization: Millennial Words

In a world turned upside down by rapid industrialization and technological innovation, and characterized by shifting national borders and political alignments, the kind of street signage that for artists and photographers of the late nineteenth and early twentieth centuries had been a novel phenomenon was now not only ubiquitous, but also betrayed curious dislocations in the relationships between the global and the local, the public and the personal. Responding to this situation, the Canadian artist Ken Lum, for example, juxtaposed the familiar look, format and rhetoric of banal shop advertising with the absurd, amusing and disturbingly emotional or political. Mimicking the cheap signs that often blight major cities worldwide, Lum had the owners of a business called 'Hanoi Travel' offer 'Disneyland Packages', while the adjustable type underneath the sign asks us to 'Remember the people's war'. In Lum's dystopic world, the desire to communicate the truths of an often traumatic personal experience to anyone who will listen challenges, but does not exactly nullify, the day-to-day reality of 'business as usual'. The private realm of an alienated consciousness is played out within a typographical space and style originally designed to exclude such signs of the personal, and the kind of display fonts and presentational supports that were pioneered in the late nineteenth century become the means by which the individual desperately seeks to be heard. Similarly, the American artist Jack Pierson, in an act of seemingly desperate recuperation that, like Lum, sought to resist the commercial dominance of language, imbued the neutral and functional typography of old shop fascias with the language of the emotions. Countering the fundamentally 'non-communicative' logic of the mass media meant for Lum and Pierson seeking to use an alienated language to give voice to basic human feelings.

For the English artist Simon Patterson, on the other hand (and like Picabia seventy years before), the goal seemed to be more to assault the culturally cemented bond between subject and name that is the basis of public signage. Established informational systems are scrambled by Patterson, and even though his strategy actually proceeded by way of a certain logic (that of analogy), the results are bafflingly alien. In *The Great Bear* (1992) [*13*], for example, he took the well-known map of the London Underground transport system and replaced the names of the stations with those of famous people past and present (Leicester Square becomes Lawrence Olivier), the title of the work being a pun on the category of 'star'. Another English artist, Fiona Banner, also seemingly drawing on the dislocations inherent in media overload, engineered confusion of a different kind, making crazy translations across media by transcribing into words the narratives of classic films such as *Bullitt* [*158*], *Lawrence of Arabia* and *Apocalypse Now*. But her walls of words deliberately and dramatically fail to capture the complexities of their

157 **Jack Pierson** *Desire, Despair* 1996
Constructed out of a junked shop fascia, words for basic human emotions take the shape of a powerful religious symbol.

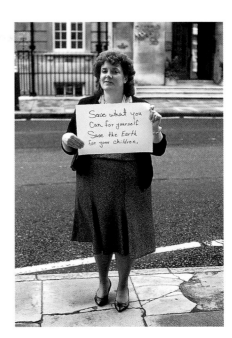

sources, while inserting the artist's own cautious subjectivity into already-given mass-media forms.

Such works have their roots sunk firmly in the soil of popular culture, a central characteristic of much late twentieth-century word-based art. Recognition of the chaos and confusion in the public and private forests of signs is counterbalanced by a desire to make art accessible and free from the narcotic force of the mass media. Typical of this spirit was a series of photographic works by the English artist Gillian Wearing, who took her camera out onto the streets of her native London and asked passers-by to write down what was really on their minds. The resulting texts, scribbled artlessly in felt-pen by the subjects themselves, are by turns funny, sad and disturbing. Here writing also becomes a vessel for some kind of desperate authentic communication, and carries a confessional tone that might short-circuit the banality of normal public discourse. This acceptance of the normative usages of language in art signals the abandonment of modern art's romance with the dream of a universal language. Art would now often be characterized by a kind of stoic realism and pragmatism. Words and their normal contexts – usually *English* words specifically – were recognized and exploited as something that everyone could understand, reading and writing now in theory being universal.

The desire for a publicly accessible style was particularly evident in the use artists made of popular visual and verbal idioms, such as mass-market genres like the comic and the cartoon. But artists in the 1990s no longer dealt so much in appropriation and subversion as a desire to directly emulate 'democratic' styles. The prolific output of drawings by the American artist Raymond Pettibon [8], for example, is clearly related to the conventions of the comic book. But once the viewer/reader familiarizes themselves with the promiscuous cultural references that populate the work, it quickly becomes clear that Pettibon is actually better seen within a broader context –

159 **Gillian Wearing** *Signs that say what you want them to say and not signs that say what someone else wants you to say* 1992–93 Part of a series in which Wearing asked people to write down what was on their mind and then photographed the results.

160 **Tracey Emin** *Mad Tracey from Margate, Everyone's Been There*
1997
'Our Trace' from Margate shares with us her hopes and fears.

indeed a typically contemporary condition – that acknowledges no hard and fast distinction between 'high' and 'low' culture, or between the literary and the visual.[1] Significantly, Pettibon has also preferred to work in media that are pre-mechanical and pre-electronic, making drawings exclusively in ink and watercolour on paper, or sometimes directly onto the gallery wall, suggesting a desire to resist the lure of the technological in favour of something more direct and personal.

In the quest for a raw kind of self-expression or self-declaration, the English artist Tracey Emin also appropriated 'low' media, placing her own name and autobiography at the centre of her work. *Mad Tracey from Margate, Everyone's Been There* (1997) assaults the viewer with a cacophony of crudely rendered but visually dynamic texts that have been painted and sewn onto a blanket. The appliqué style Emin has used relates to traditionally 'feminine' practices, and signals in uncompromising terms the work's distance from institutional and commercial design. This places it instead within the unsophisticated and less supervised sphere of the domestic and amateurish. But a reading of Emin's texts quickly belie the innocence of the means, setting up a conflict between style and content. We seem to be party to snatches of overheard conversation and to posted expletives or other graffiti-like statements.

Such works suggest that as the millennium came to its end many artists felt compelled to explore a more overtly subjective idiom, one in which word and image were now inextricably linked. And whether the message was conveyed through the visual or the verbal was less important than ensuring that some kind of comprehensible message was actually communicated at all. But such preoccupations with the self and with the ways in which the mass media could be 'detourned' towards more personal and emancipatory ends were also to be increasingly shadowed by the complex multiculturalism of a global society in which margin and mainstream were thoroughly confused. What, it might be asked, was the future of language in this modern-day Tower of Babel?

As we have seen, by naming things and people, language is intimately tied up with issues of possession and power. In the case of proper names, for example, the act of personal naming becomes intricately bound up with psychic, social and cultural controls, providing a sense of fixed identity for the self, offering society a primary means of surveillance and record-keeping, and equipping a culture with the power to colonize. Indeed, a fundamental recognition of marginalized and silenced peoples is that all acts of naming are also acts of imperialism. For many, speaking or writing thus means the necessity of using a language and learning an alphabet that is not their own, a tongue and/or script in which, as feminists and ethnic minorities have argued, the self is cast not as a subject but rather as an object or absence. Language, in this context, is something oppressively inscribed on the subject, making them *intelligible* and therefore an object of control.

The ramifications of linguistic colonization – of the repressive connection between nomination and possession – became a central aspect of the work of the German artist Lothar Baumgarten. Behind the texts, photographs, films and installations that he produced since the 1970s lay the quest to bring the

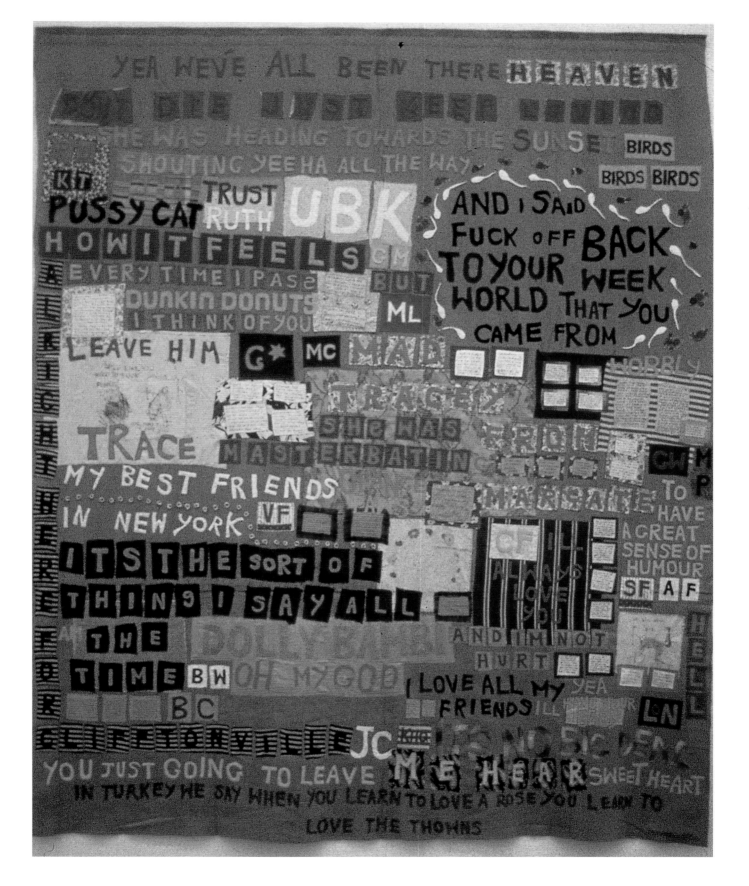

161 **Glenn Ligon** *Untitled (I do not always feel colored)* 1990
The stencilled text becomes progressively and deliberately more
illegible as the artist repeats the same provocative phrase.

margins to the centre through acts of substitution and renaming. One project
was to involve the inscription on the varied surfaces of the Western art world
of the alphabetically transcribed names of Amazonian tribes: names that
Baumgarten sought to bring back from the oblivion into which they had
been forcibly consigned.

But while Baumgarten was a Westerner who elected to speak on behalf of
silenced Third World peoples, the expansion of the art world during the
1990s also meant that within the context of the Western cultural mainstream
the works of artists from marginal cultures could themselves be seen and
heard at first hand. The Western, white middle- or upper-class heterosexual
male who had largely determined what was to be regarded as legitimate
cultural currency – and whose words it is that we have (mostly) seen
inscribed in the works illustrated in this book – was to be increasingly
challenged not only by the voices of women, the urban or suburban masses,
gays and lesbians, but also by peoples from around the world. The black, gay
American artist Glenn Ligon, for example, sought to expose such prejudices
within supposedly progressive Western art. In a series of stencil paintings
that clearly invoked the work of Jasper Johns, he challenged the visual and
conceptual conventions for merging text and image in avant-garde art.
But unlike Johns, Ligon was not concerned with using text to produce an
anonymous, mechanized, analytical anti-aesthetic art, but rather to force into
view the shape and content of a previously hidden narrative of oppression.
Taking texts by black writers, Ligon inscribed words on canvas with paint
stick and stencil, and the accumulation of oil on the stencil gradually clotted
the letters' outlines and progressively obliterated the shape of the text, which
therefore moved inexorably towards illegibility. The rationality and clarity
intended by language is undermined by the brute fact of the materials, and
here flatness, all-over black and white text, and the discursiveness of words,
allude neither to the aesthetic nor to the analytic realm but rather to the
struggle to speak and to be heard in a culture that has not traditionally
provided either the means or the space.

The New York-based Iranian exile Shirin Neshat evoked the
oppressiveness of written language from within the context of the
conservative Islamic culture in which she grew up. In *Unveiling* (1993), from
a series of works entitled *Women of Allah*, Neshat wrote on the exposed face
and chest of a woman dressed in traditional Islamic head-covering,
literalizing the nightmare of a wholly controlled body. But although the
calligraphy might seem to thus render the subject subordinate to social and
religious order, in fact, the text is an excerpt from a poem in Farsi by the
Iranian feminist Furough Farokhzad that uses the image of a neglected
garden as a metaphor for the mistreatment of women. Furthermore, in
contradiction of Islamic law the woman's body is partially exposed.
So, Neshat challenged the association of script with patriarchal Law, turning
language against the oppressor. But the probable illegibility of the text for a
Western audience certainly contributes an additional ambiguity to her work
and, on the face of it, the writing appears to carry the more orthodox and
oppressive message.

In this multicultural world, furthermore, a different light could be cast on
traditional Western attitudes, including the segregation of word and image

that has underpinned them. The will to *aesthetic* purity might be seen as inseparable from other more invasive forms of essentialism. Thus, the white South African Marlene Dumas saw attitudes to word and image as mirroring the racial politics that long divided her native country. As her watercolour *Sold Against One's Will* [*9*] and the quotation cited in the Introduction suggest, the function of appended texts for Dumas was awkwardly to implicate her images in a storyline that was decidedly stained, impure and morally troubling, one that belied both the apparent innocuousness of an unlabelled picture and the innocent connotations of the work's medium.

The culturally nomadic work of Simryn Gill, meanwhile, an Indian woman born in Singapore, raised in Malaysia, and who now lives in Australia, explores Western distinctions between 'nature' and 'culture', 'primitive' and 'academic' in a situation where old boundaries have been erased, and where assumptions about the exoticism of the 'other' were no longer sustainable. In *Washed Up* (1995) [*164*], for instance, Gill etched a random selection of English words onto sea-washed glass collected from the beaches of Malaysia and Singapore. While the power of the colonizer persists within the now independent nations through the dominance of the English language, Gill appropriates these linguistic implants, recognizing that any hard-and-fast distinction between an indigenous and foreign language or culture is belied by the fact of her own post-colonial hybridity.

The Ukrainian artist Ilya Kabakov evoked another non-Western cultural attitude to explain the prevalence of words in his own art. He argued that, like many other artists working in Russia, his work was premised on a tradition that refused to acquiesce to a Western aesthetic, which valued, as he put it, purely 'visual' qualities. In this rival tradition, Kabakov noted, 'artists work only with visual art, and if an artist uses text, it is considered very bad. The idea of connecting the visual and the text in the Western world

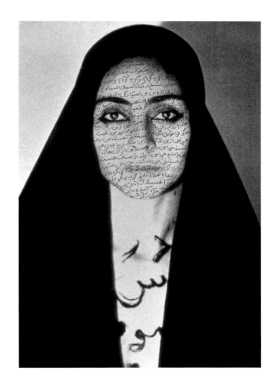

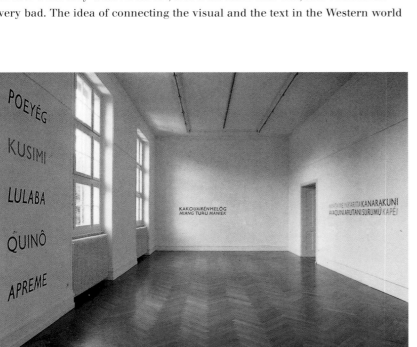

162 **Shirin Neshat** *Unveiling* 1993
A poem in Farsi about the mistreatment of women in Iran covers the exposed skin of a woman.

163 **Lothar Baumgarten** *Eldorado* 1987
The names of endangered Amazonian tribes are inscribed on the walls of an art gallery.

164 **Simryn Gill** *Washed Up* 1995
Glass pieces washed up on the beaches of Malaysia and Singapore have been inscribed by the artist with English words – the language of the powerful.

is absolutely idiotic, like mixing sugar and salt'. But he added: 'To me this great development of a purely visual art is an exception in the history of world art.'[2]

In the 1980s such voices from behind the Iron Curtain began to be heard as the climate of the Cold War thawed. Kabakov's *Carrying Out the Slop Pail* (1980), for example, exposed the sordid truth behind the rhetoric of the Soviet Union's 'classless society' by mimicking a notice board listing the six-year rota for putting out rubbish of a communal apartment building. Moving to the West after the end of Communism in 1989, and often working in collaboration with his wife Emilia, Kabakov began to extend his exploration of visual–verbal hybrids by producing monumental installations – 'total installations' as he called them [*11*]. In these he engaged the viewer in the complex activity of negotiating spaces and different informational codes, inventing a series of fictitious scenarios and stories for a cast of characters, and deploying a vast repertoire of found and constructed objects, interactive environments, and complex word and image interactions. This engendered an experience in which the viewer/reader is absorbed into the narratives that recreate the familiar bureaucratic and communal interiors of the Soviet era. In these works, Kabakov's model was as much the novel or the theatre as it was the visual arts, as they concerned expanded notions of literary narrative form. But in them a shift takes place from linear text to overall pattern, and in this context, Kabakov's work exemplifies the notion of the artwork as a thoroughly disseminated and decentred 'text' in which words, images and sounds are inserted into a multidimensional informational network. The traditional notion of the authentic authorial voice has been replaced with the continuous activity of adopting ready-made identities from those which already exist in the cultural network. Indeed, by conjuring up a richly inventive cast of characters through which to express the complexities of his experience, Kabakov was also representative of a significant aspect of the word-imbued art of the 1990s in general – the merging of the literary

165 **Ilya Kabakov** *Carrying Out the Slop Pail* 1980
A mock noticeboard carrying an apartment's rota for putting out trash becomes a way of commenting on the banal realities of Soviet life.

imagination with that of the visual. The customary division of labour between the artist and the writer has broken down as a new fusion of intentions and media take place.

The backdrop to Kabakov's complex works was the legacy of the routine violations of language in the Communist Bloc. Dissidents under Soviet rule, noted another Ukrainian artist, Svetlana Kopystiansky, were thus made especially aware that language was always tied to ideology. Looking back over the Communist era, Kopystiansky observed that after the Revolution of 1917 'the act of changing spelling was not only symbolic but actual – a blow to the old culture and the old consciousness.'[3] In an attempt to challenge this kind of control, dissidents often drew on the experiments of the Russian avant-garde in the years preceding and just after the Revolution, but they were also conscious of the limits placed on such experimentation by the realities of their political situation. Kopystiansky, working sometimes in collaboration with her husband Igor, used the confusion of the verbal and visual registers as a way of resisting the authoritarian control of language, and a series of landscape paintings completed by Kopystiansky during the

166 **Svetlana Kopystiansky** *Seascape* 1984
A text by the Russian writer Turgenev generates the image of a tranquil seascape.

period of 'glasnost' are composed of hundreds of handwritten words – in the case of *Seascape* (1984) taken from a novel by Turgenev.

For artists in another Communist state, China, attitudes to language were even more critical. In a work from 1987, Huang Yongping brought together books symbolic of Eastern and Western knowledge (a history of Chinese art and a history of modern Western art) only to reduce them to an illegible mess by having them washed for two minutes in a washing machine.[4] Such suspicion was motivated by the context of a repressive political system in which written texts were highly valued and, as a result, stringently controlled, while playing a dominant role as propaganda. 'Words alone could determine a person's fate', noted another Chinese artist, Xu Bing, of his childhood under Mao. 'They could kill one person, and ensure a very good life for someone else. There was a saying then: "Pick up a pen, just as you would pick up a knife or gun." My memory of life at that time, is crowded with those written Chinese characters, from the sky to the ground, everywhere on the street, just everywhere, these big character posters and slogans.'[5] In *A Book from the Sky* (1987–91) Bing responded to this situation by inventing a fake Chinese writing, painstakingly adopting the paraphernalia of traditional word-block printing and the format of the scroll

167 **Xu Bing** *A Book from the Sky* 1987–91
Mock Chinese ideograms produced and presented with meticulous attention to traditional methods deliberately fail to communicate any actual linguistic meaning.

in order to produce an installation that in its fidelity to the traditional media scrupulously established grounds for communication, which were then just as scrupulously denied. By making calligraphy illegible, Bing effectively turned writing into series of spatial figures, and as visual forms rather than linguistic vessels, he also neutralized them as potential tools of propaganda.

The political control of language in non-democratic nations, the clashing of tongues in confrontations between different ethnic groups, the evident failures of communication endemic within a multicultural world, all add a new global dimension to the profound distrust of language that has shadowed much Western word-art. 'I am trying to deal with different tongues speaking at the same time', noted the Uruguayan artist Carlos Capelán,[6] and the contemporary experience of displacement and hybridity would become a central aspect of his work. A heady mixture of many languages suffuses Capelán's multi-media installations; the environment in *Jet Lag Mambo* from 2000, for example, is designed to suggest a domestic interior, but the familiarity and tranquillity of the setting has been undermined by the multiplicity of inscribed handwritten texts that jostle for space and attention along with washes of mud, primitive line drawings and various kinds of object such as light fittings. The texts, which are in a number of different languages, are sometimes the artist's own writings, sometimes quotations. A few of them have been crossed out. 'Language is constantly evolving, it is a living organism', Capelán noted. 'This is why I paint over some of the

168 **Carlos Capelán** *Jet Lag Mambo* (detail) 2000
A chaotic mixture of texts compete with pictures and furniture in a room-size installation that reflects the nature of our contemporary Tower of Babel.

169 **Guillermo Kuitca** *Nordrhein* 1992
A map of part of western Germany painted on a mattress. Kuitca has
deliberately chosen somewhere far from his native Argentina – the
words and symbols are alien to him.

quotations I've written. You're not able to read them because forgetting is part of memory.'[7]

For another South American, the New York-based Argentinian artist Guillermo Kuitca, this Babel-like situation meant a world in a permanent state of trauma, a condition for which the political oppression in his native Argentina provided the specific background. In focusing on the dissembling of road maps, family trees, city plans, and other two-dimensional formats intended to structure, make legible and control knowledge, Kuitca sought to undermine the certainties these schema foster, inflicting on them the kind of disruptions that evoke an awareness of a dislocated and disturbed psychological condition. *Nordrhein* (1992), a map painted on a mattress, takes as its source a section of western Germany, and Kuitca said he was drawn to the fact that the places in the maps meant nothing to him – they did not signify – and were, as he put it, 'just names. The name and its sound and resonance'.[8]

In this post-colonial world languages often circulate, mingle and bear strange fruit, without first consulting those who write dictionaries. So, in the work of the African artist Frédéric Bruly Bouabré, for example, the language of the oppressor – in this case, French – has been adapted and redirected to sustain indigenous needs. By exploiting the skills of writing taught to a previously aural culture, Bouabré's drawings express the complexities of contemporary tribal custom in Ivory Coast through a combination of legible French words, pictograms and entirely invented alphabets, as well as images. But they epitomize not merely the hybrid nature of contemporary African language usage, but also that of the increasingly multi-ethnic and multicultural 'global village' as a whole. Indeed, these works highlight what is perhaps the most significant consequence of the contemporary multicultural and global network of communication, as far as language is concerned: 'creolization'.[9] The kind of rich verbal melange, originally limited to the linguistic experience of the slave population of the Caribbean, is now being produced on a worldwide scale through cultural mobility, flux and diversity. As a result, at the beginning of the new millennium the inherent imperialism of language is to some extent being countered by instances of non-totalitarian appropriation. At the same time, this flux has led to a growth in awareness and acceptance of the foreignness and intrinsic untranslatability of different cultures.

170, 171 **Frédéric Bruly Bouabré** *Museum of African Face (Scarifications)* 1991–92
Works by an artist from Ivory Coast combine French words (the language of the former colonists and now the official language of the African state), pictograms, and invented script in order to create a rich post-colonial semiotic melange.

172 **Knowbotic Research** Frame from *I0_dencies – questioning urbanity; Tokyo, Sao Paulo, Ruhrgebiet, Venezia* 1997–99
This site-specific digital project seeks, say its creators, to test 'oscillations and transformations of potential agencies and potential (group) subjectivities in the interface'.

17

Epilogue: Hypertexts and Future Words

If the chaos of the nineties reflects a radical shift in the paradigm of visual literacy, the final shift away from the Lascaux/Gutenberg tradition of a pre-holographic society, what should we expect from this newer technology, with its promise of discrete encoding and subsequent reconstruction of the full range of sensory perception?
– Rosebuck and Pierhal, 'Recent American History: A Systems View'[1]

A spoof on an academic citation from a fictitious text, the above quotation comes from a short story written in 1977 by the American 'cyberpunk' novelist William Gibson. It provides a glimpse into a future in which technology has freed humanity altogether from dependence on one- and two-dimensional media and from any grounding in the specificites of time and place. In this world the so-called 'Lascaux/Gutenberg tradition' of image- and word-based forms has ceded to a new era in which both are rendered suddenly obsolete as carriers of information.

But today Gibson's science fiction is fast becoming science fact. 'Cyberspace is a new form of perspective', declares the influential cultural critic Paul Virilio. 'It does not coincide with the audio-visual perspective which we already know.'[2] Within what Virilio calls a new 'tactile perspective' of 'tele-contact', the distance and structure that had been established by the traditional media implodes, and as a zero-dimensional virtual reality is born the boundaries between the physical and the virtual, time and space, mind and matter, the natural and the mechanical become blurred. Cyberspace thus heralds the beginning a whole new era and, as Virilio warns, the impact of this transformation on consciousness is going to be – indeed already is – traumatic, and produces in people a state of 'shock, a mental concussion'.[3]

The potential of such technologically induced sensory overload was first explored by artists such as the American Laurie Anderson, who from the late 1970s began incorporating new media into her performances. Anderson brought together elements of song, video, slide projection, oral narration and written texts in what amounted to a vast extension in the range of the concept of the Wagnerian 'total work of art'. In particular, video's ability to duplicate and exploit older conventions such as film could offer artists such as Anderson new possibilities for the temporal unfolding of narrative, thus in the process challenging the ideal of the work of art as an object for contemplative absorption. The lessons of mechanical reproduction already explored in collage and photomontage were now fused with quite new characteristics that represented a bridge between the old static media. Exploiting the inherent immateriality and mutability of the electronic media, numerous text fragments, images and sounds could be linked, opening up

173 **Laurie Anderson** *Songs & Stories from Moby Dick* 1999
An inter-media spectacle bringing together imagery, text, sound and the charismatic presence of the artist.

174 Gary Hill *Incidence of Catastrophe* 1987–88
A still from the final moments of the video. A stick prods the abject naked body of the artist as giant words close in.

175, 176 Lynn Hershman *Lorna* 1979–84
Two stills from the first interactive art videodisc.

the possibility of different modes of viewer/reader interaction and producing different kinds of temporal unfolding of text sequences.

In the newly emergent field of Video art, the American video artist Gary Hill, for example, noted that what interested him was 'a relation of language and image. One tends to question the other…. It's not so much about duality, but about what happens in the middle. This is possible because of the electronic media. It really allows that reflexive space where both absence and presence take place.'[4] In being more image-based and by functioning in real time, Hill argued, video produced signs that work very differently from those present in the normal reading/writing context, and which by also being less mediated were more closely integrated with the body. In his video *Incidence of Catastrophe* (1987–88), he focused specifically on the materiality of language and explored the confrontation between the discursiveness of text and the 'figurality' of the body, setting in play a mixture of image, voice, writing, reading and raw corporeal presence, which collide in a narrative inspired by the artist's reading of a translation of Maurice Blanchot's 1941 novel *Thomas l'Obscur*.

The manipulations evident in Hill's work reveal characteristics of video that are not shared with film, and also how video could offer much greater scope for the manipulation of image and text. With digitalization, however, a further revolution occurred. Formally discrete signs could now be dissolved into a seemingly endless stream of data flow, dematerialized in the continuum of countless electronic 'bits' in which all information is reduced to the binary code of zeros and ones. Letterforms that had originally been established as a consequence of basic technical limitations imposed in the production of discrete material embodiments – first made by hand and then later mechanically with metal punches – were suddenly liquefied. Early in the twentieth century, with the development of photographic and electronic printing techniques, traditional letterforms had become potentially far more

malleable, but with digital electronic technology these physical limitations disappeared altogether and a totally fluid situation emerged in which letters are merely part of the raster grid of a matrix of integers. More broadly, however, an electronically produced text could also display a number of new characteristics that structurally set it apart from traditionally scripted or printed texts. These included not only fluidity, but also permeability of boundaries, simultaneous and mass dissemination, and non-degradability. The term computer 'window', for example, suggests a metaphor that relates the computer screen not to the flat world of two-dimensional signs but rather to that of three-dimensional spatial forms. But the typical computer screen layout also borrows from the whole history of the development of writing, incorporating aspects of the Egyptian papyrus roll, the medieval codex and the printed book, while at the same time adding wholly new features such as 'tiled' and 'staked' inserts.

Digital technology opened up a whole new range of creative possibilities, in particular in relation to greater audience participation. 'Hypertext' writing, for example, constitutes a form of text that is interactive and non-sequential, thereby allowing a reader to chose their own route through a network of links that branch off in directions they can determine themselves. Thus, in the 1980s, the British artist Roy Ascott would pioneer new levels of user involvement in a number of interactive digital works using text, such as *La Plissure du Texte: A Planetary Fairy Tale* (1983), which involved groups of artists located in eleven cities around the world in the creation of a collective narrative.[5] With the incorporation of video clips into the continuum of digital technology, a new interactive 'hypermedia' art form was born that could augment the inter-medial process by bringing together written, visual, and aural media into a unity. Here, unlike in the linear or hierarchical structure of traditional print media, a multi-linear and interactive network emerged that had no obvious beginning or ending, top or bottom.[6] From 1979 to 1984, the American artist Lynn Hershman produced the first art videodisc, *Lorna*, an interactive program that allowed the viewer to determine the narrative form of the work, with text, image and sound united through computer technology to break down the barrier between artwork and audience. For Hershman such interactivity was a fundamentally liberating activity: 'The media bath of transmitted, pre-structured and edited information that surrounds, and some say alienates, people is washed away, hosed down by viewer input. Altering the basis for the information exchange is subversive and encourages participation creating a different audience dynamic'.[7]

Like Ascott's, Hershman's early work was still essentially text led, with the interactive element based in the verbal prompts of linear text. But as technology became more sophisticated a fully integrated approach was made available in which greater attention could be paid to the visible status of writing and to its fluid integration into a continuum of text, image, and sound. So, while words also remained central to the groundbreaking computer-generated work *The Legible City* (1989–91) by the Australian artist Jeffrey Shaw, they were now part of a fully inter-medial event. In Shaw's work, text was given the role of carrier of the deposits of personal and historical memories that were made to overlay, and give structure to, the anonymous surface of the city. The viewer/reader, seated on a stationary

177, 178, 179 **Jeffrey Shaw** *The Legible City* 1989–91
Participant 'cycle' through a computer generated 'wordscape', determining themselves the route taken.

bicycle, could actually 'ride' through streets in which the buildings were made up of computer generated three-dimensional letters. The route and speed of the tour were controllable, and on the way different textual threads were encountered that related to the history of the locations in which the work was physically presented.[8]

Interactivity was also at the core of many works that during the late 1990s began to engage with the nature of the World Wide Web as a vast network of data. Within this labyrinth – where word, image and sound increasingly function together – artists no longer made distinctions between the visual and the verbal, often seeing themselves as hackers generating *samizdat* data in order to emancipate content and form from enslavement to commercial and political interests. Such acts of 'culture jamming'[9] can be compared to Situationist-style *détournement*, but any hopes of bringing about the imminent collapse of the capitalist order were now usually replaced by the more modest goals of subversively interrupting the flow of data and potentially empowering marginalized social groups.

Such strategies should be seen within the context of the imbalances of power that are the day-to-day realities of cyberspace, for in spite of the radical challenge it poses to conventional media, the World Wide Web remains essentially a commercially motivated medium dominated by a single language. Indeed, while from the perspective of the post-colonial experience the process of 'creolization' had furthered the differentiation and dispersal of languages, on the information superhighway, the future of verbal language looks more likely to be characterized by consolidation and homogenization. To that extent, the much-vaunted universalism of the Internet actually constituted a new kind of linguistic imperialism, and outside the First World the Internet's expansion merely heralded a new era of colonization, as the hierarchical structures of the English alphabet and the remorseless logic of Western capitalism imposed themselves yet more comprehensively across the world through the global control of information. This was a situation in which a new social polarization also emerged, one that divided those with the necessary technology, skills and language, from those without. Indeed any Utopian celebration of the new media has to be countered – at least for the time being – by the realities of an Internet that is actually, as the new media theorist Lev Manovich puts it, 'a space of homogeneity, of currency exchange shops, of Coca-Cola signs, of raves and fashion CDs, of constant youth, itself the best symbol of leaving roots and tradition behind, the space where everything can be converted into money signs, just like a computer can convert everything into bits.'[10]

Subverting the flow of data could, however, be seen as a way of empowering local communities and sub-cultures. Knowbotic Research, for example, an Austrian collective composed of the artists Yvonne Wilhelm, Alexander Tuchacek and Christian Huebler set out to destabilize hierarchies of information, and in works such as *IO_dencies* (1997–99) [*172*][11] created computer-based interfaces combining word, image and sound, which were designed to involve local participants wherever the work was presented in an ongoing and potentially empowering exploration of the multi-layered experience of their environment. They thus claimed to be 'testing what the political effects might be', and argued that their goal was to incorporate 'the

potential of agency in the multiple movements of information', with their focus being 'the oscillation and transformation of potential agencies and potential (group) subjectivities in the interface'.[12]

'Culture jamming' could also take place on the level of form. The conventional web browser through which a user sources information is designed to retrieve the pre-configured content from web-pages. But in *Netomat* [180], a work by the American artist Maciej Wisniewski from 1999, a program was created that could free information from this rational grid. The viewer/reader typed in words and phrases that commanded the specially designed browser to search for information in the form of words, images and sounds, and in an exhibition installation the resulting data was made to flow simultaneously onto the gallery walls without regard for the display design of the sources. Wisniewski saw cyberspace as potentially comprised of unpredictable flows of data, and this highly unstable source of information he described evocatively as the Internet's 'subconscious'.[13] In this sense, Wisniewski's work breathed new life into the understanding of the connection between the activity of sign-making and the mechanisms of the unconscious. But now, these were non-rational processes that had been deflected away from the body and onto the mediations of technology, a technology that was radically restructuring consciousness through its transformation of writing and picturing spaces, and in the process creating a potentially revolutionary new hybrid 'species' – the 'cyborg' or cyber-organism.[14]

'Nothing since the invention of photography has had a greater impact on artistic practice than the emergence of digital technology', declared the curator Lawrence Rinder in the catalogue to 'BitStreams', an exhibition of American digital art held at the Whitney Museum in 2001.[15] This is also an impact that can be easily disseminated, and the ready availability of software such as Adobe Photoshop and various databases, alongside the possibility of downloading information from the Web, have given artists unprecedented freedom to select and manipulate words, images and sounds, as well as to use the Internet as a virtual gallery space within which to exercise greater control and facilitate access by wider audiences. Indeed, it can be argued that the new digital media have brought into sight the kind of universal language of which the avant-garde once dreamed, a language based on the fusion of words and images into a sign system that one enthusiast has called 'iconographics'.[16] A cut-and-paste language is therefore coming into existence, catapulting the avant-garde's techniques of collage, montage, photomontage and interactive participation to new levels of sophistication. The World Wide Web, the Internet, e-mail, chat rooms, conferencing, hypertext, text-messaging, as well as more sophisticated forms of inter-medial interaction such as MUDs (Multi-User Dimensions), CAVEs (Cave Automatic Virtual Environments), and so on, are thus fundamentally transforming the way words and images are used and experienced. In the day-to-day reality of the World Wide Web something like a new language has also emerged, one that cannot be defined according to the old categories, and that even poses a profound challenge to traditional notions of human consciousness. David Crystal, a leading authority on language, sees in the present realities of usage the emergence of what he calls a whole new

medium – 'Netspeak' – that, in effect, constitutes a 'third medium' beyond speech and writing. E-mail, for example, has introduced a new kind of inscription that is closer to oral discourse, and Crystal sees the digital medium as 'more than an aggregate of spoken and written features…it does things that neither of these other mediums do, and must accordingly be seen as a new species of communication.'[17]

But eventually digitalization may well do away with verbal language altogether. The influential philosopher of new media Vilém Flusser, for example, suggested that 'the easiest way to imagine the future of writing if the present trend toward a culture of techno-images goes on is to imagine culture as a gigantic transcoder from text into image.'[18] The various media are being drawn together within the complex web of the digital data matrix, and traditional assumptions about the distinctions between the visual and the verbal are being swept away. Cyberspace seems to fulfil the emancipatory promise of electronic media predicted by Marshall McLuhan, and – at least for those who see it as a Utopia – it heralds the dawn of a better era for humanity, one characterized by a society without an oppressively hierarchical structure founded on the rigid linear forms engendered by the centrality of print media, one infused instead with the evanescence of speech and the sensuality of images. This will be a new 'network culture' in which the old hierarchies disintegrate as information is increasingly disseminated and democratized.

180 **Maciej Wisniewski** *Netomat* 1999
A special browser designed by the artist allows participants to liberate web-based data from the constraints of the design of its parent website.

The *closure* of the book, the *retreat* from the word and from a culture based on the veristic, legible, linear and congruent written word suggest that we are now at the end of an epoch – the epoch dominated by the protocols of print. In its place a new consciousness is emerging modelled on the structures of very different image-based media that repudiate linearity and are far more fluid and multiple, without beginning or end. These will be plural, rather than based on discrete levels and essences, and will blur the boundaries between maker and user. And as the influence of the book wanes, writing will move towards very different processes of making, such as modelling and drawing, just as at the same time objects and images are themselves being increasingly produced using the same mechanical operations involved in the making of texts.[19]

More broadly, the assault on the traditional epistemological and moral certainties initiated in the late nineteenth century has led at the beginning of the twenty-first to a fundamental undermining of faith in the power of language, and for most of us it is no longer possible to believe with conviction in some divine *Logos*, or even in the ability of the word to mirror the world. It is to the abstract formulae of science that we now look for certainty, not words. Furthermore, the Babel that assaults us on a daily basis in the multicultural marketplace might well lead us to despair over the possibilities of any real translation and true dialogue, as instead we become increasingly marooned in mutually incomprehensible cultures. On the other hand, these same effects of globalization have also brought to the West a host of new voices, narratives and typographic styles. These serve to counter Western preoccupations with language's opacity and failure.

So what, finally, have the artists discussed in this book collectively contributed to the understanding of the relationship between word and image? And what does the future hold for these interactions? They have helped expand awareness of a variety of writing, reading and imaging spaces, and thus they have also challenged basic assumptions about human consciousness. In a culture that has been dominated by the segregation of word from image, by the devaluing of the image as a source of information, and in which the use of verbal language is often characterized by harsh and anonymous regiments of printed letters held within the constraining structure of the folio book, artists have mixed up words and images, infusing text with vibrant colours, confusing customary relationships. They have reintroduced the sign-making spaces of the tablet, the scroll and the manuscript, which demand very different kinds of writing and reading action and different modes of visual scanning. To a far greater extent than at any time since the invention of printing artists now emphasize the *textuality* of writing itself, that is, of writing as a visible form functioning within a specific space, rather than merely the transparent vessel for speech and the preservation of memories. This foregrounding of textuality resists the inclination to read words for their linguistic meaning, and instead makes us prone to experience them both as spatial figures and as forms with their own intrinsic history – the history carried in typography.

Just as in society as a whole – walk down the main street of any town or turn on the television – the conventions in art that have kept word and image in separate categories are being abandoned. Indeed, artists today understand

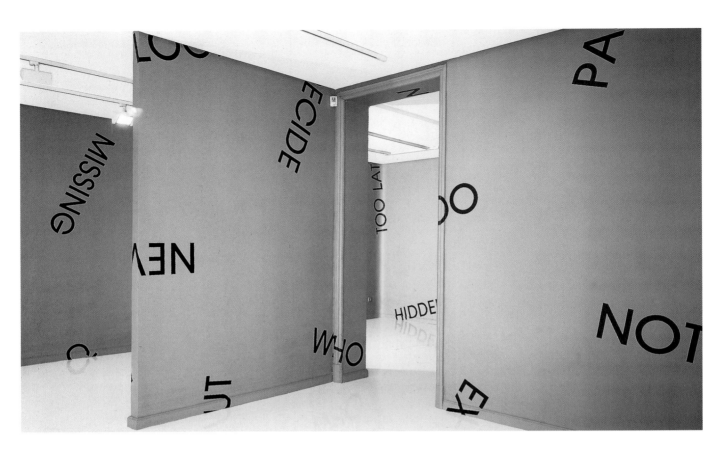

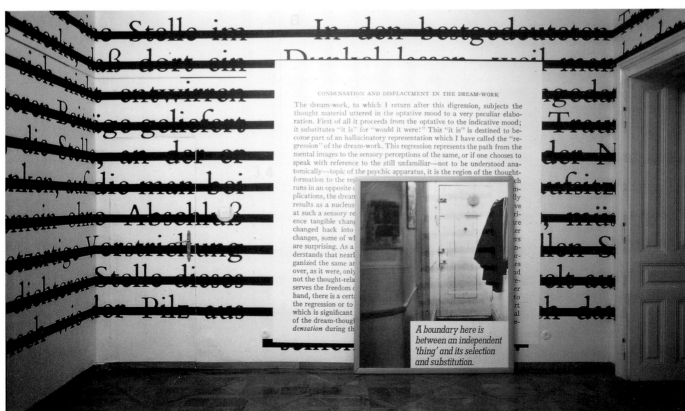

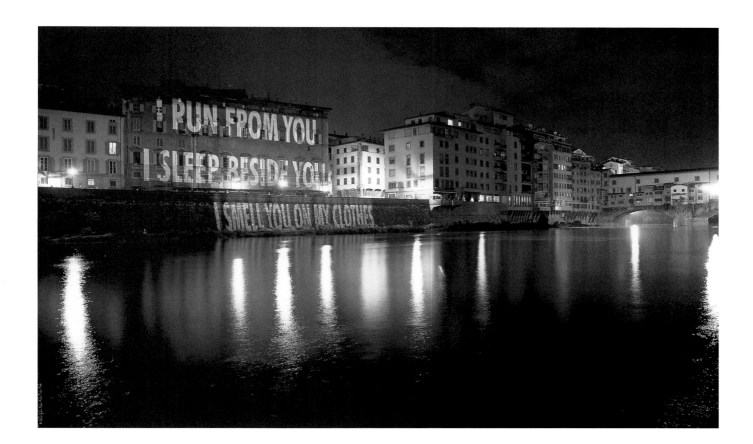

the relationship between the visual and the verbal very differently from the way they did only a century ago. Certainly, the use of written language in art is no longer so contested, and the desire of an artist like Marlene Dumas in the early 1980s to muddy the pure waters of the visual with the worldliness of words is perhaps no longer met with the kind of opposition it once was. Meanwhile, the pioneers of text-based art from the 1960s and 1970s have continued to explore and expand the range of their work, entering the mainstream and often moving into large-scale and assertively visual installations using new technology. With the emergence of electronic and digital media, many of the radical experiments of the avant-garde have been greatly extended, and as we have seen, artists have been quick to respond to the new possibilities offered by such technological innovations, in the process crafting wholly new kinds of spaces, new kinds of sign systems, and new kinds of relationships. Indeed, Richard Wagner's mid-nineteenth-century vision of the 'total work of art' now seems to be within reach, and notions of the 'intermedial' work have been expanded beyond anything envisaged by the likes of Dick Higgins.

But while artists may recognize that all representations are socially conditioned – that everything is to some extent an already written 'text' open to discursive interpretation – and while it is commonplace to say that we *read* images as well as words, so too have artists become aware of the limitations of the discursive model as a master term. They have launched an offensive against all forms of fundamentalist thinking, wielding the weapons of indeterminacy and ambiguity against those who seek to control the codes

183 **Jenny Holzer** *Arno* 1996
Newly available light-projection technology allows the artist to temporarily turn the side of a building into a vast reading space carrying an evocative text.

181 **Robert Barry** *Installation at Galleria 57* 1991
A recent work by Robert Barry (see p.139) in which words become powerfully visual and spatial presences.

182 **Joseph Kosuth** *Zero & Not Exhibition* 1989
The artist develops ideas that were first explored in his pioneering work of the 1960s, but now presented in a more environmental and site-specific form.

we use. As a result, attention has often been turned to what lies beyond the matrix of signs, pulsing to the rhythms of desire – out there in what Lacan called the 'Real' and driven by the force of what Derrida called the 'trace' and Lyotard the 'figural' – in a semiotic maelstrom of excess that presses relentlessly upon the placid surface of language. But despite this task, even among contemporary intellectuals and artists of the vanguard the need for some kind of basic human communication has also often come to seem more important than the kinds of interrogation and deconstruction of signs that once preoccupied the avant-garde. Furthermore – and despite the 'non-communicative' logic of the mass media – it is today more often recognized that language, rather than functioning in isolation from the texts and external contexts within which words take their meaning, can still have value within a complex, interactive and living environment of continually refreshed daily usage. Ultimately, however, whether a contemporary artist uses words, images, sounds or combinations of all of these, seems less important than how they seek to position themselves in relation to the informational matrix. The artist in this situation becomes a cartographer of all media – someone who independently maps information as it incessantly flows across the vast and ever metamorphosizing data ocean.

The neon sign glows above the neo-classical portico of a dilapidated Victorian building in London's East End: EVERYTHING IS GOING TO BE ALRIGHT. This is a work that has shed many of the constraints of earlier art. It uses recent technology and is decisively situated within the fluid public sphere. Words have replaced images, or words have become images. In this, it is typical of the boundary-less art of the present. But what, we might ask, do these words mean? Are they perhaps a message from some religious sect, or the fiat of an authoritarian movement? Maybe they are the by-line for some business? Then again, are these words just giving public form to a naive or drug-induced state of nonchalance or, from another perspective altogether, could they be giving shape and meaning to a now sadly outdated declaration from the building itself – one assuring us of the promise of the 'eternal values' that were once embodied by its classical architecture? Or maybe we should see this sign as sending us a message of a rather more amorphous and mystical kind, offering transcendence of worldly and transient pleasures and hope at the dawning of a new millennium? A work by the Scottish artist Martin Creed, this particular 'writing on the wall' decisively and finally dissolves the boundaries between word and image.

184 **Martin Creed** *Work No. 203, Everything is going to be alright*
2001
Art in the public domain and carrying a powerful message. But how
exactly are we meant to interpret these words?

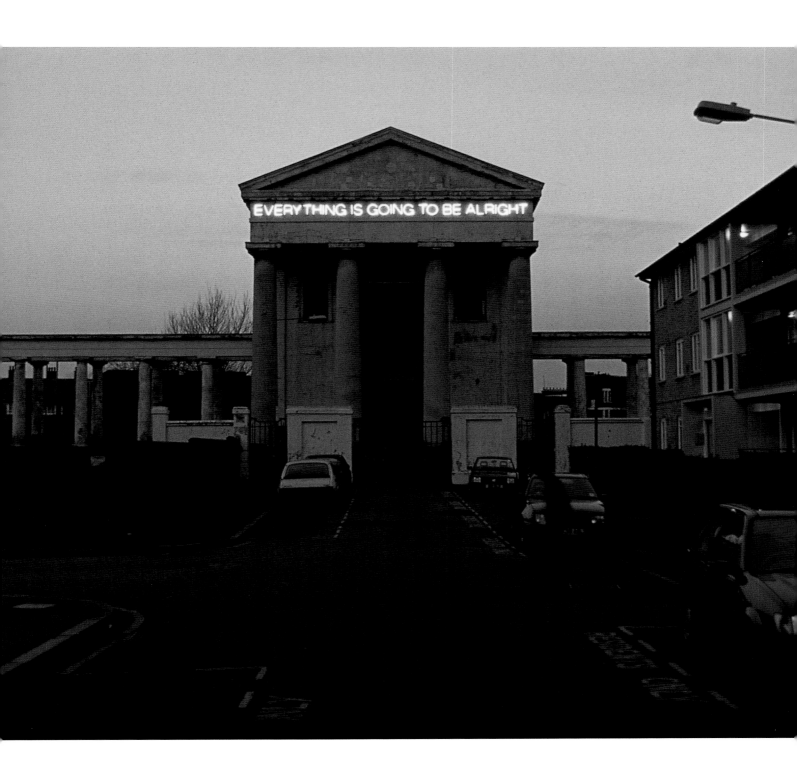

Notes

All web addresses were correct at the time of publication.

p. 1

1 H. Ball, 'Flucht aus der Zeit' (originally published 1927), excerpted in R. Motherwell (ed.), *The Dada Painters and Poets: An Anthology* (trans. E. Jolas), Cambridge, Mass., and London, 1951 (2nd edn 1979), p. 52

Foreword

1 A. Reinhardt, 'Art in Art is Art-As-Art (Art-as-Art Dogma, Part III)', *Lugano Review* (1966), reprinted in B. Rose (ed.), *Art as Art: The Selected Writings of Ad Reinhardt*, Berkeley and Los Angeles, 1991, p. 2

2 J. Derrida, *De la Grammatologie*, 1967. Translated as *Of Grammatology* (trans. G. Chakravorty Spivak), Baltimore and London, 1976, p. 9

1 Introduction: Words and Pictures

1 Marlene Dumas quoted in J. Brand, N. Gast and R.-J. Muller (eds), *De Woorden en de Beelden: Tekst en Beeld in de Kunst van de Twintigste Euew/The Words and the Images: Text and Images in the Twentieth Century*, exh. cat., Centraal Museum, Utrecht, 1991, p. 246

2 For an accessible discussion of 'left' and 'right' brains, see L. Schlain, *The Alphabet Versus the Goddess: The Conflict Between Word and Image*, New York, 1998, ch. 5. Schlain's panoptic study posits a distinction that is also rooted in gender differences. The alphabet is made synonymous with (largely bad) male characteristics, and the 'Goddess' – the image – synonymous with (largely good) female characteristics. Whatever the merits of Schlain's thesis, its publishing success does reflect the general concern over deep-seated transformations occurring in contemporary culture, concerns that also serve as a context for the present study.

3 C. S. Peirce, 'What is a Sign' (1894) in *Essential Peirce*, vol. II, The Peirce Editorial Project (ed.), Bloomington, Ind., 1998

4 F. de Saussure, *Cours de Linguistique générale*, 1916. Translated as *Course in General Linguistics* (trans. W. Baskin), New York, 1966

5 I draw here on L. H. Hoek, 'Image and Word: An Exciting Relationship', in *Interactions* [The Bulletin of International Association of Word and Image Studies], 12, April 1994, at *http://www.iawis.org*

6 M. Merleau-Ponty, *The Phenemology of Perception* (1962), (trans. C. Smith), London, 1989, p. 401

7 Plato, 'Phaedrus', 274E–276A, in *Plato in English*, vol. VI, (trans. H. N. Fowler), London, 1919, pp. 563–67

8 John 1:1. 'Word' here is a translation of the Greek *logos*, which can also mean 'ratio'.

9 The words of the Last Supper are flanked by the text of the Ten Commandments. In Islam, on the other hand, the spirit of monotheistic iconoclasm would lead to the flowering of a stridently visual form of calligraphy, which sought to transform the visual to the verbal.

10 This is a view that originates with G. E. Lessing, *Laocoon: An Essay upon the Limits of Poetry and Painting* (1796) (trans. E. Frothingham), New York, 1969

11 This view is closely associated with the thought of I. Kant, *Critique of Judgement* (1790) (trans. J. C. Meredith), Oxford, 1952

12 C. Greenberg, 'The Pasted Paper Revolution', *Art News*, September 1958, pp. 46–49, 60–61. Quoted in J. O'Brian (ed.), *Clement Greenberg: The Collected Essays and Criticism*, Chicago, 1993, vol. 4, *Modernism with a Vengeance (1957–1969)*, p. 62

13 See, on Cubism, the pioneering work, R. Rosenblum, *Cubism and Twentieth Century Art*, London, 1960; and 'Picasso and the Typography of Cubism', in R. Penrose and J. Golding (eds), *Picasso in Retrospect*, London, 1973. For a more recent discussion, see R. Krauss, *The Picasso Papers*, London, 1998

14 The term 'topographic' is used in this context in J. D. Bolter, *Writing Space: The Computer, Hypertext, and the History of Writing*, Hillsdale, N. J., 1991, p. 25

2 Grand Bazar Universel: Impressionist Words

1 K. Marx and F. Engels, *Communist Manifesto* (1848), (chapter trans. S. Moore), London, 1967, p. 83.

2 E. de Amicis, 'The First Day in Paris' (1878), first published in English in E. de Amicis, *Studies of Paris* (trans. W. W. Cady), London and New York, 1879. Quoted in C. Harrison and P. Wood (eds), *Art in Theory 1815–1900*, Oxford, 1998, pp. 884–85

3 In fact, the journal is probably *La Vie Moderne*, a fashionable publication founded in 1879 and in which Manet's own drawings sometimes appeared. See T. Reff, *Manet and Modern Paris*, Chicago and London, 1982, p. 84

4 M. Talmeyer, 'L'Age de L'Affiche', *Revue des Deux Mondes* 137, September 1896, pp. 201–206. Quoted in K. Varnedoe and A. Gopnik, *High and Low: Modern Art and Popular Culture*, New York, 1990, p. 236.

5 F. Nietzsche, 'On Truth and Lie in an Extra-Moral Sense' (1873) in E. Kaufmann (ed. and trans.), *The Portable Nietzsche*, New York, 1954, pp. 46–47

3 Merahi metua no Tehamana: Symbolist Words

1 Quoted in P.-L. Matthieu, *The Symbolist Generation 1870–1910*, New York, 1990, p. 123

2 The Japanese writing system utilizes three different forms: Chinese characters, which are essentially ideograms, and two alphabets. See S. R. Fisher, *A History of Language*, London, 1999, pp. 104–105

3 C. Baudelaire, 'Correspondences' in *Baudelaire: Selected Poems* (trans. J. Richardson), Harmondsworth, 1975, p. 42

4 G.-A. Aurier, 'Le Symbolisme en peinture: Paul Gauguin', *Mercure de France*, II, Paris, 1891. Translated by H. R. Rookmaaker and H. B. Chipp in H. B. Chipp, *Theories of Modern Art: A Sourcebook by Artists and Critics*, Berkeley and Los Angeles, 1968, p. 91

5 ibid.

6 A. Rimbaud, *Oeuvres poétiques*, Paris, 1964, p. 130.

7 S. Mallarmé, *Mallarmé: The Poems* (trans. K. Bosley), Harmondsworth, 1978, pp. 258–97.

8 R. Wagner, 'Outline of the artwork of the Future' in *The Artwork of the Future* (1849). Trans. by W. A. Ellis in R. Packer and K. Jordan (eds), *Multimedia: From Wagner to Virtual Reality*, New York and London, 2001, p. 4

9 Rimbaud, *Oeuvres poétiques*, p. 75

10 S. Mallarmé, 'Les Mots Anglais', cited in J. Drucker, *The Alphabetic Labyrinth*, London, 1995, p. 245

11 Odilon Redon quoted by Octave Mirabeau in O. Mirabeau, 'Art et la nature', *Le Gaulois*, 26 April 1888. Quoted in M. Stevens, 'The Transformation of the Symbolist Aesthetic' in D. W. Druick (ed.), *Odilon Redon*, London, 1994, p. 208

12 Letter to André Fontainas, 1899. Quoted in J. C. Welchman, *Invisible Colors: A Visual History of Titles*, New Haven and London, 1997, p. 96

13 Interest among scholars of language in its primitive forms and their visualizations was widespread in the second half of the nineteenth century. The pseudo-scientific theories that were expounded often had little more validity than Mallarmé or Rimbaud's essays into the origins and meaning of the alphabet. For the modern deciphering of Rongorongo – which turns out to be a nineteenth century form of native pictogram inspired by Western alphabetic models – see S. R. Fischer, *A History of Writing*, London, 2001, pp. 290–91.

14 V. Kandinsky, 'On the Question of Form', *Die Blaue Reiter*, 1912. Reprinted in K. Lankeit (ed.), *The Blue Rider Almanac*, (trans. H. Falkenstein), London, 1974, p. 165

4 KUB: Cubist Words

1 The anecdote is the poet Guillaume Apollinaire's. Cited in L. C. Breunig (ed.), *The Cubist Poets in Paris: An Anthology*, Lincoln, Neb., and London, 1995, p. xv

2 G. Apollinaire, 'The New Spirit and the Poets' (1918) in G. Apollinaire, *Selected Writings of Guillaume Apollinaire* (trans. R. Shattuck), New York, 1971, p. 229

3 Braque came from a family of painters and decorators and his father ran a house-painting business. He inherited trade secrets and formulas which became an essential part of his work, not least the practice of stencilling, which provided the artisan with an easy method for painting letters.

4 G. Braque, 'Braque, la peinture et nous', *Cahier d'art* 29, no. 1, October 1956. Quoted in translation in C. Poggi, *In Defiance of Painting: Cubism, Futurism, and the Invention of Collage*, New Haven and London, 1992, p. 104

5 See P. Leighton, *Re-Ordering the Universe: Picasso and Anarchism 1897–1914*, Princeton, 1989

6 See R. Rosenblum, 'Picasso and the Typography of Cubism' in R. Penrose and J. Golding (eds), *Picasso: 1881–1973*, London, 1973. For an updated version, see 'Cubism as Pop Art' in K. Varnedoe and A. Gopnik (eds), *Modern art and Popular Culture: Readings in High and Low*, New York, 1990

7 M. Raynal, 'Ou'est ce que…le Cubisme?', *Comoedia Illustré*, Paris, December 1913. Quoted in J. Golding, *Cubism: A History and Analysis (1907–1914)*, London, 2nd edn, 1968, p. 60

5 Parole-in-Libertà: Futurist Words

1 B. Cendrars, 'Advertising=Poetry' (1924) in R. Dumay and N. Frank (eds), *Oeuvres complètes*, Paris, 1968–1971, vol. VI, pp. 87–88. Quoted in M. Perloff, *The Futurist Moment: Avant-Garde, Avant-Guerre, and the Language of Rupture*, Chicago, 1986, p. 9

2 F. T. Marinetti, 'Destruction of Syntax – Imagination without Strings – Words-in-Freedom', *Lacerba*, Florence, 15 June 1913. Reprinted in U. Apollonio (ed.), *Futurist Manifestos* (trans. R. W. Flint), London, 1973, p. 99

3 Apollonio (ed.), *Futurist Manifestos*, p. 98

4 ibid. p. 100

5 ibid. p. 104

6 F. T. Marinetti, 'The Geometric and Mechanical Splendour and the Numerical Sensibility', published in two parts in *Lacerba*, Florence, 15 March 1914 and 1 April 1914. Reprinted in Apollonio (ed.), *Futurist Manifestos*, p. 157

7 Marinetti observed, for example: 'In my poem "Zang Tumb Tumb" I describe the shooting of a Bulgarian traitor with a few words-in-freedom, but I prolong a discussion between two Turkish generals about the line of fire and the enemy cannon.' Apollonio (ed.), *Futurist Manifestos*, p. 155

8 F. T. Marinetti, *Zang Tumb Tumb*, Milan, 1914, and *Les Mots en Liberté Futuristes*, Milan, 1919

9 F. T. Marinetti, 'Destruction of Syntax', Apollonio (ed.), *Futurist Manifestos*, p. 95

10 C. Carrà, 'The Painting of Sounds, Noises and Smells', *Lacerba*, Florence, 1 September 1913, Apollonio (ed.), *Futurist Manifestos*, p. 111

11 C. Carrà, letter dated 11 July 1914 in M. D. Gambillo and T. Fiori (eds), *Archivi del futurismo*, Rome, 1958–1962, vol. I, p. 341. Quoted in Perloff, *The Futurist Moment*, p. 61

12 Italian entry into the war was delayed until May 1915

13 G. Apollinaire, *Calligrammes, Poèmes de la paix et de la guerre (1913–1916)*. Translated as *Calligrammes, Poems of Peace and War (1913–1916)* (trans. A. Hyde Greet), Berkeley and Los Angeles, 1980. 'Calligrammes' or 'pattern poetry' were nothing new. Well-known examples are George Herbert's 'The Altar' and 'The Mouse's Tail' from Lewis Carroll's *Alice's Adventures in Wonderland*. See D. Higgins, *Pattern Poetry: Guide to an Unknown Literature*, Albany, New York, 1987. Higgins defines 'pattern poetry' as 'visual poems, intermedial texts between literature and visual art.'

14 G. Arbouin, 'Devant l'ideogramme d'Apollinaire, *Soirées de Paris*, July, 1914. Quoted and translated in J. Brand, N. Gast and R.-J. Muller (eds), *De Woorden en de Beelden: Tekst en Beeld in de Kunst van de Twintigste Euew/The Words and the Images: Text and Images in the*

Art of the Twentieth Century, exh. cat., Centraal Museum, Utrecht, 1991, p. 38

15 The reproduction of Cendrars and Delaunay-Terk's poem is in Dumay and Frank (eds), *Oeuvres complètes*, vol. I, pp. 16–32. Cendrars's text is translated in W. Albert, *Selected Writings of Blaise Cendrars*, New York, 1962, pp. 66–99

16 A facsimile reproduction of *Blast* is available published by Black Sparrow Press.

17 E. Pound, *ABC of Reading*, London, 1934, p. 3. For Imagism see W. Pratt (ed.), *The Imagist Poem*, New York, 1963. Pound would develop his interest in writing as spatial figure, employing Chinese ideograms in his *Cantos*, London, 4th collected edn, 1987

18 For 'zaum' poetry see C. Douglas (ed.), *Velimir Khlebnikov: Collected Works* (trans. P. Schmidt), Cambridge, Mass., 1987

6 L.H.O.O.Q: Dada Words

1 R. Hülsenbeck, 'Collective Dada Manifesto', lecture delivered at the I. B. Neumann Gallery, Berlin, February 1918 and published in R. Hülsenbeck (ed.), *Dada Almanac*, Berlin, 1920. Reprinted and translated in R. Motherwell (ed.), *The Dada Painters and Poets: an Anthology* (trans. R. Mannheim), Cambridge, Mass. and London, 1981 (originally published 1951), p. 244

2 Hausmann, quoted in H. Bergius, 'Dada, the Montage, and the Press: Catchphrase and Cliché as Basic Twentieth Century Principles' in S. C. Foster (ed.), *Dada: The Coordinated of Cultural Politics*, Crisis and the Arts: The History of Dada, I, New York, 1996, p. 113

3 K. Schwitters, 'Lanke Tr Gl (kerzoo aus meiner soonate in uurlauten)', *Transition*, no. 21, 1932. Reprinted in M. A. Caws, *Surrealist Painters and Poets: An Anthology*, Cambridge, Mass., 2001, p. 372

4 Hülsenbeck (ed.), *Dada Almanac*

5 H. Ball, 'Dada Fragments', 1916–17, *Flucht aus der Zeit*, 1927. Translated as J. Elderfield (ed.), *Flight out of Time: A Dada Diary*, Documents of Twentieth Century Art (trans. A. Raimes), Berkeley and Los Angeles, 1996, p. 67

6 T. Tzara, *Seven Dada Manifestos and Lampisteries* (trans. B. Wright), London, 1977, p. 39

7 T. Tzara, 'Dada Manifesto', *Dada*, no. 3, 1918. Reprinted in Motherwell (ed.), *Dada Painters and Poets*, p. 76

8 Ball in Elderfield (ed.), *Flight out of Time*, p. 66

9 M. de Zayas, '291 – A New Publication', *Camera Work* 48, New York, October 1916. Quoted in W. Camfield, *Francis Picabia: His Art, Life, and Times*, Princeton, N. J., 1979, p. 75

10 See, for example, A. Jarry, *Ubu Roi*, 1896, and R. Roussel, *Impressions d'Afrique*, 1912.

11 'M. B.' (Marcel Boulanger?), 'Le Dadaisme n'est qu'une Farce inconsistante', *L'Action Français*, Paris, 14 February 1920. Quoted in Camfield, *Francis Picabia*, n. 11, p. 137

12 F. Picabia, 'Declaration of Francis Picabia', *Ecrits, 1913–1920*, 1975. Reprinted in J. Brand, N. Gast and R.-J. Muller (eds), *De Woorden en de Beelden: Tekst en Beeld in de Kunst van de Twintigste Euew/The Words and the Images: Text and Images in the Art of the Twentieth Century*, exh. cat., Centraal Museum, Utrecht, 1991, p. 65

13 Marcel Duchamp in interview with James Johnson Sweeney, 1946. Reprinted in M. Sanouillet and E. Peterson (eds), *The Essential Writings of Marcel Duchamp*, London, 1975, p. 125

14 ibid. p. 141

15 Marcel Duchamp in interview with Arturo Schwartz. See A. Schwartz, *The Complete Works of Marcel Duchamp*, New York, 1969, p. 195

16 Sanouillet and Peterson (eds), p. vii

17 J. Arp, 'Dada was not a farce' (1949). Translated by R. Mannheim in Motherwell (ed.), *Dada Painters and Poets*, p. 294

18 Ball in Elderfield (ed.), *Flight out of Time*, p. 71

19 ibid.

20 R. Hausmann, 'Typografie', *Qualität*, 10, Berlin, 1932. Quoted in T. O. Benson, *Raoul Hausmann and Berlin Dada*, Ann Arbor, Mich., 1987, p. 90

21 ibid. p. 175

22 ibid. p. 93

23 Signed by Richard Hülsenbeck and Raoul Hausmann, 'What is Dadaism and what does it want in Germany?', *Der Dada*, (Berlin), no. 1, 1919. Translation by

R. Mannheim in Motherwell (ed.), *Dada Painters and Poets*, p. 41

24 H. Richter, *Dada: Art and Anti-Art* (trans. D. Britt), London, 1965, p. 151

25 K. Schwitters, 'Merz' in *Das Litterarische Werk*, 1981. Quoted in Bergius, 'Dada, the Montage, and the Press', pp. 128–29

7 Futura: Constructivist Words

1 *L'Esprit Nouveau*, no. 21, 1924. Illustrated in B. Fer, D. Batchelor, P. Wood, *Realism, Rationalism, Surrealism: Art Between the Wars*, New Haven and London, 1993, p. 94

2 I. K. Bonset, 'Toward a Constructive Poetry', *Mécano*, nos 4–5, Leiden, 1923. Translated in S. Bann (ed.), *The Tradition of Constructivism* (trans. I. and O. van Os), London, 1974, p. 109

3 E. Lissitzky and I. Ehrenburg, 'The Blockade of Russia is Coming to an End', orig. pub. in *Vesch/Gegenstand/ Object* (Berlin) Nos 1–2, March–April 1922. Translated by S. Bann in *Tradition of Constructivism*, p. 55

4 L. Moholy-Nagy, 'Contemporary Typography – Aims, Practise, Criticism', *Gutenberg Festschrift*, 1925. Translated in K. Passuth, *Moholy-Nagy*, London, 1985, p. 293.

5 W. Benjamin, 'The Work of Art in the Age of Mechanical Reproduction', *Zeitschrift für Sozialforschung*, vol. V, 1, 1936. Translated in H. Arendt (ed.), *Illuminations* (trans. H. Zorn), London, 1973, p. 213

6 ibid.

7 Arendt (ed.), *Illuminations*, p. 219

8 ibid. p. 227

9 F. Léger, 'The New Realism Goes On', originally published in English, *Art Front*, New York, vol. 3, no. 1, February 1937. Reprinted in C. Harrison and P. Wood (eds), *Art in Theory 1815–1900*, Oxford, 1998, p. 496

10 F. Léger, *Function of Painting: Fernand Léger* (trans. and ed. E. F. Fry), Documents of Twentieth Century Art, New York, 1965, p. 150

11 E. Lissitzky, 'Our Book', *Gutenberg-Jarhbuch*, 1926–27. Reprinted in R. Hertz and N. M. Klein, *Twentieth Century Art Theory: Urbanism, Politics, and Mass Culture*, Englewood Cliff, N. J., 1990, pp. 295, 297

12 The complete poem, 'The Great Figure' published in the collection *Sour Grapes* (1921), is: 'among the rain/and lights/I saw a figure 5/in gold/on a red/firetruck/moving/tense/unheeded/to gong clangs/siren howls/and wheel rumbling/through the dark city.' *William Carlos Williams: The Collected Poems*, vol. 1 (1909–1939), Newcastle, 2000, p. 174

13 For a further discussion of Russian Constructivism and the Communist regime see Chapter 9.

14 For a facsimile reprint and translation see E. Lissitzky and V. Mayakovksy, *For the Voice* (trans. P. France), London, 2000

15 E. Lissitzky and M. Stam, 'Die Reklame', *ABC*, no. 2, Berlin, 1924. Quoted in S. A. Mansbach, *Visions of Totality: Lazlo Moholy-Nagy, Theo van Deosburg, and El Lissitzky*, Ann Arbor, 1978, p. 100

16 E. Lissitzky, 'Typography of Typography', *Merz*, no. 4, Hanover, 1923. Reprinted and translated in Hertz and Klein, *Twentieth Century Art Theory*, p. 290

17 T. van Doesburg, 'Avondpost', 28 February, 1914. Quoted in M. Friedman, *De Stijl: 1917–1931, Vision of Utopia*, Oxford, 1982, p. 53

18 Lissitzky, 'Our Book' in Hertz and Klein, *Twentieth Century Art Theory*, pp. 293–94

19 S. Eisenstein, 'Word and Image' in *Film Sense* (1947) (trans. J. Leyda), New York, 1975, pp. 3–65

20 See, for example, K. Pomorska and S. Rudy (eds), *Ramon Jakobson, Language in Literature*, Cambridge, Mass., and London, 1987

21 O. Brik, 'The so-called "formal method"', *LEF*, 1923. Quoted in B. Fer, 'The Language of Construction' in Fer et al., *Realism, Rationalism, Surrealism*, p. 122

22 Moholy-Nagy, 'Contemporary Typography' in Passuth, *Moholy-Nagy*, p. 293

23 ibid. pp. 294–95

24 In a language in which all nouns start with a capital, and in a period when 'Fraktur' was still the norm, Bauhaus strictures were particularly and deliberately controversial.

25 J. Tschichold, 'Elemental Typography', *Typographische Mitteilungen*, Berlin, no. 10, 1925. Translated in R. Kinross, *Modern Typography: An Essay in Critical*

History, London, 1992, pp. 87–89

26 J. Tschichold, *The New Typography* (trans. R. McLean), Berkeley and Los Angeles, 1995

27 L. Moholy-Nagy, 'Typophoto'. Quoted in J. Fiedler (ed.), *Photography at the Bauhaus*, London, 1990, pp. 137–38

28 K. Schwitters, 'Rules About Typography', *Merz*, Typoreklame issue, Hanover, 1924. Reprinted and translated in Hertz and Klein, *Twentieth Century Art Theory*, p. 299

8 L'Alphabet des rêves: Surrealist Words

1 A. Breton, *Nadja* (1928) (trans. R. Howard), New York, 1976

2 L. Aragon, *Le Paysan de Paris* (1926) (trans. S. W. Taylor), London, 1980, p. 104

3 W. Benjamin, 'Der Surrealismus', *Literarische Welt*, no. 5, Berlin, 1929 in four instalments. Reprinted in *One-Way Street* (trans. E. Jephcott and K. Shorter), London, 1997, p. 230

4 A. Breton, 'Les Mots sans rides', *Littérature*, 7 (new series), December 1922. Reprinted in A. Breton, *Les Pas perdues*, 1924. Translated as 'Words without Wrinkes' in *The Lost Steps* (trans. M. Polizzotti), Lincoln, Neb., and London, 1996, p. 100

5 ibid. p. 100

6 ibid. pp. 100–101

7 ibid. p. 100

8 ibid. p. 102

9 A. Breton, *Manifeste de Surréalisme*, 1924. Translated in P. Walberg, *Surrealism*, London, 1965, p. 72

10 ibid.

11 A. Breton, 'Entrée des Médiums', *Littérature*, 6 (new series), 1 November 1922. Translated as 'The Mediums Enter' in *The Lost Steps*, p. 90

12 A. Breton and P. Soupault, *Les Champs magnétique*, Paris, 1921

13 A. Breton, 'Second Manifeste de Surréalisme', *La Revue Surréaliste*, 12, 15 December 1929. Translated in *Manifestoes of Surrealism* (trans. R. Seaver and H. R. Lane), Ann Arbor, Mich., 1969, p. 146

14 Breton, 'The Mediums Enter', pp. 93–95

15 This point is made in J. C. Welchman, *Invisible Colours: A Visual History of Titles*, New Haven and London, 1997, p. 240

16 The phrase is used as the title of André Breton's 1932 novel, *Les Vases communicants*. Translated as *Communicating Vessels* (trans. M. A. Caws and G. T. Harris), Lincoln, Neb., and London, 1990

17 L. Aragon, introduction to *Max Ernst: Exposition de collages*, exh. cat., Galerie Gohmans, Paris, March 1930. Trans. as 'The Challenge to Painting' in P. Hulten (ed.), *The Surrealists Look at Art*, Venice, Calif., 1990, p. 56

18 A. Breton, foreword to *La femme 100 têtes*, 1929. Translated as *The Hundred Headless Woman* (trans. D. Tanning). Excerpted in J. Rothenberg and S. Clay, *A Book of the Book: Some Works and Projections about the Book and Writing*, New York, 2000, p. 215

19 L. Wittgenstein, *Tractatus Logico-Philosophicus*, 1924, (trans. D. G. Pears and B. F. MacGuiness), London, 1961. For a discussion of the connection between Wittgenstein's theories and Magritte see S. Gablik, *Magritte*, London, 1970, pp. 122–44

20 M. Foucault, *Ceci n'est pas une pipe*, 1973. Translated as *This Is Not A Pipe* (trans. and ed. J. Harkness), Berkeley, Los Angeles and London, 1983, p. 15

21 J. Miró, 'Statement', *Minotaure*, Paris, December 1933. Quoted in Rowell, M. (ed.), *Joan Miró: Selected Writings and Interviews*, London, 1987, p. 122

22 A. Breton, 'Le Surréalisme et la peinture', *La Revolution surréaliste*, Paris, vol. 1, July, 1925. Translated as *Surrealism and Painting* (trans. S. W. Taylor), New York, 1972, p. 68

23 ibid.

24 A. Masson, 'Le Peintre et ses fantasmes', *Le Rebelle au surréalisme: Ecrits*, quoted and translated in D. Ades, *André Masson: Line Unleashed*, exh. cat., Hayward Gallery, London, 1987, p. 3.

9 Beat the Whites with the Red Wedge: Words and Power

1 V. I. Lenin, *Novaya Zhizin*, no. 12, Moscow, 13 November 1905. Quoted in I. Golomstock, *Totalitarian Art*, London, 1990, p. 32

2 'Program of the Productivist Group', *Egyseg*, Vienna, 1922. Quoted in S. Bann (ed.), *The Tradition of Constructivism* (trans. I. and O. van Os), London, 1974, p. 18.

3 ibid. p. 20

4 G. Klucis, preface to exhibition catalogue *Fotomontage* 1931. Quoted in D. Ades, *Photomontage*, London and New York, 1976, p. 15.

5 E. Lissitzky, 'Our Book', *Gutenberg-Jahrbuch*, 1926–27, Reprinted in R. Hertz and N. M. Klein, *Twentieth Century Art Theory: Urbanism, Politics, and Mass Culture*, Englewood Cliff, N. J., 1990, p. 295.

6 W. Benjamin, 'The Work of Art in the Age of Mechanical Reproduction', 1936, reprinted in H. Arendt (ed.), *Illuminations* (trans. H. Zorn), London, 1973, pp. 234–35

7 H. Bayer, 'Simplified Script' (1925). Reprinted in F. Whitford, *The Bauhaus: Masters and Students by Themselves*, London, 1992, p. 240

8 J. Tschichold, 'Speech at Type Directors' Seminar', 18 April 1959. Quoted in R. McLean, *Jan Tschichold: Typographer*, London, 1975

9 G. Orwell, *Nineteen Eighty-Four* (1949) in *The Complete Novels of George Orwell*, Harmondsworth, 1983, p. 773

10 Rudolf Koch, quoted in H.-P. Willberg, 'Fraktur and Nationalism' in P. Bain and P. Shaw (eds), *Blackletter: Type and National Identity*, New York, 1998, p. 42

11 See, for example, J. Aynsley, *Graphic Design in Germany, 1890–1945*, London, 2000

12 T. Adorno, *Prisms* (1967) (trans. S. and S. Weber), Harvard, Mass., 1981, p. 34

13 G. Steiner, 'The Hollow Miracle', *Language and Silence*, London, 1967, p. 122

10 Writing Degree Zero: Post-War Words

1 See J.-P. Sartre, *L'Être et le Néant*, 1943, translated as *Being and Nothingness* (trans. H. E. Barnes), New York, 1956, pp. 47–72

2 See M. Heidegger, *Zein und Zeit*, 1927, translated as *Being and Time* (trans. J. Macquaurie and E. Robinson), Oxford, 1962.

3 J.-P. Sartre, *La Nausée*, 1938. Translated as *Nausea* (trans. R. Baldick), Harmondsworth, 1965, p. 182

4 S. Beckett, *Transition*, no. 5, Paris, 1949. Reprinted in S. Beckett and G. Duthuit, 'Proust: Three Dialogues' (trans. S. Beckett), London, 1965, pp. 97–126

5 I. Isou, *Introduction à une Nouvelle Poesie et une Nouvelle Musique*, 1947. See translation by D. W. Seaman in *Visible Language*, vol. 18, no. 3, 1985, p. 72

6 The collection is now in Lausanne, Switzerland.

7 J. Dubuffet, 'L'Art Brut preferé aux art culturels', 1948. Reprinted and translated in C. Harrison and P. Wood (eds), *Art in Theory 1815–1900*, Oxford, 1998, p. 595

8 ibid.

9 The hyperbolic use of words, musical notation and images.

10 A. Jorn, 'Les formes conçus commes langage', *Cobra*, no. 2, Paris, 1949. Quoted in *Aftermath: Visions of Man in Post-War Paris* (trans. S. Wilson), exh. cat., Barbican Art Gallery, London, 1982, p. 107

11 M. Merleau-Ponty, 'L'Oeil et l'esprit', *Art de France*, no. 1, Paris, January 1961. Translated as 'Eye and Mind' in G. A. Johnson (ed.), *The Merleau-Ponty Aesthetic Reader: Philosophy and Painting* (trans. M. Smith), Evanston, Ill., 1993, pp. 123–24

12 A. Jorn, 'De profetiske harper', *Helbresten*, Amsterdam, no. 2, 1944. Quoted in H. Westgeest, *Zen in the Fifties: Interactions between East and West*, Amsterdam, 1996, p. 136, n. 71. P. Alechinsky, 'De Japanse Calligraphie in een Nieuwe Phase', *Museumjournaal*, 2, Amsterdam, 1956, quoted in Westgeest, *Zen in the Fifties*, p. 113

13 H. Michaux, 'Movements', 1950–51. Quoted in K. Stiles and P. Selz (eds), *Theories and Documents of Contemporary Art: A Sourcebook of Artists' Writings*, Berkeley and Los Angeles, 1996, p. 46

14 G. Mathieu, 'Towards a New Convergence of art, Thought and Science', *Art International*, London, vol. 4, no. 2, May 1960. Excerpted in ibid. p. 701. Merovingian is the style of Gaul and Germany in the period c. 500–750. The calligraphic script is characterized by a richly imaginative play on Roman letters. See G. Bologna, *Illuminated Manuscripts: The Book before Gutenberg*, London, 1988, p. 36

15 Quoted in A. Augusti, *Antoni Tàpies: The Complete Works*, vol. 3, 1969–75, Barcelona, 1992, p. 12

16 M. Tobey, 'Interview with William Seitz', 1962, *Tobey Papers, Archives of American Art, Washington DC*, quoted in Westgeest, *Zen in the Fifties*, p. 49

17 Gorky and De Kooning also learnt lessons from sign-painters, employing their specially designed brushes in order to achieve the characteristic whiplash line of their paintings.

18 See R. Holt, *Lee Krasner*, New York, 1993, pp. 43–46. On Gottlieb's 'pictogram' paintings see *The Pictograms of Adolph Gottlieb*, exh. cat., Adolph and Esther Gottlieb Foundation, New York, 1994

19 See P. Karmel, 'Pollock at Work: The Films and Photographs of Hans Namuth' in K. Varnedoe with P. Karmel, *Jackson Pollock*, London, 1998, pp. 87–137

20 H. Rosenberg, 'The American Action Painters', *Art News*, New York, December 1952. Reprinted in H. Rosenberg, *The Tradition of the New*, New York, 1959

21 For Newman's views on the 'New Man' see 'The Sublime is Now', 1949, reprinted in J. P. O'Neill (ed.), *Barnett Newman: Selected Writings and Interviews*, Berkeley and Los Angeles, 1990, pp. 170–73

22 Robert Ryman interviewed by Robert Storr in R. Storr, *Robert Ryman*, exh. cat., Tate Gallery, London, 1993, p. 70

23 The term 'demotic' is used in this context by A. C. Danto, 'Cy Twombly', *The Madonna of the Future: Essays in a Pluralistic Art World*, Berkeley and Los Angeles, 2001, pp. 95–94

24 R. Barthes, 'Cy Twombly: Works on Paper', *L'obvie et l'obtus*, 1982. Translated in *The Responsibility of Forms* (trans. R. Howard), Berkeley and Los Angeles, 1985, p. 158. On p. 160 Barthes adds, 'Of writing TW [Twombly] retains the gesture, not the product'.

11 Intermedia: Neo-Dada Words

1 D. Higgins, 'Statement on Intermedia', *Dialectics of Centuries*, 1966. Reprinted in E. Armstrong and J. Rothfuss (eds), *In the Spirit of Fluxus*, Minneapolis, 1993, pp. 172–73

2 M. McLuhan, 'The Media Fit the Battle of Jericho', *Encounters*, no. 6, 1956. Reprinted in E. McLuhan and F. Zingrone (eds), *Essential McLuhan*, London, 1995, p. 300

3 M. Bense, 'Koncrete Poesie', I, *Koncrete Poesie International*, 1965. Quoted in J. Brand, N. Gast and R.-J. Muller (eds), *De Woorden en de Beelden: Tekst en Beeld in de Kunst van de Twintigste Euew/The Words and the Images: Text and Images in the Art of the Twentieth Century*, exh. cat., Centraal Museum, Utrecht, 1991, p. 129. For examples of Concrete Poetry see M. E. Solt, *Concrete Poetry: A World View*, Bloomington, Ind., 1968. An excellent online collection is the Sackner Archive of Concrete and Visual Poetry database at *http://www.rediscov.com/sackner*

4 For the importance of Max Bill to typography see G. Fleischmann, H. R. Bosshard and C. Bignens, *Max Bill: Typography, Advertising, Book Design*, Berne, 1999

5 D. T. Suzuki, *An Introduction to Zen Buddhism* (1948), London, rev. edn, 1983, p. 59

6 ibid. p. 61

7 See D. Charles and J. Cage, *For the Birds*, Boston and London, 1981

8 R. Rauschenberg, *Sixteen Americans*, exh. cat., Museum of Modern Art, New York, 1959. Reprinted in D. Ashton, *Twentieth Century Artists on Art*, New York, 1985, p. 243

9 Robert Rauschenberg quoted in M. L. Kotz, *Rauschenberg: Art and Life*, New York, 1990, p. 83

10 J. Cage, 'Robert Rauschenberg', *Metro*, Milan, May 1961. Reprinted in J. Cage, *Silence*, Cambridge, Mass., 1969, p. 98

11 Rauschenberg, *Sixteen Americans*, p. 243

12 L. Steinberg, 'Reflections on the State of Criticism' in L. Steinberg, *Other Criteria: Confrontations with Twentieth Century Art*, London and New York, 1972, p. 182

13 A. Kaprow, *Assemblages, Environments & Happenings*, New York, 1966, p. 161

14 G. Maciunas, 'Fluxus Broadside Manifesto', New York, September 1965. Quoted in T. Kellein, *Fluxus*, London, 1995, p. 135

15 ibid. p. 134

16 Y. Ono, 'To the Weslyan People', 1966, in *Grapefruit*, 1974. Quoted in K. Stiles and P. Selz (eds), *Theories and Documents of Contemporary Art: A Sourcebook of Artists' Writings*, Berkeley and Los Angeles, 1996, p. 737

17 G. Brecht, 'Project in Multiple Dimensions' in H. Martin (ed.), *An Introduction to George Brecht's Book of the Tumbler on Fire*, 1978. Excerpted in Stiles and Selz (eds), *Theories and Documents*, p. 333

18 'Event Scores', illustrated in Stiles and Selz (eds), *Theories and Documents*, p. 354

19 J. de la Villeglé, *Villeglé: Lacéré anonyme*, exh. cat., Musée d'art moderne de la ville de Paris, Centre Georges Pompidou, Paris, 1977, p. 21

20 G. Debord and G. J. Wolman, 'Methods of Detournment', *Les Lèvres Nues*, Paris, no. 8, May 1956. Translated in K. Knabb (ed. and trans.), *Situationist International Anthology*, Berkeley, Calif., 1981, p. 15

21 G. Debord and A. Jorn, *Mèmoires. Structures portantes d'Asger Jorn*, Copenhagen, 1959

12 Coca-Cola: Pop Words

1 S. Stitch, *Made in USA: An Americanisation in Modern Art, The 50s & 60s*, Berkeley, 1987, p. 89

2 Like Léger, Davis's interest in the signs of mass culture was also tied to a Left-wing political agenda. See, for example, *Stuart Davis: Art and Theory*, exh. cat., Brooklyn Museum, New York, 1978

3 Letter to architects Alison and Peter Smithson, 16 January 1957, in R. Hamilton, *Richard Hamilton: Collected Words, 1953–1982*, London, 1982, p. 28

4 L. Alloway, 'The Long Front of Culture', *Cambridge Opinion*, 17, 1959, in J. Russell and S. Gablik, *Pop Art Redefined*, London, 1969, p. 41

5 ibid.

6 M. McLuhan, *Understanding Media: The Extensions of Man*, London, 1975, p. 512

7 The 'Futura' typeface and its imitators remained leading choices among typographers, but were joined in the early 1960s by two new and immediately popular sans serifs, 'Univers' and 'Helvetica'.

8 J. Johns, 'Møde med Jasper Johns', interview with Gunnar Jespersen, *Berlingske Tidende*, 23 February 1969 (trans. S. de Francesco), as quoted in K. Varnedoe, *Jasper Johns: A Retrospective*, New York, 1996, p. 34n.

9 Jasper Johns, interview with David Sylvester, BBC, 10 October 1965, as quoted in C. Harrison and P. Wood (eds), *Art in Theory 1900–1990*, Oxford, 1992, p. 721

10 ibid.

11 Johns would have had direct experience of the military use of stencil. He was drafted in 1951, and while stationed in Japan during the Korean War, was assigned to Special Forces, where he made posters. He was discharged in 1953. See Varnedoe, *Jasper Johns*, pp. 111–12

12 Silk-screen printing belongs to the same family of techniques as the stencil, and involves passing ink through a synthetic fabric stretched over a frame with a blade called a squeegee so that it flows through unblocked areas on to the surface. A print can also be made from a photograph using photosensitive chemicals, a technique pioneered by both Warhol and Rauschenberg.

13 Stitch, *Made in USA*, p. 109n.

14 Russell and Gablik, *Pop Art Redefined*, p. 41

15 A. Warhol, 'What is Pop Art?', interview with G. Swenson, *Art News*, November 1963, in Russell and Gablik, *Pop Art Redefined*, p. 117

16 'Interview with Ruscha in his Hollywood studio', 1981, interview with Paul Karlstron, California Oral History Archives of American Art, Smithsonian Institution. In A. Schwartz (ed.), *Ed Rusha. Leave Any Information at the Signal: Writings, Interviews, Bits, Pages*, Cambridge, Mass., and London, 2002, pp. 150–51

17 'Ed Ruscha, Young Artist: Dead Serious about Being Nonsensical', interview with Patricia Failing, *Art News*, April 1982. Reprinted in Schwartz (ed.), *Ed Rusha*, p. 234

18 Comic books are the work of three distinct professions: artist, letterer and inker.

19 See V. Packard, *The Hidden Persuaders*, London, 1957

20 H. Marcuse, *One-Dimensional Man: Studies in the Ideology of Advanced Industrial Society*, 2nd edn, London, 1991, p. 85

13 Art As Idea As Idea: Conceptual Words I

1 This is discussed in L. R. Lippard and J. Chandler, 'The Dematerialization of Art', *Art International*, vol. 12, no. 2, New York, February 1968. Reprinted in A. Alberro

and B. Stimpson, *Conceptual Art: A Critical Anthology*, Cambridge, Mass., 1999, pp. 46–50

2 Editorial in *Art-Language*, vol. 1, no. 1, London, 1969. Reprinted in Alberro and Stimpson, *Conceptual Art*, p. 99

3 C. Lévi-Strauss, *Triste Tropique*, 1955. Translated as *Triste Tropique* (trans. J. and D. Weightman), New York, 1974, p. 299

4 See, for example, L. Althusser, *Pour Marx*, 1965. Translated as *For Marx* (trans. B. Brewster), Harmondsworth, 1969

5 R. Barthes, *Eléments de la semiologie*, 1964. Translated as *Elements of Semiology* (trans. A. Lavers and C. Smith), New York, 1967, p. 25

6 R. Barthes, *Mythologies*, 1957. Translated as *Mythologies* (trans. A. Lavers), New York, 1972, p. 155

7 See, for example, J. L. Austin, *How To Do Things With Words*, Cambridge, Mass., 1962

8 See N. Chomsky, *Syntactic Structures*, The Hague, 1957

9 See, for example, C. Shannon and W. Weaver, *The Mathematical Theory of Communication*, Urbana, 1949; N. Wiener, *Cybernetic: Or Control and Communications in the Animal and the Machine* (1948), Cambridge, 1967; J. von Neuman, *The Computer and the Brain*, New Haven, 1949

10 J. Kosuth, 'Art as Idea as Idea', interview with Jeanne Siegel broadcast on WBAI-FM, 7 April 1970. Reprinted in G. Guercio (ed.), *Joseph Kosuth: Art after Philosophy and After. Collected Writings, 1966–1990*, Cambridge, Mass., 1991

11 H. Rosenberg, 'Art and Words', *New Yorker*, 29 March 1969. Reprinted in G. Battock (ed.), *Idea Art: A Critical Anthology*, New York, 1973, pp. 151–52. The classic exposé of this is Tom Wolfe's *The Painted Word*, Toronto, New York, London and Sydney, 1976

12 K. McShine, *Information*, exh. cat., Museum of Modern Art, New York, 1970, p. 139

13 ibid. pp. 139–40

14 ibid.

15 S. Le Witt, 'Paragraphs on Conceptual Art', *Artforum*, vol. 5, no. 10, New York, September 1967. Reprinted in Alberro and Stimpson, *Conceptual Art*, p. 15

16 John Baldessari in conversation with Coosje van Bruggen. Cited in C. van Bruggen, *John Baldessari*, New York, 1990, p. 89

17 'John Baldessari; Recalling Ideas', an interview with Jeanne Siegel. J. Siegel, *Art Talk: The Early '80's*, New York, 1988, pp. 37–58

18 L. Weiner, 'Statement', *Arts Magazine*, New York, April 1970. Reprinted in Battock (ed.), *Idea Art*, p. 175

19 ibid.

20 Lawrence Weiner interviewed by Phyllis Rozenzweig in *Lawrence Weiner: Works With The Passage Of Time*, exh. cat., Hirshhorn Museum and Sculpture Garden, Washington, D.C., 1990, unpag.

21 Lawrence Weiner interviewed by Jean-Marc Poinset, 1988, quoted in B. Pelzer, 'Dissociated Objects: The "Statements" Sculptures of Lawrence Weiner', *October*, Fall 1999, p. 86

22 Benjamin H. D. Buchloh in conversation with Lawrence Weiner in A. Alberro and A. Zimmerman, B. H. D. Buchloh and D. Batchelor, *Lawrence Weiner*, London, 2000, p. 23

23 Arakawa and M. Gins, *The Mechanism of Meaning* (1979), New York, rev. edn 1988

24 For Wittgenstein and 'language games' see L. Wittgenstein, *Philosophical Investigations* (trans. G. E. M. Anscombe), London, 3rd edn 1953

25 Joseph Kosuth interviewed by Jeanne Siegel in Guercio (ed.), *Joseph Kosuth*, p. 52

26 ibid.

27 C. Harrison, *Essays on Art & Language*, Oxford, 1991, p. 56

28 V. Burgin, 'Socialist Formalism', *Studio International*, London, vol. 191, no. 980, March/April 1976. Reprinted in Harrison and Wood (eds), *Art in Theory*, p. 915

29 Hans Haake, 'Shapolsky et al. Manhattan Real Estate Holdings, A Real-Time Social System, as of May 1, 1971' first shown at Galleria François Lambert, Milan, January 1972

30 T. Phillips, 'Notes on "A humument"' in *Tom Phillips: Works and Texts*, London, 1992, p. 252

31 Editorial, *Art-Language: The Journal of Conceptual Art*, London, May 1969. Reprinted in Alberro and Stimpson, *Conceptual Art*, p. 99

32 Lawrence Weiner's 'Statement', for example was designed to appear as a work in itself in the journal *Arts Magazine* (see note 16 above). Other significant examples are Dan Graham's 'Homes for America', spread published in *Arts*, 41, no. 3, December 1966–January 1967, and Robert Smithson's 'A Tour of the Monuments of Passiac, New Jersey' in *Artforum*, December 1967

14 A Heap of Language: Conceptual Words II

1 Cited in M. Rohan, *Paris '68*, London, 1988, p. 78

2 R. Barthes, 'Lecture in Inauguration of the Chair of Literary Semiology, Collège de France', 1976. Quoted in H. Foster, *Recodings: Art, Spectacle, Cultural Politics*, Port Townsend, Wash., p. 108

3 J. Derrida, *De la Grammatologie*, 1967. Translated as *Of Grammatology* (trans. G. Chakravorty Spivak), Baltimore and London, 1976, p. 156

4 J. Derrida, *Positions*, 1972. Translated as *Positions* (trans. Alan Bass), Chicago, 1981, p. 26

5 J. Derrida, *Of Grammatology*, p. 86

6 M. Foucault, *Les Mots et les Choses: Une archéologie des sciences humaines*, 1966. Translated as *The Order of Things: An Archaeology of the Human Sciences* (trans. A. Sherdian), London, 1970

7 J. Lacan, *Ecrits*, 1966. Translated as *Ecrits: A Selection* (trans. A. Sheridan), London, 1977

8 J.-F. Lyotard, *Discours/figure*, Paris, 1971

9 Joseph Beuys interviewed by Achille Bonito Oliva, in A. B. Oliva, *Dialoghi d'Artista, Incontri con 'Arte Contemporanea, 1970–1984*, 1984. Translated in J. Siegel, *Art Talk: The Early '80's*, New York, 1988, p. 82

10 G. B. Salerno *Alighiero e Boetti, Insicuro Noncurante*, 1986. Quoted in C. Christov-Bakargiev, *Arte Povera*, London, 1999, p. 85

11 R. Smithson, 'A Sedimentation of the Mind: Earth Projects', *Artforum*, September 1968. Reprinted in N. Holt (ed.), *The Writings of Robert Smithson: Essays with Illustrations*, New York, 1979, p. 87

12 ibid. p. 154

13 Mel Bochner quoted in T. Godfrey, *Conceptual Art*, London, 1998, p. 164

14 This is something that has also been recognized by the pioneers of 'idea-art', as the more recent works of such artists as Robert Barry, Lawrence Weiner and even Joseph Kosuth show (see pp. 206–207).

15 John Baldessari interviewed by Jeanne Siegel in Siegel, *Art Talk*, p. 59

16 I. H. Finlay, 'Detached Sentences on Concrete Poetry (undated) in J. Brand, N. Gast and R.-J. Muller (eds), *De Woorden en de Beelden: Tekst en Beeld in de Kunst van de Twintigste Euew/The Words and the Images: Text and Images in the Art of the Twentieth Century*, exh. cat., Centraal Museum, Utrecht, 1991, p. 159.

17 ibid.

18 Finlay consistently works with a variety of craftspeople and so, like Weiner and other Conceptualists, sees the artist's role as giving birth to the idea.

19 Marcel Broodthaers interviewed by Ludo Bekkers, 1970. Quoted in B. H. D. Buchloh, 'Marcel Broodthaers: Allegories of the Avant-Garde', *Artforum*, New York, May 1980. Reprinted in Brand, Gast and Muller (eds), *De Woorden en de Beelden*, p. 161

20 M. Broodthaers, 'Ten Thousand Francs Reward', 1974. Reprinted in 'Broodthaers: Writings, Interviews, Photographs', *October*, B. H. D. Buchloh (ed.), no. 42, Fall 1987, p. 38

21 Bruce Nauman quoted in R. Storr, 'Beyond Words' in N. Benezra and K. Halbreich, *Bruce Nauman: Exhibition Catalogue and Catalogue Raisonne*, exh. cat., Walker Art Center, Minneapolis, in association with the Hirshhorn Museum and Sculpture Garden, Smithsonian Institute, Washington, D.C., 1994, p. 55

22 H. Cixous, 'The Laugh of the Medusa' (trans. K. Cohen and P. Cohen), *Signs*, summer 1976. Reprinted in E. Marks and I. de Courtivron (eds), *New French Feminism: An Anthology*, New York, 1981, p. 249

23 'Nancy Spero: Woman as Protagonist', interview with Jeanne Siegel in Siegel, *Art Talk*, p. 261

24 H. Cixous, 'The Laugh of the Medusa' in Marks and de Courtivron (eds), *New French Feminism*, p. 257

25 Hanne Darboven quoted in I. Burgbacher-Krupka, *Hanne Darboven: Constructed Literary Musical*, Reihe Cantz, 1994, p. 12

26 Hanne Darboven interviewed by Franz Meyer, 1991, quoted in ibid. p. 40

15 The Prison-House of Language: Postmodern Words

1 'Anselm Kiefer' interview with Donald Kuspit, 1987, in J. Siegel, *Art Talk: The Early '80's*, New York, 1988, p. 90

2 'Dialogues' in *Tim Rollins + KOS*, exh. cat., Whitechapel Art Gallery, London, 1988. Reprinted in J. Brand, N. Gast and R.-J. Muller (eds), *De Woorden en de Beelden: Tekst en Beeld in de Kunst van de Twintigste Euew/The Words and the Images: Text and Images in the Art of the Twentieth Century*, exh. cat., Centraal Museum, Utrecht, 1991, p. 242

3 R. Venturi, D. Scott Brown and S. Izenour, *Learning from Las Vegas*, Cambridge, Mass., 1977, p. 8

4 J. Baudrillard, 'The Masses: The Implosion of the Social in the Media' (trans. M. Maclean), *New Literary History*, vol. 16, no. 3, Spring 1985. Reprinted in M. Poster (ed.), *Jean Baudrillard: Selected Writings*, London, 1988, p. 207

5 The phrase is used in F. Jameson, *The Prison-House of Language: a Critical Account of Structuralism and Russian Formalism*, Princeton, N. J., 1972

6 J. Baudrillard, 'The Precession of Simulacra' (trans. P. Foss and P. Patton), *Art & Text*, no. 11, September 1983. Reprinted in B. Wallis (ed.), *Art After Modernism: Rethinking Representation*, New York, 1984, p. 253

7 'Barbara Kruger: Pictures and Words', interview with Jeanne Seigel, 1987, in Siegel, *Art Talk*, p. 300

8 'Pictures and Promises', *The Kitchen*, New York, January 1981

9 Cited in G. Marcus, 'Wool's Word Paintings', *Parkett*, Berne, no. 33, September 1992, p. 87.

10 R. Vaneigem, *Traité de savoir-vivre à l'usage des jeunes generations*, 1967. Translated as *The Revolution of Everyday Life* (trans. J. Fullerton and P. Sieveking), London, 2nd edn 1979

11 Quoted in N. Kernan, 'Richard Prince', *Apocalypse: Beauty and Horror in Contemporary Art*, exh. cat., Royal Academy of Arts, London, 2000, p. 39

12 Siegel, *Art Talk*, p. 302

13 ibid.

14 ibid. p. 303

15 For a fuller list see D. Joselit, J. Simon and R. Saleci, *Jenny Holzer*, London, 1998, pp. 116–25

16 Jenny Holzer interviewed by Diane Waldman, June 6 and July 12, 1989, in D. Waldman, *Jenny Holzer*, exh. cat., Guggenheim Museum, New York, 2nd edn, 1997, p. 31

17 J. Holzer, 'Book Report: a Response to Artists' Choice', 1997, in Joselit, Simon and Saleci, *Jenny Holzer*, p. 104

18 Holzer's 'adaweb' project which went online in 1995 invites people to add new truisms. At *http://adaweb.com/cgi-bin/jfsjr/truism*

19 Quoted in C. Squires, 'Divisionary Syn(tactics): Barbara Kruger has her way with words', *Artnews*, New York, no. 86, February, 1987. Reprinted in Brand, Gast and Muller (eds), *De Woorden en de Beelden*, p. 255

20 Interview with Catherine Kinley, 1985, *Susan Hiller: 'Balshazzar's Feast'*, exh. cat., Tate Gallery, London, 1985. Reprinted in B. Einzig (ed.), *Thinking About Art: Conversations with Susan Hiller*, Manchester, 1996, pp. 93–94

21 Interview with Rozsika Parker, 1984, in *Susan Hiller 1973–83, The Muse My Sister*, exh. cat. Orchard Gallery, Londonderry, 1984. Reprinted in ibid. p. 51

22 ibid.

23 Heiferman, M. (ed.), *Image World: Art and Media Culture*, exh. cat., Whitney Museum of American Art, New York, 1989, p. 17

16 Creolization: Millennial Words

1 See *Raymond Pettibon: A Reader*, exh. cat., Philadelphia Museum of Art, Philadelphia and The Renaissance Society at the University of Chicago, Chicago, 1998

2 Ilya Kabakov in conversation with Amei Wallach in A. Wallach, 'Utopia and Beyond', *Contemporary Visual Art*, London, no. 14, 1997, p. 24

3 Svetlana Kopystiansky interviewed by Gavin Jantjes (1997) in G. Jantjes, *A Fruitful Incoherence: Dialogues with Artists on Internationalism*, London, 1998, p. 73

4 The luckless volumes were actually Wang Bomin's *History of Chinese Painting* and Herbert Read's *Concise History of Modern Painting*.

5 Interview with Xu Bing, 'Twixt East and West', was formerly online at *http://www.virtualchina.com/ archive/leisure/art/xubing.html*

6 Carlos Capelán interviewed by Gavin Jantjes (1998) in Jantjes, *A Fruitful Incoherence*, p. 40.

7 ibid. p. 42

8 G. Kuitca, '"Iterations": Letters between Lynne Cooke and Guillermo Kuitca' in *Guillermo Kuitca: Burning Beds, A Survey 1982–1994*, exh. cat., Contemporary Art Foundation, Amsterdam, 1994, p. 17.

9 See P. E. Bocquet, 'The Visual Arts and Créolité' in G. Mosquera (ed.), *Beyond the Fantastic: Contemporary Art Criticism from Latin America*, London, 1995, pp. 114–20. See also O. Enwesor, 'The Black Box', exh. cat., 'Documenta 11', Ostfildern, 2002, pp. 42–55

17 Epilogue: Hypertexts and Future Words

1 W. Gibson, 'Fragment of a Hologram Rose', 1977. Reprinted in W. Gibson, *Burning Chrome*, London, 2000, pp. 56–57

2 P. Virilio, 'Speed and Information; Cyberspace Alarm!', *Le Monde Diplomatique*, Paris, August 1995. Reprinted in D. Trend (ed.), *Reading Digital Culture* (trans. P. Reimens), Oxford, 2001, p. 24.

3 ibid.

4 Gary Hill interviewed by Gianni Romano, quoted in H. K. Bhabha, 'Beyond the Pale: Art in the Age of Multicultural Translation' in E. Sussman (ed.), *1993 Whitney Biennial Exhibition*, exh. cat., Whitney Museum of American Art, New York, 1993, p. 68

5 See R. Ascott, *Telematic Embrace: Visionary Theories of Art, Technology, and Consciousness* (ed. E. A. Shanken), Berkeley and Los Angeles, 2001. By 'telematic' Ascott means the interconnection between computers and telecommunication which is opening up new possibilities in participatory interaction. Ascott's 'La plissure du text' can be viewed online at: *http://telematic.walkerart.org*

6 For examples of 'hypertext' and 'hypermedia' works as well as an archive of Pattern and Concrete Poetry see, for example, *http://www.ubu.com*

7 L. Hershman, 'The Fantasy Beyond Control' (1990) in *Art & Design, Art and Technology*, 1994. Reprinted in R. Packer and K. Jordan (eds), *Multimedia: From Wagner to Virtual Reality*, New York and London, 2001, p. 301

8 The work has been presented in Karlsruhe, Amsterdam and New York. In New York the area between 34th and 66th Street and Park and 11th Avenue on Manhattan was represented and eight independent narratives written by Shaw's collaborator Dirk Groenveld could be followed – fictional monologues by Ed Koch, Frank Lloyd Wright, Donald Trump, Noah Webster, a tourist, a con man, an ambassador and a cab driver. O. Seifert, 'The Legible City' in H. Klotz (ed.), *Media Scape*, exh. cat., Guggenheim Museum, New York, 1996, p. 48

9 The term was coined by Mark Dery. See 'Culture Jamming: Hacking, Slashing and Sniping in the Empire of Signs' at *http://www.essentialmedia.com/ Shop/Dery.html*

10 L. Manovich, online conversation recorded in A. Scholder and J. Crandall (eds), *Interaction: Artistic Practise in the Network*, New York, 2001, p. 53

11 Accessible online at: *http://www.krcf.org/krcfhome*

12 'Knowbotic Research' in Scholder and Crandall (eds), *Interaction*, pp. 115, 120

13 Quoted in *Data Dynamics*, exh. pamphlet, Whitney Museum of American Art, New York, 2001, unpag. *Netomat* also exists online at: *http://www.netomat.net*

14 The term was first coined by Donna Hathaway in D. Hathaway, *Simians, Cyborgs, and Women: The Reinvention of Nature*, London, 1991

15 L. Rinder, *Bitstreams*, exh. cat., Whitney Museum of American Art, New York, 2001, p. 1

16 N. Negroponte, *Being Digital: A Road Map for Survival on the Information Superhighway*, London, 1995

17 D. Crystal, *Language and the Internet*, Cambridge, 2002, pp. 47–48

18 V. Flusser, 'The Future of Writing', *Yale Journal of Criticism*, vol. 6, no. 2, Fall 1993. Reprinted in A. Ströll (ed.), *Vilém Flusser: Writings*, Minneapolis and London, 2002, p. 67

19 While it is clear that radical innovations have shifted written language away from the conventions of print, the normal web interface (GUI – graphical user interface) as it exists today, and as the term web-*page* itself suggests, is still essentially structurally modelled on the book space. Although the computer screen may be dominated by graphic icons, by 'tiled' and 'staked' folders, and hypertextual links, the activity of reading off the screen in normal usage is still not so very different from reading the page of a book, while once a text is printed out, its relationship to the traditional page is again firmly established. Indeed, while the rigid linearity of text may be recognized and criticized as an outdated convention – one that parallels the way in which we repressively structure and chronologically narrate our own lives – this convention is not perhaps in the end one that should necessarily be abandoned lightly in favour of the 'hypertextual' alternatives, because the more traditional experience of reading and writing seems so closely bound up with the basic human need to assuage fundamental existential anxieties about the nature of time and space. For a spirited defence of the book in the age of new media, see U. Eco, The 'Future of the Book' in G. Numberg (ed.), *The Future of the Book*, Berkeley and Los Angeles, 1997. In this context, see an online project with which I am myself involved, initiated by the English artist Simon Morris. It makes the Internet a space for a collective celebration of the book through the ongoing posting of bibliographies of books chosen by a continually increasing number of participants. 'Bibliomania' can be found at: *http://www.bibliomania. org.uk*. Morris has also printed a book-format version of the project. For related works by the author see: *www.simonmorley.com*

Bibliography

Exhibition catalogues for which there is no named author or editor are indexed by title.

General Texts

Ades, D., *Photomontage*, New York, 1976
Ameline, J.-P. (ed.), *Face à la Histoire: L'artiste moderne devant l'événement historique*, exh. cat., Centre Georges Pompidou, Paris, 1996
Ashton, D., *Twentieth Century Artists on Art*, New York, 1985
Austin, J. L., *How To Do Things With Words*, Cambridge, Mass., 1962
Bann, S., 'The Mythical Conception Is the Name: Titles and Names in Modern and Post-Modern Painting, *Word & Image*, vol. 1, no. 2, April–June 1985
Barasch, M., *Theories of Art: From Plato to Winckelmann*, New York and London, 2000
Barnicot, J., *A Concise History of Posters*, London, 1972
Barthes, R., *Elements of Semiology* (trans. A. Lavers and C. Smith), New York, 1967
—, *Mythologies* (trans. A. Lavers), New York, 1972
—, *S/Z* (trans. R. Howard), New York, 1974
—, *The Responsibility of Forms* (trans. R. Howard), Berkeley and Los Angeles, 1991
Belting, H., *Likeness and Presence: A History of the Image before the Era of Art* (trans. E. Jephcott), Chicago, 1994
Benjamin, W., 'The Work of Art in the Age of Mechanical Reproduction' in H. Arendt (ed.), *Illuminations* (trans. H. Zorn), London, 1973
Brand, J., N. Gast and R.-J. Muller (eds), *Der Woorden en de Beelden*: *Texte en beeld in de kunst van de twintigiste eeuw/The Words and the Images: Text and Image in the Art of the Twentieth Century*, exh. cat., Centraal Museum, Utrecht, 1991
Brinker, H., *Zen in the Art of Painting* (trans. G. Campbell), London and New York, 1987
Brozen, Y., *Advertising and Society*, New York, 1974
Bryson, N., *Word and Image: French Painting of the Ancien Régime*, Cambridge, 1981
Butor, M., *Les Mots dans la peinture*, Geneva, 1969
Cheetham, M. A., *The Rhetoric of Purity: Essentialist Theory and the Advent of Abstract Painting*, Cambridge, 1991
Chipp, H. B. (ed.), *Theories of Modern Art: A Sourcebook by Artists and Critics*, Berkeley and Los Angeles, 1968
Chomsky, N., *New Horizons in the Study of Language and Mind*, Cambridge, 2000
Conrad, P., *Modern Times*, London, 2000
Constantine, M., *Word and Image: Posters from the Collection of the Museum of Modern Art*, exh. cat., Museum of Modern Art, New York, 1968
Crow, T., *Modern Art and the Common Culture*, New Haven, Conn., 1996
Culler, J., *On Deconstruction: Theory and Criticism after Structuralism*, London, 1983
Davis, E., *TechGnosis: Myth, Magic and Mysticism in the Age of Information*, London, 1999
Derrida, J., *Of Grammatology* (trans. G. C. Spivak), Baltimore and London, 1981
Dews, P., *Logics of Disintegration: Post-Structuralist Thought and the Claims of Critical Theory*, London and New York, 1987
Drucker, J., *The Visible Word: Experimental Typography and Modern Art, 1909–1923*, Chicago, 1994
—, *The Century of Artists' Books*, New York, 1995
—, *Figuring the Word: Essays on Books, Writing, and Visual Poetics*, New York, 1998
Eco, U., *Semiotics and the Philosophy of Language*, Bloomington, Ind., 1984
—, 'The Future of the Book' in G. Numberg (ed.), *The Future of the Book*, Berkeley and Los Angeles, 1997
Eisenstein, E., *The Printing Press as an Agent of Change: Communications and Cultural Transformations in Early-Modern Europe*, vol. 1–2, Cambridge, 1979

Ewen, S., *Captains of Consciousness: Advertising and the Social Roots of the Consumer Society*, New York, 1975
Flusser, V., *Writings* (ed. A. Ströll, trans. E. Eisel), Minneapolis, Minn., and London, 2002
Foucault, M., *The Order of Things: An Archaeology of the Human Sciences* (trans. A. Sheridan), London
Freedberg, D., *The Power of Images: Studies in the History and Theory Response*, Chicago, 1989
Gamboni, D., *Potential Images: Ambiguity and Indeterminacy in Modern Art*, London, 2002
Gandelman, C. (ed.), 'Inscriptions in Painting', *Visible Language*, vol. 23, no. 2/3, 1989
Gombrich, E., 'Image and Word in Twentieth-Century Art', *Word & Image*, vol. 1, no. 3 July–September 1986
Goodman, N., *Languages of Art: An Approach to a Theory of Symbol*, Indianapolis and Cambridge, 1976
Grail, M., *Lipstick Traces: A Secret History of the Twentieth Century*, London, 1989
Harrison, C., and P. Wood (eds), *Art in Theory: 1900–1990: An Anthology of Changing Ideas*, Oxford, 1992
Harrison, C., P. Wood, J. Gaiger (eds), *Art in Theory: 1815–1900: An Anthology of Changing Ideas*, Oxford, 1998
Hartman, J., *The History of the Illustrated Book*, London, 1981
Hayakawa, S. I., *Language in Thought and Action* (1939), London, 3rd edn, 1974
Hertz, R., and N. M. Klein, *Twentieth Century Art Theory: Urbanism, Politics, and Mass Culture*, Englewood Cliffs, N. J., 1990
Higgins, D., *Pattern Poetry: Guide to an Unknown Literature*, Albany, N. Y., 1987
Hoek, L. H., 'Image and Word: An Exciting Relationship', *Interactions: Bulletin of International Association of Word and Image Studies (IAWIS)*, no. 12, April 1994, *http://www/et.uv.nl/scholar_assocs/iawis/interactions/int.12.html*
Jacobson, R., *Language in Literature* in K. Pomorska and S. Rudy (eds), Cambridge, Mass., and London, 1987
Jay, M., *Downcast Eyes: The Denigration of Vision in Twentieth Century French Thought*, Berkeley and Los Angeles, 1993
Kern, S., *The Culture of Time and Space: 1880–1918*, Cambridge, Mass., 1983
Khalfa, J. (ed.), *The Dialogue between Painting and Poetry: Livres d'artistes, 1874–1999*), exh. cat., Cambridge, 2001
Kostelanetz, R. (ed.), *Esthetics Contemporary*, Buffalo, N. Y., 1989
Krauss, R. E., *The Originality of the Avant-Garde and Other Myths*, Boston, Mass., 1986
Kress, G. and T. van Leeuwen, *Reading Images: The Grammar of Visual Design*, London, 1996
Kristeva, J., *Language: The Unknown* (trans. A. M. Menke), New York, 1989
Lacan, J., *Écrits: A Selection* (trans. A. Sheridan), London, 1977
McGann, J. T., *The Textual Condition*, Princeton, N. J., 1991
—, *Black Riders: The Visible Language of Modernism*, Princeton, N. J., 1993
McLuhan, M., *The Gutenberg Galaxy: The Making of Typographic Man*, Toronto, 1962
Manning, J., *The Emblem*, London, 2002
Marcuse, H., *One-Dimensional Man: Studies in the Ideology of Advanced Industrial Society*, London, 1991
—, *Understanding Media*, London, 1964
Megill, A., *Prophets of Extermity: Nietzsche, Heidegger, Foucault, Derrida*, Berkeley and Los Angeles, 1985
Merleau-Ponty, M., *Phenomenology of Perception* (trans. C. Smith), London, 1989
Miller, H., *Illustration*, London, 1992
Mitchell, S., *The Rise of the Image, The Fall of the Word*, Oxford and New York, 1998
Mitchell, W. J. T., *Iconology: Image, Text, Ideology*, Chicago, 1986
—, *Picture Theory: Essays on Verbal and Visual Representation*, Chicago, 1994
Ong, W., *Orality and Literacy: The Technologising of the Word*, London, 1982
Oosterling, H., 'Intermediality, Art Between Images, Words and Actions' in J.-M. Shaeffer (ed.), *Think Art: Theory and Practice in Art Today*, Witte de With, Center for Contemporary Art, Rotterdam, 1998
Packard, V., *The Hidden Persuaders*, London, 1957
Packer, R., and K. Jordan (eds), *Multimedia: From Wagner to Virtual Reality*, New York and London, 2001
Peirce, C. S., 'What is a Sign' in The Peirce Editorial Project (ed.), *Essential Peirce*, Bloomington, Ind., 1998
Pergrum, M. A., *Challenging Modernity: Dada Between*

Modernism and Postmodernism, New York and Oxford, 2000
Perloff, M., *Twentieth Century Modernism: The 'New' Poetics*, Oxford, 2002
Pincker, S., *The Language Instinct: The New Science of Language and Mind*, London, 1995
Plato, 'Phaedrus' in *Plato in English*, vol. VI, (trans. H. N. Fowler), London, 1919
Rothenberg, J., *Technicians of the Sacred*, New York, 1968
— and S. Clay (eds), *A Book of the Book: Some Works and Projections about the Book and Writing*, New York, 2000
Sass, L., *Madness and Modernism: Insanity in the Light of Modern Art, Literature and Thought*, Cambridge, Mass., and London, 1992
Saussure, F. de, *Course in General Linguistics* (trans. W. Baskin), New York, 1966
Scobie, S., *Earthquakes and Explorations: Language and Poetry from Cubism to Concrete Poetry*, Toronto, Buffalo and London, 1997
Seitz, W., *The Art of Assemblage*, exh. cat., Museum of Modern Art, New York, 1961
Shlain, L., *The Alphabet Versus the Goddess: The Conflict Between Word and Image*, London, 1998
Sparrow, J., *Visible Words: A Study of Inscriptions in and as Books and Works of Art*, Cambridge, 1969
Die Sprache der Kunst: Die Bezeihung von Bild und Text in der Kunst des 20. Jarhunderts, exh. cat., Wien Kunsthalle, Stuttgart, 1993
Stafford, B. M., *Body Criticism: Imaging the Unseen in Enlightenment Art and Medicine*, Cambridge, Mass., and London, 1991
—, *Good Looking*, Cambridge, Mass., and London, 1992
Steiner, G., *Language and Silence*, London, 1967
—, *After Babel: Aspects of Language and Translation*, Oxford, 1975
—, 'After the Book' in *On Difficulty and Other Essays*, Oxford, 1980
—, 'The Retreat from the Word', *George Steiner: A Reader*, Harmondsworth, 1984
Steiner, W., *The Colors of Rhetoric: Problems in the Relation between Modern Literature and Painting*, Chicago, 1982
Stiles, K., and P. Selz (eds), *Theories and Documents of Contemporary Art: A Sourcebook of Artists' Writings*, Berkeley and Los Angeles, 1996
Suzuki, D. T., *An Introduction to Zen Buddhism*, London, rev. edn, 1983
Timms, E., and D. Kelly (eds), *Unreal City: Urban Experience in Modern European Literature and Art*, Manchester, 1985
Tufte, E. R., *Envisioning Information*, Cheshire, Conn., 1990
Ulmer, G. L., *Applied Grammatology: Post(e) Pedagogy from Jacques Derrida to Joseph Beuys*, Baltimore and London, 1985
Varnedoe, K., and A. Gopnik (eds), *High and Low: Modern Art and Popular Culture*, exh. cat., Museum of Modern Art, New York, 1991
Welchman, J. C., *Invisible Colours: A Visual History of Titles*, New Haven and London, 1997
Wescher, H., *Collage* (trans. R. E. Wolf), New York, 1968
Wittgenstein, L., *Philosophical Investigations* (trans. G. E. M. Anscombe), London, 3rd edn, 1953
Wollheim, R., 'Pictures and Language' in *The Mind and Its Depths*, Cambridge, Mass., 1983
Words: Works from the Arts Council Collection, exh. cat., Hayward Gallery, South Bank Centre, London, 2002

Calligraphy and Typography

Bain, P., and P. Shaw, *Blackletter: Type and National Identity*, New York and Princeton, N. J., 1998
Billeter, J.-F., *The Chinese Art of Writing*, New York, 1990
Blackwell, L., *Twentieth Century Type: Remix*, London, 1998
Bologna, G., *Illuminated Manuscripts: The Book before Gutenberg*, London, 1988
Bolter, J. D., *Writing Space: The Computer, Hypertext, and the History of Writing*, Hillsdale, N. J., 1991
Bringhurst, R., *The Elements of Typographic Style*, Vancouver, 1992 and 1996
Christin, A.-M., *A History of Writing: From Hieroglyphics to Multimedia*, Paris, 2002
Drucker, J., *The Alphabetic Labyrinth: The Letters in History and Imagination*, London, 1995
Fisher, S. R., *A History of Language*, London, 1999
—, *A History of Writing*, London, 2001
Friedl, F., N. Ott and B. Stein (eds), *Typographie: Wann Wer Wie*, Cologne, 1998

Gauer, A., *History of Calligraphy*, London, 1994

Gray, N., *A History of Lettering*, Oxford, 1986

Jean, G., *Writing: The Story of Alphabets and Scripts*, London, 1992

Kinross, R., *Modern Typography: An Essay in Critical History*, London, 1992

Lewis, J., *The Twentieth Century Book*, London, 1967

——, *Typography/Basic Principles*, London, 2nd edn, 1967

McLean, R., *Typography*, London, 1980

Reisner, R., *Graffiti: Two Thousand Years of Wall Writing*, New York, 1971

Spencer, H., *The Liberated Page*, London, 1987

Impressionism, Symbolism and Expressionism

Brettell, R., *Impression: Painting Quickly in France*, New Haven and London, 2000

Curtis, G., *Visual Words: Art and the Material Book in Victorian England*, Aldershot, Hants, 2002

Danielsson, B., 'Gauguin's Tahitian Titles', *The Burlington Magazine*, 109, no. 769, April 1967

Delevoy, R. L., *Symbolism and Symbolists*, New York, 1978

Dorra, H., *Symbolist Art Theories*, Berkeley and Los Angeles, 1994

Frèches-Thory, C., and A. Terrace, *The Nabis*, Paris, 1990

Fried, M., *Realism, Writing, Disfiguration*, Chicago, 1987

Hofstätter, H., *Art Nouveau: Prints, Illustrations and Posters*, Ware, Herts., 1984

Lankeit, K., (ed.), *The Blue Rider Almanac* (trans. H. Falkenstein), London, 1974

Leeman, F., 'Odilon Redon: The Image and the Text' in D. W. Druick (ed.), *Odilon Redon*, London, 1994

Madsen, S. T., *Art Nouveau* (trans. R. Christophersen), London, 1967

Matthieu, P.-L., *The Symbolist Generation: 1870–1910*, New York, 1990

Offenstadt, P., *Jean Béraud – The Belle Epoque: A Dream of Times Gone By*, Cologne, 1996

Reff, T., *Manet and Modern Paris*, Chicago and London, 1982

Robinson, D., *William Morris, Edward Burne-Jones and the Kelmscott Chaucer*, London, 1982

Rubin, J., *Manet's Silence and the Poetics of Bouquets*, Cambridge, Mass., 1994

Rubin, W. (ed.), *Primitivism in Twentieth Century Art*, vol. I, exh. cat., Museum of Modern Art, New York, 1984

Whitford, F., *Japanese Prints and Western Painters*, London, 1977

Wichman, S., *Japonisme: The Japanese Influence on Western Art since 1858*, London, 1981

Wilton, A., and R. Upstone, *The Age of Rossetti, Burner-Jones and Watts: Symbolism in Britain*, exh. cat., Tate Gallery, London, 1997

Zurier, R., R. W. Snyder and V. M. Mecklenberg, *Metropolitan Lives: The Ashcan Artists and their New York*, exh. cat., Whitney Museum of American Art, New York, 1995

Cubism and Futurism

Apollinaire, G., *Selected Writings of Guillaume Apollinaire*, R. Shattuck (ed. and trans.), New York, 1971

Apollonio, U. (ed.), *Futurist Manifestos*, London, 1973

Breunig, L. C. (ed.), *The Cubist Poets in Paris: An Anthology*, Lincoln, Neb., 1995

Compton, S. P., *The World Backwards: Russian Futurist Books, 1912–1916*, London, 1978

Cooper, D., *The Cubist Epoch*, London (in association with Los Angeles County Museum of Art) and Metropolitan Museum of Art, New York, 1971

Cottingham, D., *Cubism in the Shadow of War: The Avant-Garde and Politics in Paris, 1905–1914*, New Haven, Conn., 1998

Flint, F. W. (ed. and trans.), *Marinetti: Selected Writings*, London, 1972

Frascina, F., 'Realism and Ideology: An Introduction to Semiotics and Cubism' in C. Harrison, F. Frascina and G. Perry, *Primitivism, Cubism, Abstraction: The Early Twentieth Century*, New Haven and London, 1993

Golding, J., *Cubism: A History and Analysis (1907–1914)*, London, 2nd edn, 1968

Greenberg, C., 'The Pasted Paper Revolution' in J. O'Brian (ed.), *Clement Greenberg: The Collected Essays and Criticism*, vol. IV, Chicago, 1993

Hanson, C. (ed.), *The Futurist Imagination: Word and Image in Italian Futurist Painting, Drawing, Collage, and Free-Word Poetry*, New Haven, Conn., and London, 1983

Krauss, R., *The Picasso Papers*, London, 1998

Leighton, P., *Re-Ordering the Universe: Picasso and Anarchism, 1897–1914*, Princeton, N. J., 1989

Leymarie, J., *George Braque*, exh. cat., Solomon R. Guggenheim Museum, New York, 1988

Molinari, D., *Robert and Sonia Delaunay*, Paris, 1987

Perloff, M., *The Futurist Moment: Avant-Garde, Avant-Guerre, and the Language of Rupture*, Chicago, 1986

Poggi, C., *In Defiance of Painting: Cubism, Futurism, and the Invention of Collage*, New Haven, Conn., 1992

Rewald, J., and L. Zelevansky (eds), *Picasso and Braque: A Symposium*, New York, 1992

Rosenblum, R., 'Picasso and the Typography of Cubism' in R. Penrose and J. Golding (eds), *Picasso: 1881–1973*, London, 1973

——, *Cubism in Twentieth Century Art*, New York, 1976

——, 'Cubism as Pop Art' in K. Varnedoe and A. Gopnik (eds), *Modern Art and Popular Culture: Readings High and Low*, New York, 1990

Schwartz, W., *The Cubists*, London, 1971

Taylor, C. J., *Futurism: Politics, Painting, Performance*, Ann Arbor, Mich., 1974

Weiss, J., *The Popular Culture of Modern Art: Picasso, Duchamp and Avant-Gardism*, New Haven, Conn., 1994

White, J. J., *Literary Futurism: Aspects of the First Avant-Garde*, Oxford, 1990

Constructivism

Bann, S. (ed.), *The Tradition of Constructivism*, London, 1974

Bowlt, J. E. (ed.), *Russian Art of the Avant-Garde: Theory and Criticism*, London, rev. and enlarged edn, 1988

Fer, B., 'The Language of Construction' in B. Fer, D. Batchelor, P. Wood, *Realism, Rationalism, Surrealism: Art Between the Wars*, New Haven and London, 1993

Fiedler, J. (ed.), *Photography at the Bauhaus*, London, 1990

Fleischmann, G., H. R. Bosshard and C. Bingens, *Max Bill: Typography, Advertising, Book Design*, Zurich, 1999

Francia, P. de, *Fernand Léger*, New Haven, Conn., 1983

Friedman, M., *De Stijl: 1917–1931, Vision of Utopia*, Oxford, 1982

Fry, E. F. (ed.), *Fernand Léger: Functions of Painting* (trans. A. Anderson), New York, 1965

Gray, C., *The Great Experiment: Russian Art (1863–1922)*, London, 1962

Jaffé, H. L. C., *De Stijl: 1917–1931*, Cambridge, Mass., 1986

Janecek, G., *The Look of Russian Literature: Avant-Garde Visual Experiments, 1900–1930*, Princeton, N. J., 1984

Kaplan, L. *Lazlo Moholy-Nagy: Biographical Writings*, Durham, N. C., 1995

Kostelanetz, R. (ed.), *Moholy-Nagy*, New York, 1970

Léger and Purist Paris, exh. cat., Tate Gallery, London, 1970

Lernons, L. T., and M. J. Reis (eds and trans) *Russian Formalist Criticism: Four Essays*, Lincoln, Neb., 1965

Lissitzky, E., and V. Mayakovksy, *For the Voice* (trans. P. France), London, 2000

Lodder, C., *Russian Constructivism*, New Haven, Conn., 1983

McLean, R., *Jan Tschichold: A Life in Typography*, London, 1997

Mansbach, S. A., *Visions of Totality: Lazlo Moholy-Nagy, Theo van Doesburg, and El Lissitzky*, Ann Arbor, Mich., 1978

Passuth, K., *Moholy-Nagy*, London, 1985

Tschichold, J., *The New Typography* (trans. R. McLean), Berkeley and Los Angeles, 1995

Tupitsyu, M., *El Lissitzky: Behind the Abstract Cabinet*, New Haven, Conn., 1999

Whitford, F., *The Bauhaus: Masters and Students by Themselves*, London, 1992

Dada and Surrealism

Adamowicz, E., *Surrealist Collage in Text and Image: Dissecting the Exquisite Corpse*, Cambridge, 1998

Ades, D. (ed.), *Dada and Surrealism Reviewed*, exh. cat., Arts Council of Great Britain, London, 1978

Aichele, K. P., *Paul Klee's Pictorial Writing*, Cambridge, 2003

Aragon, L., *Paris Peasant*, (trans. S. T. Watson), London, 1971

Ball, H., *Flight out of Time: A Dada Diary* (ed. J. Elderfield, trans. A. Raimes), Berkeley and Los Angeles, 1996

Benson, T. O., *Raoul Hausmann and Berlin Dada*, Ann Arbor, Mich., 1987

——, 'Conventions and Constructions: The Performative Text in Dada' in S. C. Foster (ed.), *Dada: The Coordinates of Cultural Politics*, New York, 1996

Bergius, H., 'Dada, the Montage, and the Press: Catchphrase and Cliché as Basic Twentieth Century Principles' in S. C. Foster (ed.), *Dada: The Coordinates of Cultural Politics*, New York, 1996

Blavier, A., *René Magritte: Ecrits Complèts*, Paris, 1979

Breton, A., *Nadja* (trans. R. Howard), New York, 1960

——, *What is Surrealism? Selected Writings* (ed. and Introduction by F. Rosemont), London, 1978

——, *The Lost Steps* (trans. M. Polizzotti), Lincoln, Neb., and London, 1996

Buskirk, M., and M. Nixon, *The Duchamp Effect*, Cambridge, Mass., 1996

Cabanne, P., *Marcel Duchamp*, New York, 1971

Camfield, W., *Francis Picabia: His Art, Life, and Times*, Princeton, N. J., 1979

Caws, M. A., *The Surrealist Look: An Erotics of Encounter*, Cambridge, Mass., 1997

——, *Surrealist Painters and Poets: An Anthology*, Cambridge, Mass., 2001

Clair, J. (ed.), *Marcel Duchamp: abécédaire*, exh. cat., Centre Georges Pompidou, Paris, 1977

Cohen, A., 'The Typographical Revolution: Antecedents and Legacy of Dada Design' in S. Foster and R. Kuenzli (eds), *Dada Spectrum: The Dialectics of Revolt*, Madison, 1979

Crone, R., and J. L. Koerner, *Paul Klee: Legends of the Sign*, New York, 1991

Dachy, M., *The Dada Movement: 1915–1923*, New York, 1990

Dickman, V. (ed.), *Henri Michaux: The Language of Being*, exh. cat., Whitechapel Art Gallery, London, 1999

Duve, T. de, *Pictorial Nominalism: On Marcel Duchamp's Passage from Painting to the Readymade* (trans. D. Polan), Minneapolis, Minn., 1991

Elderfield, J., *Kurt Schwitters*, London, 1985

Foster, H., *Compulsive Beauty*, Cambridge, Mass., 1993

Foster, S. (ed.), *Dada: The Coordinated of Cultural Politics*, (Crisis and the Arts: The History of Dada Volume I), New York, 1996

Foucault, M., *This is Not a Pipe* (trans. J. Harkness), Berkeley and Los Angeles, 1983

Freeman, J. (ed.), *The Dada and Surrealist Word-Image*, exh. cat., Los Angeles County Museum of Art, Los Angeles, and Boston, Mass., 1989

Gablik, S., *Magritte*, London, 1970

Gaughan, M., 'Dada Poetics: Flight out of Sign?' in S. C. Foster (ed.), *Dada: The Coordinates of Cultural Politics*, New York, 1996

Hahn, O., *Masson*, New York, 1965

Hedges, I., *Languages of Revolt: Dada and Surrealist Literature and Film*, Durham, N. C., 1983

Hess, H., *George Grosz*, New Haven and London, 1985

Hubert, R. R., *Surrealism and the Book*, Berkeley and Los Angeles, 1988

Hülsenbeck, R., *Dada Almanac* (English translation presented by M. Green), London, 1993

Hulton, P., *The Surrealists Look at Painting*, Venice, Calif., 1990

Krauss, R., *The Optical Unconscious*, Cambridge, Mass., 1993

Kuenzli, R. F., 'Hans Arp's Poetics: The Sense of Dada "Nonsense"' in R. Sheppard (ed.), *New Studies in Dada: Essays and Documents*, Driffield, England, 1981

——, *Marcel Duchamp: Artist of the Century*, Boston, Mass., 1990

Kurt Schwitters: I is Style, exh. cat., Stedelijk Museum, Amsterdam, and Rotterdam, 2000

Lancher, C. (ed.), *Paul Klee*, exh. cat., Museum of Modern Art, New York, 1987

Makela, M., and P. Boswell, *The Photomontages of Hannah Höch*, exh. cat., Walker Art Center, Minneapolis, 1997

Matthews, J. H., *Languages of Surrealism*, Columbia, Miss., 1986

Michaux, H., *Déplacements Dégagements/Spaced, Displaced* (trans. D. and H. Constantine), Newcastle-upon-Tyne, 1992

Moffitt, J. F., 'Marcel Duchamp: Alchemist of the Avant-Garde' in M. Tuchman (ed.), *The Spiritual in Art: Abstract Painting 1890–1985*, exh. cat., Los Angeles County Museum of Art, Los Angeles, and New York, 1986

Motherwell, R. (ed.), *The Dada Painters and Poets: An Anthology*, Cambridge, Mass., 2nd edn, 1981

Penrose, R., *Joan Miró*, London, 1970

Richter, H., *Dada: Art and Anti-Art* (trans. D. Britt), London, 1965

Rosemont, F., *André Breton and the First Principles of Surrealism*, London, 1978

Rothenberg, J., and P. Joris (eds), *PPPPPP. Kurt Schwitters: Poems, Performance Pieces, Proses, Plays, Poetics*, Cambridge, Mass., 2002

Rowell, M. (ed.), *Joan Miró: Selected Writings and Interviews*, London, 1987

Russell, J., *Max Ernst: Life and Work*, New York, 1967

Sanouillet, M., and E. Peterson (eds), *The Essential Writings of Marcel Duchamp*, London, 1975

Sheppard, R. (ed.), *New Studies in Dada: Essays and Documents*, Driffield, England, 1981

Spies, W., *Max Ernst Collages: The Invention of the Surrealist Universe* (trans. John William Gabriel), New York, 1988

—— (ed.), *Max Ernst: A Retrospective*, exh. cat., Tate Gallery, London and Munich, 1991

Sylvester, D., *Magritte*, London, 1992

Torczyner, H., *Magritte: Ideas and Images*, New York, 1979

Tzara, T., *Seven Dada Manifestos and Lampisteries*, London, 1977

Watts, H., 'Arp, Kandinsky, and the Legacy of Jakob Böhme' in M. Tuchman (ed.), *The Spiritual in Art: Abstract Painting 1890–1985*, exh. cat., Los Angeles County Museum, Los Angeles, and New York, 1986

Welchman, J. C., 'After the Wagnerian Bouillabaisse: Critical Theory and the Dada and Surrealist Word-Image' in J. Freeman (ed.), *The Dada and Surrealist Word-Image*, exh. cat., Los Angeles County Museum of Art, Los Angeles, and Cambridge, Mass., 1987

Young, A., *Dada and After: Extremist Modernism and English Literature*, Manchester, 1981

Art and Power

Années 30 en Europe: Le Temps menaçant, 1929–1939, Centre Georges Pompidou, Musées de la Ville de Paris, Paris, 1997

Art and Power: Europe under the Dictators, 1930–1945, exh. cat., Hayward Gallery, London, 1995

Aynsley, J., *Graphic Design in Germany, 1890–1945*, London, 2000

Etlin, R. A. (ed.), *Art, Culture, and Media under the Third Reich*, Chicago, 2002

Golemstock, I., *Totalitarian Art* (trans. R. Chandler), London, 1990

The Great Utopia: The Russian and Soviet Avant-Garde, 1915–1932, exh. cat., Guggenheim Museum, New York, 1992

Groys, B., *The Total Art of Stalin: Avant-Garde, Aesthetic Dictatorship, and Beyond* (trans. C. Rougle), Princeton, N. J., 1992

Kahn, D., *John Heartfield: Art and Mass Media*, New York, 1986

Lowenthal-Felstiner, M., *To Paint Her Life: Charlotte Salomon in the Nazi Era*, New York, 1994

Orwell, G., *Nineteen Eighty-Four* in *The Complete Novels of George Orwell*, Harmondsworth, 1992

Railing, P. (ed.), *Voices of Revolution: Collected Essays*, London, 2000

Salomon, C., *Charlotte: Life or Theater? An Autobiographical Play* (trans. L. Vennewitz), New York, 1981

Post-War

Aftermath: France 1945–1954. New Images of Man, exh. cat., Barbican Art Gallery, London, 1982

Atkins, G., *Asger Jorn: The Crucial Years, 1954–1964*, London and Paris, 1997

Augusti, A., *Antoni Tàpies: The Complete Works*, vols 1–4, Barcelona, 1992

Barthes, R., 'Cy Twombly: Works on Paper' in *The Responsibility of Forms* (trans. R. Howard), Berkeley and Los Angeles, 1985

Beckett, S., and G. Duthuit, *Proust: Three Dialogues* (trans. S. Beckett), London, 1965

Beyond Reason: Art and Psychosis (Works from the Prinzhorn Collection), exh. cat., Hayward Gallery, South Bank Centre, London, 1997

Ceysson, B., 'L'écriture griffée ou peindre le réel réalisé' in *L'Écriture griffée*, exh. cat., Musée d'Art Moderne de Saint-Etienne, Saint-Etienne, 1993

CoBrA: Art expérimental, 1948–1951, Munich and Lausanne, Musée cantonal des Beaux-Arts, Lausanne, 1997

Danto, A., 'Cy Twombly' in *The Madonna of the Future: Essays in a Pluralistic Art World*, Berkeley and Los Angeles, 2001

Demetrion, J. T. (ed.), *Jean Dubuffet, 1943–1963: Paintings, Sculptures, Assemblages*, Washington, 1993

Dubuffet, J., *Asphyxiating Culture and Other Writings* (trans. C. Volk), New York, 1988

Fischer, P., *Abstraction, Gesture, Écriture: Paintings from the Daros Collection*, Zurich, Berlin and New York, 1999

Foster, S. C. (ed.), 'Lettrisme: Into the Present', *Visible Language*, vol. 17, no. 3, 1983

Gough, H. F., *Franz Kline: The Vital Gesture*, exh. cat., Cincinnati Art Museum, Cincinnati, and New York, 1985

Heidegger, M., *Being and Time* (trans. J. Macquarie and E. Robinson), Oxford, 1962

Holt, R., *Lee Krasner*, New York, 1993

Isidore Isou & La Méca-Esthetique (1944–1987), exh. cat., Galerie de Paris, Paris, 1987

Kenan, A., and R. Caillois, *Alechinsky*, Musée d'Art moderne de la Ville de Paris, Paris, 1975

Lambert, J.-C., *CoBrA* (trans. R. Bailey), London, 1983

Legrand, F. C., 'The Sign and the "Open Form"' in J. Leymarie (ed.), *Abstract Art Since 1945*, London, 1971

Maizels, J., *Raw Creation: Outsider Art and Beyond*, London, 1996

Mark Tobey, exh. cat., Musée des Arts Décoratifs, Paris, 1961

Monroe, A., *Japanese Art After 1945: Scream Against the Sky*, New York, 1994

Morganthael, W., *Madness and Art: The Life and Works of Adolf Wölfli*, A. H. Esman, Lincoln, Neb., and London, 1992

Morris, F. (ed.), *Paris Post War: Art and Existentialism, 1945–1955*, exh. cat., London, Tate Gallery, 1993

Paris – Paris: Créations en France 1937–1957, exh. cat., Centre Georges Pompidou, Paris, 1981

The Pictograms of Adolph Gottlieb, exh. cat., Adolph and Esther Gottlieb Foundation, New York, 1994

Rosenberg, H., 'The American Action Painters' in *The Tradition of the New*, New York, 1959

Sartre, J.-P., *Being and Nothingness* (trans. H. E. Barnes), New York, 1956

——, *Nausea* (trans. R. Baldick), Harmondsworth, 1965

Storr, R., *Robert Ryman*, exh. cat., London, 1993

Szeemann, H. (ed.), *Cy Twombly: Paintings, Works on Paper, Sculpture*, New York, 1987

Tapié, M., *Un Art Autre*, Paris, 1952

Tuchman, M., and C. S. Eliel, *Parallel Visions: Modern Artists and Outsider Art*, exh. cat., Los Angeles County Museum of Art, Los Angeles, 1992

Varnedoe, K., and P. Karmel, *Jackson Pollock*, exh. cat., Tate Gallery, London, 1998

Westgeest, H., *Zen in the Fifties: Interactions between East and West*, Amsterdam, 1996

Neo-Dada

Armstrong, E., and J. Rothfuss (eds), exh. cat., *In the Spirit of Fluxus*, Walker Art Gallery, Minneapolis, 1993

Bann, S., *Concrete Poetry: An International Anthology*, London, 1967

Ben: Je Cherche La Vérité, exh. cat., Musée d'Art Moderne, Nice, 2001

Cage, J., *Silence*, Cambridge, Mass., 1969

Charles, D., and Cage, J., *For the Birds*, Boston and London, 1981

Hains, R., C. Bompuis and M. Dachy, *Raymond Hains*, exh. cat., Museu d'Art Contemporani de Barcelona, Barcelona, 2001

Home, S., *What is Situationism? A Reader*, Edinburgh, 1996

Identité Italienne, Centre Georges Pompidou, Musée d'Art Moderne de la Ville de Paris, Paris, 1981

Joseph, B. W. (ed.), *Robert Rauschenberg*, Cambridge, Mass., 2002

Kaprow, A., *Assemblages, Environments & Happenings*, New York, 1966

Kellein, T., *Fluxus*, London, 1995

Knabb, K., *Situationist International Anthology*, Berkeley, Calif., 3rd edn, 1995

Kotz, M. L., *Rauschenberg: Art and Life*, New York, 1990

Kultermann, U., *Art-Events and Happenings* (trans. J. W. Gabriel), London, 1971

Manzoni, P., G. Celant, J. Thomson and A. Constanti, *Piero Manzoni*, exh. cat., Serpentine Gallery, London, 1998

Restany, P., *1960: Les Nouveau Réalistes*, exh. cat., Musée d'Art Moderne de la Ville de Paris, Paris, 1986

Roth, D., *Books and Graphics*, Stuttgart, 1979

Solt, M. E. (ed.), *Concrete Poetry: A World View*, Bloomington, Ind., 1967

Steinberg, L., 'Reflections on the State of Criticism', *Other Criteria: Confrontations with Twentieth Century Art*, London and New York, 1972

Suzuki, D. T., *An Introduction to Zen Buddhism*, London, rev. edn, 1983

Villeglé: Lacéré Anonyme, exh. cat., Musées d'Art Moderne de la Ville de Paris, Paris, 1977

Williams, E., and A. Noël (eds), *Mr. Fluxus, a Collective Portrait of George Maciunas, 1961–1978*, London, 1997

Pop

Alloway, L., *Network: Art and the Complex Present*, Ann Arbor, Mich., 1984

Benezra, N., and K. Brougher, *Ed Ruscha*, exh. cat., Hirshhorn Museum and Sculpture Garden, Smithsonian Institution, Washington, D.C. and Museum of Modern Art, Oxford, 2000

Crow, T., *The Rise of the Sixties: American and European Art in the Era of Dissent, 1955–1969*, London, 1996

Hamilton, R., *Collected Words: 1953–1982*, London, 1983

Huyssen, A., 'The Cultural Politics of Pop' in M. Berger (ed.), *Modern Art and Society: An Anthology of Social and Multicultural Readings*, New York, 1994

The Independent Group: Postwar Britain and the Aesthetics of Plenty, exh. cat., Institute of Contemporary Art, Boston, 1990

Inge, M. T., *Comics as Culture*, Jackson, Miss., 1990

Livingstone, M., *Pop Art: A Continuing History*, London, 1990

Loberl, M., *Image Duplicator: Roy Lichtenstein and the Emergence of Pop Art*, New Haven, Conn., 2002

Massey, A., *The Independent Group: Modernism and Mass Culture in Britain, 1945–1959*, Manchester, 1995

Modern Dreams: The Rise and Fall and Rise of Pop, exh. cat., Institute of Contemporary Art, Boston, 1988

Orton, F., *Figuring Jasper Johns*, London, 1994

Russell, J. and S. Gablik, *Pop Art Redefined*, London, 1969

Ryan, S. E., *Robert Indiana: Figures of Speech*, New Haven, Conn., 2000

Schwartz, A. (ed.), *Ed Ruscha: Leave Any Information at the Signal. Writings, Interviews, Bits, Pages*, Cambridge, Mass., 2002

Stich, S., *Made in USA: An Americanization in Modern Art, the '50s & '60s*, exh. cat., Berkeley and Los Angeles, 1987

Stuart Davis: Art and Theory, exh. cat., Brooklyn Museum, New York, 1978

Varnedoe, K. (ed.), *Jasper Johns: Writings, Sketchbook, Notes, Interviews*, New York, 1996

——, *Jasper Johns: a Retrospective*, exh. cat., Museum of Modern Art, New York, 1996

Waldman, D., *Roy Lichtenstein*, exh. cat., Solomon R. Guggenheim Museum, New York, 1993

White, E. M. (ed.), *The Pop Culture Tradition*, New York, 1972

Conceptual Art

Abrioux, Y., *Ian Hamilton Finlay: A Visual Primer*, London, 2nd edn, 1992

Alberro, A., A. Zimmerman, B. H. D. Buchloh and D. Batchelor, *Lawrence Weiner*, London, 1996

Alberro, A., and B. Stimson (eds), *Conceptual Art: A Critical Anthology*, Boston, Mass., 1999

Alighiero e Boetti, exh. cat., Whitechapel Art Gallery, London, 1999

Arakawa and M. Gins, *The Mechanism of Meaning*, New York, rev. edn, 1988

Battock, G., *Idea Art*, New York, 1973

Benezra, N., *Bruce Nauman: Exhibition Catalogue and Catalogue Raisoné* in J. Simon (ed.), exh. cat., Walker Art Center, Minneapolis, in association with Hirshhorn Museum and Sculpture Garden, Smithsonian Institution, Washington, D.C., 1994

Bird, J., J. Isaac and S. Lotringer, *Nancy Spero*, London, 1996

Brugge, C. van, *John Baldessari*, New York, 1990

Buchloh, B. H. D. (ed.), *Broodthaers, Writings, Interviews, Photographs*, Cambridge, Mass., 1988
—, 'Spero's Other Traditions' in C. M. de Zegher (ed.), *Inside the Visible: An Elliptical Traverse of Twentieth Century Art, in, of, and from the Feminine*, exh. cat., Cambridge, Mass., 1996
Burgin, V., *Works and Commentary*, London, 1973
—, *Between*, exh. cat., Oxford and Institute of Contemporary Art, London, 1986
Chiong, K., 'Kawara On Kawara', *October*, Fall 1999
Christov-Bakargiev, C., *Arte Povera*, London, 1999
David, C. (ed.), *Marcel Broodthaers*, Galerie Nationale du Jeu de Paume, Paris, 1991
Debord, G., *The Society of the Spectacle* (trans. M. Imrie), London and New York, 1990
Einzig, B. (ed.), *Thinking About Art: Conversations with Susan Hiller*, Manchester, 1996
Fisher, J., 'Susan Hiller: Élan and other Evocations' and C. de Zegher (ed.), *Inside the Visible: An Elliptical Traverse of Twentieth Century Art, in, of, and from the Feminine*, exh. cat., Cambridge, Mass., 1996
Franz, E. (ed.), *Robert Barry*, Bulefeld [n.d]
Fuchs, R., *Richard Long*, exh. cat., London and Solomon R. Guggenheim Museum, New York, 1986
Godfrey, T., *Conceptual Art*, London, 1998
Goldwater, M. (ed.), *Marcel Broodthaers*, exh. cat., Walker Art Gallery, Minneapolis, 1989
Graw, I., 'Work ennobles – I'm staying bourgeois (Hanne Darboven)' in C. de Zegher, *Inside the Visible: An Elliptical Traverse of Twentieth Century Art, in, of, and from the Feminine*, exh. cat., Cambridge, Mass., 1996
Guercio, G. (ed) *Joseph Kosuth: Art After Philosophy and After: Collected Writings, 1966–1990*, Cambridge, Mass., 1991
Harrison, C., *Essays on Art & Language*, Oxford, 1991
Holt, N. (ed.), *The Writings of Robert Smithson: Essays and Illustrations*, New York, 1979
Iverson, M., D. Crimp, H. K. Bhaba, *Mary Kelly*, London, 1997
Jaudon, S., and J. Kozloff, 'Art Hysterical Notions of Progress and Culture' (1978) reprinted in H. Robinson (ed.), *Feminism-Art-Theory: An Anthology, 1968–2000*, Oxford, 2001
Kelly, M., *Mary Kelly: Post-Partum Document*, London, 1983
Languages: An Exhibition of Artists Using Word and Image, exh. cat. Arts Council of Great Britain, London, 1965
Lawrence Weiner: Works With The Passage Of Time, exh. cat., Hirshhorn Museum and Sculpture Garden, Washington, D.C., 1990
McShine, K. L. (ed.), *Information*, exh. cat., Museum of Modern Art, New York, 1970
Marks, E., and I. de Courtivron, (eds), *New French Feminism: An Anthology*, New York, 1981
Meyer, U., *Conceptual Art*, New York, 1972
Morgan, R. C., *Art into Ideas: Essays on Conceptual Art*, Cambridge, 1996
Osborne, P., *Conceptual Art*, London, 2002
Parker, R., and G. Pollock, *Framing Feminism: Art and the Women's Movement, 1970–1985* (1987), London, 1995
Pelzer, B., 'Dissociated Objects: The Statements/Sculptures of Lawrence Weiner', *October*, Fall 1999
Phillips, T., *The Heart of A Humument*, Stuttgart, 1985
—, *Tom Phillips: Work and Texts*, London, 1992
Pollock, G., 'Inscriptions in the Feminine' in C. de Zegher, *Inside the Visible: An Elliptical Traverse of Twentieth Century Art, in, of, and from the Feminine*, Cambridge, Mass., 1996
Prinz, J., *Art Discourse/Discourse in Art*, New Brunswick, N. J., 1991
Richardson, B., *Bruce Nauman: Neons*, exh. cat., Baltimore Museum of Art, Baltimore, Md., 1982
Rohan, M., *Paris '68: Graffiti, Posters, Newspapers, and Poems of the Events of May 1968*, London, 1988
Shapiro, G., *Earthwards: Robert Smithson and Art after Babel*, Berkeley and Los Angeles, 2000
Sigmar Polke: Join the Dots, exh. cat., Tate Gallery Liverpool, Liverpool, 1995
Szeemann, H. (ed.), *When Attitudes Become Forms: Works-Concepts-Processes-Situations-Information*, exh. cat., Kunsthalle, Bern, 1969
Tsai, E., *Robert Smithson Unearthed: Drawings, Collage, Writings*, New York, 1991
Tufnell, B., and A. Wilton, *Hamish Fulton: Walking Journey*, exh. cat., Tate Gallery, London, 2002
Wallis, B. (ed.), *Hans Haacke: Unfinished Business*, New Museum of Contemporary Art, New York, 1987
Watkins, J., and R. Denizot, *On Kawara*, London, 2002

Post-Modernism

Adriani, G., *Anselm Kiefer: Bücher, 1969–1990*, 1990
Arasse, D., *Anselm Kiefer*, London, 2002
Barbara Kruger, exh. cat., Museum of Contemporary Art, Los Angeles, 1999
Castleman, C., *Getting Up: Subway Graffiti in New York*, Cambridge, Mass., 1982
Foster, H. (ed.), *The Anti-Aesthetic: Essays on Postmodern Culture*, Port Townsend, Wash., 1983
—, *Recodings: Art, Spectacle, Cultural Politics*, Port Townsend, Wash., 1985
Gudis, C. (ed.), *A Forest of Signs: Art in the Crisis of Representation*, exh. cat., New Museum of Contemporary Art, New York, 1989
Harvey, D., *The Condition of Postmodernity*, Oxford, 1989
Heiferman, M. (ed.), *Image World: Art and Media Culture*, exh. cat., Whitney Museum of American Art, New York, 1989
Joselit, D., J. Simon and R. Saleci, *Jenny Holzer*, London, 1998
Julian Schnabel, exh. cat., Fundació Joan Miró, Barcelona, 1995
Kruger, B. (curator), *Artists' Use of Language (Part I and II)*, a checklist for the exhibitions, New York, 1983
—, *Remote Control: Power, Culture, and the World of Appearances*, Boston, Mass., 1993
Linker, K., *Love For Sale: The Words and Pictures of Barbara Kruger*, New York, 1990
Lovejoy, M., *Postmodern Currents: Art and Artists in the Age of Electronic Media*, Upper Saddle River, N. J., 2nd edn, 1997
Marshall, R., *Jean-Michel Basquiat*, exh. cat., Whitney Museum of American Art, New York, 1993
Ong, W., 'Subway Graffiti' in C. Ricks and L. Michaels (eds), *The State of the Language*, London, 1990 edn
Owens, C., *Beyond Recognition: Representation, Power, and Culture* (ed. S. Bryson, B. Kruger, L. Tillman and J. Weinstock), Berkeley and Los Angeles, 1992
Plant, S., *The Most Radical Gesture: The Situationist International in the Post-Modern Age*, London, 1992
Poster, M. (ed.), *Jean Baudrillard: Selected Writings*, London, 1988
Prince, R., *Richard Prince: Adult Comedy Action Drama*, Zurich, 1995
Richard Prince, exh. cat., Whitney Museum of American Art, New York, 1992
Sayre, H. M., *The Object of Performance: The American Avant-Garde since 1970*, Chicago, 1989
Siegel, J. (ed.), *Art Talk: The Early Eighties*, New York, 1988
Wagstaff, S., *Comic Iconoclasm*, exh. cat., Institute of Contemporary Art, London, 1987
Waldman, D., *Jenny Holzer*, exh. cat., Solomon R. Guggenheim, New York, 2nd edn, 1997
Wallis, B. (ed.), *Art After Modernism: Rethinking Representation*, New Museum of Contemporary Art, New York and Boston, 1984
Wollheim, R, 'Tim Rollins and Kids of Survival', *Modern Painters*, spring 1998

Contemporary Art

Ascott, R., *Telematic Embrace: Visionary Theories of Art, Technology, and Consciousness*, (ed. E. A. Shanken), Berkeley and Los Angeles, 2001
Babel: Contemporary Art and the Journeys of Communication, exh. cat. Ikon Gallery, Birmingham, 1999
Bhabha, H. K., 'Beyond the Pale: Art in the Age of Multicultural Translation' in E. Sussman (ed.), *1993 Whitney Biennial*, Whitney Museum of American Art, New York, 1993
Blazwick, I., and B. Fibicher (eds), *Simon Paterson*, London, 2002
Bocquet, P. E., 'The Visual Arts and Créolité' in G. Mosquera (ed.), *Beyond the Fantastic: Contemporary Art Criticism from Latin America*, London, 1995
Cooke, L., *Guillermo Kuitca: Burning Beds*, Amsterdam, 1994
Crystal, D., *Language and the Internet*, Cambridge, 2001
Druckney, T. (ed.), *Electronic Culture: Technology and Visual Representation*, New York, 1996
Enwesor, O., 'The Black Box', *Documenta 11*, exh. cat., Hatje Cantz, Frankfurt, 2002
Ferguson, R., M. Gever, T. Minh-ha and C. West, *Out There: Marginalization and Contemporary Culture*, exh. cat.,

The New Museum of Contemporary Art, New York, and Boston, Mass., 1990
Ferguson, R., D. De Silva and J. Slyce, *Gillian Wearing*, London, 1999
Fisher, J. (ed.), *Global Visions: Towards a New Internationalism in the Visual Arts*, London, 1994
Gary Hill, exh. cat., IVAM Centre Del Carme, Madrid, 1993
Groys, B., D. A. Ross and I. Blazwick, *Ilya Kabakov*, London, 1998
Higgins, D., *Modernism Since Postmodernism: Essays on Intermedia*, San Diego, 1997
Horrocks, C., *Marshall McLuhan and Virtuality*, Duxford, Cambs., 2000
Jantjes, G., *A Fruitful Incoherence: Dialogues with Artists on Internationalism*, London, 1998
Kabakov, I., *The Palace of Projects, 1995–1998*, London and Museo Nacional Centro de Arte Reina Sofia, Madrid, 1998
Ken Lum, exh. cat., Witte de With Center for Contemporary Art, Rotterdam, and Winnepeg Art Gallery, Winnepeg, 1990
Klotz, H. (ed.), *Media Scape*, exh. cat., Solomon R. Guggenheim Museum, New York, 1996
Kraus, R., *Brushes with Power: Modern Politics and the Chinese Art of Calligraphy*, Berkeley and Los Angeles, 1991
Levinson, P., *Digital McLuhan: A Guide to the Information Millennium*, London, 1999
Levitte-Harten, D., and J. Harten, *Svetlana Kopystiansky: The Library*, exh. cat., Kunsthalle Dusseldorf, Dusseldorf, 1994
Lütticken, S., 'From Media to Mythology: Art in the Age of Convergence', *New Left Review*, no. 6, November/December 2000
Lunenfeld, P., *Snap to Grid: A User's Guide to Digital Arts, Media, and Cultures*, Cambridge, Mass., 2001
Manovich, L., *The Language of New Media*, Cambridge, Mass., 2001
Marcus, G., 'Wool's Word Paintings', *Parkett*, 33, September 1992
Marlene Dumas: Miss Interpreted, exh. cat., van Abbemuseum, Eindhoven, 1992
Merck, M., and C. Townsend (eds), *The Art of Tracey Emin*, London, 2002
Negroponte, N., *Being Digital: a Road Map for Survival on the Information Superhighway*, London, 1995
Raymond Pettibon: A Reader, exh. cat., Philadelphia Museum of Art, Philadelphia, and The Renaissance Society at the University of Chicago, Chicago, 1998
Rinder, L., *Bitstreams*, exh. cat., Whitney Museum of American Art, New York, 2001
Scholder, A., and J. Crandall (eds), *Interaction: Artistic Practice in the Network*, New York, 2001
Simryn Gill: Selected Works, exh. cat., Art Gallery of New South Wales, Sydney, 2000
Spiller, N. (ed.), *Cyber-Reader: Critical Writings for the Digital Era*, London, 2002
Storr, R., D. Cooper and U. Loock, *Raymond Pettibon*, London, 2001
Trend, D. (ed.), *Reading Digital Culture*, Oxford, 2001
A Way with Words: Selections from the Whitney Museum of American Art, exh. cat., Whitney Museum of American Art, New York, 2001
Welchman, J. C., *Art After Appropriation: Essays on Art in the 1990s*, Amsterdam, 2001
— (ed.), *Rethinking Borders*, London, 1996
Williams, L. R., 'Fiona Banner' in *Spellbound: Art and Film*, exh. cat., South Bank Centre, London, 1996
Winckler, D. (ed.), 'Interactivity, Interconnectivity and Media, *Visible Language*, vol. 31, no. 2, 1997
Xu Bing, exh. cat., New Museum of Contemporary Art, New York, 1998

List of illustrations

Measurements are given in centimetres, followed by inches, height before width before depth, unless otherwise stated.

1 Fiona Banner, *Car Chases (Bullitt)* (detail), 1998. Silkscreen print, 130 x 170 (51 x 67). Courtesy the Artist and Frith Street Gallery, London

2 Mel Bochner, *Language is Not Transparent*, 1970. Installation, chalk and paint on wall, 182.9 x 121.9 (72 x 48). Installation at Dwan Gallery, New York, 1970. Courtesy Sonnabend Gallery, New York

3 Ed Ruscha, *"-So"*, 1999. Acrylic on canvas, 162.6 x 162.6 (64 x 64). Private Collection. Courtesy Anthony d'Offay Gallery, London. Copyright Ed Ruscha

4 René Magritte, *The Betrayal of Images*, 1928–29. Oil on canvas, 60 x 81 (23⅝ x 31⅞). Los Angeles County Museum of Art. Purchased with funds provided by the Mr and Mrs William Preston Harrison Collection. Photo courtesy Sidney Janis Gallery, New York. © ADAGP, Paris and DACS, London 2003

5 Lawrence Weiner, *A Basic Assumption*, 1999. Installation, dimensions variable. Courtesy the Artist and Marian Goodman Gallery, New York. © ARS, New York, and DACS, London, 2003

6 'Cave canem' (Beware of the dog), before AD 79. Mosaic from Pompeii. Museo Nazionale, Naples

7 Fra Angelico, *Annunciation* (detail), c. 1432–33. Tempera on wood, 175 x 180 (68⅞ x 70⅞). Museo Diocesano, Cortona

8 Raymond Pettibon, *No Title (Just what was)*, 2001. Pen and ink on paper, 32.4 x 50.2 (12⅞ x 19⅞). Courtesy Regan Projects, Los Angeles

9 Marlene Dumas, *Sold against One's Will*, 1990–91. Oil on canvas, 70 x 50 (27½ x 19½). Courtesy Gallery Paul Andriesse, Amsterdam

10 Richard Estes, *M104*, 1999. Oil on canvas, 111.8 x 200.7 (44 x 79). © Richard Estes. Courtesy Marlborough Gallery, New York

11 Ilya Kabakov, *The Communal Kitchen*, 1991. Wood, board, paint construction, room, household objects, enamel on masonite paintings with household objects, photographs, texts, folding paper screens, overall height 600 x 600 (236⅛ x 236⅛). Installation, Sezon Museum, Nagano, Japan, 1993. Collection Musée Maillol, Paris. © DACS 2003

12 Book of Kells, folio 8 recto, beginning of the *Breves causae* of Matthew, c. 800. Manuscript illumination. Trinity College Library, Dublin

13 Simon Patterson, *The Great Bear*, 1992. Four-colour lithograph in glass and anodised aluminium frame, edition of 50, 109.2 x 134.6 x 5 (43 x 53 x 2). Copyright Simon Patterson and Transport for London. Image courtesy Lisson Gallery, London. Photo John Riddy

14 Albrecht Dürer, *Desiderius Erasmus of Rotterdam*, 1526. Engraving, 24.9 x 19.3 (9⅞ x 7⅝). British Museum, London

15 Evangelical-Lutheran Congregation altarpiece, Dinckelsbühl, 1537. Dinckelsbühl Museum, Germany

16 Eugène Atget, *Little Market, Place Saint-Medard, Paris 5*, 1898. Collection Musée Carnavalet, Paris

17 Edouard Manet, *Woman Reading*, 1878–79. Oil on canvas, 61.2 x 50.7 (24⅛ x 20). © Art Institute of Chicago, Mr. and Mrs. Lewis Larned Coburn Memorial Collection, 1933.435

18 Gustave Caillebotte, *Interior*, 1880. Oil on canvas, 116 x 89 (45⅝ x 35). Private Collection

19 Jean Béraud, *Colonne Morris* (Morris Column), 1870. Oil on canvas, 35 x 26 (13⅞ x 10¼). Walters Art Gallery, Baltimore. Photo Bridgeman Art Library, London. © ADAGP, Paris, and DACS, London, 2003

20 Raoul Dufy, *Posters at Trouville*, 1906. Oil on canvas, 54 x 73 (21¼ x 28¾). Formally in the Vinot Collection. © ADAGP, Paris and DACS, London 2003

21 John Sloan, *Hairdresser's Window*, 1907. Oil on canvas, 81 x 66 (31⅞ x 26). Wadsworth Atheneum, Hartford, Connecticut. The Ella Gallup Sumner and Mary Catlin Sumner Collection Fund

22 Henri de Toulouse-Lautrec, *Aristide Bruant dans son cabaret* (Aristide Bruant in his Cabaret), 1892. Colour lithograph, poster for the Eldorado. 137 x 96.5 (53⅞ x 38). Collection Mr and Mrs Herbert D. Schimmel, New York

23 Pierre Bonnard, *France-Champagne*, 1891. Poster. Bibliothèque Nationale, Paris. © ADAGP, Paris, and DACS, London, 2003

24 Vincent van Gogh, *The Bridge in the Rain (after Hiroshige)*, 1887. Oil on canvas, 73 x 54 (28⅞ x 21¼). Van Gogh Museum, Amsterdam

25 Utagawa Hiroshige, *The Ohashi Bridge in the Rain*, c. 1857. Woodblock, 36.9 x 24.7 (14½ x 9⅜). The Mann Collection, Highland Park, Illinois

26 Dante Gabriel Charles Rossetti, *Proserpine*, 1877. Oil on canvas, 119.5 x 57.8 (47 x 23). Private Collection, London. Photo Christie's Images, London

27 William Morris, page from *The Works of Geoffrey Chaucer*, Kelmscott Press, 1896. British Museum, London

28 Stéphane Mallarmé, spread from *Un Coup de dés jamais n'abolira le hasard*. Paris, 1914

29 Paul Gauguin, *Tehamana Has Many Ancestors (Merahi metua no Tehamana)*, 1893. Oil on canvas, 76.3 x 54.3 (30 x 21⅜). © Art Institute of Chicago. Gift of Mr. and Mrs. Charles Deering McCormick, 1980.613

30 Ernst Ludwig Kirchner, *Die Brücke*, 1910. Woodcut. Galerie Arnold, Dresden. © by Dr. Wolfgang & Ingeborg Henze-Ketterer, Wichtrach/Bern

31 Pablo Picasso, *Landscape with Posters, Sorgues*, July 1912. Oil on canvas, 46 x 61 (18⅛ x 24). National Museum of Art, Osaka. © Succession Picasso, DACS 2003

32 Georges Braque, *The Portuguese*, Autumn 1911–early 1912. Oil on canvas, 117 x 81 (46 x 32). Kunstmuseum, Basel. Gift of Raoul La Roche, 1952. © ADAGP, Paris and DACS, London 2003

33 Pablo Picasso, *Guitar, Sheet Music and Wine Glass*, November 1912. Pasted paper, gouache and charcoal on paper, 47.9 x 36.5 (18⅞ x 14⅜). Marion Koogler McNay Art Museum, San Antonio. © Succession Picasso, DACS 2003

34 Pablo Picasso, *Still Life 'Au Bon Marché'*, spring 1913. Oil & pasted paper on cardboard, 24 x 36 (9½ x 14⅛). Ludwig Collection, Aachen. © Succession Picasso, DACS 2003

35 Page from *Le Journal*, 25 January 1913. Bibliothèque Nationale, Paris

36 Georges Braque, *The Programme of the Tivoli Cinema, Sorgues*, after October 31, 1913. Gesso, pasted paper, charcoal, and oil on paper, mounted on canvas, 65.6 x 92 (25⅞ x 36¼). Collection Rosengart, Lucerne. © ADAGP, Paris and DACS, London 2003

37 Pablo Picasso, *Glass and Bottle of Suze*, 1912. Pasted paper, gouache and charcoal, 65.4 x 50.2 (25⅞ x 19⅞). Washington University Gallery of Art, St Louis. © Succession Picasso, DACS 2003

38 Georges Braque, *Bach*, 1913. Paper collage, 62.5 x 48.3 (24½ x 19). Öffentliche Kunstsammlung, Basel. © ADAGP, Paris and DACS, London 2003

39 Francesco Cangiullo, *Pisa*, 1914. Watercolour and pencil on paper. Calmarini Collection, Milan. © DACS 2003

40 Filippo Tommaso Marinetti, 'Pallone Frenato Turco' from *Zang Tumb Tumb*, 1914. Marinetti Archive, Beinecke Library, Yale University, New Haven. © DACS 2003

41 Carlo Carrà, *Interventionist Demonstration*, 1914. Tempera and collage on cardboard, 38.5 x 30 (15⅛ x 11⅞). Mattioli Collection, Milan. © DACS 2003

42 Umberto Boccioni, *The Charge of the Lancers*, 1915. Tempera and collage on pasteboard, 32 x 50 (12⅞ x 19⅝). Ricardo and Magda Jucker Collection, Milan

43 Gino Severini, *Cannon in Action*, 1915. Oil on canvas, 50 x 60 (19⅝ x 23⅝). Städelisches Kunstinstitut, Frankfurt am Main (on loan from private collection). © ADAGP, Paris and DACS, London 2003

44 Robert Delaunay, *L'Equipe de Cardiff* (The Cardiff Team), 1913. Oil on canvas, 326 x 208 (128⅜ x 81⅞). Musée d'Art Moderne de la ville de Paris. © L & M Services B.V. Amsterdam 20021202

45 Guillaume Apollinaire, 'Il Pleut', July 1914. Published in *SIC*, December 1916

46 Kasimir Malevich, *Woman at a Poster Column*, 1914. Oil on canvas, collage, 71 x 54 (28 x 21¼). Stedelijk Museum, Amsterdam

47 George Grosz, *The City*, 1916–17. Oil on canvas, 100 x 102 (39⅜ x 40⅛). Mr and Mrs Richard L. Feigen, New York. © DACS 2003

48 Opening of the First Dada International Fair, Burchard Gallery, Berlin, June 1920. Photograph

49 Tristan Tzara, page from '*391*' no. 14, November 1920. British Library, London

50 Francis Picabia, *Prenez garde à la peinture* (Pay attention to painting), 1919. Oil, enamel and metallic paint on canvas, 91 x 75 (36 x 28⅞). Moderna Museet, Stockholm. © ADAGP, Paris and DACS, London 2003

51 Marcel Duchamp, *Apolinère Enameled*, 1916–17. Painted tin advertisement, 23.5 x 33.7 (9¼ x 13¼). Philadelphia Museum of Art. Louise and Walter Arensberg Collection. Photo Graydon Wood, 1994. © Succession Marcel Duchamp/ADAGP, Paris and DACS, London 2003

52 Marcel Duchamp, *L.H.O.O.Q.*, 1919. Photographic reproduction and pencil, 19.6 x 12.3 (7⅜ x 4⅞). Private Collection, Paris. © Succession Marcel Duchamp/ADAGP, Paris and DACS, London 2003

53 Marcel Duchamp, *La Mariée mise à nu par ses célibataires, même (Boîte verte)* (The Bride stripped bare by her Bachelors, even (Green Box)), 1934. 93 facsimiles (photographs, drawings and manuscript notes, 1911–15), contained in a green cardboard box, 33.2 x 28 x 2.5 (13¼ x 11 x 1). Private Collection, Paris. © Succession Marcel Duchamp/ADAGP, Paris and DACS, London 2003

54 Hannah Höch, *Cut with the Cake Knife*, c. 1919. Collage, 114 x 89.8 (44⅞ x 35⅜). Staatliche Museen, Berlin. © DACS 2003

55 Raoul Hausmann, *ABCD*, 1923–24. Collage of pasted papers, 40.7 x 28.5 (16 x 11¼). Musée National d'Art Moderne, Centre Georges Pompidou, Paris. © ADAGP, Paris and DACS, London 2003

56 Kurt Schwitters, *Bild mit heller Mitte* (Picture With Light Centre), 1919. Collage of paper with oil on cardboard, 84.5 x 65.7 (33¼ x 25⅞). Museum of Modern Art, New York. © DACS 2003

57 Examples of handwritten and typewritten script in A. Ozenfant and C. E. Jeanneret, 'Formation de l'optique moderne', *L'Esprit Nouveau*, no. 21, 1924. Da Capo Press Reprint, 1968, New York.

58 Fernand Léger, *La Ville* (The City), 1919. Oil on canvas, 231 x 297 (91 x 116⅞). Philadelphia Museum of Art, A. E. Gallatin Collection. © ADAGP, Paris and DACS, London 2003

59 Walker Evans, *Roadside Stand near Birmingham, Alabama*, 1936. Library of Congress, Washington D. C., LC-USF342-8255A

60 Charles Demuth, *I Saw the Figure Five in Gold*, 1928. Oil on composition board, 90.2 x 76.2 (35½ x 30). Metropolitan Museum of Art, New York. Alfred Stieglitz Collection 1949 (49.59.1)

61 Alexander Rodchenko, *Osip Brik*, 1924. Photograph. Galerie Gmurzynska, Cologne. © DACS 2003

62 Laszlo Moholy-Nagy, *Yellow Disc*, 1919–20. Oil on linen, 66 x 51 (26 x 20‰). Davis Museum and Cultural Center, Wellesley College, Wellesley, Massachusetts, Gift of Mrs. Sibyl Moholy-Nagy. Photo Steve Briggs. © DACS 2003

63 Laszlo Moholy-Nagy, *Typo-Collage*, 1922. 38 x 27 (15 x 10⅝). Collection of Hattula Moholy-Nagy. © DACS 2003

64 Kurt Schwitters, double page spread from 'Typoreklame' issue of *Merz*, 1924. © DACS 2003

65 Paul Renner, 'Futura', 1928. Photograph. Courtesy of St Bride's Library, London

66 André Breton, *Object–Poem*, 1935. Collaged objects on board, 16.5 x 20 (6½ x 7¾). Roland Penrose Collection, London. © ADAGP, Paris and DACS, London 2003

67 Jacques-André Boiffard, *Boulevard Magenta devant le Sphinx-Hôtel (Boulevard Magenta, outside the Sphinx Hotel)*. Photograph in André Breton, *Nadja*, Éditions Gallimard, Paris, 1928

68 Paul Klee, *Eros*, 1923. Watercolour on paper, mounted on cardboard, 33.3 x 24.5 (13¼ x 9⅝). Collection Rosengart, Lucerne. © DACS 2003

69 Max Ernst, *Pietà or Revolution by Night*, 1923. Oil on canvas, 115.9 x 88.9 (45⅝ x 35). Tate Gallery, London. © ADAGP, Paris and DACS, London 2003

70 René Magritte, *The Interpretation of Dreams*, 1927. Oil on canvas, 38 x 55 (15 x 21½). Staatsgalerie Moderner Kunst, Munich. © ADAGP, Paris and DACS, London 2003

71 René Magritte, *'Les Mots et les images'*, 1929. Pen and ink drawing, 27.5 x 21.2 (10⅞ x 8⅜). Galerie Isy Brachot, Brussels. © ADAGP, Paris and DACS, London 2003

72 Max Ernst, *Picture Poem*, 1923–24. Oil on canvas, 65 x 52 (25⅝ x 20½). Baron and Baronne Urvater. © ADAGP, Paris and DACS, London 2003

73 Joan Miró, *Ceci est la couleur de mes rêves* (This is the Colour of my Dreams), 1925. Oil on canvas, 96.5 x 129.5 (38 x 51). Private collection. Courtesy Pierre Matisse Gallery, New York. © Succession Miro, DACS 2003

74 André Masson, *Furious Suns*, 1925. Pen and ink on paper, 42.2 x 31.7 (16⅝ x 12½). Museum of Modern Art, New York. © ADAGP, Paris and DACS, London 2003

75 Henri Michaux, *Alphabet*, 1927. Ink on paper, 36 x 26 (14⅛ x 10¼). Collection Claire Paulhan, Paris. © ADAGP, Paris and DACS, London 2003

76 Shen Zhou, *Ode to the Pomegranate and Melon Vine*, c. 1506–1509. Pen and ink and watercolour on paper, 149 x 75.5 (58⅝ x 29¾). The Detroit Institute of Arts. Founders Society purchase, Mr and Mrs Edgar B. Whitcomb fund. Photo Bridgeman Art Library, London

77 A view of Room 3 in 'Entartete Kunst' (Degenerate Art), Munich 1937, showing the projection along the south wall, including the Dada wall. Photo Bildarchiv Preussischer Kulturbesitz, Berlin

78 Gustav Klucis, design for poster *The Electrification of the Entire Country*, 1920. Photomontage State Museum of Mayakovsky, Moscow

79 El Lissitzky, *Beat the Whites with the Red Wedge*, 1919–20. Poster, 48.5 x 69.2 (19⅛ x 27¼). Stedelijk Van Abbemuseum, Eindhoven. © DACS 2003

80 John Heartfield, *Hangman and Justice*, 1933. John Heartfield Archiv, Akademie der Kunste zu Berlin. Inv. No. 733. © DACS 2003

81 Joan Miró, *Aidez L'Espagne* (Help Spain), 1936. Screen print on arches paper, 32 x 25.3 (12⅝ x 10). © Succession Miro, DACS 2003

82 Charlotte Salomon, Page from *Leben? Oder Theater?* (Life? Or Theatre?), no. 4315-2159, 1940–42. Gouache on paper, 32.5 x 25 (12⅞ x 9⅞). Collection Jewish Historical Museum, Amsterdam. © Charlotte Salomon Foundation

83 Jean Dubuffet, *Wall with Inscriptions*, 1945. Oil on canvas, 99.7 x 81 (39¼ x 31¾). Museum of Modern Art, New York. © ADAGP, Paris and DACS, London 2003

84 Isidore Isou, *AMOS ou Introduction à la métagraphologie*, 1952. Gouache on black and white photograph, 59 x 28.5 (15⅝ x 11¼). Courtesy the Artist

85 Adolf Wölfli, *General View of the Island Neveranger* (General-Ansicht del Insel Niezohrn), 1911. Pencil and coloured pencil on newsprint, 99.8 x 71.2 (39⅛ x 28). Adolf Wolfi Stiftung, Kunstmuseum, Bern

86 Pierre Alechinsky, *Writing Exercise* (Exercise d'Ecriture), 1950. Destroyed. © ADAGP, Paris and DACS, London 2003

87 Henri Michaux, *Indian Ink Drawing*, 1959. Indian ink on paper, 75 x 105 (29¾ x 41⅜). Musée Nationale d'Art Moderne, Paris, Fonds D.B.C. AM 1976-1169 D. © ADAGP, Paris and DACS, London 2003

88 Antoni Tàpies, *Grisos amb traços negres Núm XXXIII*, (Grey with Black Traces XXXIII), 1955. Mixed media on canvas, 162.5 x 130 (64 x 51¼). Collection of Contemporary Art, Fundación "La Caixa" Barcelona. © DACS 2003

89 Mark Tobey, *Shadow Spirit of the Forest*, 1961. Tempera on paper, 48.4 x 63.2 (19 x 24⅞). Courtesy Kunstsammlung Nordrhein-Westfalen. Photo Walter Klein, Dusseldorf. Estate of Mark Tobey © Seattle Art Museum

90 Jackson Pollock, *Stenographic Figure*, c. 1942. Oil on canvas, 101.6 x 142.2 (40 x 56). Museum of Modern Art, New York. © ARS, New York and DACS, London 2003

91 Rudolph Burckhardt, *Pollock Painting*, 1950. Photograph. © Estate of Rudy Burckhardt/VAGA, New York/DACS, London, 2003

92 YU-ICHI (Yu-ichi Inoue), *Bone*, 1959. Performance. YU-ICHI (Yu-ichi Inoue). © UNAC TOKYO

93 Franz Kline, *Untitled*, c. 1952. Oil on telephone book paper, 27.5 x 23 (10⅞ x 9) Estate of Franz Kline. © ARS, New York, and DACS, London 2003

94 Robert Ryman, *Untitled*, 1959. Oil paint on stretched cotton canvas, 111.1 x 111.1 (43¾ x 43¾). Courtesy of Pace Wildenstein, New York. Photo Gordon Riley Christmas. © 2003 Robert Ryman

95 Cy Twombly, *The Italians*, 1961. Oil, pencil and crayon on canvas, 199.5 x 259.6 (78¾ x 102¼). Museum of Modern Art, New York, Blanchette Rockefeller Fund. Courtesy the Artist

96 Cy Twombly, *Panorama, New York City*, 1955. House paint, crayon and chalk on canvas, 257 x 339 (101¼ x 133½). Thomas Ammann Fine Art, Zurich. Courtesy the Artist

97 Robert Rauschenberg, *Trophy I (For Merce Cunningham)*, 1959. Oil, pencil, metallic paint, paper, fabric, wood, metal, newspaper, printed reproductions and photograph on canvas, 167.6 x 104.1 x 15 (66 x 41 x 2). Kunsthaus, Zurich. © Robert Rauschenberg/VAGA, New York/DACS, London 2003

98 Eugen Gomringer, *Silencio*, 1954. Sackner Archive of Concrete and Visual Poetry, Florida. Courtesy the Artist

99 Dieter Roth, Ideogram from *Bok*, 1956–59. © Dieter Roth Foundation, Hamburg. Photo Heini Schneebeli

100 Allan Kaprow, *Words*, 1961. Rearrangeable environment with lights and sounds. Courtesy the Getty Research Library. Photo © Robert R. McElroy/VAGA, New York/DACS, London 2003

101 Fluxus Collective, *Fluxkit*, 1964. This example 1966. Vinyl case with mixed media, 30.5 x 44.5 x 12.7 (12 x 17½ x 5). The Gilbert and Lila Silverman Fluxus Collection, Detroit

102 Ben Vautier, *Le Magasin de Ben*, 1962. Installation, dimensions variable. Collection of the Artist. © ADAGP, Paris, and DACS, London 2003

103 Yoko Ono, *Smoke Painting*, 1961. © 1961 Yoko Ono

104 Piero Manzoni, *Living Sculpture*, 1961. Performance. © DACS 2003

105 Raymond Hains, *Paix en Algérie* (Peace in Algeria), 1956. Torn posters on canvas, 37.5 x 52.5 (14⅝ x 12⅝). Collection Ginette Dufrêne, Paris. © ADAGP, Paris and DACS, London 2003

106 Mimo Rotella, *Cinemascope*, 1962. Torn posters on canvas, 175 x 133 (68⅞ x 52⅜). Museum Ludwig, Cologne. © DACS 2003

107 Asger Jorn and Guy-Ernest Debord, page from *Mémoires*, 1959. Oil, ink and collage on paper. 27.5 x 21.6 (10⅞ x 8½). Musée Nationale d'Art Moderne, Paris, Centre Georges Pompidou, Paris. © Asger Jorn/DACS 2003

108 View of Times Square at night, New York City, c. 1968. Courtesy Getty Images. Photo Frederic Lewis/Getty Images

109 Stuart Davis, *Lucky Strike*, 1924. Oil on paperboard, 46 x 61 (18 x 24). Hirschhorn Museum & Sculpture Garden, Smithsonian Institution, Museum Purchase, 1974. Photo Lee Stalworth. © Estate of Stuart Davis/VAGA, New York/DACS, London 2003

110 Peter Blake, *On the Balcony*, 1956–57. Oil on canvas, 121 x 91 (47 ⅞ x 35 ⅞). Tate Gallery, London. © Peter Blake, 2003. All Rights Reserved, DACS

111 Richard Hamilton, *Just What Is It That Makes Today's Homes So Different, So Appealing?*, 1956. Collage on paper, 26 x 25 (10¼ x 9⅞). Kunsthalle, Tübingen. Prof. Dr. Georg Zundel Collection. © Richard Hamilton, 2003. All Rights Reserved, DACS

112 Jasper Johns, *Numbers in Colour*, 1958–59. Encaustic and newspaper on canvas, 168.9 x 125.7 (66½ x 49½). Albright Knox Art Gallery, Buffalo. Gift of Seymour H. Knox, Jr., 1959. © Jasper Johns/VAGA, New York/DACS, London 2003

113 Andy Warhol, *Five Coke Bottles*, 1962. Oil on canvas, 40.5 x 51 (16 x 20). Collection Richard H. Solomon, New York. © The Andy Warhol Foundation for the Visual Arts, Inc./ARS, New York and DACS, London 2003

114 Jasper Johns, *Map*, 1961. Oil on canvas, 198.1 x 312.7 (78 x 123⅛). The Museum of Modern Art, New York. Gift of Mr. & Mrs. Robert C. Scull, 1963. © Jasper Johns/VAGA, New York/DACS, London 2003

115 Robert Indiana, *The Demuth American Dream #5*, 1963. Oil on canvas, 365.8 x 365.8 (144 x 144). © Art Gallery of Ontario, Toronto. Gift from the Women's Committee Fund, 1964. Photo Carlo Catenazzi. © ARS, NY and DACS, London 2003

116 Ed Ruscha, *Large Trademark with Eight Spotlights*, 1962. Oil on canvas, 169.6 x 338.5 (66¾ x 133¼). Whitney Museum of American Art, New York. Copyright Ed Ruscha

117 Roy Lichtenstein, *Hopeless*, 1963. Oil on canvas, 112 x 112 (44 x 44). Kunstmuseum Basel, Ludwig Collection. © Estate of Roy Lichtenstein/DACS 2003

118 Panel from *Run for Love! In Secret Hearts*, # 83 (November 1962). '*Secret Hearts*' #83. © 1962 DC Comics. All Rights Reserved. Used with Permission

119 John Baldessari, *Tips for Artists*, 1967–68. Acrylic on canvas, 172.7 x 143.5 (68 x 56½). Collection of the Broad Art Foundation, Santa Monica, Calif. Courtesy the Artist and Marian Goodman Gallery, New York

120 Sigmar Polke, *Moderne Kunst* (Modern Art), 1968. Acrylic, lacquer on canvas, 150 x 125 (59 x 49¼). Sammlung Fröhlich, Stuttgart. Copyright the Artist

121 Lawrence Weiner, *Earth to Earth Ashes to Ashes Dust to Dust*, 1970. Language and materials referred to, dimensions variable. Solomon R. Guggenheim Museum, New York. Panza Collection, Gift, 1992. Photo David Heald. © The Solomon R. Guggenheim Foundation, New York. © ARS, New York and DACS, London 2003

122 Arakawa and Madeline Gins, from *The Mechanism of Meaning*, 'Meaning of Intelligence', panel 3 of 5, 1969. Acrylic on canvas, 243.8 x 172.7 (96 x 68). Ludwig Collection, Aachen. Courtesy Ronald Feldman Fine Arts, New York. Copyright Arakawa and Madeline Gins

123 On Kawara, *May 19, 1991*, 1991. "Today" Series No. 14. Liquitex on canvas, 25.5 x 33 (10 x 13). Private Collection, Turin. Courtesy Lisson Gallery, London. Photo Sue Ormerod, London

124 Joseph Kosuth, *Titled (Art as Idea as Idea (Idea))*, 1967. Black and white photograph, 121.9 x 121.9 (48 x 48). Private Collection. © ARS, New York and DACS, London 2003

125 Art & Language, *Secret Painting (Ghost)*, 1968. Acrylic on canvas and photostat. 2 parts, 92 x 92 (36¼ x 36¼). Collection Fundacion Berardo, Lisbon. Courtesy Lisson Gallery, London. Photo Stephen White, London

126 Hans Haacke, *Mobilization*, 1975. Four-colour silkscreen on acrylic plastic, 146 x 122 (57½ x 48), edition of 6. Collection Valerio Raspollini and others. Courtesy the Artist. © DACS 2003

127 Victor Burgin, *A Promise of Tradition*, 1986. Photographic print, 101.6 x 152.4 (40 x 60). Museum of Modern Art, Oxford. Courtesy Lisson Gallery, London and the Artist

128 Martha Rosler, *The Bowery in Two Inadequate Descriptive Systems*, 1974–75. 45 black and white photographs and 3 black panels, 20.3 x 25.4 (8 x 10) each. Edition of 5. © Martha Rosler, 1974–75. Courtesy Gorney Bravin + Lee, New York

129 Tom Phillips, page from *A Humument*, 1967. Courtesy the Artist

130 Joseph Beuys, *Art=Capital*, 1980. Chalk on painted wood panel, iron frame, 244 x 122 (96 x 48). Marx Collection, Berlin. © DACS 2003

131 Atelier Populaire, Paris, *La Lutte Continue* (The Struggle Continues), 1968. Poster

132 Mario Merz, *Igloo di Giap (Se il nemico si concentra perde terreno, se si disperde perde forza)*, 1968. Glass, metal, wax, stone, earth, sticks and other materials. 120 x 200 (47¼ x 78¾). Musée National d'Art Moderne, Centre Georges Pompidou, Paris. Courtesy Archivio Merz

133 Maurizio Nannucci, *Phonetic Alphabet*, 1967–68. 240 x 9 x 3 (94½ x 3½ x 1¼). Courtesy the Artist

134 Alighiero Boetti, *Ordine e disordine* (Order and Disorder), 1974. Embroidery, 45.7 x 43.2 (18 x 17). Courtesy Archivio Alighiero Boetti, Rome. © DACS 2003

135 Richard Long, *A Line in the Himalayas*, 1975. Framed work, photography and text. © Richard Long

136 Hamish Fulton, *The Pilgrim's Way*, 1971. Photograph with text, 61.3 x 66.5 (24¼ x 26¼). Courtesy the Artist

137 Robert Smithson, *A Heap of Language*, 1966. Pencil on paper, 16.5 x 56 (6½ x 22). Museum Overholland, Nieuwersluis. © Estate of Robert Smithson/VAGA, New York/DACS, London 2003

138 Ian Hamilton Finlay, *Westward-facing Sundial*, 1971. Courtesy the Artist. Photo David Paterson

139 Marcel Broodthaers, *Museum*, 1968–69. Plastic, 2 parts (black, white), 85 x 120 (32¾ x 47¼). Municipal Van Abbe Museum, Eindhoven. © DACS 2003

140 Bruce Nauman, *Run from Fear, Fun from Rear*, 1972. Neon tubing with clear glass tubing suspension frames, 2 parts; 20.3 x 116.8 x 5.7 (8 x 46 x 2¼) and 18.4 x 113 x 5.7 (7½ x 44½ x 2¼). Edition of 6. Collection Gerald S. Elliot, Chicago. © ARS, New York and DACS, London 2003

141 Nancy Spero, *The Hours of the Night*, 1974. Handprinting and gouache collage on paper (11 panels), 274.3 x 670.6 (108 x 264). Collection of the Artist. Photo David Reynolds

142 Hanne Darboven, *Seven Panels and Index*, 1973. Graphite on white wove paper, panels 177.8 x 177.8 (70 x 70), index 106 x 176 (41¾ x 69¼). © Art Institute of Chicago. Barbara Neff Smith Memorial Fund, Barbara Neff Smith & Solomon H. Smith Purchase Fund, 1977.600a-h. Courtesy Sperone Westwater Gallery, New York

143 Mary Kelly, *Post-Partum Document: Documentation VI, Pre-writing Alphabet, Exergue and Diary*, 1978. Perspex units, white card, resin, slate. 1 of 15 units, each 20 x 25.5 (7¾ x 10). Collection, Arts Council of Great Britain. Courtesy the Artist. Photo Ray Barrie

144 Barbara Kruger, *Untitled (I shop therefore I am)*, 1987. Photographic silkscreen on vinyl, 304.8 x 304.8 (120 x 120). Private Collection, Zurich. Courtesy Mary Boone Gallery, New York

145 Henry Chalfant, *Dust Sin*, 1982. Photograph. From *Subway Art* by Martha Cooper and Henry Chalfant, Thames & Hudson Ltd., London, 1984

146 Tim Rollins and KOS, *From the Animal Farm I*, 1985–88. Acrylic/paper, linen, 139.7 x 203.2 (55 x 80). Private Collection. Courtesy the Artists

147 Julian Schnabel, *Ignatius of Loyola*, 1987. Oil on tarpaulin, 457.2 x 355.3 (180 x 152). Photo courtesy PaceWildenstein, New York. © 2002 Julian Schnabel

148 Jean-Michel Basquiat, *Untitled*, 1984. Acrylic, silkscreen and oilstick on canvas, 233.5 x 195.5 (88 x 77). Robert Miller Gallery, New York. © ADAGP, Paris and DACS, London 2003

149 Anselm Kiefer, *Märkische Heide* (Heath of the Brandenburg March), 1974. Oil, acrylic and shellac on burlap, 118 x 254 (46½ x 100). Van Abbe Museum, Eindhoven. Courtesy the Artist

150 Simon Linke, *Franz Kline, Summer 1975*, 1989. Oil on canvas, 75 x 75 (129½ x 129½). Courtesy Lisson Gallery, London. Photo Sue Ormerod

151 Christopher Wool, *Untitled*, 1990–91. Enamel on aluminium, 274.5 x 182.9 (108 x 72). Courtesy Christopher Wool, Luhring Augustine Gallery, New York

152 Richard Prince, *What A Kid I Was*, 1989. Acrylic and silkscreen on canvas, 172.7 x 121.9 (68 x 48). Courtesy Barbara Gladstone Gallery, New York. Photo Larry Lame

153 Ashley Bickerton, *Tormented Self-Portrait (Susie at Arles) #2*, 1988. Mixed media construction, 228.6 x 175.3 x 45.7 (90 x 69 x 18). Courtesy Sonnabend Gallery, New York

154 Jenny Holzer, *Survival*, 1988–89. Electronic sign, Piccadilly Circus, London. Photo Paul Wrede. © ARS, New York and DACS, London 2003

155 Susan Hiller, *Élan*, 1982. 13 C-type photographs and vocal soundtrack, 7 minutes, 213.4 x 94 (84 x 37). Courtesy the Artist

156 Ken Lum, *Amir New & Used*, 2000. Plexiglas, powdercoated aluminium, enamel paint, glue and plastic letters. 152.4 x 213.4 (60 x 84). Edition of 2. Courtesy Andrea Rosen Gallery, New York. Photo Oren Slor. © Ken Lum

157 Jack Pierson, *Desire, Despair*, 1996. Metal, plastic, plexiglass and wood, 298.5 x 142.9 (117½ x 56¼). Whitney Museum of American Art, New York: Purchase, with funds from the Painting and Sculpture Committee, 97.102.2a-1. Courtesy the Artist

158 Fiona Banner, *Car Chases (Bullitt)* (detail), 1998. Silkscreen print, 130 x 170 (51 x 67). Courtesy the Artist and Frith Street Gallery, London

159 Gillian Wearing, *Signs that say what you want them to say and not signs that say what someone else wants you to say*, 1992–93. C-type print, 40 x 30 (15¾ x 11¾). Courtesy Maureen Paley Interim Art, London

160 Tracey Emin, *Mad Tracey from Margate, Everyone's Been There*, 1997. Appliquéd blanket fabric from clothing provided by friends, 215 x 267 (84½ x 105½). Courtesy Jay Joplin/White Cube (London). Photo Stephen White

161 Glenn Ligon, *Untitled (I do not always feel colored)*, 1990. Oil stick and gesso on wood, 203.2 x 76.2 (80 x 30). Private Collection. Courtesy the Artist

162 Shirin Neshat, *Unveiling*, 1993. RC print & ink, 152.4 x 101.6 (60 x 40). Courtesy Barbara Gladstone Gallery, New York. Photo Plauto. © 1993 Shirin Neshat

163 Lothar Baumgarten, *Eldorado*, 1987. Installation. Installation view at the Kunsthalle, Bern. © DACS 2003

164 Simryn Gill, *Washed Up*, 1995. Etched sea-washed glass, dimensions variable. Courtesy of Roslyn Oxley, 9 Gallery, Sydney

165 Ilya Kabakov, *Carrying Out the Slop Pail*, 1980. Enamel on masonite, 150 x 210 (59 x 82). Collection Kunstmuseum, Basel. © DACS 2003

166 Svetlana Kopystiansky, *Seascape*, 1984. Tempera on canvas, 70 x 90 (27½ x 35½). Courtesy of the Artist and the Lisson Gallery, London

167 Xu Bing, *A Book from the Sky*, 1987–91. Installation at the National Gallery, Beijing. Rice paper, Eastern book printing and binding equipment, 5 m. x 10 m. x 25 m. (16 ft x 33 ft x 82 ft). Copyright Xu Bing

168 Carlos Capelán, *Jet Lag Mambo* (detail), 2000. Indian ink drawings, texts, wall lamps and wall decoration plaster. Installation, Henie Onstad Kunstsenter, Oslo. Photo Alfredo Pernin. Copyright Carlos Capelán

169 Guillermo Kuitca, *Nordrhein*, 1992. Oil on mattress, 203.2 x 203.2 x 10.2 (80 x 80 x 4). Collection UBS Painewebber, Inc., New York. Courtesy Sperone Westwater, New York

170, 171 Frédéric Bruly Bouabré, *Museum of African Face (Scarifications)*, 1991–92. Series of 162 drawings, coloured pencil, ballpoint pen on cardboard, 9.5 x 15 (3¾ x 5¾). Courtesy of C.A.A.C. – The Pigozzi Collection, Geneva

172 Knowbotic Research, *I0_dencies – questioning urbanity; Tokyo, Sao Paulo, Ruhrgebiet, Venezia*, 1997–99. Collaborative network project and interactive installation. © Knowbotic Research

173 Laurie Anderson, *Songs & Stories from Moby Dick*, 1999. Live Performance. Courtesy of Canal St. Communications. Photo Frank Micelotta

174 Gary Hill, *Incidence of Catastrophe*, 1987–88. Video still, colour video/sound. Duration 43:51 mins. Courtesy Barbara Gladstone Gallery, New York

175, 176 Lynn Hershman, *Lorna*, 1979–84. Interactive videodisk. Courtesy Lynn Hershman

177, 178, 179 Jeffrey Shaw, *The Legible City*, 1989–91. Computer graphic installation. Collection of ZKM-Medienmuseum, Karlsruhe. Courtesy the Artist

180 Maciej Wisniewski, *Netomat*, 1999. Screenshot. Courtesy the Artist

181 Robert Barry, *Installation at Galleria 57, Madrid*, 1991. Plastic film letters on painted wall. Courtesy the Artist

182 Joseph Kosuth, *Zero & Not Exhibition*, 1989. Installation at Freud Museum, Vienna. Photo © Sigmund Freud Museum, Vienna. © ARS, New York and DACS, London 2003

183 Jenny Holzer, *Arno*, 1996. Xenon projection, approximately 60.69 m. x 35.05 m. (200 ft x 115 ft), Florence. Photo Attilio Maranzano. © ARS, New York and DACS, London 2003

184 Martin Creed, *Work No. 203, Everything is going to be alright*, 2001. Neon, 61 x 1219.2 (24 x 480). Installed at Clapton, London. Courtesy Gavin Brown's Enterprise, New York

Index